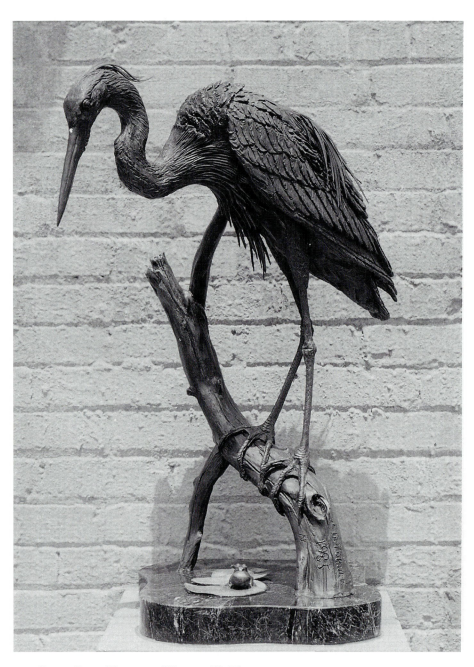

GREAT BLUE HERON BY WILLIAM H. TURNER

Brookgreen Gardens Sculpture

BY ROBIN R. SALMON

Volume II

Printed by order of the Trustees
BROOKGREEN GARDENS
1993

*The printing of this publication is made possible
by a generous grant from Dorothy R. Blair of Naples, Florida.*

*Funds from the South Carolina Arts Commission
which receives support from the National Endowment for the Arts
have assisted in the preparation of the manuscript.
These funds are part of annual grants
which support the arts programming of Brookgreen Gardens.*

Contents

SCULPTURE *(Illustrations are listed in italics)*

SCULPTURE (continued)

Acknowledgments

There are many contributions that go into the publication of a book. First, and foremost, my deepest thanks and appreciation go to Dorothy R. Blair of Naples, Florida, whose generosity made the printing of this second volume possible. Her interests in sculpture and in nature, two purposes of Brookgreen Gardens, have led her to support many worthy activities in these areas. I am extremely grateful to this gracious lady for believing that this, too, was a worthy project.

Second, appreciation goes to Beatrice Gilman Proske of Ardsley, New York, whose life work has centered upon sculpture. She is not only an inspiration and a role model, but a dear friend. She is also a hard act to follow and I am continually challenged to maintain the distinctive flair and high standard which she always places upon her work.

I especially thank Gurdon L. Tarbox, Jr., President of Brookgreen Gardens, for the fine photographs which illustrate this volume and for his unending encouragement. The photography of sculpture, especially outdoor sculpture, is a difficult and demanding combination of science and art which few people have mastered. Gurdon Tarbox is most certainly one of the finest photographers in this specialized field. The photograph of *Diana of the Chase* for the dust jacket is a testimony to his special talent.

There are a number of colleagues who have generously taken time to read some of the entries and who have made valuable comments in that regard. Those who deserve special thanks are Donna Hassler of The Metropolitan Museum of Art, Susan James-Gadzinski of the Pennsylvania Academy of the Fine Arts, Susan Menconi of the Richard York Gallery, Theodora Morgan and Gwen Pier of the National Sculpture Society, and George Gurney of the National Museum of American Art

The individual sculptors, their families and their staffs have been most cooperative in sharing information and in providing comments on the entries. They made the task easier and, quite often, a delightful experience for me.

The staff of Brookgreen Gardens has provided me with an enjoyable working atmosphere and has rendered valuable assistance. My thanks go to Anna Kinsey, who helped to proof read the manuscript and, in general, made

everything easier for me; and to Amy Shaver, Marilyn Helmrich and Amelia McFadden, who compiled and arranged many of the references.

Thanks also go to Lorna Ausband of Ausband & Norton, Inc., who has performed the Herculean task of typesetting and layout for this book. Her knowledge and invaluable good humor on this and all our projects make working with her a true joy.

Finally, I wish to thank a particular gentleman for his support and friendship.

Robin R. Salmon
Vice President of Academic Affairs
and Curator of Collections

Preface

It has been my good fortune to have the original catalogue of the sculpture at Brookgreen Gardens carried on by a person in sympathy with my own principles. The chief purpose was to record accurately the major events in each artist's life and to indicate his place in the artistic movements of the time. The narrative should be concise but enjoyable to read. It was important to grasp the spirit of each piece of sculpture and to interpret in words its special qualities. Such an ambitious undertaking is fraught with difficulties. Since writing is a skill not closely related to that of the sculptor, efforts in that medium can never be entirely successful; they can only be suggestive.

There were available to the author two sources, at least, that could not be used for the first volume. It has become clear from the records kept at Brookgreen that the choice of sculpture to be acquired was entirely in Anna Hyatt Huntington's hands as long as she was active, and her comments on these acquisitions are invaluable. She was also interested in the art library at Syracuse University to which in the 1960s she sent archival material from her studio, believing that the librarians there would index it by modern methods so that it could be used by students and scholars.

The author has brought to the task of describing sculpture the basic ideas that governed the first volume while using her own individual gifts as a writer to express her thoughts. She, too, believes that the human body is an extraordinary creation, an inexhaustible source for artistic inspiration.

Beatrice Gilman Proske
Ardsley, New York
January 20, 1993

Introduction

Work on this volume began in 1988 when I was given authorization by the Board of Trustees to move forward with an update to the work, *Brookgreen Gardens Sculpture*. That book, authored by Beatrice Gilman Proske and last revised in 1968, had become the definitive work on American figurative sculpture. The need was great to include new information on the many sculptors and their sculpture which had been acquired since 1968. This volume is a continuation of *Brookgreen Gardens Sculpture;* it is not a revision. Volume II is intended to be the companion to Volume I. The individual using it as a reference will note that many of the sculptors' entries refer to Volume I for additional information and, in some instances, for the complete biographical material.

Part of the difficulty in a work such as this comes in writing objectively about a person's life work, condensing it into a few paragraphs that contain the most important information, then trying to present it in an interesting, readable style. What is more difficult is to ask an artist (or artist's family) to read his or her biography and to provide corrections or criticism, then to incorporate that material into the text while maintaining an overall balance.

Compounding the difficulty is the fact that Brookgreen Gardens is continually adding sculpture to its collection. At what point does one draw the final line? As each new piece of sculpture was acquired it became clear that some were more important than others and some were of such significance that they could not be omitted. That line was extended several times until it was obvious that it could be extended no more. As a result, the last chronological entry in the book is S.1992.005 — *April* by Charles Parks.

At this point, mention must be made of two works which were acquired after the final line had been drawn. Both of these sculptors had not previously been part of the Brookgreen Gardens collection and both will be dealt with fully in the next publication.

Bacchus by Horatio Greenough (1805-1852) is an important work since this little bust was the sculptor's first attempt at stone carving. It was done about 1819 when Greenough was 14 years old. Although it bears the mark of an

amateur, as it was his first work, and as he was considered the first American who determined from youth that sculpture would be his profession, it takes on a greater significance. What is also significant is that this sculpture remained for more than 150 years with the family of the friend to whom the sculptor gave it. The story of its location becomes remarkable as it revolves around generations of people affiliated with Brookgreen Gardens and its property.

Love's Memories, a white marble statue of Cupid seated on an Ionic capital, was acquired just before this book went to press. Dated 1875, this was one of a few ideal figures modeled by Thomas Ball (1819-1911) at a period that was filled with commissions for portraits and public monuments.

These acquisitions strengthen the collection and reflect the ongoing goal to acquire works by early American sculptors. As Brookgreen Gardens' sculpture collection continues to expand, every effort is made to acquire those works that are considered the best examples of an artist. At this writing, the collection numbers 540 works by 238 sculptors, and it is unrivalled.

Unless otherwise stated, all photographs in this publication were taken by Gurdon L. Tarbox, Jr. The dimensions of each piece of sculpture are listed in order of height, width and depth unless otherwise indicated.

– R.R.S.

SCULPTORS
and their works

Hiram Powers

THE MOST FAMOUS American sculptor of his day, Hiram Powers was the eighth of nine children born to Stephen and Sarah (Perry) Powers. His birth occurred at Woodstock, Vermont, on July 29, 1805. His father, a farmer and blacksmith, moved the family to New York State and then to a small town near Cincinnati, Ohio. Here, Hiram Powers showed an early tendency toward a creative and mechanical ability. After the death of his father he found work doing odd jobs and eventually was hired at the age of 17 as a mechanic in a clock factory. In 1828 he got a job modeling figures in wax and devising ways to repair and mechanize exhibits in Dorfeville's Western Museum.

Shortly after his marriage to Elizabeth Gibson in 1832, he visited the studio of a German sculptor, John Eckstein, and for the first time saw sculpture in marble. He and two other students, Henry Kirke Brown and Shobal Clevenger, studied with Eckstein and shared creative ideas. After producing busts for two years, he traveled to Washington, DC, in 1834, set up a studio and accepted commissions for portrait busts. This move was suggested by Nicholas Longworth, a Cincinnati patron who recognized his talent and provided letters of intro-duction. While in Washington he modeled busts of Chief Justice John Marshall, the orator Daniel Webster, South Carolina statesman John Calhoun and President Andrew Jackson. In 1837 Powers embarked on a study trip to Italy which was financed by Nicholas Longworth and the Preston family of South Carolina. Senator William C. Preston was impressed with Powers' portraits of statesmen and encouraged his brother, John S. Preston, who had never seen his work, to donate an annual amount for the sculptor's income. Like Longworth, the Prestons believed in the cultivation of sculptors. Before the trip, Hiram Powers made portrait busts of Mr. & Mrs. John S. Preston and later named his son Preston in appreciation of his benefactors.

Powers settled in Florence and stayed there for the rest of life. He built a villa with a fine garden at one end of the Piazza Maria Antonia in 1867, and his studio became an attractive spot for tourists. Along with other sculptors of the time, he was attracted to Florence because it had a less restrictive government and this freedom held more creative promise for artists. The pace of life was slower than that of Rome and suited the expatriate Americans who flocked there. Although he made only one return trip to America, neither did he travel widely in Europe. As a result his sculpture was not greatly influenced by the old masters and remained more distinctly American.

The most famous of his ideal figures was *The Greek Slave*, a sculpture which

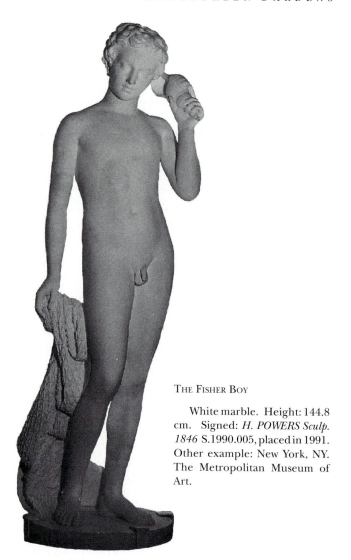

THE FISHER BOY

White marble. Height: 144.8 cm. Signed: *H. POWERS Sculp. 1846* S.1990.005, placed in 1991. Other example: New York, NY. The Metropolitan Museum of Art.

caused a stir when it was first exhibited in London in 1845. Two years later it was shown in the United States. Although the nudity was at first deemed improper, the figure ultimately brought Powers acclaim in Europe and America. What he did for American sculpture was to make it available to the public, encouraging Americans to look at sculpture. Much of his work was purchased for private collections, although a figure entitled *America* was done for the United States Capitol and Congress purchased life-sized statues of Benjamin Franklin and Thomas Jefferson for the foot of the stairways to the

Senate and the House Chambers. He declined to enter competitions and even to submit preliminary designs for approval of commissioned work believing that such directions and restrictions were unnecessary for an established artist.

Hiram Powers enjoyed solving problems of a mechanical nature and invented a special file for use with marble and the machine with which to manufacture the file. Working in a special room adjacent to his studio, he built a machine to punch holes in iron and devised other labor saving devices in relation to his sculpture. When an attempt to lay the Atlantic cable between the United States and England was unsuccessful in 1858, he experimented with his own engineering method that he believed would work.

Hiram Powers was elected an honorary member of the National Academy of Design in 1838. In 1841 he was given a professorship in the Royal Academy of Fine Arts in Florence, a singular honor.

Hiram Powers died at Florence in 1873.

The Fisher Boy

While *The Greek Slave* was being cut in marble, Hiram Powers was working on a model of a sculpture for Hamilton Fish of New York. The sculptor wrote, "It represents a lad of thirteen years holding a conch shell to his ear with one hand, while in the other is held a fishing net and a boat tiller. He is listening to the sound of the sea, believing that the shell has the power to warn him of the weather."[1] Powers drew upon Italian folklore as a device to allow him to portray a young male nude without controversy. Although the figure would have been widely accepted in Italy, it needed to be placed in a literary context in order to be accepted in America. The shell was copied from an example borrowed from the Grand Ducal Cabinet in Florence.

Work on this piece started in February of 1844 and the carving was completed in November of 1845. At that time Robert Stephenson of Newcastle-on-Tyne, Northumberland, England, visited Powers' studio, saw *The Fisher Boy*, and ordered the cutting of this example for the sum of £200. It was exhibited at the Royal Academy of Arts in London in 1847 and in the Exhibition of the Industry of All Nations at the City Art Gallery in Manchester in 1851. Only six examples of this sculpture were carved.

1 Crane, Sylvia E., *White Silence* (University of Miami Press, Coral Gables, FL, 1972) p. 205.

Randolph Rogers

ONE OF A GROUP of American neo-classical sculptors working in Rome in the latter half of the 19th century, Randolph Rogers came to be known as a literary sculptor: one who interpreted in his work themes from literature and the Bible. He was born July 6, 1825, at Waterloo, New York, to John and Sara (McCarthy) Rogers. When he was about nine years old, his family moved to Ann Arbor, Michigan, which was a territory of the United States. In his youth he apprenticed to a baker, clerked in a dry goods store and worked as a freelance illustrator for the local newspaper, *The Michigan Arbus.*

At the age of 22 he traveled to New York and secured a job in the dry goods firm of John Steward and Lycurgis Edgerton. In his spare time he kept busy by modeling statuettes and busts of their children. After recognizing his artistic talent, they funded a trip to Italy for him. He traveled to Florence in 1848 where he studied at the Accademia di San Marco under Lorenzo Bartolini until 1850, learning to work in clay and plaster. He did not study stone carving since that job customarily was left to studio assistants.

Following Bartolini's death he moved to Rome and set up a studio in the English-speaking quarter, where he remained for the next twenty years. During this time he created a bust entitled *Night,* shown in the National Academy of Design exhibition in 1852, and the biblical figure, *Ruth Gleaning,* which became immensely popular and focused international attention upon Rogers and his work. His skillful interpretation of biblical and literary themes led to important patronage.

In 1854 he received his first public commission: a life-size marble statue of John Adams completed in 1859 for Mount Auburn Cemetery in Cambridge, Massachusetts.[1] It was intended to be one of a series of portraits of Massachusetts citizens for the chapel. Its popularity in Boston led to further commissions including *Angel of the Resurrection,* done three years later for the funerary monument of Samuel Colt at Hartford, Connecticut. The figure of an angel holding a trumpet was based on verses from I Corinthians. In 1855 he returned briefly to the United States and repaid the loan of his benefactors, Steward and Edgerton.

From 1855 to 1858 Rogers worked on bronze doors for the entrance from the rotunda to the House Chamber of the Capitol in Washington, D.C. Scenes from the life of Christopher Columbus were depicted in eight low-relief panels bordered by allegorical figures of Europe, Asia, Africa, America and portraits of sixteen historic individuals who supported Columbus' travels. A lunette

over the doorway depicted the first landing in the new world. The doors were cast in bronze in 1860 at the Royal Bavarian Foundry in Munich.

He married Rosa Gibson in 1857. That same year he had been engaged by the governor of Virginia to complete the colossal Washington Monument at Richmond. The work had been left unfinished as a result of the death of the sculptor, Thomas Crawford. Rogers modeled two of the six standing figures — Meriwether Lewis and Nelson — and three seated allegorical figures representing the ideals of justice, independence and the Bill of Rights. Since Crawford had completed the other four figures, Rogers saw that they were shipped to Munich for casting.

Soldier of the Line, his first large military monument, was commissioned by the city of Cincinnati in 1863. In subsequent years, he received orders for similar monuments to commemorate the War Between the States at Providence, Rhode Island, Detroit, Michigan, and Worcester, Massachusetts. Work on these commissions lasted a number of years. The Providence memorial, dedicated in 1871, featured a colossal female figure wearing a liberty cap, angels with swords pointed downward representing peace and other figures depicting the armed forces. Perhaps his best work was represented by the figures of *Michigan* and *Emancipation*, part of the Detroit monument which was completed in 1873. *Genius of Connecticut*, atop the dome of the state Capitol at Hartford, was produced in 1877. No doubt a by-product of the recognition brought about by the many civic and municipal commissions, Rogers was appointed professor of sculpture at the Accademia di San Luca at Rome in 1873 and was named councilor in 1875.

Seated Lincoln, a colossal bronze statue commissioned for Fairmount Park in Philadelphia, was placed in 1870. It featured the president in a relaxed posture, legs crossed, deep in thought. Five years later, a statue of *William Henry Seward* for Madison Square Garden in New York City, was criticized in the belief that Rogers merely modeled a new head and put it on the body of the figure of Lincoln. Erected in 1876, it was the first heroic statue of a citizen of New York State.

Although he received numerous commissions for portrait busts, from time to time he created classical figures inspired by mythology, such as *Psyche*. One of his most popular works, *The Lost Pleiad*, was reproduced by the workmen in his Italian studio over one hundred times for wealthy American patrons. *The Last Arrow*, an equestrian group in the collection of the Metropolitan Museum of Art, was one of his last works, done in 1880. It depicts an Indian on horseback shooting an arrow at an unseen enemy while another Indian dies on the ground beneath the horse. Although dramatic and perhaps sentimen-

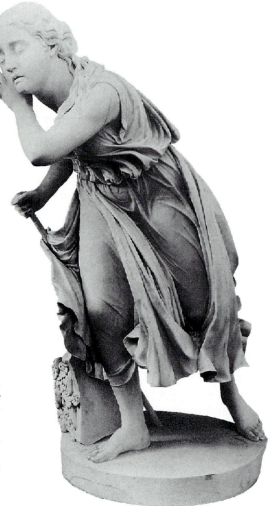

NYDIA, THE BLIND FLOWER GIRL
OF POMPEII

White marble. Height: 92.8 cm.
Signed: *Randolph Rogers Rome*
S.1988.003, placed in 1988. Other
examples: New York, NY. The Metro-
politan Museum of Art; Boston, MA.
Museum of Fine Art; Atlanta, GA. High
Museum of Art; Chicago, IL. The Art
Institute.

tal, the work represents the only time Rogers drew inspiration from a subject in American history.

In 1882, Rogers was paralyzed by a stroke which terminated his creative output. Two years later he was decorated with the order of Cavaliere della Corona d'Italia and knighted by King Umberto of Italy. In failing health and recognizing that his sculptural career was over, from 1886 to 1888, he sent most of the casts representing his life work to the Museum of Art and Architecture, part of the University of Michigan at Ann Arbor.[2] Randolph Rogers died at Rome on January 15, 1892 and was buried in San Lorenzo Cemetery.

Nydia, The Blind Flower Girl of Pompeii

A young blind woman, wearing a costume of Ancient Rome and holding a staff in her right hand, leans forward and cupping her left hand to her ear, listens intently. She is depicted during the destruction of Pompeii by the eruption of Mount Vesuvius in 79 A.D. Her hair has loosened in waves on her shoulders and her clothing is windblown. A broken Corinthian capital lies at her feet. The figure is carved in sharp outlines with narrow folded drapery. The pupils of the girl's eyes are not carved, adding to the illusion of blindness.

The figure was inspired by the character of Nydia, the blind flower girl from the novel by Edward Bulwer-Lytton, *The Last Days of Pompeii*, written in 1835. "She was dressed simply in a white tunic, which reached from the neck to the ankles...her features were more formed than exactly became her years, yet they were soft and feminine in their outline, and, without being beautiful in themselves, they were almost made so by their beauty of expression; there was something ineffably gentle, and you would say patient, in her aspect...A look of resigned sorrow, of tranquil endurance, had banished the smile, but not the sweetness, from her lips; something timid and cautious in her step — some-thing wandering in her eyes, led you to suspect the affliction which she had suffered from her birth: — she was blind; but in the orbs themselves there was no visible defect — their melancholy and subdued light was clear, cloudless, and serene...and then guiding her steps by a long staff, which she used with great dexterity, she took her way homeward."[3]

Nydia was first modeled in 1855 and, for over 30 years, continued to be carved by craftsmen at Rogers' Rome studio in fulfillment of orders from patrons. Probably his best known work, it was exhibited at the Philadelphia Centennial Exposition in 1876. Its popularity there led him to offer the figure in two sizes — a life-size version and a one-third reduction.[4] This example is one of the reductions, ordered by the Houston family of Philadelphia c.1880.

1 The statue is now at Memorial Hall, Harvard University.
2 Most of the plaster casts no longer exist.
3 Bulwer-Lytton, Edward, *The Last Days of Pompeii*, Dodd, Mead & Company, New York, 1946 (reprint), p.38 and p.41.
4 The lifesize figure was 55" in height and the reduction was 36".

Edward Kemeys

EDWARD KEMEYS, considered America's first sculptor of animals, was born at Savannah, Georgia, on January 31, 1843. He was the son of William and Abby Brenton (Greene) Kemeys from Scarborough, New York and Providence, Rhode Island. The death of his mother resulted in their return to New York about 1846 where Edward attended public school in Scarborough and New York City. At the age of thirteen, he first saw the frontier and its native wildlife while visiting relatives in Illinois. He spent summers on the prairies during the 1850s which quickened his interest in the wild, particularly the abundant animal life.

By the age of 17 he began working in the iron business, although the exact type of work he did is not known. In 1862 at the age of 19, he enlisted in the 65th Volunteer Regiment of the State of New York and served in the Peninsula campaigns of the War Between the States. Upon discharge, he re-enlisted in the 4th United States Colored Heavy Artillery where he attained the rank of captain in Company H. In 1866 he resigned and moved to Illinois to farm where he found that even army life had not prepared him for the discipline and routine required of a farmer. Nearly 30 years later, Kemeys spoke about this period of his life: "About this time I felt a great change coming…All this time I had been restless and unsatisfied…I couldn't content myself much longer dreaming and hunting…I fell asleep…and the voice woke me up — 'What are you doing here? You have not done your work.' I did not know what to do. I went back to work like a man sentenced to hang…Couldn't see any other way out of it, but suddenly I found myself on my way to New York."[1]

From 1866 until his first sculpture was produced in 1870, there is uncertainty as to the extent of his art studies. Kemeys professed to be a self-taught sculptor who possessed a keen interest in animals and learned by observation.[2] In later years he gave credit to hunting as being a form of artistic training. By observing and participating in the action of hunting, killing and preparing the meat and pelt, he acquired knowledge of animal anatomy, habit and instinct. In every sense, he became one with the animals for man himself was frequently the object of the hunt in the untamed frontier of the American West.

After returning to New York in the winter of 1867 he took a job with the civil engineering corps as an axeman felling trees in Central Park. One of the highlights of this job was his ability to study the wild animals in the Park Zoo. In interviews made by magazine writers in the latter part of the 19th century, Kemeys stated that after watching a sculptor in the zoo modeling a wolf, he

returned to his camp and fashioned a wolf's head in wax which his fellow workmen praised for its likeness. Encouraged by their response he fashioned a second head of "Lap," the workmen's pet Eskimo dog. He felt he had finally found his true life's work and soon produced two full scale groups.

His first sculptures, *Wounded Wolf* and *Wolf at Bay*, were dated 1870. In 1872 *Hudson Bay Wolves*, a life-size group of two wolves fighting over a carcass, was bought and erected by the Fairmount Park Art Association at Philadelphia. Money from the sale enabled him to return to the West in 1873 where he traveled Colorado's Arrickaree River and Wyoming's Wild River County and Great Bull River. Kemeys lived among hunters, trappers and Indians while he observed wild animals in the mountains and on the plains. His friend, the writer and critic, Julian Hawthorne, wrote of this trip: "...he always respects the modesty of nature, and never yields to the temptations to be dramatic and impressive at the expense of truth."[3]

He returned to New York and opened a studio. Here he produced a number of works that were cast in bronze including *Deer and Panther*, *Raven and Coyote*, and *Playing Possum*. *Under the Wolfskin*, a group depicting a freshly-slain bison and an Indian wearing a wolfskin, was shown at Stevens', a New York Gallery, in April 1874. *Playing Possum* was exhibited in 1876 at the Centennial Exposition in Philadelphia.

By 1877 he had traveled to London with Julian Hawthorne and held an exhibition of bronze groups and plasters at a small gallery. They were received favorably and *Deer and Panther* was sold to a collector in London. Kemeys moved on to Paris where *Bison and Wolves* was shown at the Salon of 1878 and attracted positive response from critics. Both English and French critics hailed his art as the beginnings of a national school since his self-taught style developed without benefit of European study. He had the opportunity to view the work of Barye and other French animaliers, but could not completely appreciate their significance nor the experience of being among French sculptors. The study of caged creatures now meant nothing to him after the thrill of first-hand experience of the wild. Kemeys felt confined and longed for the excitement of the frontier.

In 1879 he returned to the United States and traveled to the West where he studied live and dead animals, making dissections to improve his anatomical knowledge. Modeled in 1881, *Still Hunt*, a tense mountain lion about to seize its prey, was purchased by New York City for Central Park and unveiled in 1883. The clay model of this work, along with several smaller clay groups, was shown at the Exhibition of American Taxidermy that same year.

Financing for his western journeys was always a concern for Kemeys. In

1883, in order to secure funding for future trips, he proposed to the Smithsonian Institution to donate his model of *Still Hunt* along with 23 other models to "be an original and unique collection for the Government..." At the same time he asked the Smithsonian to fund his next trip. His proposal was taken under advisement but, although the gift of the sculpture was accepted, no financial assistance was offered.[4]

On June 13, 1885 he was married in his New York studio to Laura Swing of Bridgeton, New Jersey. She had been his pupil and also had studied under Lorado Taft. They moved into the former home of the painter George Inness in Eagleswood, a section of Perth Amboy, New Jersey.

In 1887, following the success of *Still Hunt,* a major work was a colossal *Bison Head* for the east side of the Missouri River railroad bridge linking Omaha, Nebraska to Council Bluffs, Iowa. Kemeys received the commission from Charles F. Adams, president of the Union Pacific Railroad. When it was cast in August 1887, it was considered the largest single bronze casting ever made in the United States. The *Bison Head,* placed on the bridge in 1888, signified the West looking to the East. It was removed in 1916 and later donated for scrap metal during World War II.

In 1892 Edward and Laura Kemeys moved to Chicago and set up a studio, Wolfden, in Bryn Mawr, Illinois. They lived there until 1900 but continued to travel to the West every summer. About this time he began to use the image of a wolf's head as a signature on his sculpture. By 1893 his career had reached its height as work for the World's Columbian Exposition was underway. He created twelve sculptures at his studio in Horticulture Hall and may have worked closely with at least four other animal sculptors: A. Phimister Proctor, Edward Clark Potter, A. A. Waagen and Theodore Baur. Chief among his works for the fair were four *American Panthers,* located on the bridge at the West Central Entrance to the Manufacture Building, and pairs of *Grizzly Bears* and *Bison.* The Panthers were praised as "quite extraordinary examples of animal sculpture..." and Kemeys was awarded a medal for his work.[5] A pair of monumental *Lions* were displayed at the Jackson Park fairgrounds. Mrs. Henry Field donated funds for casting and, on May 10, 1894, the bronzes were dedicated at the west entrance of the new Art Institute of Chicago.

As a result of his success at the Exposition, Kemeys was elected a member of the newly formed National Sculpture Society in the summer of 1893. At about the same time a commission came from Owen F. and Arthur T. Aldis who were constructing the Marquette Building, named in honor of the Jesuit missionary priest, Jacques Marquette, one of the founders of the Chicago area. He was to create relief portraits in bronze of Indian leaders and explorers of

the Mississippi valley. The reliefs were placed over the lobby elevators in 1895. Kemeys also executed the decorative work on the building's bronze doors including panther head push plates.[6]

A departure from animal sculpture was the John Noble Fountain for the Hot Springs Reservation in Hot Springs National Park, Arkansas. The small birdbath-like basin decorated by central figures was completed by June 1894. Kemeys also modeled decorative eagles to be cast in bronze for the park. At about the same time he produced a series of bas-reliefs featuring four strongly modeled scenes of habits of the American panther: *Feeding, At Bay, Still Hunt* and *At Play.*[7] In 1898 he created a fountain in memory of Benjamin F. Johnson for Champaign, Illinois. *A Prayer for Rain* featured an heroic figure of an Indian in ceremonial dress with arms raised in supplication for rain, flanked by a panther and deer. It was commissioned for a public park by the Johnson Estate and dedicated on June 10, 1899.

In 1886 Edward Kemeys had authored a series of thirteen articles for *Outing Magazine*. Published at about the same time was a series of articles by Theodore Roosevelt and the two men became friends. Roosevelt provided a letter of introduction when the sculptor moved to Washington, D.C. in 1902 and assisted him in obtaining an invitation to exhibit at the Louisiana Purchase Exposition held at Saint Louis in 1904. Kemeys created four small figures of bears placed at the side entrances of the Missouri State Building for which he won a medal.

By 1904, however, he was in declining health and his career was waning as other animaliers with more thorough training had arrived on the scene. Anxious to find a permanent place for his works, Kemeys contacted The Metropolitan Museum of Art. Although the museum declined his offer, it did acquire in 1907 *American Panther and her Cubs* which was cast in bronze from the original plaster.[8] Finally, on February 27, 1907, the new National Gallery of Art, part of the United States National Museum, received his collection of 47 plaster and bronze works.[9] His death occurred at Washington, D.C. on May 11, 1907. He received burial with military honors in the National Cemetery at Arlington, Virginia.

Although his work was not always technically nor anatomically perfect, Edward Kemeys was without a doubt the first American sculptor to devote his career to the depiction of native wild animals. His entry in the *Dictionary of American Biography* stated: "...just what he did can never be done again in our country, because already civilization has obliterated the lairs of the wild. His works are therefore historic records...His mastery in animal subjects is shown by a certain 'impressionistic realism.' For niceties of technique he cared

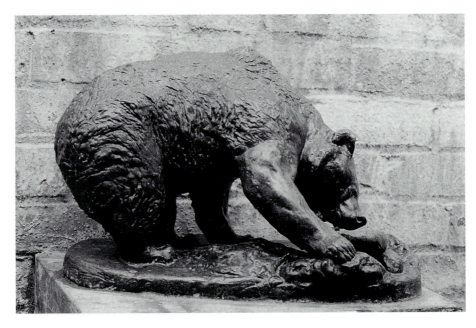

A Grizzly Grave Digger

Bronze. 26.7 x 41.9 x 24.2 cm. Signed on top of base: *E. KEMEYS* [wolf's head monogram]; on rear edge: *grizzly grave digger.*

little."[10] Lorado Taft wrote: "…he was one of the first to see and appreciate the immediate world about him, to recognize the artistic possibilities of our own land and time."[11]

A Grizzly Grave Digger

A grizzly bear, its weight supported on three legs, nuzzles the head of a big-horned sheep while it scrapes the earth next to the sheep head with its right front paw. The modeling reflects little anatomical effort. The bear's fur is indicated in an overall pattern of strokes.

The original model for *A Grizzly Grave Digger* was one of a collection of works presented by the sculptor to the United States National Museum (now the Smithsonian Institution — National Museum of American Art) in 1883. In 1893 the model along with others was returned to Kemeys and sent to the American Bronze Company, Grand Crossing, Illinois, for casting on May 19, 1893. By 1898 the bronze was in the collection of Miss Margaret Watson of Chicago. She donated it along with five other bronzes to the Art Institute of

Chicago in 1899. In December 1907, *A Grizzly Grave Digger* was lent by Miss Watson to the Kemeys memorial exhibition at the Corcoran Gallery in Washington, DC. In 1956 the Art Institute transferred the bronze to the Field Museum of Natural History where it remained until it was deaccessioned in 1986 and purchased by Brookgreen Gardens.[12]

1 Hamlin Garland, "Edward Kemeys — A Sculptor of Frontier Life and Wild Life," *McClures Magazine*, V (July, 1895) p. 121.

2 "All this without instruction? Nothing but the study of fact," he said. *Ibid.*, pp. 123-4.

3 Julian Hawthorne, "American Wild Animals in Art," *The Century Magazine*, XXVII (June, 1884), p. 214.

4 Michael Richman, "Edward Kemeys (1843-1907), America's First Animal Sculptor," *Fine Art Source Material Newsletter*, Vol. 1, No. 5, May 1971, p. 104, Field Museum of Natural History, Archives, Chicago. The collection of models was returned at Kemeys' request for casting in 1893 and was subsequently destroyed. Kemeys donated replacements which are now in the collection of the National Museum of American Art.

5 Caffin, Charles H., *American Masters of Sculpture*, Doubleday, Page & Co., New York, 1915, pp. 197-198.

6 Other prominent artists worked on this building, as well. Hermon A. MacNeil was commissioned to create bronze plaques of scenes from the travels of Marquette and his fellow explorer, Louis Jolliet, for the building facade and J. A. Holzer, one of the foremost mosaicists of the time, designed a glass mosaic depicting Marquette with the Indians of Illinois for the lobby rotunda.

7 Michael Richman, *op.cit*, p. 116, Field Museum of Natural History, Archives, Chicago. *Still Hunt* was exhibited at Kennedy Galleries in New York in 1971 and was acquired by The Metropolitan Museum of Art in 1972.

8 Albert TenEyck Gardner, *American Sculpture, A Catalogue of the Collection of The Metropolitan Museum of Art*, p.39. The catalogue entry states: "Cast in bronze from the original plaster in 1907 specially for the Museum."

9 Michael Richman, *op.cit.*, p. 118, Field Museum of Natural History, Archives, Chicago.

10 *Dictionary of American Biography*, (vol. X, n.d.), Field Museum of Natural History, Archives, Chicago.

11 Lorado Taft, *The History of American Sculpture*, MacMillan Company, New York, 1924, p.473.

12 Letter from Dr. George Gurney, Curator of Sculpture and Painting, National Museum of American Art, Washington, DC, September 30, 1987.

Jonathan Scott Hartley

ONE OF THE early American sculptors, Jonathan Scott Hartley, was born at Albany, New York, September 23, 1845, to Joseph and Margaret (Scott) Hartley. He was educated at the Albany Academy and, as a teenager, worked in a marble yard. His first teacher was the New England sculptor, Erastus Dow

Palmer. In 1863 and occasionally thereafter Hartley worked in Palmer's studio, assisting as a marble cutter on various commissions. About 1865, he traveled to London for a three year period of study in the evenings at the Royal Academy while he worked during the days as a stonecarver to support himself. After spending a year studying in Berlin, he returned to the United States. A subsequent trip to Rome for a few months and a year of study in Paris completed his student days.

Hartley returned to the United States in 1875 and opened a studio in New York City. His first work in the new studio, *A Little Samaritan*, was exhibited in 1876 at the Centennial Exposition in Philadelphia. His initial works were idealized creations. One of the most popular, *The Whirlwind*, was done in 1878. His first public commission, a statue of one of the Puritan founders of Springfield, Massachusetts, *Miles Morgan*, was completed in 1882. Two years later Hartley again exhibited work at the Royal Academy in London; in 1889 he won a silver medal there. The year before that, at the age of 43, he married the daughter of the landscape painter, George Inness.

Jonathan Hartley's talents as a portrait sculptor were in great demand. His portraits were praised for their true representation of each subject: "A bust by Hartley is considered by many a synonym for the most precise and authentic characterization possible. Nothing could be more admirable than the conscience which the sculptor shows in these closely studied works. Nothing could be more penetrating."[1] His reputation in this field was so great and the commissions so plentiful that he was forced to give up for a time any other kind of sculpture work.

Hartley was a member of The Player's Club where he became acquainted with the Shakespearian actors Edwin Booth and Lawrence Barrett. His portrait busts of *Lawrence Barrett as "Cassius"*, done in 1884, and *Edwin Booth as "Brutus"*, from 1889, are faithful records of the subjects. Both busts are owned by The Player's Club of New York. The National Museum of American Art has in its collection a bust of William T. Evans cast in 1904. After exhibiting in the Buffalo Exposition of 1901, where he won a bronze medal, Hartley exhibited the plaster reliefs of a medal of George Inness at the National Academy of Design. A portrait bust of his father-in-law, dated 1891, is also in the collection of the academy.

Busts of notable artists and writers included those of Daniel Huntington, Thomas Moran, Elliott Daingerfield, Susan B. Anthony and William Cullen Bryant. For his hometown of Albany, Hartley modeled a portrait of his teacher, Erastus Dow Palmer, which was placed in the Albany Institute. A relief of Dr. Armsby, first located in the Albany Rural Cemetery, is in the office of the

cemetery superintendent. Hartley's busts of *Ralph Waldo Emerson, Washington Irving* and *Nathaniel Hawthorne,* part of a series of nine eminent men of letters, are located on the main facade of the Library of Congress in Washington, D.C. Sculptors of other busts in the series were Herbert Adams and F. Wellington Ruckstuhl.

For the Louis J. M. Daguerre Monument in Washington, D.C., Hartley utilized a typical neoclassical composition. A robed female figure kneeling on the base of the pedestal places a laurel wreath over a high-relief portrait panel of Daguerre, inventor of the daguerreotype. A globe, hung with another garland of laurel and symbolic of the daguerreotype's worldwide influence, surmounts the monument. It was presented to the American people in 1890 by the Photographers Association of America and was originally placed in the rotunda of the Arts and Industries Building of the Smithsonian Institution.[2]

The John Ericsson Monument was placed in Battery Park at New York City in 1893 to commemorate the designer of the Union ironclad ship, *Monitor,* which battled the Confederate vessel, *Merrimac,* at Hampton Roads, Virginia on March 9, 1862. The standing figure of Ericsson holds in its left hand a model of the ship and in its right hand a sheaf of mechanical sketches. Bronze tablets on the pedestal include a low relief of the *Monitor* in action. A statue of Alfred the Great, one of eight balustrade figures on the 25th Street side of the New York Supreme Court, Appellate Division, was done in 1900. The following year Hartley was commissioned to create a statue of the Reverend Thomas K. Beecher for Elmira, New York.

In addition to his studio work, Jonathan Hartley was a professor of anatomy at the Art Students League and served as its president from 1878 to 1880. He published his instructions for modeling in 1885: "The study of planes or flats in modeling is all important... A correct measurement in a cast is like an outline drawing — it is the backbone of the work."[3] Hartley was elected an academician of the National Academy of Design in 1891 and was a member of the National Sculpture Society. A sketch class that met in his studio on Broadway later became the Salmagundi Club, of which he was a founding member. Jonathan Scott Hartley died in New York City on December 6, 1912.

The Whirlwind

A slender female figure enveloped in swirling drapery struggles against the wind. Her right arm is caught in the swirl as she grasps part of the drapery in her left hand. Her hair streams around her head. She stands on a pedestal

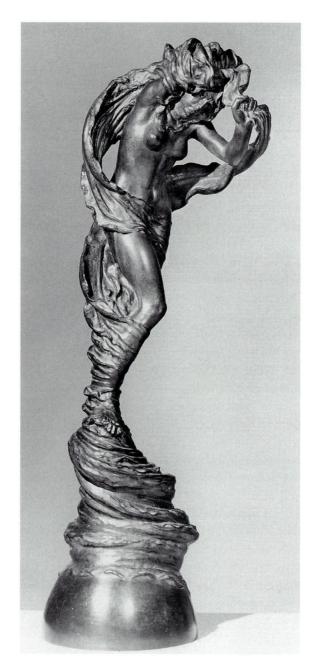

THE WHIRLWIND

Bronze. Height: 76.8 cm. Signed: *WHIRLWIND/ Copyrighted by J. S. Hartley Sc/1896* Founder's mark: "Cast by Bureau Brothers" S.1982.005, placed in 1982.

covered by the swirling drapery, giving the visual impression of a tornado. The entire composition moves in an upward spiral.

The sculptor first exhibited a version of this sculpture at the National Academy of Design in 1878. Lorado Taft wrote of it: "Mr. Hartley's professional fame was made… by 'The Whirlwind,' which appeared in 1878, and was much complimented in its day for the originality of the thought and the vigor with which it was developed."[4] It is thought that Hartley remodeled the piece and exhibited this second version at the National Academy of Design in 1896.[5]

1 Lorado Taft, *The History of American Sculpture*, (1903, revised edition, 1924, reprint 1969), p. 264.
2 The Daguerre Monument was moved outside to the grounds of the building in 1897 and, in 1969, was placed in storage.
3 Jonathan S. Hartley, "How to Model in Clay," *Art Amateur*, 12 (1885), pp. 34-36.
4 Lorado Taft, *op.cit.*
5 Susan E. Menconi, *Carved and Modeled: American Sculpture 1810-1940*, Hirschl & Adler Galleries, Inc., New York, NY, (1982), p. 45.

Harriet Hyatt Mayor

PLEASE REFER TO *Brookgreen Gardens Sculpture* pp. 49-50 for the sculptor's biography.

Anna Vaughn Hyatt (Huntington)

This portrait bust of Anna Vaughn Hyatt was modeled by her sister in 1895 when the subject was 19 years old. It depicts a beautiful young woman in a chemise, with long hair parted in the center and a loose braid curling over her right shoulder. Tendrils of hair frame her face which has a pensive expression emphasized by downcast eyes. The bust was cut in marble and remained in the family until 1990 when it was donated to Brookgreen Gardens by Brantz Mayor, a son of the artist. Another example of this work in marble is in the collection of the American Academy of Arts and Letters.

At the request of Anna Hyatt Huntington, a mold was made from this bust in preparation for casting a bronze version of the portrait. The plaster mold was made by John Rochovansky of Westport, Connecticut, and the bust was

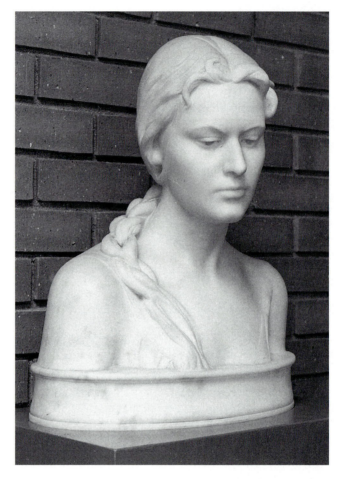

ANNA VAUGHN HYATT (HUNTINGTON)

　　　White marble. 50.8 x 44.5 x 19.1 cm. S.1990.002, placed in
1990. Gift of Brantz and Ana Mayor. Other example: New York.
NY. American Academy of Arts and Letters.

cast by Modern Art Foundry of Long Island City, New York. The bronze bust
was located at Anna Hyatt Huntington's home, Stanerigg Farm, in Bethel,
Connecticut, before it was brought to Brookgreen Gardens in 1971.

　　　Bronze.　49 x 42 x 19 cm.　S.1971.010, placed in 1971.　Gift of Anna Hyatt Huntington.

Augustus Saint-Gaudens

FOR THE sculptor's biography, please see pp. 7-11 of *Brookgreen Gardens Sculpture.*

Diana

The Roman goddess of the chase stands on her left foot on tiptoe upon a sphere, with her right leg slightly lifted behind her for balance. Her left arm is extended straight out to her side, holding a bow. Her right arm is upraised and pulled back, holding in place an arrow which is about to be released from the bowstring. Her gaze travels down the length of the arrow, siting it in preparation for its release. The figure's hair is upswept and gathered in a knot at the top of her head.

This sculpture, the artist's only nude female figure, has an interesting and complicated history. In 1890 construction began on the original Madison Square Garden in New York City. The building was designed by Stanford White, one of America's most talented architects. Augustus Saint-Gaudens, White's close friend and frequent collaborator, was given the honor of creating an ideal figure to top the tower of this building.

This commission was so important to Saint-Gaudens that in 1886, four years before the building construction had started, he began a series of studies for the ideal figure of *Diana*. His first study for the head was a portrait bust of Davida Johnson Clark, his mistress, who served as the model for many of his female figures. From there he created a full figure in plaster. The plaster was mechanically enlarged to eighteen feet and a statue of iron and gilded copper was made from it.

In a gala ceremony in October 1891, the large figure of *Diana* was installed atop the tower. It weighed 2,000 pounds and was designed as a revolving windvane. A billowing loop of drapery was to act as a rudder and the bow and arrow were to be the pointer. Unfortunately, because of an error in balance and construction, *Diana* did not revolve. Both the sculptor and the architect soon acknowledged that the massive figure was out of proportion with the tower.

Diana was removed in September 1892, sent to Chicago and installed on the dome of the Agriculture Building at the World's Columbian Exposition where it was partially destroyed by fire in 1894. The upper portion of the figure was

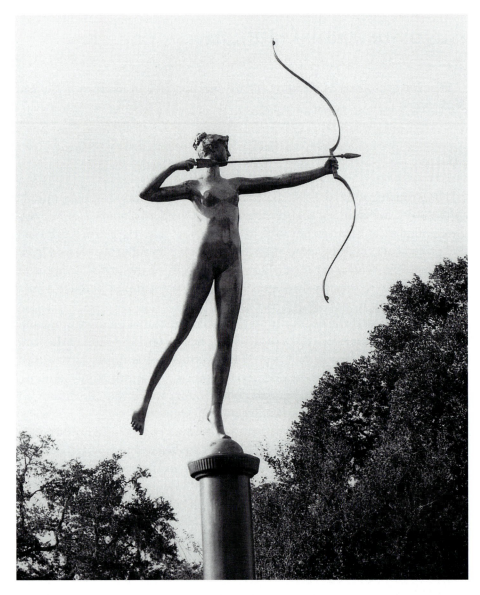

DIANA

 Bronze. Overall height: 264.2 cm. S.1990.003, placed in 1991. Gift of Joseph Veach
Noble in honor of Olive Ashley Mooney Noble. Other examples: Philadelphia, PA.
Philadelphia Art Museum (full figure); New York, NY. The Metropolitan Museum of Art
(gilded, half-size), Madison Square Garden Corporation (half-size); Fort Worth, TX.
Amon Carter Museum (gilded, half-size and cement, half-size); Princeton, NJ. Princeton
University Art Museum (half-size); Cornish, NH. Saint-Gaudens National Historic Site
(half-size plaster model and half-size bronze); Washington, DC. National Gallery of Art
(reduction).

sent along with other remnants from the Exposition to storage in the base-
ment of the Field Museum. In 1909, in conjunction with an exhibition of Saint-
Gaudens' work at the Art Institute of Chicago, the top portion of the figure was
shown there. After that, it disappeared.

Once *Diana* had been removed from Madison Square Garden, Saint-
Gaudens immediately set to work on a modified version in gilded copper
which was smaller (13 feet) and lighter. It was more delicately proportioned
and the drapery was more gracefully arranged. His brother, Louis, was given
credit for finishing the model for the figure. The new *Diana* was installed on
the tower in 1894, and remained in place (even though her drapery was lost
in a high wind) until the building was demolished in 1925. The sculpture
remained in storage until 1932 when it was donated to the Philadelphia
Museum of Art.

The nude female figure initially caused quite a stir but it was eventually
accepted as a beautiful symbol of the time: "Diana was one of Saint-Gaudens'
happiest achievements. People who remembered New York in the nineties
said that the golden goddess typified the city at a joyous period when the future
seemed bright, the gilded era never-ending. When Madison Square Garden
was pulled down in 1925 and Diana disappeared, a light seemed to go out."[1]

In 1894 Saint-Gaudens had presented a unique Portland cement version of
Diana to Stanford White. This piece was cast by John H. A. Walthausen of New
York City from the original half-size plaster model from which the second
version was mechanically enlarged. The half-size plaster model was destroyed
in 1904 in a studio fire at Aspet, Saint-Gaudens' home in Cornish, New
Hampshire. For this reason, the cement cast, which stood for many years in
the garden of Box Hill, Stanford White's Long Island estate, remains an
important detailed record of the sculpture as originally created by Saint-
Gaudens.

Diana was copyrighted in January 1895, but Saint-Gaudens began to
produce reductions almost as soon as the figure was finished. The reductions
were not made mechanically. They were remodeled by hand and show
significant differences in hair, bow style and pedestal style from one edition to
another. Some were sold in the gallery of Tiffany Jewelers. Several of these
reductions are in museums including the National Gallery of Art at Washing-
ton, DC, and the Carnegie Museum of Art at Pittsburgh.

In 1927 the White family commissioned the Osterkampmead Corporation
in New York City to cast a bronze from the cement *Diana*. This work was done
by Priessmann, Bauer & Co., a foundry in Munich, Germany. In 1928, a second
gilded bronze was made at the request of the Metropolitan Museum of Art in

New York and stood for many years above the museum's main staircase. Another gilded bronze made at that time, as well as the cement cast, are in the collection of the Amon Carter Museum in Fort Worth, Texas.

In 1979 the cement cast was used again as a model for another edition of bronzes. The Madison Square Garden Corporation commissioned a new bronze *Diana* in recognition of their Centennial Celebration. A limited edition of six was cast at the Bedi-Makky Art Foundry, one of which was permanently installed at Madison Square Garden. Others from the edition are located at the Princeton University Art Museum, at Brookgreen Gardens, and in private collections.

1 Tharp, Louise Hall, *Saint-Gaudens and the Gilded Era* (Little Brown and Company, Boston, 1969) p. 259.

Carl Akeley

CARL ETHAN AKELEY was born on a farm at Clarendon, New York, May 19, 1864, to Daniel Webster and Julia (Glidden) Akeley. From an early age he roamed the woods near his home and observed animals in action. At the age of 12 he had his first experience with taxidermy when he skinned and stuffed a dead canary and mounted it on a branch. A year later he learned additional taxidermy techniques by borrowing a book from a friend. In order to more realistically present his mountings, he took painting lessons from a local artist and painted backgrounds for his assemblages. Eventually, he amassed an impressive natural history collection.

At the age of 19 he was employed as a taxidermist by Ward's Natural Science Establishment in Rochester, New York. In 1885 Carl Akeley had the task of mounting the skin and skeleton of Jumbo, a huge elephant from the P.T. Barnum circus which had been killed by a train. After that, he worked at the Milwaukee Public Museum and the dioramas of indigenous animals he installed there set new standards in the field of collections exhibition. Akeley believed that an animal had to be mounted artistically to be able to communicate its inner spirit. But the life of the animal could not really be understood unless the animal was seen in the context of its environment. This was achieved through the use of real elements from that environment in conjunction with a curved background painted in perfect perspective. A diorama of a muskrat

group in the Wisconsin marshlands was the first complete habitat display to unfold the life of the creature both scientifically and artistically.

For a period he was chief taxidermist at the new Field Columbian Museum in Chicago and traveled to Africa to collect specimens of elephants and other animals for exhibits. Chief among his work at the Field Museum was a series of four groups of deer, representing the changes in the animals through the seasons. This work caught the attention of President Theodore Roosevelt who invited Carl Akeley to dinner in the White House. A friendly relationship formed which continued to the end of Roosevelt's life. In 1909 Akeley became associated with the American Museum of Natural History in New York City. He was determined to find a better method of taxidermy and, after many experiments, developed a technique involving sculpture which enabled a more life-like presentation.

Akeley came to sculpture logically since modeling in clay was central to his technique of taxidermy. In order to increase his knowledge he spent hours in the New York City art museums studying examples of animal sculpture. The subject of his first sculpture was his favorite — the African elephant. The group he produced, *The Wounded Comrade*, was immediately successful. It was exhibited at the National Academy of Design in 1913 and he was elected to membership in the National Sculpture Society in 1914. Membership in the National Institute of Social Sciences was conferred upon him in 1916 for bringing the science of taxidermy into the realm of the arts. He also was a member of the Architectural League of New York, the Franklin Institute and the Explorers Club.

As a sculptor, Carl Akeley depicted accurately the wild animals he observed in their wild situations. His animals have a distinctive power and vitality that is possible only through intimate knowledge of animal anatomy and characteristics, and of their surroundings. *Jungle Football*, a group of four young elephants kicking around a part of a termite mound, depicts the playfulness of these mammals. In contrast, the fight for life in the jungle is presented in *Lion and Buffalo*, a small bronze of an attacking lion struggling to bring down a water buffalo.

In 1919, a monumental sculpture of an alert, semi-recumbent lion was envisioned by Akeley as a memorial to Theodore Roosevelt, and although he had the support of the Roosevelt family in this venture, the Roosevelt Memorial Association decided instead to sponsor a national competition for the memorial. By 1925 Akeley withdrew the lion from the competition and the work was never finished. His last sculpture, left incomplete at his death, was *Lion Rampant*, a portrayal of a wounded lion rearing up on its hind legs and

trying to remove an arrow from its head. Though unfinished, the work depicts remarkable feeling and energy.

The Old Man of Mikeno, a portrait bust of a silverback gorilla based on a death mask Akeley took of the animal during an expedition to central Africa in 1921, is a sensitive interpretation of animal personality. This individual is a focal point of a gorilla diorama at the American Museum of Natural History and also served as a pivotal point in the life of Carl Akeley. Akeley had gone to the area of the Virunga Volcanoes (where the Belgian Congo, Uganda and Ruanda-Urundi intersect) to study the mountain gorilla and to gather data that would justify collecting specimens for a group diorama. From this study, he determined that indiscriminate hunting had become too common and ultimately he was converted from hunter to conservationist. The result of his conservation effort was the establishment of Parc National Albert, an international research area and sanctuary protecting not only the gorillas but other animals, plants and the Pygmy tribes living within its boundaries. It was the first of its kind on the African continent and the first in the world established for scientific research as well as conservation. Another goal of the 1921 expedition was to make photographic studies and motion pictures which reflected Akeley's belief that Africa was a place of extraordinary beauty — not one of horror and darkness. His account of his travels, *In Brightest Africa,* supported this fact, as well.

His most controversial work, *The Chrysalis,* was another result of his gorilla expedition. In it, the figure of a man emerges from a cocoon of a gorilla skin. When it was submitted for exhibition at the National Academy of Design in 1924 it was refused and fueled a controversy then simmering in society that exploded a year later with the Scopes Trial. The Reverend Charles Francis Potter of the West Side Unitarian Church in New York, a supporter of the evolution theory, asked permission to exhibit the sculpture in his church. Another ambitious work, *Nandi Lion Spearing,* is a series of three groups depicting a ritual performed by the Nandi tribe of West Africa, known for their courage. Castings in bronze are in the African Hall at the American Museum of Natural History and at The Field Museum in Chicago.

Akeley was chiefly known as a curator and a sculptor, but he also had a notable record as an engineer. One of his inventions was the Akeley Camera, a motion picture camera with a swivel device which made it possible to swing the camera in all directions with a panoramic sweeping motion. It also featured special lenses and an increased angle shutter opening. The camera was first tested when it recorded the performance of the race horse, Man-o'-War, in the 1920 Kentucky Derby, and was successfully used by newsreels, the

movie industry and by the military. Another invention introduced to the public in 1910 was the cement gun, a device which allowed liquid cement or gunite to be sprayed through a nozzle. Akeley also invented gunite, a material having the constituents of concrete but varying in proportions and consistency. The cement gun and gunite were first used in the building of the Panama Canal. Since its invention it has been widely used in marine engineering, shipbuilding and in reinforcing buildings, domes and other structures. For this invention, Akeley was awarded the John Scott Legacy Medal of the Franklin Institute for the Promotion of the Mechanical Arts in 1916.

His first wife, Delia Reiss, nicknamed "Mickie," was a fearless explorer and hunter who accompanied him on expeditions. During their 1910 African expedition she single-handedly formed a team to track and rescue Akeley on Mt. Kenya after he had been severely mauled by a bull elephant. Married to Akeley on December 23, 1902, she was a nonconformist who was able to live out her aspirations in a male-oriented world through him, but their relationship was stormy. They were divorced in March of 1923. Mickie Akeley continued her work after the divorce and became the first woman to lead expeditions alone into the African interior. On October 18, 1924, he married Mary Leonore Jobe, a scholar and explorer, who was on the staff of the American Museum of Natural History. In 1929, her account of his life, *Carl Akeley's Africa*, was published.

At his death from an unspecified illness on November 17, 1926, in Kabara, Belgian Congo (now Zaire), he was collecting specimens for the American Museum of Natural History. He was buried by his wife and other members of the expedition on the slopes of Mount Mikeno near the location depicted in the gorilla diorama at the museum. The Akeley Hall of African Mammals, begun in 1929 and opened in 1936, was dedicated to his memory. Aside from his work to protect the gorilla, Akeley's greatest accomplishment may have been the dioramas in the African Hall. The naturalist and scientist, Dr. George B. Schaller, wrote: "As a teenager, I at times visited the American Museum of Natural History, where I lingered longest in the Akeley African Hall. So realistic are his dioramas that I was transported to the Serengeti plains, up among the mountain gorillas in the Virunga Volcanoes, and other mysterious and exotic places that fill an adventurous young heart with longing. In an age before zoos emulated natural habitats for their animals, Carl Akeley's dioramas recreated the African wilderness so faithfully that they surpassed the reality of early films..."[1]

THE WOUNDED COMRADE

Bronze. 29.2 x 33 x 43.2 cm. Signed: *The Wounded Comrade* / © *Carl Akeley* / *1913* S.1992.002, placed in 1992. Gift of Robert V. Hatcher, Jr. Other examples: New York, NY. American Museum of Natural History, The Brooklyn Museum.

The Wounded Comrade

Two African elephants are standing on either side of a third wounded elephant, supporting him with their bodies, as he is led to safety. Akeley depicted a common practice among elephant family groups where the females in a herd come to the rescue of an injured or fallen bull. Although he witnessed this type of activity on other occasions, the scene depicted in this sculpture was based on an incident related to him by another hunter. The qualities of animal love and compassion, a theme central to many Akeley bronzes, are shown in the tenderness of one rescuer's trunk curled protectively over the wounded animal's face.

The Wounded Comrade, Akeley's first sculpture in bronze, was shown at the winter exhibition of the National Academy of Design in 1913. The example at Brookgreen Gardens is a posthumous casting made by Turner Sculpture from the sculptor's original model.

1 Penelope Bodry-Sanders, *Carl Akeley, Africa's Collector, Africa's Savior* (Paragon House, New York, 1991), p. 264.

Carl Milles

CARL MILLES did not set foot upon the American shore until he was 59 years old, yet he was an important figure in American sculpture. Marked by an impish sense of humor and a love of satire, his work presented his personal philosophy: life was to be enjoyed. This joy of life was expressed in sculpture having great movement and motion that spoke of human warmth and spiritual hope. Water was a key element in the expression of this work. The Orpheus Fountain in front of the Opera House in Stockholm and the Poseidon Fountain at Gothenburg were among his finest creations.

Carl Wilhelm Andersson Milles was born near Uppsala, Sweden, on June 23, 1875, the son of Emil Andersson and Walborg Maria (Tisell) Milles. After attending school in Stockholm, in 1892 he was apprenticed to a cabinet-maker for five years. During this time he attended evening classes at the Stockholm Technical School where he studied woodworking, carving and modeling. In 1897 he was awarded a cash prize by the Swedish Society of Arts and Crafts and he accepted an invitation to go to Santiago, Chile to manage a school in Swedish gymnastics. En route he stopped in Paris and, entranced by its artistic atmosphere, remained there until 1904 while supporting himself as a cabinet-maker and ornament-molder. He attended lectures at the Colarossi Academy and classes at the Ecole des Beaux Arts. Milles became attracted to the decorative elements in the work of Dalou and Falguiere and was influenced by Maillol and Bourdelle. He also frequented the studio of Auguste Rodin where he worked for a while as an assistant and received encouragement. During this period his figures became stylized and elongated with an emphasis on upward movement. *A la Belle Etoile*, a stone sculpture of two homeless people huddling together on a park bench, shows the influence of Rodin and illustrates the adverse circumstances Milles lived under during his time in Paris.

At the Exposition Universalle in 1900 he was awarded an honorable mention. After exhibiting at the Paris Salon and entering a sculpture competition in his home town, Milles traveled in Holland and Belgium where he became familiar with the sculpture of Charles Meunier. In 1904 he settled in Munich and in the following year married Olga Louise Granner, an Austrian portrait painter. By 1906 they were back in Sweden where he had received a commission for the monumental statue of Gustavus Vasa to be placed at the Nordic Museum in Stockholm. At that time he became a member of the Royal Academy of Art. Despite this recognition, his highly personal style in sculpture frequently ran against the prevailing taste and was often criticized.

Although his work was well received in 1914 at the Baltic Exhibition held in
Malmo, by 1917 he was so dissatisfied that he destroyed most of the models in
his studio. From this point he entered a period of rapid stylistic development
which included the use of granite as a medium. *Sun Glitter*, an exuberant naiad
upon the back of a dolphin, done in 1918, masterfully captured the feeling of
rapid movement. In 1920 he was elected professor of modeling at the Royal
Academy of Art in Stockholm. Within five years, at the age of fifty, Milles again
was receiving acclaim for his sculpture. In 1925 he was awarded the Gold
Medal at the Exposition International des Arts Decoratifs et Industriels
Modernes in Paris. *The Sun Singer*, a monumental figure with arms raised to
the heavens as he sings, was commissioned by The Swedish Academy as a
tribute to Esaias Tegner and dedicated in a public square at Stockholm in
1926. An international career was launched in 1927 at the Tate Gallery in
London, the first showing of his sculpture outside Sweden.

In 1929 Carl Milles made his first visit to the United States. His fellow
Scandinavian, the architect Eliel Saarinen, was the director of the Cranbrook
Academy of Art at Bloomfield Hills, Michigan. Milles's appointment as
resident sculptor and head of the department of sculpture in 1931 marked a
new phase in his career. In 1934 the Cranbrook Foundation acquired an
impressive collection of his sculpture including the humorous *Jonah Fountain*.
Through the 1930s his work traveled to exhibitions in St. Louis, Cleveland,
Detroit and New York — all cities which acquired major fountain sculpture by
Milles. *The Triton Fountain* was done in 1936 for the Art Institute of Chicago.
Meeting of the Waters, a fountain group of 19 fantasy figures celebrating the
joining of the Mississippi and Missouri Rivers, was placed in 1940 across from
Union Station at St. Louis. *Man and Nature* was acquired for the Time-Life
Building in New York in 1940. At the 1939 New York World's Fair, Milles
placed two of his monumental works: *The Astronomer*, a standing figure peering
inquisitively toward the heavens, was exhibited near the Perisphere, and *The
Pony Express* was located in front of the American Telephone and Telegraph
Building. For the National Memorial Park, a private cemetery at Falls Church,
Virginia, Milles created the *Fountain of Faith*, a joyous group of 37 bronze
figures depicting a belief in the continuity of life. The figures seem to hover
and dance above the water which sprays upon vignettes portraying the joyful
reunion of souls after death. This work was created over a twelve year period
beginning in 1940. A bronze of the heroic *Sun Singer* was placed there in 1948.

Since his student days Milles had collected works of antiquity including
sculpture, architectural fragments and columns. These works, as well as his
own sculpture, were integrated into his home and studio, Millesgarden, built

THE FOUNTAIN OF THE MUSES

Bronze. S.1983.001-016, placed in 1984. Height: The Poet, 289.6 cm; The Architect, 274.3 cm; The Musician, 266.7 cm; The Painter, 297.2 cm; The Sculptor, 304.8 cm; Aganippe, 94 cm; Centaur, 106.7 cm; Faun, 141 cm; Dolphins (three), 61 cm; Leaping fish, 27.9 cm; Boar fountainhead, 15.5 cm; Wolf fountainhead, 14.3 cm; Horse fountainhead, 19.4 cm; Fish head (not installed), 14 cm. Other example: Millesgarden, Lidingo, Sweden (Aganippe, The Sculptor, The Musician, The Painter, two dolphins).

in 1908 at Lidingo, a rocky promontory on Lake Vartan across from Stockholm. In 1936 he established a foundation to operate the site and donated it to the people of Sweden. In 1948 his collection of antiquities was acquired by the Swedish State for safekeeping at Millesgarden.

Carle Milles received a number of professional honors during his career. In 1935 Yale University conferred upon him an honorary degree of Doctor of Humane Letters. In 1938 he was awarded gold medals by the American Institute of Architecture and by the Architectural League of New York. The Royal Academy at London elected him to honorary membership in 1940. The

AGANIPPE FROM THE FOUNTAIN OF THE MUSES

American Academy of Arts and Letters recognized his work in 1943 when he received its Award of Merit, as did the National Academy of Design, in 1948, when he was elected to membership. In 1945 Carl and Olga Milles became American citizens, but in 1951 they left the United States and moved to Rome where Milles had been offered use of a studio by the American Academy. In 1953 Stockholm University awarded him an honorary Doctor of Philosophy degree. On the occasion of his eightieth birthday in 1955, he received a replica of his monumental sculpture *Poseidon* as a gift from the Swedish government and the Founder's Medal from the Cranbrook Foundation.

Carl Milles died at Millesgarden on September 19, 1955, and was buried there. Today Millesgarden is opened to the public as a museum. In 1982 he was posthumously honored by the Swedish Council of America with the Swedish Heritage Award at a gala in New York City in the presence of the King and Queen of Sweden.

The Fountain of the Muses

This fountain group consists of eight major figures and seven secondary figures, modeled in a studio at the American Academy at Rome. The work was commissioned by the trustees of The Metropolitan Museum of Art in 1949 and the casting of the final figures were completed and delivered just six months before the sculptor's death in 1955. The group was cast by Bearzi Foundry in Florence, Italy.

Carl Milles expressed his personal interpretation of the fountain in a document written just three weeks before his death:

"Of the eight fountain figures round and in the pool — five of these represent the arts — men who just have been drinking the holy water from the Godess Aganippe's well. Famous water helping the musical artists as well as all artists to get the right spirit to work and create. Here we see them rushing home filled with enthusiasm — each one with his new ideas forcing them to hurry.

"Each artist carries his symbol with him:

The Poete — the blue bird.

The Architect his new formed column.

The Musician his old interesting instrument.

The Painter — here represented by Eugene Delacroix — his Flowers.

The Sculptor is reaching for his gift from the Gods — as the Painter and the Musician have not yet grasped their symbols — These gifts from their Gods are just comming — These artists *feel* them and grasp for them.

"Behind these running artists are:

The Godess Aganippe waving good wishes to the artists, and in the same time playing with a fish below in the water.

A centaur has dressed up to mirroring himself in the water — on the other side is a faune taking musical lessons from a bird.

<div align="right">Carl Milles</div>

The jets from the fishes have to come as high as possible

<div align="right">Sept. 1955"[1]</div>

The Fountain of the Muses was purchased from The Metropolitan Museum of Art on December 6, 1982. It had been exhibited in the pool of the Lamont Wing from 1956 until 1982. Castings of four of the large figures are exhibited at Millesgarden.

1 Taylor, Francis Henry, "Aganippe: The Fountain of the Muses," *The Metropolitan Museum of Art Bulletin*, Volume XIV, Number 5, 1956, p. 112.

William Zorach

WILLIAM ZORACH was born at Euberick, Lithuania, February 28, 1887, to Aaron and Toba (Bloch) Zorach. His father came to the United States and, after settling in Port Clinton, Ohio, sent for his family when William was four years old. Within three years the Zorach family moved to Cleveland where there was more economic opportunity. A public school teacher encouraged his interest in drawing and helped him obtain part-time work at the Morgan Lithograph Company.

By the age of fifteen he was apprenticed to a lithographer and began art studies at night at the Cleveland School of Art. During the winter of 1904 he went to New York and studied painting at the National Academy of Design under E. M. Ward, Francis C. Jones and George W. Maynard. For the next three years he traveled between Cleveland and New York, spending winters studying at the Academy and summers working in the lithography shop to earn money for his studies. During his last year at the Academy, Zorach briefly studied drawing with George Bridgman at the Art Students' League. Feeling that he needed more instruction, in the fall of 1909 he went to Paris where he attended several schools. There he was exposed to powerful changes in the art world including Impressionism, Cubism and Fauvism and eventually enrolled at La Palette, a Fauvist school run by John Duncan Ferguson. Zorach became interested in the bold and brilliant colors used by Van Gogh and Gauguin and in the new conception of form espoused by Cezanne. Four of his paintings were exhibited at the Salon d'Automne in 1911. At La Palette he met another Fauvist painter, Marguerite Thompson of Fresno, California, whom he married in 1912 after returning to the United States.

From the time the Zorachs opened their studio in Greenwich Village, they were involved in the avant-garde circles of art, literature and theater. Both William and Marguerite Zorach exhibited paintings in the Armory Show of 1913. While spending the summer of 1916 on Cape Cod, they designed sets and decoration for the Provincetown Players, a drama group that included among its members the playwright Eugene O'Neill, the poet Edna St. Vincent Millay, and the writers John Reed and Louise Bryant. Among his friends in Greenwich Village were William Carlos Williams, Marianne Moore and Alfred Kreymborg, with whom he discussed and read poetry, and fellow artists, Max Weber and Marsden Hartley. He even had some poems published in *Others*, an early literary effort of the group, and in the magazine *Poetry*. In addition to painting, Marguerite Zorach embroidered intricate tapestries, for which she

became widely known, and made designs for fabric.

By 1917, having the need to express his art in another medium, Zorach took up wood carving although he continued to paint and exhibit watercolors. His first attempt, a bas-relief carved from butternut drawer panels, was made at Echo Farm in Plainfield, Massachusetts. Thus, with no training in technique, he began to explore the art of sculpture. Fellow artists Gaston Lachaise and Hunt Diederich encouraged his experimentation in wood carving. During the summer of 1918 he modeled decorative pots and small figures in ceramic. One of these, *First Steps*, a figure of his daughter learning to walk, later was cast in bronze.

In the spring of 1920 the Zorach family traveled to the San Joaquin Valley in California for an extended visit with Marguerite Zorach's parents. He spent five months sketching and painting in the Yosemite Valley and survived a disastrous fall while mountain climbing with the photographer Ansel Adams. Some of his watercolors produced during this time were exhibited in San Diego. During this exhibit he formed friendships which resulted a few years later in a commission to design a monumental frieze for the facade of the Los Angeles City Hall. The theme of the history of California was utilized in highly simplified forms praised by critics when the model was exhibited in New York. But the commission fell through during the Depression years.

Eventually William Zorach decided that sculpture, with its opportunity of three-dimensional expression, was his true vocation and, by 1922, he had decided to devote himself primarily to sculpture. A lack of sculptural training freed Zorach to approach it directly. As one of the first American sculptors to join and promote the revival of carving directly in stone using no preliminary model, he had an interest in primitive art and was influenced by the sculpture of the Aztecs, Mayans, Eskimos and Africans. The form in direct carving is dictated primarily by the material, following natural lines in the wood or stone. Zorach wrote: "In direct carving you retain the volume and the form expands. The power and strength that exists in the stone reveals itself to you. But you have to recognize it, you have to be in tune. You have got to be equipped to see what is going on in the stone, what is unfolding, what the stone is revealing to you as you chip away...In cutting stone you are continually cutting away and the sculpture grows larger. In modeling you are constantly adding clay and the form shrinks."[1] He preferred to work alone, employing workmen only for mechanical copying, if necessary. Marguerite Zorach influenced his art through designs for her own work and assisted him occasionally by making preliminary drawings for sculpture designs. Often she, the children and their pets were the subjects of his sculpture. Themes of human relationships were

predominant: love, devotion, friendship, motherhood. During the 1920s and 1930s Zorach exerted the greatest influence and was the most articulate spokesman for the direct carving movement in the United States.

Floating Figure, carved in African mahogany in 1922, was done during his last summer at Provincetown. It is in the collection of the Albright-Knox Art Gallery at Buffalo, New York. For the Provincetown Art Association he gave a lecture on the modern point of view in art that was published in *Arts Magazine.* In 1924, only two years after he turned his attention to sculpture, the Kraushaar Galleries in New York held his first solo show.

From 1927 to 1930 William Zorach worked on what he considered his finest sculpture — a monumental and realistic but simplistically rendered *Mother and Child* carved in Spanish florida rosa marble. In 1931 it was awarded the Logan Medal of the Art Institute of Chicago and in 1955 was acquired by The Metropolitan Museum of Art. By 1930 plans for Radio City Music Hall were underway and Zorach was asked to make designs for sculpture to go in the downstairs lounge and the upstairs foyer. *The Spirit of the Dance,* a female figure posed on one knee as if bowing to an audience, was selected, cast in aluminum and placed. Shortly afterward it was removed — along with other works by Robert Laurent and Gwen Lux — because its nudity was deemed immoral by the management of the music hall. An outcry from critics, museum curators and the public caused it to be returned to its location. In 1931 his walnut carving, *Pegasus,* done in 1925, was acquired for the permanent collection of The Whitney Museum of American Art. *Embrace,* a group of two over-life-size figures modeled in clay in 1933 and later cast in bronze, is in The Brooklyn Museum.

In the spring of 1923 William and Marguerite Zorach purchased a house and land on Robinhood Cove near Bath, Maine for use as a summer residence. The native stone or "Maine boulders" that he found on the beach in front of his house revealed beautiful colors, textures and patterns when carved and was a favorite medium for a number of small works. More often, the coloring and veining in the stones suggested forms of animals or small heads. *Seated Cat,* a 1925 portrait of Tooky, a family pet, was purchased by The Metropolitan Museum of Art after being shown at the Second National Exhibition of American Art in 1937.

The design for *Football Player,* one of four figures of athletes originally intended for the terrace of the Rockefeller estate at Pocantico, had been rejected by John D. Rockefeller, Jr. Liking the design, Zorach carved it in red Swedish granite. For a number of years it was exhibited in the garden of The Newark Museum and, in 1958, was donated by the sculptor to Bowdoin College

at Brunswick, Maine. An awareness of elementary geometrical shapes is evident in *Child with Cat*, one of many portraits of his daughter, Dahlov. Carved in Tennessee marble in 1926, it is now owned by the Museum of Modern Art. *Quest*, a serene monumental head of a woman reminiscent of Egyptian sculpture, was carved in Pentelic marble from 1940 to 1942 and acquired by the Wichita Art Museum. Dating from 1941, a black granite *Head of Christ* with a powerful, penetrating gaze is at the Museum of Modern Art, and *Head of Moses*, carved in granite in 1956, is located in Earl Hall on the campus of Columbia University.

In 1935 William Zorach was one of several sculptors invited to submit designs for statuary to be placed in the new Post Office Building in Washington, D.C. After receiving the greatest number of votes from the committee, Zorach and Paul Manship were commissioned to create the two heroic figures for this building. By a flip of a coin, it was decided that he would depict Benjamin Franklin and Manship would portray Samuel Osgood, the first Postmaster General. The commission was unusual for Zorach: it was the first time he had executed a conventional portrait statue, much less one of a well-known historical figure. He prepared by reading historical accounts of the man and his writings. A good likeness was achieved by careful study of a Houdon bust of Franklin in the collection of The Metropolitan Museum of Art. Although he preferred to carve the statue himself, it was completed by workmen in the stone carving studio of Edmundo Quattrocchi. The statues of Benjamin Franklin and Samuel Osgood were installed in August 1937.

The 1939 World's Fair held in New York provided an opportunity for many artists during the final years of the Depression. His heroic architectural group in plaster, *Builders of the Future*, depicting the importance of manual labor in the development of civilization and the family, was exhibited in the Rose Court between the buildings of New York City and Business Systems and Insurance. Zorach was one of many artists who urged Robert Moses, the New York City Parks Commissioner, to preserve in permanent form the art works created for the fair. But, due to lack of funds, the plasters were destroyed after the fair closed. In addition, Zorach was on the committee for a major show of 1,200 works by American artists, exhibited in the Contemporary Art Building, and helped write an introduction to the sculpture section of the accompanying catalogue. The original model for his statue of Benjamin Franklin was in the exhibition.

Teaching was an important part of William Zorach's work. In 1929 he became an instructor in sculpture at the Art Students League in New York, a position he held until 1960, and he was a visiting instructor at the Des Moines

Art Center. Many of his students went on to become fine sculptors in their own right. Zorach tried the apprentice system but was not satisfied with the process, preferring the more flexible teacher-student relationship over that of master-apprentice. He wrote and lectured on the art of children at The City and Country School and other progressive schools in New York City.

He was one of the founding members of The Sculptors Guild and helped organize and publicize its first outdoor show held on Amsterdam Avenue near Grand Central Station in 1938. The Guild, which espoused direct carving of realistic subject matter, was founded in opposition to the more traditional views of the National Sculpture Society. Some members of the Guild began to introduce political and social themes into their work. Later, William Zorach and other artists of eastern European extraction were accused of political extremism, particularly in the McCarthy Era of the 1950s, and lost commissions as a result. Designs for reliefs portraying the "Spirit of Texas" were commissioned in 1953 by the Bank of the Southwest in Houston. Depicting themes of the past, the abundant land, man's modern development, and the cycle of generations, the designs suddenly were rejected by bank officials and the commission was not completed. Cast in polished aluminum, the reliefs were purchased later by Fairleigh Dickinson University for the facade of a new library building.

Four floating figures and groups in high relief representing the theme, "Man's achievement through labor," project from the white marble facade of a building at the Mayo Clinic, Rochester, Minnesota. Done in 1952 and 1953, the bronze reliefs are considered his most successful architectural work. Six years before his death, he created a bas-relief in granite of six figures surrounded by symbols of Manhattan for the entrance to the Civil Court at the Municipal Court Building in New York. Retrospectives of his work were held in 1950 at the Art Students League and in 1959 at the Whitney Museum of American Art. In 1958 he received the Avery Award from the Architectural League. Zorach was elected to the National Institute of Arts and Letters in 1953 and was awarded its gold medal for sculpture in 1961. A memorial exhibition was held there in 1969.

William Zorach received honorary degrees from three Maine colleges: Bowdoin College in 1958, Colby College in 1961 and Bates College in 1964. He was the author of two books, *Art is My Life: The Autobiography of William Zorach* and *Zorach Explains Sculpture: What It Means and How It Is Made*, and a number of magazine articles. He died at Bath, Maine, on November 16, 1966.

The sculptor summed up his feelings about his art in a statement written just before his death: "When I began carving directly in stone, almost all sculptors

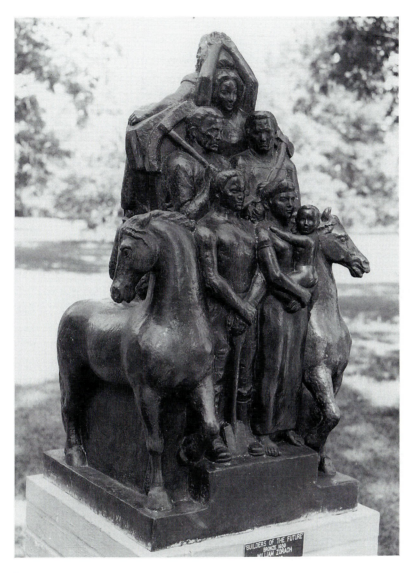

Builders of the Future

Bronze. 114.3 x 58.4 x 58.4 cm. Signed: *Zorach / 1/6* Gift of William N. Bloom
S.1982.002, placed in 1982.

modeled in clay and then had it cast in plaster and eventually turned it over
to a professional stone-carver to point up and copy in stone. There was almost
no one I could ask about carving direct…Today, again, sculptors have almost
given up carving directly in stone or even wood. It takes too long; they can't

bear to spend so much time on one work of art and there are so many easier and more intriguing ways of doing things…Stone-carving is work. To me nothing approaches the beauty and satisfaction of a work carved directly in stone. Each piece is unique, and he who owns one by a real artist possesses a bit of eternity."[2]

Builders of the Future

For the New York World's Fair in 1939, Zorach submitted a sketch of two figures, male and female, seated back to back in a dance posture, which the Board of Design rejected. Having no time to design another sketch, he invited a representative of the board to his studio to choose from other completed models. In keeping with the fair's slogan, "Building the World of Tomorrow," a pyramidal group of workers, builders and pioneers, flanked by two horses, was chosen and given the title, *Builders of the Future.* The group, a model originally proposed for a monument at Denver, Colorado, exemplified the character, stamina and determination of the American people.

The small model was enlarged in plaster to heroic size by professional enlargers, but, during the process, its simple details were embellished. Zorach worked for one month to return the enlargement to its original design in time for placement in the Rose Court in December 1938. The heroic plaster was later destroyed. This bronze casting is of the original quarter-size model. Although an edition of six was authorized, only two castings were made.

1 Zorach, William, *Art is My Life, The Autobiography of William Zorach* (The World Publishing Company, Cleveland and New York, 1967) p.85.
2 *Ibid.,* p.173.

Vincent Glinsky

SEE *Brookgreen Gardens Sculpture,* pp. 424-428, for the artist's biography. Vincent Glinsky received the C. Percival Dietsch Award from the National Sculpture Society in 1968 for his work in Carrara marble, *Awakening,* which was similar to the example by the same title in the Brookgreen Gardens collection. In 1972 he received the Society's bronze medal for *Hymn to the Moon,* a howling coyote carved in Tennessee marble. Vincent Glinsky died at his home in New

York City on March 19, 1975. The 1975 annual exhibition of The Sculptors Guild was a tribute to Glinsky who had been a founding member of the organization.

The Dreamer

A female figure in repose, lies on her side with legs curled beneath her body and head resting upon folded arms. The figure, rounded and smooth with features and hair vaguely defined, is barely separated from the rock on which it reclines. The meditative quality of the work is enhanced by the soft forms and beautiful line.

Vincent Glinsky came from Russia to America when he was eight years old. Early in his career he set up a studio in Rome and began to perfect his style by intense study of Roman classical art and a self-imposed standard of excellence with which he measured each of his creations during this time. After eighteen months he traveled to Paris by way of Venice and Florence and stayed there for another year. Upon returning to New York, he had enough work to arrange a solo exhibition. *The Dreamer* is an example of Glinsky's sculpture from that period in Europe.

Marble. 17.8 x 22.9 x 5.7 cm. Signed: *V GLINSKY* / © S.1984.001, placed in 1984. Gift of Rodney L. Propps.

Anna Hyatt Huntington

PLEASE REFER TO *Brookgreen Gardens Sculpture*, pp. 168-180, for additional information about the sculptor.

Anna Hyatt Huntington died at her home, Stanerigg Farm, in Bethel, Connecticut, on October 4, 1973. Her sculpture career, which began when she was 13 years old and continued until her death at the age of 97, was filled with awards and honors; many of them are detailed in Volume I. In recognition of the 75th anniversary of the National Sculpture Society in 1968 the anniversary medal was struck in gold and presented to her. In 1985 she was inducted into the South Carolina Hall of Fame in honor of her outstanding career as a sculptor and the national recognition brought to South Carolina

by Brookgreen Gardens.

She was a pioneer in the use of aluminum as a sculpture medium: "I started to use aluminum for my animal pieces back in the early 30s, as the somber effect of bronze never seemed satisfactory. I asked the Roman Bronze Works of Corona to experiment with an aluminum casting for me and it proved most satisfactory, giving a life and brilliance of surface that showed fine modeling in even a poor light and I have used it ever since whenever possible."[1]

Toward the end of her life, her style of sculpture changed dramatically. Works modeled in the 1960s are marked by rough or exaggerated modeling, such as spiky hair and scowling faces, and although true to life, show less of the grace and beauty of her earlier pieces. Although she had always preferred to depict action in her sculpture, she now focused on scenes and events which had great drama and movement.

One of her later equestrian monuments was *Sybil Ludington*, known as the female Paul Revere, astride her spirited horse, with a switch as a riding crop, shouting the alarm. The monument was placed at Carmel, New York and a small version is in the Daughters of the American Revolution Museum at Washington, DC. Her last large-scale work was a monument to the Revolutionary War hero, General Israel Putnam, dedicated in 1969 at Putnam State Park near Redding, Connecticut. He is shown shaking his fist as he escapes from the British by riding his horse down a series of steps cut into a steep rock precipice. This monumental work was completed in 1966 when Anna Hyatt Huntington was 90 years old.

As abstract art became predominant, Anna Hyatt Huntington was increasingly despondent that her sculpture was dismissed as old-fashioned. She satisfied a personal urgency to complete her work by having a number of pieces, which had never before been cast, placed in permanent material. Art historians today are reexamining her sculpture in relation to its time and to the work of other artists. Anna Hyatt Huntington is recognized as one of the foremost American animaliers, a field she considered to be relatively untouched at the time she began to devote herself to animal sculpture.

Unless otherwise indicated, all of the acquisitions were gifts of the sculptor or of her estate. Several were older works that had just been cast, or were new versions of older pieces that she had remodeled. Most of these works were located in her studio at Stanerigg Farm or were cast for Brookgreen Gardens at her direction. A few others came to Brookgreen as a bequest of her estate or as gifts from individuals.

1 Letter to Delpha Heyward, May 27, 1955, Anna Hyatt Huntington Papers, George Arents Research Library, Syracuse University.

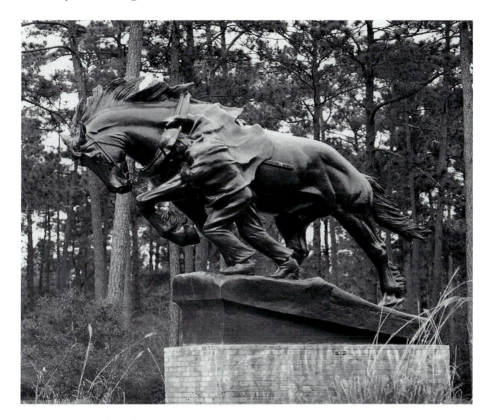

In Memory of the Work Horse

Bronze. 353.1 x 106.7 x 274.3 cm. Signed: *In Memory of the Work Horse Anna H. Huntington 1964* S.1970.001, placed in 1970. Other examples: Redding, CT. John Read Middle School (half-life-size); Washington, DC. National Museum of American Art (quarter-life-size); Syracuse, NY. Heroy Hall, Syracuse University.

Archer Milton Huntington

A dignified middle-aged man with a moustache and a receding hairline is depicted deep in thought. He wears a suit jacket over a shirt with a starched wing collar and a hand-knotted tie. This over-life-size portrait bust of the sculptor's husband, done three years after his death, was adapted from an earlier bust dating from 1924. The bust was cast by Roman Bronze Works in 1958.

Bronze. Height: 89.5 cm, Base width and depth: 24.6 x 24 cm. Signed: *Anna Hyatt Huntington 1958* On Front: *Archer M. Huntington / 1870 to 1955* S.1967.002, placed in 1967.

In Memory of the Work Horse

A farmer wearing a coat and a cap pulled down tightly, walking on an incline beside a large bridled horse, is braced against a stiff wind. The man hangs onto a plow harness around the horse's neck while his coat is blown up and over its back. The animal's head is down, as man and horse both lean into the wind.

This work is similar to a sculpture from 1913 entitled *L'Orage* (The Storm) where a horse and rider struggle against the wind. The sculptor often reworked ideas, changing the composition yet retaining the theme. Through childhood and as a young woman, Anna Hyatt often observed and worked with the huge draft horses used for plowing and hauling hay at the family sea farm, Seven Acres, at Annisquam, Massachusetts.

In Memory of the Work Horse was unveiled in a ceremony dedicating the George Washington Trail at Brookgreen Gardens on February 15, 1971.

Wildlife Column

A tall Corinthian column is embellished with designs of plants and animals. Seated at each corner of the base of the column are a fox, beaver, goose and duck. On top of the capital, rising from the center, is a spiral of heron-like birds in flight.

The sculptor used motifs from earlier works such as the tree of life with songbirds on the shaft of the column, which appeared in *The Visionaries* of 1955, and the flight of birds atop the capital, which was taken from *Rising Cranes*, done in 1934. The sculpture at first was intended to be a birdbath with the column positioned in the center of a shallow basin.

Bronze. Height: 264.2 cm. Signed: *Anna H. Huntington 1963* Founder's mark: ROMAN BRONZE WORKS INC. N.Y. S.1970.002, placed in 1971.

Lion's Share

A lion and two lionesses are tearing apart the carcass of an animal. The brutal scene is consistent with the sculptor's later period where her sculpture portrayed drama, tension and, often, unpleasant scenes.

Aluminum. 16.7 x 19.5 x 46 cm. Signed: *Anna H. Huntington 1964* On front: *LION'S SHARE* Founder's mark: ROMAN BRONZE WORKS INC. N.Y. S.1971.001, placed in 1971.

Ma Brings Home the Bacon

A jaguar drags the carcass of a gazelle which is clutched between its teeth. Motion is indicated by the angle of the jaguar's head as it pulls the animal's body to the left. A younger jaguar tugs in the opposite direction at the animal's legs as they drag on the ground.

Bronze. 38.5 x 41 x 12.5 cm. Signed: *Anna Hyatt Huntington 1964* On front: *MA BRINGS HOME THE BACON* Founder's mark: ROMAN BRONZE WORKS INC. N.Y. S.1971.002, placed in 1971.

Ma, Don't Leave Me

A colt has reared upon its hind legs, with its front legs outstretched for balance on the lower rung of a wooden fence. The mouth is opened in a pitiful whinny. Anna Hyatt Huntington had a well developed sense of humor which appeared in the humorous titles she gave to many of her early pieces, as well as to those works produced in her last years. This sculpture was modeled in 1969 when the sculptor was 93 years old.

Bronze. 31 x 31.8 x 20.5 cm. Signed: *A.H.H. 1969* S.1971.003, placed in 1971.

Mare and Foal

A reworking of an earlier theme, the sculpture depicts a standing mare nuzzling her recumbent foal. The foal has the uncertainty and ungainliness of a newborn animal.

Bronze. 24.8 x 12.9 x 33 cm. Signed: *Anna H. Huntington / 1960* Founder's mark: *Modern Art Fdry. N.Y.* S.1971.004, placed in 1971.

Mother

An elderly woman is seated propped up by pillows in an upholstered chair with her feet placed on a small footstool. She wears a long dress with a shawl, and a small lace cap is perched upon her head. In her hands is an open book. This work is a portrait of the sculptor's mother, Audella Beebe Hyatt, who was an amateur landscape painter and illustrator of her husband's natural history books.

Through the influence of her sister, Harriet Hyatt Mayor, Anna Hyatt Huntington developed a keen interest in her family's genealogy. The sculptures of *Mother, Grandmother* and *Great Great Grandmother* were the result of this interest.

Bronze. 25 x 13.5 25.5 cm. Signed: *Anna H. Huntington 1953* On front: *Mother* On right side of base: *Audella Beebe 1840-1932* On left side of base: *Married Alpheus Hyatt 1867* S.1971.005, placed in 1971.

Grandmother

An elderly woman with a stern expression stands stiffly, supporting herself with a thin wooden cane. She wears a long tailored dress with a high collar and a bustle dating from the late 19th century. Pinned upon her bodice is a lady's watch with its chain encircling her neck. In her left hand is an open fan. Her hair is braided and coiled on top of her head. The sculpture is a portrait of the sculptor's paternal grandmother, Anna Randolph Hyatt.

Bronze. Height: 48.2 cm. Signed: *A. H. Huntington* Founder's mark: R.B.W., INC. S.1971.009, placed in 1971.

Great Great Grandmother

A stout elderly woman is seated in a straight back wooden chair. She wears a long lace-collared dress and a close fitting bonnet. Her left hand rests in her lap while her right hand holds a Bible to her breast. Her face has a determined, almost severe look. This portrait of the sculptor's maternal great great grandmother, Anna Vaughn Beebe, was modeled at Stanerigg Farm, Bethel, Connecticut.

Bronze. 28 x 15.2 x 20.5 cm. Signed: *1953 A.H. Huntington* On front: *Great Great Grandmother / Anna Vaughn / Born 1767 Died 1849* On left side of base: *Daughter of Capt. John Vaughn 1732-1776* On right side of base: *Married Capt. Roderick Beebe 1771* [sic] Founder's mark: R.B.W., INC. S.1971.006, placed in 1971. Other example: New York, NY. The Hispanic Society of America.

The Original Narcissus

A chimpanzee is leaning over, gazing at his reflection in a pool, as he scratches his head inquisitively. This example is a copyrighted reproduction

from the original model which was made by Museum Pieces, Inc., in 1964, for
sale to the public.

Museum stone. 24.3 x 28 x 25.5 cm. Inscribed: *The Origion* {sic} *Narcissus* / ©*1964*
S.1971.007, placed in 1971. Other example: New York, NY. The Hispanic Society of America
(bronze).

Wrong Number

The sculptor has depicted a bust of an irate individual with fierce scowl and
wild hair who has just been awakened by the ring of a telephone. The ear piece
of an antique telephone is held next to one ear. The exaggerated expression
and rough modeling is indicative of many of the sculptor's later works. This
sculpture was modeled in 1967 and was cast by Roman Bronze Works.

Bronze. Height: 27.8 cm. S.1971.008, placed in 1971.

Fox and Goose

A fox, its hind legs lifted off of the ground, has pounced upon a goose. The
fox's mouth is clamped down on the bird's neck. The goose's wings are spread
underneath the fox's body and its legs thrash as it tries to escape.

Bronze. 41 x 40 x 45 cm. Signed: *Anna Hyatt Huntington 1936* Founder's mark: MODERN
ART FDRY. N.Y. S.1972.001, placed in 1972. Other examples: Washington, DC. National
Museum of American Art (aluminum); Boston, MA. Children's Art Centre; Brooklyn, NY.
Brooklyn Children's Museum.

Bear Hunting Grubs

A standing bear turns over a rock with one paw. Its head is lowered to
inspect the treasure beneath the rock. The bear's fur is indicated in a series
of strokes.

Bronze. 19.3 x 8.2 x 25.7 cm. Signed: *Anna Hyatt Huntington 1937* Founder's mark:
MODERN ART FDRY. N.Y. S.1972.002, placed in 1972.

Alligator

An American alligator is shown in a defense stance, with head lifted and mouth open displaying rows of sharp teeth. The tail is lifted and curved in an s-shaped pattern.

Modeled with realistic detail, this work was done in the studio at Atalaya in South Carolina: "Mr. Huntington built a house right on the beach at Brookgreen about a mile from the garden. We called it Atalaya meaning watchtower. There I had a large studio where I could bring in horses and had a lot of geese, swans, monkeys and an alligator in the studio — most of them wandering around at will — though not the alligator, he was a little too inclined to swish his tail, a formidable weapon."[2]

2 Anna Hyatt Huntington Papers, George Arents Research Library, Syracuse University, Syracuse, NY.

Brown Bears

The sculpture was cast from the same model as S.1939.001, but in bronze, rather than aluminum.[3]

3 See *Brookgreen Gardens Sculpture* (Proske), p.177.

Bronze. 114.5 x 131.1 x 86.6 cm. Signed: *Anna Hyatt Huntington 1935* Founder's mark: MODERN ART FDRY. N.Y. S.1972.004, placed in 1972. Other examples: New York, NY. The Hispanic Society of America (marble); Richmond, VA. Hospital of the Medical College of Virginia (limestone); Murrells Inlet, SC. Brookgreen Gardens (aluminum).

Boabdil

In a dramatic moment of tragedy Boabdil, the last Moorish ruler of Granada, reins in his spirited charger to turn and look back longingly at the city, just lost to the Catholic kings. He wears a long hooded robe, a loose tunic with pants belted at the waist, and high boots. This bas-relief is cast from a model for the heroic relief done in 1927 for the terrace at The Hispanic Society of America in New York City.

Bronze. 99.5 x 91 cm. Founder's mark: MODERN.ART.FDRY. / N.Y. R.1972.001, placed in 1972. Other example: New York, NY. The Hispanic Society of America (limestone high relief, heroic size).

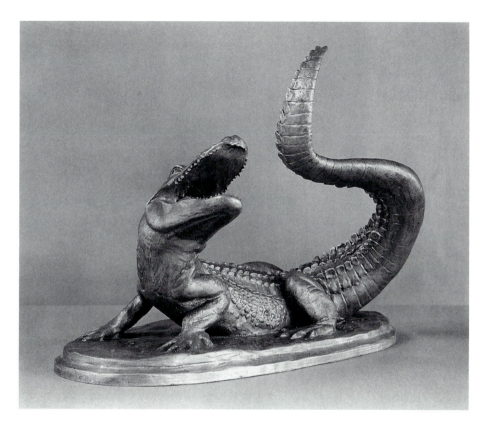

ALLIGATOR

Bronze. 49 x 28 x 54 cm. Signed: *Anna Hyatt Huntington 1937* Founder's mark:
MODERN ART FDRY. N.Y. S.1972.003, placed in 1972. Other examples: Newport News,
VA. The Mariners' Museum (aluminum); Elon, NC. Elon College.

Young Elk Running

An elk is trotting easily with head up and ears back. This little sculpture is
a one-hour study done some time between 1911 and 1914.

Bronze. 22.8 x 7.2 x 16.5 cm. Signed: *Anna V Hyatt* Founder's mark: *Modern Art Fdry. N.Y.*
S.1972.004, placed in 1972. Other example: Amherst, MA. Mead Art Museum, Amherst
College.

Virginia Doe

A doe stands alert with ears pricked, tail up and nose lifted to detect the

scent of danger. She stands lightly with right front leg and left rear leg lifted, ready to spring to safety. The sculpture was modeled in 1927.

Bronze. 27.8 x 7.8 x 20.5 cm. Signed: *A.H. Huntington* Founder's mark: MODERN ART FDRY. N.Y. S.1972.006, placed in 1972. Other example: Green Bay, WI. Neville Public Museum (aluminum).

Twin Cubs

Two bear cubs are seated lazily together. One cub leans forward with his legs on the ground as he licks his left front paw. The other leans back against his sibling in a relaxed posture and scratches his neck. The sculpture was modeled in 1937 but was cast by Modern Art Foundry in 1972.

Bronze. 15.2 x 27 x 17 cm. S.1972.007, placed in 1972.

Geisha

A French bull terrier is sitting quietly with her head lifted and turned slightly to one side. Her ears are pricked as if listening. Geisha was one of the Huntingtons' beloved pets. She was purchased while the Huntingtons were on a trip to Europe in 1932: "A[rcher] bought a French bulldog female for $100; he saw her and could not resist her."[4]

4 Diary entry, October 17, 1932, Anna Hyatt Huntington Papers, George Arents Research Library, Syracuse University.

Bronze. 17.4 x 11.4 x 10.3 cm. Signed: *Anna Hyatt Huntington 1937* Founder's mark: *Modern Art Fdry. N.Y.* S.1972.008, placed in 1972.

Deerhounds Playing

Two Scottish deerhounds face one another in a mock battle. One dog crouches on the ground with its head turned to the side and its mouth open, while the other dog has lifted one paw to swipe at its companion. The lively composition is enhanced by the attitude of playfulness. The sculptor has indicated the hair of the animals in a series of long strokes over the bodies, a method she rarely used.

On a trip to Europe in 1938, the Huntingtons brought back six puppies to start the first kennel of Scottish deerhounds in America. Their deerhounds

served as subjects for a number of her works and at least one of his poems: "I saw her walk in silver mist of morning, under the yellow trees, October lighted. I heard her call her great gray dogs to her, caressing each in turn, that none be slighted."[5]

5 Proske, Beatrice Gilman, *Archer Milton Huntington* (The Hispanic Society of America, New York, 1963), p. 25.

Bronze. 46 x 128 x 40 cm. Signed: *Anna Hyatt Huntington 1949* Founder's mark: *Modern Art Fdry. N.Y.* S.1972.009, placed in 1972. Other example: Greenville, PA. Thiel College, Langenheim Memorial Library (aluminum).

Echo with an Old Shoe

A young greyhound reclines comfortably, chewing on a high-heeled shoe held by its right front paw. This is one of several studies of Echo, another Huntington pet, done in 1935 and 1936.

Bronze. 21.5 x 50 x 29.2 cm. Signed: *Anna Hyatt Huntington 1936* Founder's Mark: MODERN ART FDRY. N.Y. S.1973.002, placed in 1973. Other examples: Charlotte, NC. The Mint Museum of Art (aluminum); Bloomington, IN. Indiana University.

Old Horse Grazing

With head lowered to the ground, an elderly horse grazes. The pelvic and rib bones protrude and the vertebrae of the spine are clearly visible beneath the thin skin. The mane and tail are short and tangled.

Bronze. 33 x 38 x 14 cm. Signed: *Anna Hyatt Huntington 1937* S.1973.003, placed in 1973. Other example: Syracuse, NY. Syracuse University Art Collections (plaster model).

Old Horse

An emaciated horse is standing at rest, its left rear foot lifted slightly, head down and tail blown between its legs. The hip bones and ribs protrude pitifully, portraying a condition of weakness and neglect.

This study and its companion, *Old Horse Grazing*, were done at Atalaya, the Huntington's winter home adjacent to Brookgreen Gardens. The subjects had been brought to Mrs. Huntington for use as models and under her care recovered to live additional years. These studies were made in preparation for a monumental equestrian statue of Don Quixote astride Rocinante, com-

pleted in 1947.

Bronze. 33 x 30.6 x 14.5 cm. Signed: *Anna Hyatt Huntington / 1937* S.1973.004, placed in 1973. Other examples: Washington, DC. National Museum of American Art (aluminum); Santa Fe, NM. Museum of New Mexico; Syracuse, NY. Syracuse University Art Collections (plaster model).

Marabou with Fish

Three marabou, their bodies facing inward on a circular base, are fighting over a fish. Each bird is depicted in a different stance: one is standing with wings slightly lifted, another is crouched on the ground with wings down, the third is standing on one leg with neck down and wings spread. There is a strong pattern of movement. The eye is drawn to the center formed by the struggle over the fish as it is torn by the three pointed beaks.

Bronze. Height: 52 cm, base diameter: 40 cm. Signed: *Anna Hyatt Huntington / © 1934* Founder's mark: MODERN ART FDRY. N.Y. S.1974.001, placed in 1974. Other examples: Charleston, SC. Gibbes Museum of Art; Terre Haute, IN. Sheldon Swope Art Gallery; Nashville, TN. George Peabody College for Teachers.

Zebra Mare and Foal

A female zebra is resting on the ground, about to rise, while her foal rears playfully in front of her. The foal stands nearly upright on its hind legs and its front legs wave in the air. This work was cast in both bronze and aluminum, and some examples were patinated to show the animals' stripes. The French inscription on the front reads, "Get up Mother, I am Hungry."

Bronze. 50.5 x 66 x 27.5 cm. Signed: *Anna Hyatt Huntington 1934©* On front: *Leve-toi Maman j'ai Faim* S.1974.002, placed in 1974. Other examples: Athens, GA. Georgia Museum of Art (aluminum); Cincinnati, OH. Cincinnati Art Museum (aluminum).

Red Doe and Fawn

A doe rests quietly on the ground and listens warily with her head lifted. Her fawn stands behind and leans against her, with its right forefoot lifted and tail up, looking in the same direction.

The companion to this group, *Red Stag*, is not in the Brookgreen collection. Both works in a larger size were placed on newel posts of stairs in front of The

Hispanic Society of America in New York City. They were modeled at Camp Arbutus in the Adirondacks, where the Huntingtons spent the summer of 1927.

Bronze. 29.8 x 33.6 x 19.2 cm. Signed: *1934* © / *Anna Hyatt Huntington* S.1977.004, placed in 1977. Other examples: New York, NY. The Hispanic Society of America (large version); Washington, DC. National Museum of American Art (aluminum).

Fish Hawk

A fish hawk perched on a rock guards its freshly caught fish. The head is lowered and wings are spread in defense of its meal. The neck and back feathers are lifted in a menacing display.

Bronze. 39.3 x 51.3 x 13.2 cm. Signed: *Anna Hyatt Huntington 1935* Founder's mark: .MODERN ART FOUNDRY. / .NEW YORK. / .N.Y. S.1978.005, place in 1978.

Sebastopol Geese

Two geese are depicted in a balanced composition. One is seated with its feet tucked under its body and neck twisted so that its head rests on its back. The other is standing and stretching out one webbed foot behind its body. The feathers are boldly indicated.

Bronze. 31.4 x 31 24 cm. Signed: *Anna Hyatt Huntington 1936* S.1978.006, placed in 1978. Other examples: Newark, NJ. The Newark Museum (aluminum); St. Petersburg, FL. Museum of Fine Arts.

Victory Horse

A spirited horse, tossing its head, prances upon a small mound. A laurel wreath signifying victory is attached upright to a harness on the horse's back. This work was modeled sometime between 1914 and 1920. In 1978 this example was donated to Brookgreen by Louise Breck Fergus of New Point, Virginia, who had won the sculpture in 1920 while studying at The Cleveland School of Art.

The donor stated: "Prior to graduation Miss Anna Hyatt came to visit our school and the sculpture class, taught by Mr. Matzen. All the students were proud to meet such a renowned artist, and particularly a woman sculptor of

animals. As a result of this visit Miss Hyatt donated a small horse cast in bronze…to the sculptor senior who won the top honor for the year. Fortunately I won this beautiful horse with the victory wreath attached to its harness."[6] A letter of congratulation from Anna Hyatt to Louise Breck accompanied the gift of the sculpture.

6 Letter from Louise Breck Fergus, 1978, Brookgreen Gardens Archives.

Bronze. Overall height: 33.7 cm. Signed: *Anna V Hyatt* Founder's mark: 2 / GORHAM CO. FOUNDERS / Q480 S.1978.010, placed in 1978. Gift of Louise Breck Fergus. Other examples: Hagerstown, MD. Washington County Museum of Fine Arts; Syracuse, NY. Syracuse University Art Collections (aluminum).

Nubian Goat

A goat is curled up at rest, its head turned around to lick its left side. The front feet are tucked under its chest and one hind leg is stretched out to the side. The long ears characteristic of the breed hang down on the sides of its face. Anna Hyatt Huntington produced a series of studies of this breed and other goats that were raised at her home. Archer Huntington was particularly fond of goat's milk and its healthful properties.

The sculpture was donated to Brookgreen Gardens in 1981 by George Kemeny of Pittsburgh, Pennsylvania.

Aluminum. 19.7 x 36.5 x 22.5 cm. Signed: *Anna Hyatt Huntington 1936 / IX* Founder's mark: ROMAN BRONZE WORKS INC. N.Y. S.1981.001, placed in 1981. Gift of George Kemeny. Other examples: New York, NY. The Hispanic Society of America (bronze); Sumter, SC. Sumter High School (variant); Washington, DC. National Museum of American Art.

Mammoth

A wooly mammoth with large curved tusks grasps a branch in its trunk and, with its head turned to the right, pulls the branch from the log. The left front foot is lifted onto the log, holding it in place. The animal's body is covered with hair, indicated by a pattern of strokes.

Anna Hyatt was commissioned by the Trustees of the Brooklyn Institute of Arts and Sciences on October 17, 1902 to create three plaster models of extinct animals for an exhibit: a mastodon, a mammoth and an Irish elk. After the exhibit closed, the models were placed in storage.

In 1984 this plaster model and the model of the mastodon were deaccessioned and donated to Brookgreen Gardens by The Brooklyn Museum.

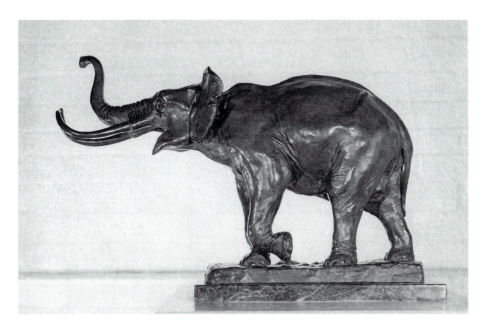

MASTODON

Bronze. 36.2 x 34.3 x 16.5 cm. Signed: *Anna V Hyatt / 1902* S.1989.004, placed in 1990.

The sculptor, Charles Parks, repaired the damaged models and delivered them to Laran Bronze, Inc., where molds were made. These unique examples were cast in bronze under his supervision in August of 1989 specifically for Brookgreen Gardens.

Bronze. 36.2 x 40.6 x 17.8 cm. Signed: *Anna V Hyatt* S.1989.003, placed in 1990.

Mastodon

A mastodon with long tusks stands with its left front foot raised, trunk lifted, and mouth open. Its left ear is held upright while the right ear is lowered and held flat against the head. The animal resembles the modern elephant with its tough, wrinkled skin.

This is one of two works cast in 1989 from plaster models that were deaccessioned and donated to Brookgreen Gardens by The Brooklyn Museum in 1984.

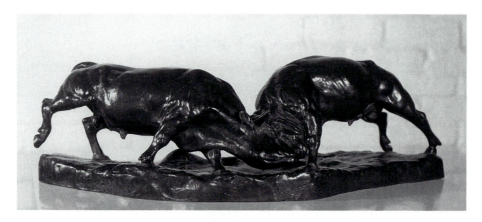

BULLS FIGHTING

Bronze. 22.2 x 65.4 x 19.7 cm. Signed: *Anna V. Hyatt* Founder's mark: *Roman Bronze Works N.Y. / 1905* Incised underneath: *N 1.* S.1991.001, placed in 1992. Gift of the estate of R. Stanley Lawton. Other examples: Roswell, NM. Roswell Museum and Art Center (aluminum); Greensboro, NC. Weatherspoon Art Gallery, University of North Carolina; New York, NY. The Hispanic Society of America (posthumous bronze cast).

Bulls Fighting

Two bulls are squared off, their powerful bodies low to the ground, horns locked in combat. The symmetry of this piece was repeated by the sculptor in other compositions of animals in combat. This sculpture was inspired by the animals the sculptor observed on her brother's farm, Porto Bello, near Leonardtown, Maryland, where she was a frequent visitor in the early years of the 20th century. *Bulls Fighting* won the Julia A. Shaw Prize of the National Academy of Design in 1928. This sculpture was a gift of the estate of R. Stanley Lawton of Indianapolis, Indiana, in 1991.

Carl Paul Jennewein

SEE *Brookgreen Gardens Sculpture*, pp. 305-311, for the sculptor's biography.

In the last years of his life honors continued to come to Paul Jennewein and his sculpture. In 1968 he was awarded the Gold Medal of the American Artists Professional League and was named honorary president of the National

Sculpture Society. His female figure, *Reflection*, received the Gold Medal at the Society's 75th anniversary exhibition. In 1970 his medallic art was recognized with the Numismatic Art Award of the American Numismatic Association. After serving with distinction for 13 years as the President of the Board of Trustees of Brookgreen Gardens, Paul Jennewein was elected President Emeritus in 1976. He died at his home in Larchmont, New York, on February 22, 1978.

A number of his personal papers were placed in the Archives of American Art at the Smithsonian Institution, Washington, DC. A few months prior to his death, he donated to Brookgreen Gardens several works of art from his studio including *Iris*, *Cupid and Crane*, *Sabrina*, *The Conqueror* and the original models of *Sancho Panza*, a standing male figure from the *Ardennes Memorial*, a classical female figure, *Arbutus*, and *Spirit of Justice*, one of the figures created for the entrance to the Rayburn Building in Washington, DC. The original models are not on exhibit.

A large bequest of sculpture, models, drawings and records from the sculptor's estate was made in 1978 to the Tampa Bay Art Center and is now housed in the Tampa Museum of Art in Florida. In 1980, Shirley Reiff Howarth authored a definitive catalogue of Jennewein's work which accompanied an exhibition of these objects at the museum.

Sancho Panza

Don Quixote's bearded, paunchy companion, Sancho Panza, stands in a relaxed position, leaning against a patient donkey, his hat pushed back on his head. His left hand is on his hip, his right elbow rests upon a blanket covering the donkey's back, and one foot is crossed nonchalantly over the other. Sancho gestures with his right hand, a typical expression of the character. His leather jerkin is belted across his belly and woolen leggings slide down his calves toward feet shod in sandals. A saddle bag hangs on the donkey's right side. A small lizard on the ground next to the donkey's left front foot completes the group.

This work was created as a result of a request by Anna Hyatt Huntington in 1968 to have a companion to her sculpture, *Don Quixote*, at Brookgreen Gardens. Jennewein studied literary references to the character of Sancho in order to capture the proper personality, and utilized the resources of The Hispanic Society of America in New York City in order to depict accurate period costume. He used himself as a model for the figure's stance and hand

SANCHO PANZA

Aluminum. 259.2 x 122 x 259.2 cm. Signed: *C. P. Jennewein / 1971.* Founder's mark:
. MODERN ART FOUNDRY . / .NEW YORK. / .NY. S.1971.011, placed in 1971.

gesture. Anna Hyatt Huntington wrote to Jennewein, "Thank you for sending the photograph of Sancho and his donkey. They are perfect and Sancho seems to be counting off time on his weary wait for his dreaming master. Please be sure your signature is prominent under this piece."[1]

Since *Don Quixote* had been cast in aluminum, a medium in which Anna Hyatt Huntington had pioneered, it was determined that Sancho Panza would be cast in aluminum, as well. The work was completed in 1971 and is unique.

1 Letter dated October 6, 1969, "Carl Paul Jennewein," Sculptor's Correspondence Files, Brookgreen Gardens Archives.

Iris

Paul Jennewein was first attracted by the grace and charm of Hellenistic sculpture and the rhythm and harmony of Greek ornamental carving. Greco-Roman statues of Aphrodite and Venus furnished the inspiration for some of his figures. The name, Iris, refers to the goddess of the rainbow and a messenger of the gods. In both Greek and Roman mythology she is called to intervene with mortals and the gods, wearing her cloak of many colors which trails across the sky in a rainbow curve.

The sculptor has recreated the curve in the unusual composition of the figure. A young woman stands on her toes with her body arched backwards. The arch of the body represents the arch of the rainbow. Both arms are raised, palms inward, a posture he successfully used six years earlier in another female figure, *Spirit of Justice*, for the Department of Justice in Washington, DC. Her legs are pressed together as if poised for ascent, creating stability and the sense of solid form. The figure stands upon a circular base of three tiers.

Jennewein began work on *Iris* in 1939 using seventeen different models to achieve the perfect female figure. In 1941 it was cast in two sizes; the sculptor himself hand burnished the bronze surface of each casting. The smaller example was acquired by Brookgreen Gardens in 1943.[2] The large bronze was exhibited at the American Academy of Arts and Letters in 1942 where it was well received, then it was shown in the "Artist's for Victory" exhibition at The Metropolitan Museum of Art in late 1942 and early 1943. This work won the Sidney B. Hollander Prize for sculpture at an exhibition of the New York chapter of the American Artists Professional League in 1944.

Despite its critical acclaim, the large version of *Iris* was not acquired by a museum during the artist's lifetime. The plaster model was placed at the American Academy of Arts and Letters, but the bronze goddess of the rainbow

remained in a place of honor before a Chinese wall hanging in the sculptor's studio.

Burnished bronze. Height: 222.3 cm. Signed; *C. P. JENNEWEIN / 19©39*. S.1978.002, placed in 1978. Gift of the sculptor.

2 See Proske, *Brookgreen Gardens Sculpture*, p. 311.

Cupid and Crane

This work, a companion piece to *Cupid and Gazelle*, was created in 1924 to celebrate the birth of the artist's third child, Alessandro. *Cupid and Gazelle*, done in 1919, was inspired by a visit to the Borghese Gardens in Rome when Jennewein was a student at the American Academy. He was struck by the contrast between the angular outlines of the animals darting about on the grounds and the soft, round lines of a baby — his first son, Paolo.[3]

In *Cupid and Crane*, a winged baby cupid sits astride a walking crane with a sinuously curved neck and graceful, sweeping neck and tail feathers. The child's left hand grasps one of the bird's long head feathers, while the right arm is outstretched for balance. The linear quality of this work is a hallmark of Jennewein's style.

3 See Proske, *Brookgreen Gardens Sculpture*, p. 310.

Sabrina

A nude young woman stands in quiet contemplation with her head turned to the right. Her right arm crosses her chest, her fingers curving beneath her chin, and her left arm hangs down behind her body. A drape falls to the ground on her right side. She is smoothly depicted in the neoclassical tradition.

This work was carved in Vermont marble in 1966. In that same year it was entered in the 17th Annual National Exhibition of Realistic Sculpture at the Museum of Fine Art in Springfield, Massachusetts, where it received Best in Show.

Vermont marble. Overall height: 92.7 cm. Signed: *C.P. JENNEWEIN Sc. / 19©66*. S.1978.003, placed in 1978. Gift of the sculptor.

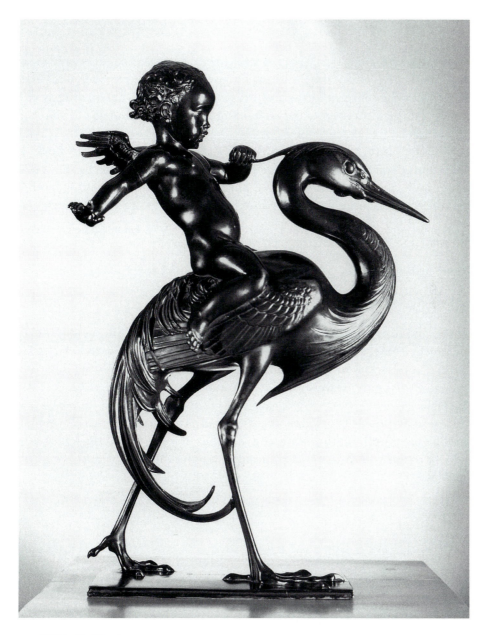

CUPID AND CRANE

Bronze. Overall height: 55 cm. Base: 13.2 x 27 cm. Signed: *C.P. JENNEWEIN* ©
S.1978.007, placed in 1978. Gift of the sculptor. Other examples: Hartford, CT. The
Wadsworth Atheneum; San Francisco, CA. Fine Arts Museums of San Francisco; Newark,
NJ. The Newark Museum; St. Petersburg, FL. The Museum of Fine Arts.

The Conqueror

A bald eagle and a snake are portrayed in fierce battle. The eagle with tense, outspread wings grasps the thrashing snake with the strong curved talons of its right foot. The snake strikes at the bird's leg. Its left foot is flat on the ground, bearing the eagle's weight, and its hooked beak is opened, ready to tear into the reptile.

This sculpture, cast in bronze in 1974, was Jennewein's last major work. It is the only depiction of an eagle by the artist in which the raptor is allowed to stand on its own — completely free of man, of architectural setting, and of symbolism. It represents nothing more than a natural act of a wild creature.

Bronze. 42.2 x 14.5 20.3 cm. Signed: *C.P. JENNEWEIN 19©74* Founder's mark: Modern Art Fndry. NY. S.1978.004, placed in 1978. Gift of the sculptor.

American Eagle

A majestic eagle stands proudly, wings spread back in an attitude of defiance. This sculpture, with its companion, was created and carved in stone in 1927 for placement atop columns at the Arlington Bridge in Washington, DC. In 1929 the eagles were also placed on gateposts at the American Embassy in Paris.

The examples at Brookgreen Gardens were cast from the artist's original models specifically for the entrance gate. The choice of aluminum was a result of the proximity of Anna Hyatt Huntington's heroic aluminum group, *Fighting Stallions.*

Aluminum. Height: 106.7 cm, Base width and depth: 61.6 x 96.5 cm. S.1977.006, placed in 1978.

American Eagle

This work is the companion to S.1977.006. Both sculptures were cast by Modern Art Foundry in 1977.

Aluminum. Height: 106.7 cm, Base width and depth: 61.6 x 96.5 cm. S.1978.001, placed in 1978.

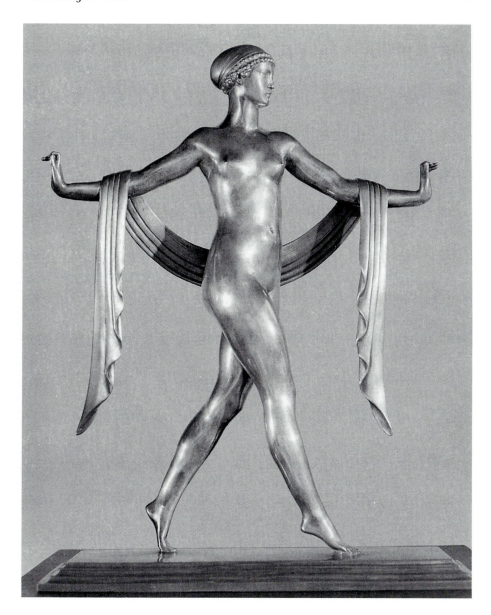

THE GREEK DANCE

 Silvered and polished bronze. Height: 46.7 cm, base width and depth: 36.8 x 11.7 cm.
Signed: *C.P. JENNEWEIN* [faintly scratched]. Founder's mark: AMER. ART F'DRY N.Y.
S.1989.001, placed in 1989. Other examples: San Diego, CA. Museum of Art (silvered
and polychrome); Tampa, FL. Museum of Art (gold-plated surmoulage).

The Greek Dance

A female figure with face in profile walks on tiptoe in a graceful sideways movement. Her arms are extended in both directions, her hands bent back at the wrist, and fingers bent forward in a gesture relating to the dance movement. A drape falls in stylized folds over each arm. Her hair is bound with a decorative cloth ornamented by two circular rows of beads. This small sculpture was one of the artist's most popular works.

The Greek Dance was created in 1926 when Jennewein was at Rome working on the pediment for the Philadelphia Museum of Art. The first example of the sculpture was acquired for Brookgreen Gardens in 1940; it was stolen in 1981. In 1984, a surmoulage casting was made from an example in the collection of James J. Jennewein, son of the sculptor, and donated to Brookgreen Gardens. It remained in the collection until the present example was acquired in 1988. The surmoulage was donated by Brookgreen Gardens to the Tampa Museum of Art in 1989.

This example was originally painted blue and orange on the surface of the polished bronze areas in imitation of the polychrome applied to works of antiquity. This coloring is similar to the polychrome that Jennewein was devising for the figures in the pediment of the Philadelphia Museum of Art. The sculpture was formerly in the collection of Mrs. John Mead Howells.

Gertrude Lathrop

For additional information on the life of the sculptor, please refer to *Brookgreen Gardens Sculpture*, pp. 408-413.

Gertrude Lathrop continued to receive awards for her sculpture, well into her later years. In 1970 she received the Saltus Gold Medal for Merit from the National Academy of Design. The Meriden Arts and Crafts Association gave her a prize in 1971, and in 1973 she received the Gold Medal for excellence in medallic sculpture from the American Numismatic Association. In 1974 she was awarded the Sharon Creative Arts Founders Prize and the Allied Artists of America presented her with its Gold Medal of Honor. In 1976 she received a silver medal from the Kent Art Association. A panel exhibiting the obverse and reverse of six of her medal designs won the Mrs. Louis Bennett Prize at the 44th

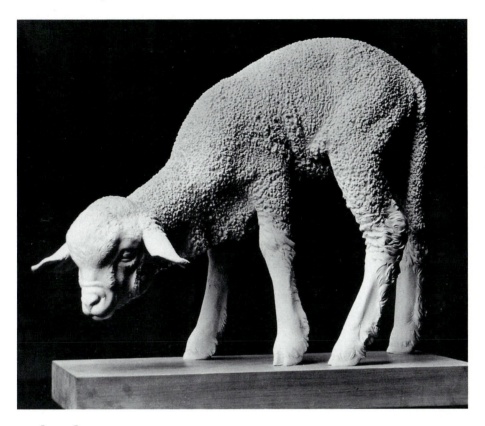

Silver-plated bronze. 42.5 x 48.3 x 21.6 cm. S.1972.011, placed in 1973.

annual exhibition of the National Sculpture Society in 1977.

Gertrude Lathrop served on the board of trustees of Brookgreen Gardens from 1974 until 1980. At her death on March 16, 1986, in Falls Village, Connecticut, she was an honorary trustee.

Little Lamb

A newborn lamb is standing with its head lowered and ears down, presenting an engaging portrait of vulnerability and gentleness. The sculptor has realistically depicted the animal's woolly coat in a pattern of textured nubs. When exhibited at the National Academy of Design in 1936, this work received the Speyer Prize. In 1937 it was awarded the Crowninshield Prize at the

Stockbridge Art Exhibition. This example was cast in 1972 for Brookgreen Gardens by Roman Bronze Works.

Gertrude Lathrop wrote, "The subject of my model was a cosset lamb that my sister brought home on her lap. My sister's book, *Bouncing Betty*, also used this lamb as a subject. Our animals usually posed for both of us and in this case did triple duty as my mother, who was a painter, painted her picture standing in a flower bed."[1]

1 Letter from Gertrude Lathrop, dated June 8, 1972, Sculptors Correspondence Files, Brookgreen Gardens Archives.

Paul Manship

PLEASE REFER TO *Brookgreen Gardens Sculpture*, pp. 285-294, for the sculptor's biography.

Nearly thirty years after his death, Paul Manship continues to interest art historians and the art world in general. Images of his sculpture have become a part of American popular culture, from backdrops for movie scenes to soft drink commercials.

In 1985 in honor of the centennial of his birth in St. Paul, the Minnesota Museum of Art mounted a major exhibition of his work which toured the country through 1987. The museum was one of two repositories which received the sculptor's studio contents and records at his death in 1966. The catalogue produced for this exhibition, *Paul Manship: Changing Taste in America*, included essays by eight guest scholars on various aspects of his sculpture and career.

In 1989 the National Museum of American Art, the other major beneficiary of the Manship bequest, organized another important exhibition, "The Art of Paul Manship," which toured the United States through 1991. A handsome catalogue was authored by Dr. Harry Rand, curator of painting and sculpture. Complementing this activity, in 1989 the sculptor's son, John Manship, published a biography entitled *Paul Manship* which told his story from another perspective, within the context of his family. This work also included an array of stunning drawings and photographs never before published.

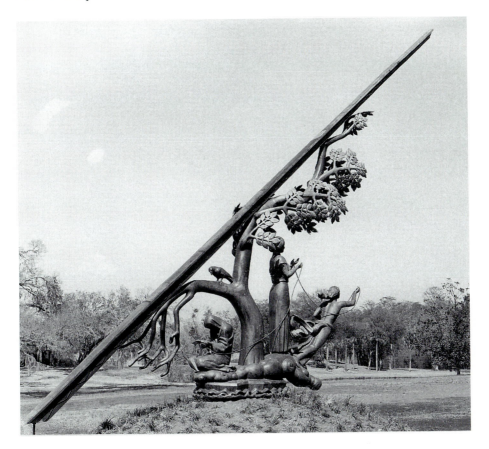

TIME AND THE FATES OF MAN

Bronze. Overall height and length: 355.6 x 330.2 cm. Gnomon length: 823 cm.
Signed: *Paul Manship Sculp / 1939* Inscribed: *Atropos / Lachesis / Clotho* S.1980.005, placed
in 1981. Other examples: Saint Paul, MN. Minnesota Museum of Art (two smaller
versions); Washington, DC. National Museum of American Art (smaller version).

Time and the Fates of Man

Paul Manship stretched the bridge between the academic tradition and the
more radical forms of modernism by accommodating the modern taste for
elegance and streamlining in his work. His two favorite devices in sculpture
— symbolism and time — are presented in this work.

The three Greek Fates, who determined the destiny of mankind, are
depicted within a composition anchored by the Tree of Life. In the front,
posed like a ship's figurehead, is Clotho, the youngest of the Fates who
presided at the moment of birth and spun the thread of life. Clotho holds in

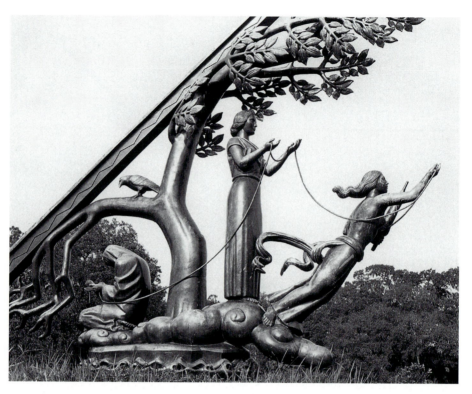

TIME AND THE FATES OF MAN

her hand a distaff and the thread runs through her fingers toward the second figure, Lachesis. She stands solidly with both arms extended, holding the thread in each hand and measuring it as it passes through her fingers. Depicted as a woman in her prime, her job was to determine the direction of life. The thread travels on behind her to the third figure, Atropos. Shown as an old woman with shears, hunched over and wearing a heavy hood, she cut the thread of life at death.

The Tree of Life symbolically spreads its branches over the three women — leafy (life) over Clotho and Lachesis, and bare (death) over Atropos. Another harbinger of death is the raven perched on a barren branch over the head of Atropos. Manship used a series of stylized lines to represent the four elements. On the base below the tree are symbols of earth, water and fire. Along the gnomon are wavy lines representing air.

An enlargement of this sculpture, the monumental centerpiece of the 1939 New York World's Fair, was exhibited in Constitution Mall in front of the Trylon and Perisphere. Also, titled *Time, The Fates, and the Thread of Life*, it stood

with four accompanying fountains depicting *The Moods of Time*. With a gnomon 80 feet in length, it was considered the largest sundial in the world.

Paul Manship was one of four sculptors commissioned to design major works by the Worlds Fair Commission. The preliminary studies were done in New York in 1938 then shipped to Paris to be enlarged. All of the monumental figures, exhibited in staff (a plaster compound), were later destroyed. This unique bronze example was cast in 1952 in Italy from one of the models. For many years, along with four bronze castings of *The Moods of Time*, it was an attraction in the gardens at Sterling Forest, a planned community in Tuxedo, New York. The sculpture had been acquired by Sterling Forest directly from Manship. On December 4, 1980, the sundial was purchased by Brookgreen Gardens at Sotheby's in New York.

Manship gave the following description of the work: "The gnomon casts its shadow on the platform dial surrounding it and registers sun-time. The gnomon is upheld by the Tree of Life, which grows out of a rocky, insular base. THE THREE FATES — Clotho, the Future, holds the distaff and is the motif of the forward curve; Lachesis, the Present, is vertical and looking ahead, and is measuring the thread as it passes through her hands; Atropos, the Past, the curved line which returns within itself, symbolises the end of things as she cuts the thread. Over her head the branches of the Tree of Life have lost their foliage, and the Raven — the Bird of Doom — sits watching her."[1]

1 "American Impressionist & 20th Century Paintings, Drawings, Watercolors & Sculpture," Thursday, December 4, 1980, Sotheby's, New York, Lot 96.

George Demetrios

GEORGE DEMETRIOS was born in Pyrgoi, Greece on April 1, 1896, to Michael and Euphthemia (Krallis) Demetrios. The family lived in northern Macedonia near the borders of Yugoslavia and Bulgaria. With the death of his father and the end of his educational opportunities in Greece, George Demetrios came to the United States alone at the age of 15 and found work as a shoeshine boy in Boston. His drawing talent was discovered by John Hybers, an illustrator and painter, who sent him to the School of the Museum of Fine Arts. Hybers arranged for Miss Charlotte Hallowell of West Medford, Massachusetts, to sponsor a scholarship.

Demetrios visited the sculptor, Charles Grafly, at his studio in Cape Ann, Massachusetts, and eventually served an apprenticeship. Grafly was a teacher at the Pennsylvania Academy of the Fine Arts and Demetrios decided to go there for additional training. In 1913 he enrolled in the Life Modeling Class and for the next five years studied formally under Grafly. In 1915 he became a citizen of the United States.

While at the Academy, Demetrios won the Edmund Stewardson Prize for figure modeling. In 1916 and 1917 he was awarded two Cresson Traveling scholarships, but the events of World War I prohibited him from using them. Demetrios left school in 1918 and due to his language skills in Greek, Turkish, Hebrew and Vlach dialect became an interpreter for the Bureau of Censorship.

In 1919, when European travel again became possible, he used the Cresson Scholarships to go to Paris where he studied at the Sorbonne and the Ecole des Beaux Arts. In 1922 he received a degree but was dissatisfied with his ability to draw. For three years he continued to practice drawing and modeling. Demetrios eventually developed a fluency of line based on a technique taught by Charles Grafly. He was deeply impressed by the prehistoric cave paintings at Marsoulas in southern France, and became inspired to capture that same quality by drawing from life.

In 1923 he returned to the United States, opened a studio in Boston and began to accept students in drawing. In 1925 he was again at the Pennsylvania Academy of the Fine Arts for two years, teaching and serving as Charles Grafly's assistant. Then, he opened the George Demetrios School of Drawing and Sculpture for winter classes in Boston. After Grafly died in 1929, Demetrios used the Grafly studio at Folly Cove for summer classes. During this time he also taught in private schools and at the Museum School in Boston.

On March 28, 1931 he married Virginia Lee Burton, a dancer, designer and writer and illustrator of children's books, whom he met when she came to him for drawing instruction. They set up housekeeping permanently in Folly Cove. She founded the Folly Cove Designers, a professional guild of craftspeople, which operated from 1941 until 1969. The group was widely known for meticulously carved linolineum blocks and printed textiles, and Virginia was successful with two of her books, *Mike Mulligan and His Steam Shovel* and *The Little House.* The latter won the Caldecott Award in 1943.

George Demetrios used the people of Cape Ann as models for the portrait heads that made up a large part of his work. These were not just likenesses of the individuals but superb character studies. A bronze head of his wife done in 1936 received the Publicover Prize for Best Sculpture from the North Shore

Art Association in 1939. *The Boss*, a portrait of Frederick Lester Poland, a blacksmith and caretaker for the Grafly Family, was exhibited at the Pennsylvania Academy of the Fine Arts in 1936. In 1950 *A Dreamer*, a head of a young boy posed by his son, Aristides, received the Thomas R. Proctor Prize for best portrait sculpture from the National Academy of Design. *Old Finlander* won the 130th Anniversary Prize at the National Academy of Design exhibit in 1955. In 1963 Demetrios was elected a National Academician and in the following year, *Young Sailor* won the Academy's Elizabeth N. Watrous Gold Medal.

In 1939 George Demetrios became interested in ceramics and porcelain sculpture. For several years he studied ceramics at the Massachusetts Institute of Technology and eventually worked with Professor Frederick H. Norton in developing a more durable type of terra cotta. During the 1940s Demetrios experienced a period of disillusionment, both with the events of World War II and with trends in the art world. When he first came to Boston he authored a book, *When I Was a Boy in Greece*, which was published in 1913. During this troubled time he turned again to writing. *When Greek Meets Greek*, which he also illustrated, was published in 1947. He was employed by the Chemical Warfare Service Development Laboratory at MIT to create a series of male heads for development and fitting of gas masks. This work entailed analyzing the anthropomorphic specifications of over 3,000 heads and creating ten composites from which three main types were developed.

In 1949 a major exhibition of his work was held at Doll and Richards Gallery in Boston. Included in this show were several of his direct line drawings, terra cotta bas-reliefs and a series of small bronzes depicting what he called "the ironies of life." Having such titles as *Lipstick Mania, Technology*, and *Politico-Hypnosis*, they were cartoon-like in content, gently satirizing the arts, the government and business. *Nude Figure*, a bas-relief of a reclining woman, c. 1939, is the epitome of his mastery of the direct line drawing and its relationship to sculpture. The lines are subtle: just enough to delineate the female figure, yet maintain a clean, spare composition.

Through the decades of the 1950s and 1960s, Demetrios experienced a surge of creativity. He continued his social commentary in sculpture with works such as *Christ on the Subway*, in which the figure of Christ is depicted with hands above His head, clutching the overhead rail, while a crush of people surrounds Him, yet ignores Him. In *Woman Manipulating Man*, the relationship between the sexes is represented by two acrobats: a woman lying on her back with her legs up, lifting a man on the soles of her feet. The viewer must decide whether the man is being balanced or juggled. Reminiscent of the

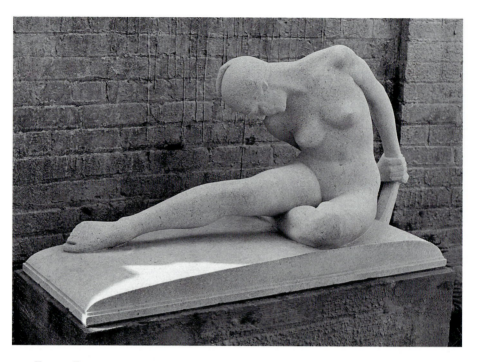

FALL OF FRANCE

Marble. 50.8 x 96.5 x 38.1 cm. S.1978.009, placed in 1978. Gift of the heirs of George Demetrios. Other example: New Britain, CT. New Britain Museum of American Art (small version).

despair found in an earlier work, *Fall of France,* Demetrios' small marble, *Monument to John F. Kennedy,* was done about 1964. In this memorial the sculptor again depicted a seated female figure with head bent low in grief, but this time her arms were stretched out in front of her body, the hands clasped in an attitude of prayer. Demetrios created a brooding portrait of his friend and fellow sculptor, Paul Manship, where details were kept to a minimum and the introspective quality of the work was strong. In 1959 he received his most important commission — an heroic bronze relief of Moses at the summit of Mt. Sinai holding on his shoulders the tablet of the Ten Commandments. It was placed on an exterior wall of the religious school at B'Nai Jehudah Synagogue in Kansas City, Missouri.

George Demetrios was a fine teacher. Walker Hancock referred to him as a "born teacher," and Paul Manship called him the best drawing teacher in America. Emphasizing what he referred to as "the ensemble" — a simplicity of line and movement which incorporated the whole figure — Demetrios taught hundreds of students, some of whom became outstanding artists. In

1968 he was awarded the 75th Anniversary Medal of the National Sculpture Society in recognition of his status as one of the foremost teachers of figure drawing in America. George Demetrios died in Gloucester, Massachusetts on December 4, 1974.

He wrote, "Drawing is not like sculpture. It is quick and when successful at all it is direct. When this drawing is used in sculpture from every conceivable point of view our sculpture is no longer stiff, it is moving, it swirls, it weaves around and around. Sculpture ceases to be tedious, it ceases to be a sort of occupational therapy. It lives, it is for the eyes."[1]

1 Demetrios, George, "My Adventure in Drawing," *National Sculpture Review*, Summer, 1969, p.25.

Fall of France

George Demetrios experienced a period of discouragement during the war years of the 1940s and was deeply moved by what was happening in Europe, especially in France and his native Greece. The sculpture, *Fall of France*, a statement of his feelings at that time, expressively depicts a mood of despair.

The entire composition of a seated female figure, head down, hands bound at her back, one leg stretched out before her, is a beautiful study of flowing line. The delicacy of the figure's pose is enhanced by the gently curving arc of the base on which she sits.

Head of a Young Man

A young man with curly hair, square jaw and serious countenance, stares straight ahead. The sculptor's understanding of the underlying anatomy and the planes of the face is evident. This is a fine example of the penetrating character studies for which Demetrios was so well known. The model was James McClellan, a student and assistant of the sculptor.

Although modeled in 1933, the head was cast in 1942 from a specially-developed terra cotta which was subject to only a small amount of shrinkage, could be colored, and could be worked during the drying period. George Demetrios was one of several sculptors working with Dr. Frederick H. Norton, Professor of Ceramics at the Massachusetts Institute of Technology, to develop a versatile and dependable terra cotta designed to meet sculptor's requirements.

Terra cotta. Height: 39.4 cm. Base: 13 cm in diameter. Signed: *Demetrios / 1933*
S.1978.008, placed in 1978. Gift of the heirs of George Demetrios.

Richard Recchia

PLEASE REFER TO *Brookgreen Gardens Sculpture*, pp. 216-218, for additional
biographical information.

Richard Recchia died on August 17, 1983, at his home in Rockport,
Massachusetts.

Flute Boy

A boy crouches with one knee on the ground while he plays a flute fashioned
from a slender branch. The work is infused with gracefulness and gaiety —
qualities that recur in his garden sculpture. Richard Recchia "always captures
the clean firm flesh of youth. His figures are rhythmical, verveful and joyful.
His children are glad to be alive... they love to feel the wind and the sun upon
their faces."[1]

The plaster model for *Flute Boy* was destroyed by a fire at the Anthony
Thieme Gallery where it was on exhibition. The only bronze cast from that
model was made for the wife of former Congressman Louis A. Frothingham
of Northeaston, Massachusetts. Mrs. John Ames, sister-in-law of Mrs.
Frothingham, allowed the sculptor to borrow the bronze in order to have a
new plaster model made. However, Mrs. Frothingham had destroyed the
original base and set the figure on a boulder, requiring that the sculptor make
a new base. The example at Brookgreen Gardens was cast by Roman Bronze
Works from the second plaster model.

In 1972 Brookgreen Gardens announced that it was accepting submissions
of work for the collection and this sculpture was one of four chosen for
purchase.

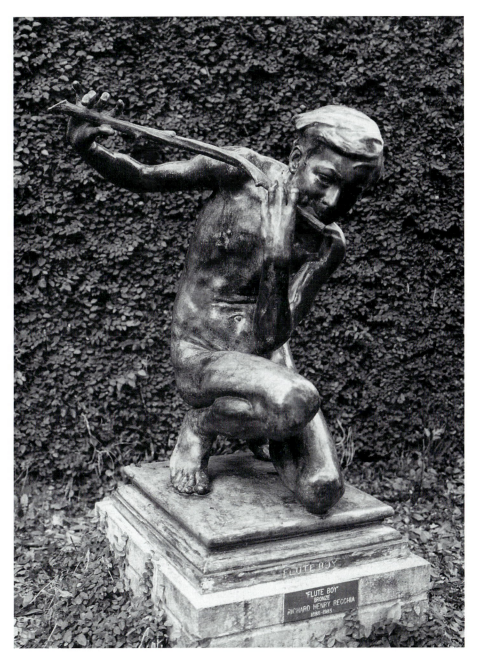

FLUTE BOY

Bronze. 92 x 46 x 52.5 cm. Signed: *R.H. RECCHIA. 1923* On the front: *FLUTE BOY*
S.1973.001, placed in 1973.

Flight

A life-size nude boy standing on tiptoe has just shot an arrow from a bow held upward above his head. The right arm is drawn back and the fingers are curved as if pulling the bow string. He looks to the sky as his eyes follow the flight of the arrow. His entire body flows upward from his toes through his extended bow arm, as though he, like the arrow, were about to fly through space.

The sculpture was modeled in 1928 and cast by the Ideal Casting Company of Providence, Rhode Island, in an edition of three. The first cast was placed in the garden of Mrs. Fred Newhall Boston at Grand Beach, Maine. This example of *Flight* was one of several art works located in the home, studio and garden of the sculptor at the time of his death. The work was donated to Brookgreen Gardens by the Richard Recchia Estate.

In 1931 *Flight* was awarded the Cross of Honor and a Gold Medal at the International Exposition Literale at Bologna, Italy.

Bronze. Overall height: 198.1 cm. Signed: *RICHARD.RECCHIA. / 1928* Founder's mark: IDEAL CASTING CO. PROV. R.I. S.1985.001, placed in 1985. Gift of the Richard Recchia Estate.

1 Hurd, Harry Elmore, "Richard Henry Recchia, Cape Ann's Only Permanent Resident Sculptor," *The Breeze,* June 26, 1931, p. 55.

Sally James Farnham

SEE *Brookgreen Gardens Sculpture* pp. 157-160 for the sculptor's biography.

The End of the Day

A female figure is seated on the ground, legs to one side, with head bowed low and both arms hanging slack in front. She is the epitome of fatigue, as if the cares of the world were heavy on her shoulders. A small bronze study of this figure was acquired by Brookgreen Gardens in 1943.[1]

The figure was inspired by an exhausted member of Isadora Duncan's dance troupe who had dropped to the floor after a strenuous practice session.

THE END OF THE DAY

 White marble. Overall height: 121.9 cm. Signed: *Sally James Farnham* S.1988.002,
placed in 1988. Gift of William F. McLaughlin.

In 1919 Irene Castle commissioned Farnham to design a monument for the grave of her husband and dance partner, Vernon Castle, who had died in 1918 while serving on an Allied training mission. She saw the study of the tired dancer and decided it was appropriate for the monument.

In 1922 the figure cut in white marble was placed at Woodlawn Cemetery in New York City. Later, concerned about the safety of the work, the family of Irene Castle replaced the marble figure with one cast in bronze. In 1988 the son of Irene Castle presented the marble sculpture to Brookgreen Gardens.

1 See Proske, *Brookgreen Gardens Sculpture*, p. 160.

Marjorie Daingerfield

THE DAUGHTER OF Elliott and Anna E. (Grainger) Daingerfield, Marjorie Jay Daingerfield was born in New York City on December 20, 1900. Her father, a well known painter and illustrator, was an academician of the National Academy of Design and member of the New York Water Color Club, the National Arts Club and the Society of American Artists. He owned the Gainsborough Studios, a large building where many prominent artists worked. *Autumn*, Elliott Daingerfield's portrait of his wife and two young daughters, was a popular reproduction in the early years of the 20th century. During her youth, Marjorie obtained firsthand knowledge of the arts through her father's influence and teaching.

Marjorie Daingerfield was intrigued with sculpture at a young age, fashioning figures out of colored clay in kindergarten. When she was twelve years old her father had one of her figures cast in bronze and his interest in her art development continued until his death in 1932. After graduation from the Velton School in New York, Miss Daingerfield attended Solon Borglum's School of American Sculpture and the Grand Central School of Art. She had the benefit of instruction from Isidore Konti, Mahonri Young, Edmond Amateis, Solon Borglum and Brenda Putnam. Extensive travel in Europe with her family increased her knowledge of art and its history.

In 1928 she married Oliver Ensworth Holmes but this brief marriage ended with his death in 1930. Miss Daingerfield by this time had formed a predilection for what was to be her specialty — portrait busts, heads and small figures. A major portion of her work included commissioned portraits of society

leaders, businessmen, educators, actors and children.

A bust of Dr. Bailey Kelly Ashford was commissioned by the School of Tropical Medicine, San Juan, Puerto Rico, in 1934. It depicts a stern, firm-jawed man in the uniform of a colonel of the United States Army Medical Corps. Although Dr. Ashford was terminally ill at the time he sat for the portrait, the sculptor, struck by his unconquerable spirit, captured his strength and determination. Other examples are located at Georgetown University, Washington, D.C., and in the Bailey K. Ashford School, Brooklyn, New York. A bust of Dr. Hamilton Holt, President of Rollins College in Winter Park, Florida, and editor of *The Independent Magazine,* was done about 1937. In 1948 a bronze portrait head of the writer and magazine editor, John Hersey, was shown in exhibitions of The Audubon Society and Pen and Brush in New York.

A series of statuettes depicting notables of the stage and opera in the 1930s and 1940s won acclaim and were among Marjorie Daingerfield's proudest creations. A bronze figure of the innovative dancer and choreographer, Martha Graham, complete with swirling robes, won the Anna Hyatt Hunting-ton Award of the Pen and Brush in 1956. A porcelain statuette of the actress Dorothy Stickney as "Vinnie" in the long-running stage presentation of *Life with Father,* done in 1942, received the Catharine Lorillard Wolfe Art Club Award. In 1950 the statuette was given to the Museum of the City of New York by Miss Stickney and her husband, Howard Lindsay. A small figure of Norman Cordon of The Metropolitan Opera in the role of "Mephistopholes" from *Faust* was cast in bronze and later exhibited at Duke University. A small bronze of Judith Evelyn as "Mrs. Manningham" in the play, *Angel Street,* was commissioned by The Drama League of New York and presented to the actress. Portrait heads of Charles and Julia Armstrong are located at the famous King Ranch in Texas. In her book, *The Fun & Fundamentals of Sculpture,* Marjorie Daingerfield expressed her feelings about portraiture: "A portrait is an interpretation. It is the artist — what he sees and feels — plus the sitter. The intangible quality of the spirit must be found and captured. An external observation alone has no life. It is the inner spirit looking out of the face that gives it life and lifts a portrait head into the realm of art."[1]

In memory of her father, Marjorie Daingerfield created a triptych relief for the Church of St. Mary the Virgin in New York. The Daingerfield family attended this Episcopal Church on West 47th Street and in 1902 Elliott Daingerfield was commissioned to paint frescoes in the Lady Chapel. The relief features his profile in a center panel flanked by two winged female figures in adjoining panels. The left figure holds a staff crowned with flowers in one hand and a scroll inscribed "Ave Maria" in the other. The right panel

depicts a warrior holding aloft a sword with a cross-shaped hilt.

On October 23, 1945, Marjorie Daingerfield married James Louis Lundean, an illustrator, writer and lecturer. While accompanying her husband on a business trip to the Southwest in 1953, she was impressed by the features of Hosteen Wanika, a Navajo Indian from Blue Canyon, Arizona. Through an interpreter, she requested that he sit for a portrait bust and, after much persuasion, he agreed. Having no modeling clay or tools, she used gravel-filled clay dug from a nearby river bed, a bent coat hanger for an armature, and her nail file and fingers to create *Agayentah*. Several months later, cast in bronze, the bust won a competition sponsored by Hobart College in Geneva, New York. At the same time, the riverbed clay from which the model was made was discovered to be rich in uranium, providing a source of income for the Navajo reservation.

Marjorie Daingerfield's father had spent his early years in Fayetteville, North Carolina and, at the turn of the century, built Westglow, a home and studio in the scenic Appalachian Mountains at Blowing Rock. Miss Daingerfield divided her time between North Carolina and New York throughout her life. As a result, private and public commissions from North Carolinians composed a significant portion of her work. Plaster heads of Charlotte businessman George Ivey and Concord textile heiress Anne Cannon Reynolds are in the Governor's Mansion in Raleigh, North Carolina. Another plaster head, *Joan of Arc*, is in the collection of The Mint Museum of Art in Charlotte and *Head of Julia* is part of the permanent collection of the Mary Duke Biddle Gallery for the Blind at the North Carolina Museum of Art in Raleigh. Bronze portrait busts of civic leader David Ovens are located at Queens College and at Ovens Auditorium in Charlotte. A portrait head of Dr. C.C. Carpenter was done in 1969 for Bowman-Gray School of Medicine at Wake Forest University in Winston-Salem.

In 1952 she was commissioned to sculpture a silver figure of Sir Walter Raleigh to be placed atop the Sir Walter Raleigh Cup, designed by Schiffman Jewelers of Greensboro, North Carolina. The cup, an annual award made by the North Carolina Literary and Historical Association, is permanently displayed in the North Carolina Museum of History in Raleigh. A replica of the figure of Raleigh was presented to Queen Elizabeth II of England.

Appassionata, a head of a young woman, shown in exhibitions of the National Academy of Design and the Pen and Brush, received a Silver Medal from the latter in 1963. A small silver figure of a Girl Scout in uniform was awarded first place in an international competition for the emblem of the Girl Scouts of America. A replica in bronze is located in Savannah, Georgia, at the

THE OFFERING

Bronze. 123.2x63.5x63.5 cm. Founder's mark: 2 Gift of Joseph D. Dulaney and Elliott D. Dulaney. S.1985.002, placed in 1985. Other example: Blowing Rock, NC. St. Mary's of the Hills Episcopal Church.

museum home of Juliette Gordon Low, founder of the Girl Scouts.

Teaching and demonstrating the techniques of sculpture was another aspect of Marjorie Daingerfield's career. She was an instructor at the Grand Central School of Art in New York from 1925 to 1927, at Rollins College in Winter Park, Florida from 1935 to 1937, and at the Norton Gallery and School of Art at Palm Beach in 1940. She authored a book, *The Fun & Fundamentals of Sculpture*, published in 1963, and lectured frequently at universities and meetings of clubs and art organizations.

Marjorie Daingerfield was a fellow of the National Sculpture Society and a member of Pen and Brush, the Catharine Lorillard Wolfe Art Club and the Blowing Rock Art Association of which she was president in 1957. Miss Daingerfield died at Westglow on March 17, 1977.

The Offering

A seated madonna with tenderness and empathy supports the infant Christ standing beside her. This is a posthumous casting from the original model designed for the Mary Garden of the Episcopal Church of St. Mary's of the Hills in Blowing Rock, North Carolina. Dedicated in 1972, it was the sculptor's last major work. The example at Brookgreen Gardens is the only other casting.

1 Daingerfield, Marjorie, *The Fun & Fundamentals of Sculpture* (Scribner's & Sons, New York, 1963), p.35.

Julian Harris

JULIAN HOKE HARRIS was born at Carrollton, Georgia, August 22, 1906, to Joseph H. and Margaret Myra (Kennedy) Harris. One of his paternal relatives was the author and folklorist, Joel Chandler Harris. He attended the Carrollton public schools.

An interest in studying illustration in New York City was abandoned when his father persuaded him to attend the Georgia Institute of Technology. During his senior year, Harris won a student competition for a stained glass design placed in Brittain Hall. In 1928 he received a degree in architecture and began work as a draftsman and designer for an architectural firm in

Atlanta. Soon afterward, during a trip to Europe, he decided that he preferred to pursue a career in sculpture rather than in architecture.

From 1930 to 1933 he studied sculpture at The Pennsylvania Academy of the Fine Arts on full scholarship and later traveled to India, Egypt and Greece. He was married to Jean Sawyer Fambrough of Atlanta on December 18, 1938. In May 1942 Harris was commissioned a first lieutenant in the Army Air Corps and served in the India-Burma theater of operation, where he rose to the rank of major and was chief of the Special Planning Section, Headquarters, A.A.F. He went on inactive reserve duty in February 1946.

Throughout his career Julian Harris was able to blend successfully his knowledge of the two complementary disciplines — sculpture and architecture. Although he did not practice architecture after 1933, he retained an architect's license. From the beginning, his designs for sculpture to ornament public buildings were in great demand in his native state and across the Southeast. In Georgia alone, he received more than 40 commissions. In 1933 he was commissioned to carve ten heads on limestone corbels of the Dining Hall Arcade at the Georgia Institute of Technology. A series of six relief figures in bronze done in 1939 were mounted on black marble spandrels on the facade of the Georgia State Office Building. For the corporate offices of the Coca-Cola Bottling Company he created decorative reliefs of the twelve signs of the zodiac in 1939. The front of the Elephant House at Atlanta's Grant Park Zoo, done in 1950, included a monolithic concrete relief of three playful elephants. Three other zoo buildings featured work by Harris: polychrome terracotta reliefs of a snarling lion and tiger faced each other on the front of the Feline House in 1956, an anodized aluminum relief of various types of gamboling apes crossed the facade of the Monkey House in 1959, and a polychrome terracotta relief depicted the range of the reptile family in a montage at the Reptile House in 1961. A limestone spandrel depicting the history of Atlanta across the side of the Constitution Publishing Company building was carved in place by the sculptor in 1947.[1] In 1964 reliefs of gold leaf on anodized aluminum decorated the Coca-Cola Pavilion at the New York World's Fair.

For the Confederate Memorial at Stone Mountain, Georgia, Harris designed models for the relief of the great Confederate generals on horseback riding across the face of the rock. The project was first envisioned by Gutzon Borglum then, after Borglum's resignation, was given impetus by Augustus Lukeman. Harris, utilizing Borglum's ideas but making the design more practical, continued the work through the 1940s. Some years later, another figure was finished in place there by Walker Hancock. He was innovative in the

SAINT FRANCIS

Bronze. 1962. Height: 88.9 cm. Signed: *Julian H Harris SC '62* © S.1985.005, placed
1985. Gift of Mr. & Mrs. John Mengel.

I studied, the more I realized how simple his life was, how he sacrificed physically and spiritually. He was not a powerful man; he was an ethereal man...and this is the way I tried to portray him."[2] The example at Brookgreen was cast by Mengel Art Foundry of Marietta, Georgia.

Adam

A kneeling male figure clothed in work pants and shoes, with chest bare, cradles a calf in his right arm and holds a handful of grain in his left hand. Three chickens peck at the ground next to his knee. Behind him are rows of corn stalks.

This sculpture and its companion, *Eve*, are scale models for reliefs on the facade of the Georgia Department of Agriculture Building in Atlanta, commissioned in 1955. The final heroic-sized work was carved in Georgia marble.

Cast stone relief. Height: 114.3 cm, width and depth: 63.5 x 15.2 cm. R.1988.003, placed in 1989. Gift of Mrs. Michael Kirbow and Mrs. E. Ward Wight, III.

Eve

A kneeling female figure in revealing drapery plucks an apple from a tree with her right hand. From her left hand dangles a bunch of grapes. She is surrounded by the bounty of the earth: fruits, vegetables and grains.

Adam and *Eve* were in the garden of the sculptor and were donated to Brookgreen by his daughters after his death.

Cast stone relief. Height: 114.3 cm, width and depth: 63.5 x 15.2 cm. R.1988.004, placed in 1989. Gift of Mrs. Michael Kirbow and Mrs. E. Ward Wight, III.

Hygeia

The goddess of medicine stands in loose drapery, her hair coiled in braids around her head. A snake curves around her right arm which she holds at her waist. Her left arm hangs at the side of her body. She looks to the left.

This figure and its companion, *Hippocrates*, were study models for two of five motifs designed in 1955 for the Henry Grady Hospital, Atlanta, Georgia.

Cast stone relief. Height: 108 cm., Base width and depth: 35.5 x 12.7 cm. R. 1988.001, placed in 1989. Gift of Mrs. Michael Kirbow and Mrs. E. Ward Wight, III.

Hippocrates

The father of modern medicine is depicted in Grecian robes and sandals, with stylized hair and beard, holding a staff at his right side and his left hand resting upon his hip. He looks to the right.

Hygeia and *Hippocrates* were located in the sculptor's garden and were donated to Brookgreen by his daughters after his death.

Cast stone relief. Height: 108 cm, Base width and depth: 35.5 x 12.7 cm. R.1988.002, placed in 1989. Gift of Mrs. Michael Kirbow and Mrs. E. Ward Wight, III.

1 It is now incorporated into the Omni MARTA station.
2 "Brookgreen Gardens 1985 Sculpture Acquisitions," *Brookgreen Bulletin*, Vol. XV, No. 3, 1985.

Willard Hirsch

ONE OF South Carolina's major sculptors, Willard Newman Hirsch, went to New York during the Depression to find a job and returned home a decade later with a firm background in figurative sculpture. He was born in Charleston, South Carolina, November 19, 1905, to Alexander A. and Miriam (Newman) Hirsch. He attended the College of Charleston and in 1932 traveled to New York City and studied at the school of the National Academy of Design and the Beaux-Arts Institute of Design. His talent was recognized quickly and he was able to continue his studies after winning prizes and a scholarship. For ten years Hirsch maintained a studio in New York City and participated in the New York City Art Project. Some of his works during that time were cast stone animals for children's play areas at the Red Hook and Queensbridge housing projects, an heroic bronze portrait bust of the Roman physician, Vesalius, at Lincoln Hospital in the Bronx, and a relief entitled *Bear Family* for the office of the Bureau of Child Guidance in Manhattan. In 1942 his bronze entitled *Tennis Players*, a linear group of two casually dressed boys with tennis rackets, was acquired by the International Business Machines Corporation to represent South Carolina in its permanent collection of sculpture of the Western Hemisphere.

At the age of 37, he was drafted into the United States Army and served at Fort Jackson in Columbia, South Carolina. While there he modeled busts of his regimental commander and commanding general from clay found on the

site. Upon discharge from military service in 1945, he opened a studio at 17 Exchange Street in Charleston and announced that he was available for commissions. To provide additional income, he taught sculpture classes at the Gibbes Art Gallery and built a kiln in which to fire the works of his students and his own terra cotta designs for birdbaths, fountains and other decorative objects. One of these early works was a perforated relief with the whimsical title, *The Dance of the Frog and the Crayfish*, for the garden of Laura M. Bragg at 38 Chalmers Street. He was married to Mordenai Raisin of Charleston on June 21, 1949.

Respect for humanity and reverence for Jewish tradition are reflected in his work. Religious commissions gave Willard Hirsch the opportunity to design screens, statues, altar panels and candelabra for many churches and synagogues. A pair of candelabra depicting the theme of the burning bush in crisscrossing lines, each terminating in a candleholder, were designed in brass for the B'nai Israel congregation in Muskegeon, Michigan. The life-size *Prophet of Admonition* and *Prophet of Consolation*, two bearded and robed figures comprised of steel outlines, were designed for Beth Elohim Temple at Charleston. For a non-sectarian chapel at Peterson Hospital in Wheeling, West Virginia, he created an open-work wrought steel screen of two praying figures, arms raised in supplication. Framing the figures are scenes from nature — wild and domestic animals and plants for food and beauty — with the sun, moon and stars shining over all. Two limestone statues of St. Paul and St. Peter are located in niches in the chapel of the University of the South at Sewanee, Tennessee.

A versatile woodcarver, Willard Hirsch produced a series of religious themed works in native woods including red oak, live oak, red cedar and sycamore. *Joshua, Elijah Fed by the Ravens, David the Psalmist* and *Boy Joseph* all made use of the mediums' natural grain and composition. In the series, the sculptor made expressive and powerful statements utilizing the imagery of the Old Testament and sometimes incorporated his personal associations into the carving. For example, small figures in a sycamore carving, entitled *Jacob's Dream*, bear a resemblance to his wife. *Jacob Wrestling*, a sycamore carving of Jacob and the angel, was presented in 1985 to Oheb Shalom Temple, Baltimore, by Mr. & Mrs. Nathan Ganse. *Gabriel with a Hot Trumpet*, a more secular interpretation inspired by a spiritual about the Judgment Day, closely followed the natural contours and grain of the original material.

Another characteristic of the sculptor was the ability to portray a sense of humor through his work. Indigenous animals of the low country, especially alligators, were incorporated into humorous designs for fountain sculpture in

bronze and terra cotta dating from the early years of his career. For the doorway to his studio at 2 Queen Street, an antebellum warehouse which he purchased in 1968 and renovated, Hirsch designed three decorative wrought iron panels depicting amphibian and invertebrate creatures such as a frog, an earthworm, snails and a crayfish.

Several sculptures convey his feeling for the playful activities of childhood. *Do-Si-Do*, a bronze group of a boy and girl joyously dancing with arms linked, was placed in 1981 in Charleston's Washington Park as a tribute to Marguerite Sinkler Valk by the Friends of Olde Charlestowne. *Falling Angel*, a humorous depiction of a little girl, pigtails flying, with arms and legs outstretched as if falling in space, is in the garden of the Gallery School of the Gibbes Museum of Art. This small bronze was acquired by the museum in 1982 through efforts of the sculptor's friends and relatives. A bronze group of two spirited horses, entitled *Playing Colts*, is located in the Ravenel Plantation garden at Olde Towne. *Little Dancers*, a relief of four children dancing in a circle, was designed in terra cotta to be placed on a garden wall. For the children's entrance of the Charleston County Library, he utilized steel bars to draw linear patterns against the building that depict four characters from *Alice in Wonderland*—Alice, the White Rabbit, Humpty-Dumpty and the Cheshire Cat.

Willard Hirsch was known as a sculptor of portraits and public monuments, especially in and around Charleston. His bronze portrait bust of Congressman L. Mendel Rivers is part of a monument located outside the annex of the Charleston County Courthouse. A bronze bust of former Mayor J. Palmer Gaillard is located in Gaillard Municipal Auditorium. A bronze half-length bust of Laura Mary Bragg, a sensitive portrait incorporating the individual's characteristic habit of adjusting her hearing aid, was given to The Charleston Museum in 1980. A life-size terra cotta head of Miss Bragg is in the collection of the Carolina Art Association. For the Supply Corps Center at the Charleston Naval Base in 1965, Hirsch designed a bronze tablet recognizing the service of Rear Admirals John J. Gaffney and Samuel McGowan. Bronze reliefs honoring John K. Cauthen and former Governor Robert E. McNair are located at Francis Marion University in Florence. A portrait plaque of Dr. John Bachman, the ornithologist and physician who founded Newberry College, was placed there in 1974.

The focal point of a pool in front of the Clemson House at Clemson University is a stainless steel *Tiger* representing the school mascot. Another school symbol, the bronze *Bulldog* of South Carolina State College at Orangeburg, was created for the student body by Hirsch. A monumental bronze statue of a 17th century Indian chief, *The Cassique of Kiawah*, was placed

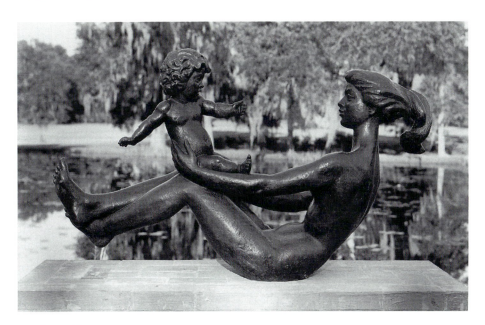

JOY OF MOTHERHOOD

Bronze. 74.9 x 142.2 x 38.1 cm. Signed: *Willard Hirsch, Sc./1970* S.1985.003, placed in 1985, partial gift of Mrs. Willard Hirsch. Other examples: Charleston, SC. Home Federal Savings and Loan; Columbia, SC. South Carolina State Museum (small model).

at Charles Towne Landing during the South Carolina Tricentennial Celebration in 1970. A panel designed by Hirsch decorates the exterior of every National Guard Armory built in South Carolina since 1953. Cast in composition stone, it depicts soldiers in uniforms representing nine of the wars in which the United States and National Guard have taken part. His design of *Justice*, a flat brass relief for the courthouse at Toombs County, Georgia, features a stylized depiction of the head, shoulders and arms of a blindfolded female holding a sword in one hand and the scales of justice in the other.

Willard Hirsch had an interest in providing opportunities to learn about art, especially for young people. In addition to many years of teaching children's classes at the Gibbes Art Gallery, he continued to instruct students privately and taught sculpture courses at Furman University, the Columbia Museum of Art, and as part of the University of South Carolina extension division. He was one of the founders of the Charleston Art School. Hirsch was a member of the South Carolina and the Charleston Artists Guilds and served as president of both. Willard Hirsch died in Charleston on November 29, 1982.

Joy of Motherhood

Infusing many of his works is the spirit of the joy of life and, in particular, the physical and spiritual bonds between mother and child. Reflecting the sculptor's personal belief that the joys of motherhood far outweigh the sorrows, this sculpture depicts a young mother at play with her child. The semi-reclining posture with its horizontal line was a composition frequently employed by the sculptor.

Joy of Motherhood was originally commissioned in 1970 as a life-size fountain group for the lobby of the Home Federal Savings and Loan of Charleston. Permission to make a posthumous casting was obtained from the financial institution in 1984. In the following year, the sculpture was cast from the original model with the permission of Mrs. Willard Hirsch by Mengel Art Foundry of Marietta, Georgia. A small bronze, possibly the model for the life-size group, was acquired by the South Carolina State Museum in 1985. Miniatures of the sculpture were cast in an edition of 20 for collectors.

Michael Lantz

MICHAEL LANTZ was born at New Rochelle, New York, April 6, 1908, to Frank and Mary (Jarvis) Lantz. His brother, the cartoonist Walter Lantz, created many animated characters for film cartoons, including Woody the Woodpecker.

Michael Lantz began the study of art at a vocational high school for boys in New York City. From 1924 to 1926 he studied at the National Academy of Design under Robert Aitken. In 1925 he was hired to assist the architectural sculptor, Lee Lawrie, and a working relationship began that continued until 1935. At the recommendation of Lawrie, from 1926 to 1931, Lantz received additional instruction at night at the Beaux-Arts Institute of Design. There he studied with a number of sculptors, including John Flanagan, Leo Lentelli, Anthony de Francisci and Edmond Amateis. During the three years following his employment with Lee Lawrie, he held a variety of jobs including a Works Project Administration position as sculpture instructor, five nights per week, at the New Rochelle Adult Education Center. On October 28, 1938 he and Regina Tuschak were married.

In early 1938 Michael Lantz received his first commission by winning a national competition to design sculpture to be placed at the apex of the Federal Trade Commission Building in Washington, DC. His bold depiction of a pair of powerful male figures subduing two rearing horses, symbolizing the commission's control of monopolies, was entitled *Man Controlling Trade*. During the summer of 1938 Lantz visited a Percheron horse farm and made clay sketches to ensure the anatomy and movements in his models. For two years, the sculptor worked on the progressively-sized models, doing much of the enlarging and plaster casting himself to conserve expenses. The carving onsite of these monumental works from limestone was done by Jacob Schwalb, a German stone carver. The group located on the Pennsylvania Avenue side of the building was carved in 1941; the group on the Constitution Avenue side was completed in 1942. Although this major award launched his career as an architectural sculptor, Lantz never did anything else quite like these two figures.

Throughout the United States he received commissions to complete figures, panels, outlines, reliefs and medals for individuals and government, business and church groups. A ten-foot bronze eagle in flight, carrying a sheaf of arrows in its talons, was placed in 1959 on the facade of the National Guard Memorial Building at Washington, D.C., and a four-foot bronze eagle was placed in 1977 at the Peoples Bank for Savings at New Rochelle. In 1969 Lantz was working on 29 bronze seals representing unity among the nations of the Pan-American Health Organization. Featuring each country's coat of arms and motto, the seals were placed on the exterior of the organization's building at Washington, D.C. in 1970. Six bronze panels for the exterior facade of a building at Howard University were done in 1969.

Michael Lantz was particularly noted in the field of religious sculpture. In 1956 he executed bronze circular reliefs depicting the symbols of the Twelve Tribes of Israel for the entrance doors of the Springhill Avenue Temple at Mobile, Alabama. One of these, *Gad*, is in the collection of the National Academy of Design. Lantz was hired by the American Battle Monuments Commission to design the World War II Memorial to soldiers who died fighting across Germany. It is located at St. Avold, Lorraine, in France, at the largest American military cemetery in Europe. An heroic stone figure of the Roman soldier, *Saint Avold*, arms raised in benediction above the entrance to the chapel, overlooks the cemetery. Another monumental stone figure representing *Sacrifice*, flanked by reliefs of four famous warriors of history, is located over the altar in the chapel. In 1969 a colossal marble *Madonna* was placed on the facade of Our Lady of Sorrow Church at Tacoma Park,

Maryland.

Sculptured outlines in bronze, a form of sculpture and its method developed by Michael Lantz, could be extensively employed in relief work for churches and public buildings. Utilizing the bronze outline, the sculptor was able to portray a story, cover a large area, and produce an art work that was structurally light in comparison with a bas-relief of comparable size. The technique was featured in an article on the subject in *National Sculpture Review*.[1] The most intricate work of this type was done for St. Peter's Chapel of the Cathedral of St. Mary Our Queen at Baltimore, Maryland. Two panels containing a total of eight figures representing the Eastern and Western Churches flanked a marble figure of St. John Vienny, also created by Lantz. Another panel for the United States Court House at Lynchburg, Virginia, featured Moses standing with the tablets of the Ten Commandments and gesturing toward the heavens. This method was used in 1968 to create four monumental panels symbolizing the old and the new in architecture for the Architects Building at Albany, New York. Lantz used this technique for other commissions at the Milwaukee City Hall, at a high school in Elmira, New York, and to decorate the Room of the Constellations on board the *S. S. United States.*

An excellent medalist, this aspect of his talent was in great demand. New York City's Golden Anniversary Medal was created in competition in 1948 and later adopted as the city's official medal. In that same year, the 37th issue of the Society of Medalists featured Lantz's depiction of two Biblical stories representing good and evil. On the obverse, John the Baptist performs his baptism of Christ in the River Jordan. The scene is encircled by a verse from the book of Matthew, "Blessed are the meek for they shall inherit the earth." On the reverse, Salome holds the severed head of John the Baptist. Seven medals, including those of *John Paul Jones* and *Oliver Wendell Holmes*, were designed for New York University's Hall of Fame for Great Americans. Lantz's design was accepted for the Brian Blaine Reynolds Medal of the American Academy of Achievement, given in conjunction with that institution's Golden Plate Award. *Thomas Jefferson and the Declaration of Independence* was designed for the series of medals issued in 1976 by the American Revolution Bicentennial Commission. The Forbes Fifty Foremost Medal, for outstanding leadership in business, given by Forbes Magazine, and the World Press Achievement Award of the American Newspaper Publishers Association Foundation were his work. In recognition of his medallic accomplishments, Lantz received the J. Sanford Saltus Medal from the American Numismatic Society in 1968. A panel of his medals, exhibited at the National Academy of Design in 1970, was awarded the Elizabeth Watrous Gold Medal. In 1977 Lantz received the Lindsey Morris

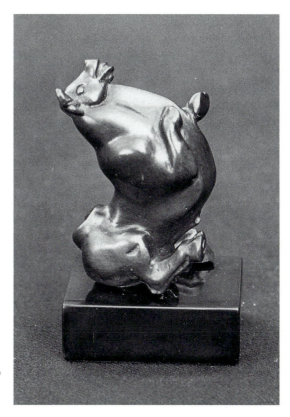

SITTING BULL

Bronze. Height: 10.2 cm, base width: 5.5 cm, base depth: 3.8 cm. Signed: *ML* [monogram]©; *No 6/20* Gift of Charlotte Dunwiddie. S.1984.004, placed in 1985.

Memorial Award for bas-relief at the 64th Annual Allied Artists of America exhibition in New York where a group of eight medals, displayed both obverse and reverse, demonstrated his medallic prowess.

During his career Michael Lantz received other important awards including a citation for his work at the Cathedral of Mary Our Queen in Baltimore where the joined efforts of nine sculptors were awarded the Henry Hering Memorial Award for ecclesiastical sculpture by the National Sculpture Society in 1961. Ten years later, he was given the prestigious Golden Plate Award of the American Academy of Achievement in recognition of outstanding accomplishments in sculpture. In 1983 he received the Leone di San Marco Award, presented to outstanding artists of Italian descent by the Italian Heritage and Culture Committee of the Bronx and Westchester.

Michael Lantz was a fellow and officer of the National Sculpture Society, having been president from 1970 to 1973. He served as editor of the Society's publication, *National Sculpture Review,* from 1955 to 1957 and from 1973 to 1984, and was named editor emeritus in 1985.[2] Interested in ways to promote

the teaching of sculpture, he persuaded his brother, Walter Lantz, to donate funds that would establish an annual grant in 1973. The Walter Lantz Prize of the National Sculpture Society is given each year to a young sculptor whose work exhibits ability in the use of form, composition and comprehension of technique.[3] Beginning in 1964 he was a sculpture instructor at the National Academy School of the Fine Arts in New York City and, he taught at the Lyme Academy of the Fine Arts in Lyme, Connecticut. In 1980 the National Sculpture Society presented to him the Herbert Adams Memorial Medal for outstanding achievement, and in 1986 awarded him its Gold Medal of Honor for his service to the organization and the profession of sculpture.

Active in many other professional organizations, Michael Lantz was an academician of the National Academy of Design, a member of the Fine Arts Federation of New York, Allied Artists of America, the Academic Artists Association, the Hudson Valley Artists Association, the American Artists Professional League and the American Numismatic Society. His death occurred at New Rochelle, New York, on April 25, 1988. The Lyme Academy of the Fine Arts held an exhibition of his work later that year.

Sitting Bull

A bull is seated upright on its hind legs, as its front legs wave in the air and its head is turned to the left with the tongue stuck out. The composition moves in an s-shape from top to bottom. The humorous attitude of the animal's pose is reinforced by the title of the work. *Sitting Bull* was shown at the National Sculpture Society exhibition in 1980 where it received the Lance International Chilmark Prize for miniature sculpture in metal.

1 "Sculpture Outlines in Bronze," Michael Lantz, *National Sculpture Review*, Winter 1962-63, pp.19-21.

2 The title of this publication was shortened to *Sculpture Review* in 1983.

3 After the sculptor's death, the prize was renamed the Michael and Walter Lantz Youth Award.

Cleo Hartwig

CLEO HARTWIG was born October 20, 1911, in Webberville, Michigan, to Albert and Julia (Klunzinger) Hartwig. She attended summer schools at The Chicago Art Institute in 1930 and 1931, and in 1932 graduated from Western Michigan University with a degree in art education. She took classes at The International School of Art's summer sessions in the Adirondacks in 1932 and 1933, and traveled and studied with that school in Poland, Hungary and Romania two years later. After coming to New York she was able to pursue her interest in sculpture, studying direct stone carving with José de Creeft and clay modeling and plaster casting at the Clay Club Sculpture Center. Miss Hartwig taught art in public school in Michigan and in private schools in New York City. She was an instructor at The Cooper Union from 1945 to 1946 and, for 26 years, taught Saturday morning sculpture classes for children at the Montclair Art Museum in Montclair, New Jersey, from 1945 to 1971.

In 1951 she and the sculptor, Vincent Glinsky, were married and shared a studio until his death in 1975. The two sculptors had mutual respect for each other's work and shared the same aesthetic values in sculpture. In 1972 and again in 1974, the two held joint exhibitions of their work.

Cleo Hartwig preferred direct carving to modeling and found that her subjects were usually suggested by the shape, color, veining and density of the stone or wood. The composition developed as the work progressed and the character of the material was revealed. Hand tools rather than power tools were used because of the quieter atmosphere, the more slowly studied approach, and the ability to achieve greater subtleties in the carving. Although she studied living models or photographs, she did not make three dimensional sketches since in direct carving the material itself often dictated changes and thus altered the original conception. She tried to achieve an aesthetically satisfying sculpture through simplification of forms. With her husband, she wrote in an article on sculpture techniques, "It is easier to reproduce all the detail one mistakenly thinks he sees in nature than to unite the lights and shadows into their larger masses. Color in nature can be confusing also when one is searching for shapes. To find the basic, essential character of a subject requires keen observation and great study. The simplest forms are the most difficult to see and to translate into sculpture." [1]

Miss Hartwig's early work was characterized by simple, compact forms, sometimes with precisely patterned detail. In later work she carried abstraction as far as recognition of the subject permitted. Features and detail were

extremely simplified or reduced to nonexistence in favor of emphasizing the shape of the subject such as the smooth roundness of a bulb or the spatial qualities of a bird in flight. Her early interest in small animals, birds, insects and plants, acquired during her childhood in rural Michigan, established a predilection for forms found in nature, but her large body of work also included distinguished interpretations of human and non-objective subjects in such diverse materials as marble, limestone, alabaster, wood, terra cotta and cast brass and bronze. Adding another facet to her work, Cleo Hartwig sometimes painted her carvings with diluted acrylic earth colors, imposing a stylized design on the stone surface, reminiscent of practices of early Egyptian, Greek and pre-Columbian artists. Her sculptural style has been compared to folk art because it is simple in form yet has great clarity and attention to detail. Her interest in incised linear patterning and her frequent use of "found" stones as material for her work support this comparison. On the other hand, Cleo Hartwig's sculpture reflects a sophistication seldom found in folk art.

Her first solo show, consisting of 29 works, was held in 1943 at the Clay Club Sculpture Center in New York City. Exhibitions of her sculpture toured Canada in 1949 and 1950, and the United States in 1965 and 1966. In the following years, she had solo shows at various galleries and museums in the Northeast and Southeast United States including the Montclair Art Museum in New Jersey in 1971 and the State University of New York at Plattsburgh in 1986. Her work was accepted for exhibition in important group shows such as those held by the National Academy of Design, The Metropolitan Museum of Art, the Whitney Museum, the American Academy and Institute of Arts and Letters, the Pennsylvania Academy of the Fine Arts, the Detroit Institute of Arts, the Chicago Art Institute and the United States Information Agency in Europe.

A family group cast in aluminum was commissioned for the facade of the Continental Casualties Building in New York City in 1945. Two terra cotta groups, *Wild Ducks*, were done for the cabin class lounge on the *S. S. United States* in 1950. *Homeward Spirit*, a life-size bronze of a kneeling female figure holding a dove, was commissioned for All Faiths' Memorial Tower located in George Washington Memorial Park, Paramus, New Jersey. Miss Hartwig created alumni awards for the Columbia University Law School Alumni Association.

The recipient of numerous honors for her work and devotion to sculpture, Cleo Hartwig won eleven awards from the National Association of Women Artists including the Anna Hyatt Huntington prize in 1945 for *Mandolin Player* in bluestone, and a Medal of Honor in 1967 for *Owl Family*, a group of four

RESTING BUTTERFLY

 Serpentine Stone. 38.1 x 15 x 33 cm. Signed at left: *C. HARTWIG* S.1980.003, placed in 1980. Gift of Joyce and Elliot Liskin.

birds, carved in grey and white alabaster. From the National Sculpture Society she received a Silver Medal in 1969 for a *Torso* in ebony, the C. Percival Dietsch Sculpture Prize in 1978 for *Juana*, a female head carved in serpentine stone, and the Edith and Richmond Proskauer Prize in 1984 for *Bulb* in serpentine

stone. From Audubon Artists she won in 1975 the Today's Art Magazine Award and Medal of Merit for *Owl* in painted limestone, the Chaim Gross Foundation Award in 1986 for *Guinea Fowl* cast in bronze, and a Medal of Honor in 1987 for *Child* carved in limestone.

Much of her work was small in scale and was sought by public and corporate institutions as well as private collectors. *Caterpillar*, carved in Belgian blue marble, is owned by the General Electric Company. *Bear Cub* in New Jersey bluestone is in the collection of The Newark Museum. The National Academy of Design owns *Night Flight* in brown steatite, and *Bird Form*, a stylistically simple bird in white terra cotta. *Tropical Fish*, carved in Siena marble, was acquired by the Detroit Institute of Arts. *Fern* in serpentine stone is owned by the National Museum of American Art. *Mother and Child*, a sensitive depiction in Tennessee marble of a young woman hugging an infant, is located at the Pennsylvania Academy of the Fine Arts. *Guinea Fowl*, stylistically simple in bronze, is at the National Museum of Women in the Arts at Washington, DC. *Quail* in marble is in the collection of the Museum of International Art located in Sofia, Bulgaria.

Active in many professional organizations, Cleo Hartwig was a member of Audubon Artists, the National Association of Women Artists, the Sculptors Guild and New York Artists Equity. She was an academician of the National Academy of Design and a fellow of the National Sculpture Society where she served on the council and on various standing committees. In 1971 she was awarded the Francis Keally Prize for service to the Society. After battling cancer of the pancreas, she died on June 18, 1988, in New York City. The National Academy of Design held a memorial service for Cleo Hartwig on October 22 of that year.

Resting Butterfly

A stylized butterfly rests lightly on the point of flight. Incised patterns based on the veining of the wings of a monarch butterfly along with the compressed mass of wings, legs and antennae present a convincing portrait.

In 1979 the sculpture was awarded the Ellin P. Speyer Prize at the National Academy of Design's 154th Annual Exhibition and in 1980 it received the Joyce and Elliot Liskin Purchase Prize at the Annual Exhibition of the National Sculpture Society. This sculpture also was exhibited in 1979 at the Sculpture Center in a show of Gallery Artists and in another show at American Standard.

The sculptor obtained the stone for *Resting Butterfly* from one of her stu-

dents who had abandoned work on a relief of a crouching female. After purchasing the stone, Miss Hartwig studied its possibilities, finding it too thin for an ordinary subject in the round. Since the shape suggested a butterfly and since the stone was soft and could be filed and rasped, it was possible to indicate the markings on the wings, something which would have been difficult in marble. [2]

1 Glinsky, Vincent and Hartwig, Cleo, "Direct Carving in Stone," *National Sculpture Review,* Summer 1965, p.25.
2 Statement by the sculptor, "Cleo Hartwig," Sculptor's Correspondence File, Brookgreen Garden Archives.

Donald De Lue

SEE *Brookgreen Gardens Sculpture,* pp. 375-379, for the sculptor's complete biography.

Donald De Lue was considered the dean of American sculpture when he died in 1988 at the age of 91. His hallmark was the heroic figure and De Lue had an impressive list of such works to his credit including *The Rocket Thrower* for the 1964 New York World's Fair. At 45 feet in height, it was the largest bronze ever cast. Since that time, he created other heroic works for public places. *Quest Eternal,* a 27-foot-high figure signifying man's aspiration to progress, was unveiled in 1969 on the Prudential Center Plaza in Boston. *Green Beret,* an impressive heroic figure representing this elite group of soldiers, was dedicated at Fort Bragg, North Carolina in 1971. An over-life-size figure of *Thomas Jefferson* was commissioned to commemorate the Louisiana Purchase and placed at Gretna, Louisiana in 1975. A monumental group entitled *The Alamo,* commissioned by the Daughters of the Republic of Texas in 1972, depicts the horror of hand-to-hand combat.

In 1985, at the age of 89, Donald De Lue was commissioned by the Society of Medalists to create its 111th issue, *Bursting the Bounds.* The theme symbolized mankind's eternal quest for ways to break through restraining limitations. The male figure shown on both the obverse and the reverse is the same human being bursting out of the confining boundary of the medal. De Lue wrote, "I wanted this single figure to personify all of us breaking out of our own handicaps to freedom. This theme inspired me to try to transcend the conventional limitations of medallic sculpture, and to create an image that

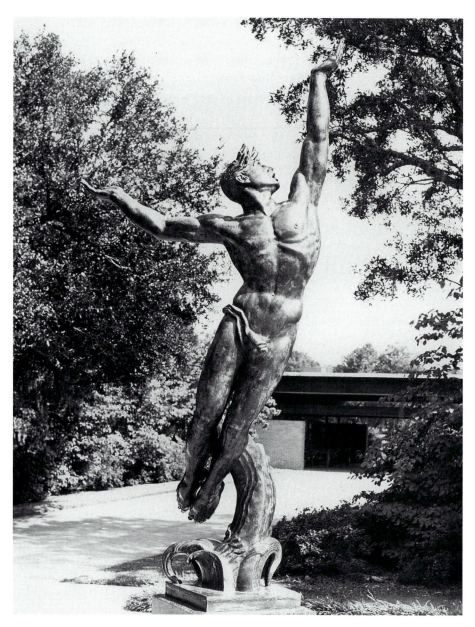

SPIRIT OF AMERICAN YOUTH

Bronze. Height: 233.7 cm. Signed: *D. DeLUE SC©1954 / 1/52* Founder's mark:
. MODERN ART FOUNDRY . / . NEW YORK . / . N.Y. . Founder's Mark: [Modern
Art Foundry Insignia] S.1981.005, placed in 1981. Other examples: St. Laurent-sur-
Mer, France. United States Military Cemetery (heroic figure); Wheaton, IL. Cantigny
War Memorial Museum of the First Division (half-size figure).

both literally and figuratively would break the boundaries of the medium."[1] This immediately successful issue in ultra-high relief redefined standards for technical capabilities in medallic art. With this work, De Lue became the first sculptor to design two regular issues of the Society.

In 1979 De Lue received the Numismatic Art Award for Excellence in Medallic Sculpture from the American Numismatic Association. His bronze figure, *George Washington At Prayer*, received the Therese and Edwin H. Richard Memorial Prize of the National Sculpture Society in 1968. *Genesis*, a muscular male figure casting a stream of stars across the heavens, was awarded the Society's Margaret Hexter Prize in 1973. The National Sculpture Society recognized his life's work in 1974 when he received its highest award, the Medal of Honor.

Donald De Lue died August 26, 1988 at Leonardo, New Jersey. He had been a trustee of Brookgreen Gardens since 1963 and served as chairman of the Art Committee. At his death he was honorary president of the National Sculpture Society. A major biography and catalogue of his work, *The Sculpture of Donald De Lue, Gods, Prophets, and Heroes,* written by D. Roger Howlett, was published in 1990. The publication accompanied an exhibition of De Lue's sculpture held at Childs Gallery in New York City. In 1986 De Lue had contracted with Childs Gallery to cast limited editions in smaller sizes of some of his well known monumental works.

Spirit of American Youth

Also called *Life Eternal*, the monumental sculpture is cast from the half-size original model of the bronze placed in 1956 at the American Cemetery near St. Laurent-sur-Mer, Normandy, France. There, at Omaha Beach and nearby Utah Beach on June 6, 1944, five United States ground and airborne divisions established an initial foothold on the European continent at the cost of heavy casualties. Commissioned by the American Battle Monuments Commission in 1949, Donald De Lue created the heroic figure of a young man reaching for the heavens as a symbol of the loss of life on D-Day. The work carries the subtitle, "Mine eyes have seen the glory of the coming of the Lord," — lines from the *Battle Hymn of the Republic.* This was the largest commission De Lue had received and its success placed him in the forefront of sculptors working in monumental scale.

For this significant work, De Lue received the Henry Hering Memorial Award of the National Sculpture Society in 1960. The thought that went into

Sculpture Society — a medal which he had designed in open competition in 1958 but had never before received. One of the early designs of the eagle was adapted as the Louise duPont Crowninshield Award of the National Trust for Historic Preservation. The example at Brookgreen Gardens is a posthumous cast made in 1980 by Bedi-Makky Art Foundry at the direction of the sculptor's widow, Tullia Manca.

Katharine Lane Weems

PLEASE REFER TO *Brookgreen Gardens Sculpture* pp. 405-408 for additional information.

Katharine Lane Weems died at her home in Manchester, Massachusetts, on February 11, 1989.

Greyhound Lying Down

A young greyhound is depicted in a relaxed position, its hind legs resting to the right side of its body. The front legs are extended in front with one paw slightly lifted. The head is held upright and the ears are down.

The sculptor owned greyhounds and whippets and often used them as subjects for her sculpture. For many years this work was placed on a shelf in the foyer at Anna Hyatt Huntington's home, Stanerigg Farm.

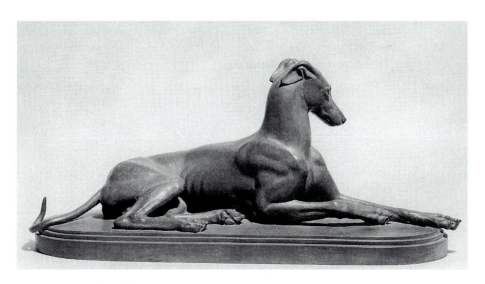

GREYHOUND LYING DOWN

Bronze. 34 x 66.5 x 18 cm. Signed: *K. LANE WEEMS* Founder's mark: ROMAN BRONZE WORKS INC., N.Y. S.1973.005, placed in 1973. Gift of Anna Hyatt Huntington.

Madeleine Park

PLEASE REFER TO *Brookgreen Gardens Sculpture*, pp. 387-389 for the sculptor's biography.

Sleeping Giraffe

A giraffe, its head resting on its back and its legs folded beneath its body, is depicted in an attitude of rest. Originally titled, *Ringling's Lying Down Giraffe*, the work is one of many versions of the animal modeled by the sculptor. The sculpture once was affixed to a wooden base, intended for display on a desk. In 1950 another casting of this work was acquired by the Rochester Memorial Art Museum in Rochester, New York. This work was exhibited in shows at the Philadelphia Fine Arts Society, The Pennsylvania Academy of the Fine Arts and the National Sculpture Society.

Madeleine Park specialized in modeling animals from life — at the circus, rodeo and zoo, at kennels or from her own menagerie at home. *Sleeping Giraffe* was a gift of H. Halsted Park, Jr. of Naples, Florida, son of the sculptor.

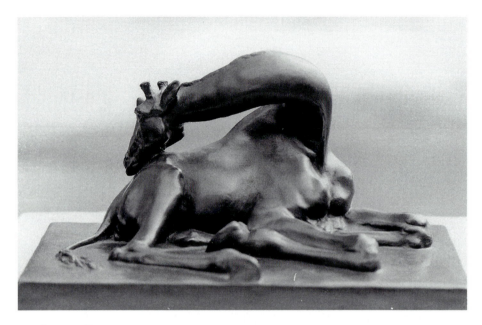

SLEEPING GIRAFFE

Bronze. 19.1 x 34.3 x 21.6 cm. Signed: *MADELEINE PARK* Founder's mark:
BEDFORD.BRONZE.FDRY. / N.Y. S.1988.004, placed in 1988. Gift of H. Halsted Park,
Jr. Other example: Rochester, NY. Rochester Memorial Art Museum.

Joseph Kiselewski

FOR THE sculptor's complete biography, please refer to *Brookgreen Gardens Sculpture* pp. 355-357.

For distinguished achievement in the art of the medal, Joseph Kiselewski was presented the J. Sanford Saltus Award in 1971 by the American Numismatic Society. In recognition of his knowledge of the field of American sculpture, Kiselewski was elected to Brookgreen Gardens' Advisory Board and served on the Art Committee.

In 1978 his portrait bust of Lee Lawrie received the Therese and Edwin H. Richard Memorial Prize at the 45th annual exhibition of the National Sculpture Society. In 1982 he received the Society's Medal of Honor for notable achievement in and for encouragement to American sculpture.

Joseph Kiselewski retired to his birthplace of Browerville, Minnesota, in the early 1980s where he worked on an autobiography and continued his interest

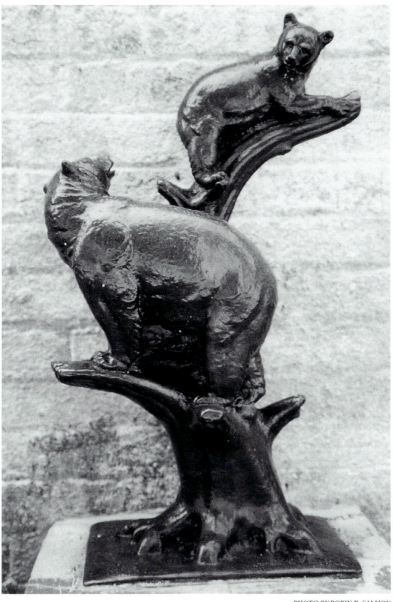

BEAR GROUP

Bronze. 65 x 30 x 23 cm. Signed: *J. Kiselewski* Founder's mark: ROMAN BRONZE WORKS INC. S.1972.010, placed in 1972. Other example: New York, NY. Carver House (life-size).

in sculpture. Excerpts from his book and other articles by him were published in issues of *National Sculpture Review.* He died in Browerville, on February 26, 1988.

Bear Group

An adult bear and a cub climb upon a bare-branched tree. The cub looks down from the highest point of the branch on which it is perched, while the adult stands on a lower branch and looks up at the cub. The two animals are placed in opposition to one another with the adult's body to the left and the cub's, to the right. Both animals have turned their heads to look back at each other. The tree's surface and the animal's fur are modeled smoothly with little detail. The overall effect is a pleasingly balanced composition.

This work, designed in 1956 with children in mind, was placed in the playground of Carver House in New York City. Commissioned by the New York City Housing authority, the sculpture was positioned to encourage climbing. The example at Brookgreen Gardens was cast in 1972 from the sculptor's model.

Bruno Mankowski

BRUNO MANKOWSKI was born in Peterhagen, Germany, near Berlin, on October 30, 1902 to Tadeusz and Emily (Kaselow) Mankowski. He received early training as a sculptor from his father, a well-known architectural sculptor, and worked for two years in the studio of Professor Joseph Thorak in Berlin. By the time he entered the Municipal and State Art Schools in Berlin he was already familiar with most techniques of sculpture. His family was supportive of his studies: "Illustrious relatives like my grandfather Anthony Mankowski who was a famous newspaper editor in his native Poland and a cousin, Constantine, who had some paintings in the Museum in Krakow gave a lot of encouragement to strive for the best. Study, hard work and perseverance did the rest to keep me going."[1]

Mankowski traveled to the United States in 1928 and became a naturalized citizen in 1933 at the age of 31. He enrolled in the Beaux-Arts Institute of

Design in New York City and quickly became known for his skill in marble carving. During the 1930s he was employed as a stone carver with the John Donnelly Company of New York City, a contractor of a number of jobs for sculptural work on buildings at the Federal Triangle in Washington, DC. Mankowski helped carve pediments for the buildings of the Post Office, Department of Labor, Interstate Commerce Commission, and decorative sculpture and a relief for the Department of Justice. *Courage,* one of three reliefs designed by Lee Lawrie for the Senate Chamber of the U.S. Capitol, was carved by Mankowski and placed when the chamber was remodeled in 1949 and 1950. In recognition of the superior craftsmanship of his work, Mankowski received honorary membership from the New York Building Congress in 1937.

Three commissions received in the following year established Mankowski's reputation as a sculptor. In 1938 he was awarded a government contract to create a plaster relief for the interior of the United States Post Office and Agricultural Building in Chesterfield, South Carolina. *The Farmer's Letter,* placed above the entrance to the postmaster's office in 1939, depicts a group of three workers seated in front of a barn, reading a letter. To the left of the group is a female picking corn; on the right is a turkey gobbler. Beyond the bird is a male hoeing cotton with a field of flowering tobacco behind him. The relief represents the work of the agricultural community served by the post office. Two monumental figures in plaster for the New York World's Fair were placed in the Court of Peace in the Federal area in 1939. *The Good Herdsman* and *Toiler of the Soil* reflected the American ideals of protection, freedom and mother-hood. Decorative figures were created the same year for the *S.S. Independence* and *S.S. Constitution* of the American Export Lines.

He served with the United States Army from 1942 to 1945. In 1949 he was commissioned to create a War Memorial Plaque for Macomb Junior High School in New York.

From the beginning of his career, Mankowski's carved figures have projected inner strength from simplified forms. *Girl with Book* is in the collection of the National Academy of Design. He has done portraits; a bust of Leonard Stone was created in 1972, and twenty portrait plaques were done for the Baseball Hall of Fame. Most of his sculpture has been carved directly in marble, wood, ivory and other materials. Architectural carvings by Mankowski are at Michigan State University in East Lansing, Michigan, a war memorial at Virginia Polytechnic Institute in Blacksburg, Virginia, and at Loyola Seminary in Shrub Oak, New York.

In 1950 Bruno Mankowski received a grant in recognition of creative work in art from the American Institute and Academy of Arts and Letters. Toward

the mid-1950s, Mankowski moved into more diverse media with designs for the Steuben Glass division of the Corning Glass Works. His crystal *Buffalo Bowl*, created in 1957, features two American bison squared off, head to head, with muscles taut and tails flying. Stands of cactus and prairie grass on each side of the animals provide a balanced composition. His work appeared in *Sculpture in Modern America*, published in 1948. He authored an article on varieties of American limestone and marble for *National Sculpture Review* in 1959.

Bruno Mankowski has received a number of major prizes for his sculpture. He was the first prize winner in 1956 at the exhibition of the American Artists Professional League. The Allied Artists of America gave him the Daniel Chester French Award in 1964 for *Bather*, a young female drying herself with a towel. The National Sculpture Society awarded him its Herbert Adams Memorial Medal in 1972 for his work in carving the figures from Luigi Persico's *The Genius of America* in the reconstructed marble pediment at the center of the East Front of the United States Capitol. In 1978 his bronze *Seated Figure*, a female nude sitting cross-legged with one arm draped above her head, received a gold medal at the annual exhibition.

Distinguished in the field of medallic art, he has designed a large number of portrait, sport and industrial medals. Included among these are the Electric Light Diamond Jubilee Medal, the Equitable Life Assurance Society's World's Fair Medal, and a medal of Franklin Delano Roosevelt for the National Commemorative Society in 1967. His design for the Medallic Art Company's 50th Anniversary Medal, chosen in competition, was awarded the Mrs. Louis Bennett Prize of the National Sculpture Society in 1953. An ivory medal portraying the carved images of Saint George and Saint Christopher received the Lindsay Morris Memorial Prize from the Allied Artists of America in 1960. For the 79th issue of The Society of Medalists in June of 1969, he utilized the theme of American folklore with depictions of Paul Bunyan and Johnny Appleseed. In 1972 his medal of the botanist Asa Gray was placed in the Hall of Fame for Great Americans at New York University. A panel of nine medals executed at various times in his career was awarded the Lindsey Morris Memorial Prize by the National Sculpture Society in 1978. The American Numismatic Society in 1960 recognized his achievements with the J. Sanford Saltus Silver Medal for medallic excellence. Twenty years later, in 1980, he received the Numismatic Art Award for Excellence in Medallic Sculpture from the American Numismatic Association. His medallic work is in the collection of the Sztuki Medalierskie in Wroclaw, Poland and the American Numismatic Society in New York City.

Bruno Mankowski was a fellow of the National Sculpture Society, an

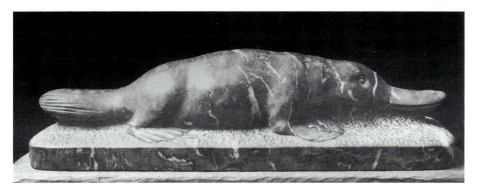

DUCKBILL PLATYPUS

Formosa marble. 15.3 x 56 x 17.2 cm. signed: *MANKOWSKI* S.1977.003, placed in 1978.

academician of the National Academy of Design, and a life fellow of the American Numismatic Society. He was a member of the Architectural League, the American Artists Professional League and Allied Artists of America. After maintaining a studio in New York City for over forty years, in 1980 he retired and moved to De Bary, Florida, where he died on July 31, 1990.

Duckbill Platypus

A platypus with short legs and webbed feet crouches atop a marble plinth. The figure is compact and smoothly carved in contrast to the roughened surface of the plinth. The animal's body is symmetrical; the opposing bill and tail provide balance. Multicolored veins in the stone add interest to the composition. *Duckbill Platypus* was carved directly in 1955 and 1956 from formosa, a rare marble. The sculptor wrote: "In the early fifties a pair of platypuses were in the New York Bronx Zoo. They were very special and received a lot of publicity for the care and the elaborate housing they received. They were, I think, the only platypuses ever in captivity; unfortunately, they mysteriously disappeared a few years later."[2]

The sculpture received First Prizes in exhibitions at the American Artists Professional League and the Meriden, Connecticut Arts Center. In 1976 it was awarded a Silver Medal by the National Sculpture Society.

1 "Bruno Mankowski," Sculptors' Files, National Sculpture Society, New York, NY.

2 Letter from the sculptor received February 1989, "Bruno Mankowski," Sculptors' Correspondence Files, Brookgreen Archives.

Edward Widstrom

EDWARD FREDERICK WIDSTROM was born at Wallingford, Connecticut, November 1, 1903, to Frederick and Viola (Kowalski) Widstrom. His formal art studies began at the Detroit School of Art. During an eighteen-month period in 1927 and 1928, he designed models of automobile radiator cap ornaments for the General Motors Corporation. After returning to New York City, he continued his training at the Art Students League.

In 1927 Edward Widstrom was married to Riccola M. Malaguti and they settled in Meriden, Connecticut. Eventually he was employed as a silverware model maker by the International Silver Company in Meriden where, from 1939 until his retirement in 1970, he designed and modeled portraits of the Presidents of the United States for commemorative spoons and a series of medallions.

Widstrom was one of the few sculptors to produce work almost exclusively in white metal, an alloy composed of tin, antimony and copper. Since this material has a low melting point, he was able to cast all his designs in his own studio. Modeled with meticulous detail, the surfaces of these metal works have a jewel-like polish achieved by hand chasing. A *Blue Heron* delicately poised on one leg won the Mrs. John Newington Award of the Hudson Valley Art Association in 1961 and the Director's Award of the Council of American Artists in 1964. The Connecticut Academy Sculpture Award was given to *Fantasy*, a tropical fish, at the Wadsworth Atheneum in Hartford in 1970. That same year a rapidly descending *Golden Eagle in Flight* received the President's Award of the American Artists Professional League. *Blue Persian Cat* was shown in the 1971 exhibition of the American Artists Professional League. *Diana*, a statuette of a female nude floating on a cloud, received the C. Percival Dietsch Prize at the National Sculpture Society exhibition in 1975.

Although he was known primarily for the decorative works in white metal, Edward Widstrom also embraced portraiture. Portrait reliefs were commissioned for public buildings in three Connecticut towns: in 1950 for the St. Stephens School in Bridgeport, in 1966 for the Municipal Building of Meriden, and in 1968 for the Marionist School in Thompson. A portrait bust of a young girl, *Norma Jeanne,* was given the Sculpture House Award of the Academic Artists' Association in 1960. Widstrom claimed the John Spring Art Founder Award in 1973 for a life-size head of *Henrick Hillbom,* a prominent Wallingford, Connecticut artist. *Donna*, a head of a young girl in cast stone, was exhibited at the National Sculpture Society in 1968. In all, he won more than 45 awards

JUNGLE RUNNER

White metal.　Height: 35.5 cm, length: 50.8 cm　Signed: *E. WIDSTROM F.N.S.S.*
S.1977.002; placed in 1977.

during his career.

Sculpture by Edward Widstrom is in the public collections of New Haven
Paint and Clay, Inc., the University of Connecticut and in many private
collections. *Evening Prayer,* a half-life-size bronze group of a mother and child,
and *Indianna Thomas,* a bronze bust of the founder, are in the permanent
collection of the Meriden Arts and Crafts Association.　In 1987, a 50th
Anniversary retrospective exhibition of Widstrom's work was held at the
association.

Edward Widstrom's talent was recognized by his peers when he was elected
a fellow of the National Sculpture Society in 1949.　Active in many art
organizations, he was a member of the American Artists Professional League,
the Hudson Valley Art Association, the Connecticut Academy of Fine Arts and
the Council of American Artists. Widstrom served on the executive board and
as sculpture chairman for the Meriden Arts and Crafts Association.　He died
June 21, 1989 at Meriden, Connecticut.

Jungle Runner

An Asian junglefowl, its body and legs posed in racing action, has sleek
horizontal lines emphasized by linear feather patterns.　The beak is open and

the neck extended in the physical effort of running. These wild birds, which resemble leghorn chickens, are known for their wariness and fiery red and golden brown plumage. The sculptor wrote, "I first got the idea for it after reading about the colorful junglefowl and its beautiful streamlined body."[1]

An example of *Jungle Runner* was exhibited in 1971 at the National Academy of Design where former United States Senator William Benton, publisher of the *Encyclopedia Brittanica* and a patron of the arts, purchased it for his private collection. The casting in the Brookgreen collection received the Silver Medal at the National Sculpture Society exhibition in 1972 and first prize at the Meriden Arts and Crafts Association Annual Exhibition.

1 Letter, June 18, 1977, "Edward F. Widstrom," Sculptor's Correspondence Files, Brookgreen Gardens Archives.

Adlai Hardin

ADLAI STEVENSON HARDIN's fulltime sculpture career began late in life, after his retirement from a New York advertising agency. Like few other artists, he successfully combined a business career with his avocation, sculpture. He was born at Minneapolis, Minnesota, September 23, 1901, the son of Martin D. and Julia (Stevenson) Hardin. His maternal grandfather was Adlai E. Stevenson, vice-president of the United States during the administration of Grover Cleveland.

While he was a boy, whittling was one of his favorite pastimes. His family moved to Chicago and he often visited sculpture exhibitions at The Art Institute, eventually taking Saturday morning drawing courses there when he was in high school. Hardin attended Princeton University and made drawings for the student humor magazine, *Tiger*, graduating in 1923 with an A.B. degree. In the following years he held jobs with various advertising agencies including the William Esty Company, where he worked from 1933 and retired as vice president in 1960.

After his marriage on February 22, 1934 to Carol Moore, a New York public school art teacher, they lived in Darien, Connecticut. Hardin obtained formal instruction in human anatomy and figure construction when he joined a life class taught once a week by Karl Lang. By 1939 he had begun to exhibit sculpture. Some of these early works, genre studies of distinctive types,

brought him fame. His *Amish Man* in bronze was acquired by The Pennsylvania Academy of the Fine Arts, and *Nova Scotia Fisherman* was awarded the Henry O. Avery Prize of the Architectural League of New York and bought by International Business Machines Corporation for its collection of sculpture of the Western Hemisphere. After this, commissions began coming which he executed in the evenings and weekends when he was away from his New York office. His work found ready acceptance by his fellow sculptors and by religious institutions in need of sculpture for their buildings.

The *Holy Family* that won the Saltus Gold Medal of the National Academy of Design in 1945 marked his considered choice of religious themes, with wood as a preferred material. When he selected *The Nativity* as the subject for the 62nd issue of The Society of Medalists in 1960 he wrote, "…it reflects…my own special interest in sculpture dealing with the great subjects of the Bible."[1]

From his studio came statues of saints such as *Saint Thomas Aquinas* carved of black walnut in 1953 for the Catholic Chapel of the Aquinas Foundation at Princeton, New Jersey. *Worshipping Figure*, a small bronze, is in the collection of the National Academy of Design. His bas-relief sculpture, beginning with medals, was winning awards by 1956. In that year *Allevare, Sedare, Sanare*, a medal for Thomas Leeming & Company, won the Lindsey Morris Memorial Prize of the National Sculpture Society. From these small works Hardin progressed to larger reliefs; *The Good Samaritan* was carved in oak for a door panel of the Meditation Room in the hospital at Stamford, Connecticut. He made the models for three panels in limestone for a new building at Princeton University in 1957. *The Student*, a young man reading a book, decorates the bookstore. Reliefs carved in walnut, *Annunciation* and *Jesus and the Doctors*, received the Daniel Chester French Medal and the Gold Medal for Sculpture from the National Academy of Design in 1964 and 1976.

In more ambitious programs for mural ornament Adlai Hardin assembled many small reliefs into a complete ensemble. One of the largest wood sculptures in New York City, dedicated in the Interchurch Center in 1960, bears the legend, "Whatever you do, do all for the glory of God." The lindenwood relief, having a width of sixteen feet and a height of eleven feet, consists of 31 figures of people at work, arranged in a shape suggesting the growth of a tree. *To the Unknown Baptist Minister*, a bronze relief for McMaster Divinity College at Hamilton, Ontario, represents various aspects of the minister's calling in a cruciform design of nine different scenes. At Ephraim, Wisconsin, where he spent the summers for many years, Hardin recreated an Indian memorial for Peninsula State Park. On a 30-foot wooden column in the form of a totem pole were carved seven reliefs of events from the area's Indian

history topped by a climbing bear, symbol of the Menominee and Potowatomi tribes. A series of figures and groups carved in basswood and placed on an interior wall of the Bowling Green office of The Seaman's Bank for Savings in New York City depicted the kinds of people who deposited their money in the bank at its inception in 1829.

Hardin's medallic works included portrait medals of *Joseph Henry* and *George Bancroft* for the Hall of Fame for Great Americans at New York University. The Bancroft medal won the Mrs. Louis Bennett Prize of the National Sculpture Society in 1965. Also among this group were a portrait plaque for the University of Rochester and a medal of Judge Bernard Botein, a president of the New York City Bar Association. In 1976 Hardin served on a jury for the United States Mint during the national competition for coins designed to commemorate the United States Bicentennial.

In 1970 Adlai Hardin received a Gold Plate Award given annually by the American Academy of Achievement in Dallas, Texas. He was elected an academician of the National Academy of Design in 1963 and a fellow of the National Sculpture Society in 1947, serving as president of the latter from 1957 to 1960. In 1962 he was Sculptor-in-Residence at the American Academy in Rome. His death occurred at Lyme, Connecticut on October 16, 1989.

Nova Scotia Fisherman

A slender young man wearing a loose sweater, vest and trousers with turned-down hip boots and a cap is seated on a wooden piling. His legs, held in place by the toes of his boots tucked around each side, straddle the piling and his hands rest flat on top of his thighs. The posture and expression convey a relaxed attitude. *Nova Scotia Fisherman* was awarded the Henry O. Avery Prize of the Architectural League of New York in 1940. This example was cast from the original model in 1977.

The sculptor made the following statement about this work: "In the summer [of 1939] my brother and I went for a week's vacation to Nova Scotia. Early one morning, in heavy fog, we went down to a wharf to meet a boat which was to take us cod fishing. While the captain of the small boat made ready, I was struck with the costume of his 17 or 18 year old son. He was slender but wore great hip boots that had been turned down at the knees and then back up again. Some sort of loose sweater with long sleeves was covered by an unbuttoned vest. On his head was a round cap with a visor.

I made a mental note of the interesting effect of the large, heavy, boots on this slightly built young fisherman and when I returned to Connecticut, I

NOVA SCOTIA FISHERMAN

Bronze. Height: 68.6 cm. Signed: *ADLAI S HARDIN 1939* ©. Founder's mark: "Modern Art Foundry N.Y." S.1977.005, placed in 1977. Other examples: New York, NY. International Business Machines Corporation; Danbury, CT. Medallic Art Company.

PHOTO BY ROBIN R. SALMON

modeled the figure sitting on a pile with the toes of the boots tucked around behind the pile. I used no model until the design as a whole was completed. Then I asked a neighbor lad to come in to pose so that I could correct some details. I put him in boots and seated him on top of a vertical log. His toes wouldn't stay behind the log with any comfort, so I remember putting two large nails in the log for him to hook his feet or toes behind. After that he sat quite comfortably and made an excellent model."[2]

1 *The Society of Medalists 62nd Issue*, November 1960, Clipping File, "Adlai S. Hardin," Brookgreen Gardens Archives.
2 "Notes on the Background of the Nova Scotia Fisherman, July 6, 1977," Sculptor's Correspondence File, "Adlai S. Hardin," Brookgreen Gardens Archives.

Edward Fenno Hoffman III

SEE *Brookgreen Gardens Sculpture*, pp. 468-472, for the sculptor's biography.

Edward Hoffman's sculpture continued to be acquired for public places and to win important awards from art organizations. Throughout his career, studies of animals, both wild and domestic, filled his studio. A life-size bronze *Fawn* was placed at the Newlin Mill Park in Concordville, Pennsylvania in 1972. In 1973 a life-size portrait bust of the architect John F. Harbeson received the Silver Medal at the National Sculpture Society's 80th annual exhibition. A model for the bust had been acquired by the National Academy of Design in 1971.

Sculpture for religious settings and depictions of children were two fields in which Edward Hoffman was well known. *Pieta*, a life-size bronze of a standing figure of the Virgin Mary supporting the body of Christ upon her outstretched arms, was placed at Our Lady of Grace Catholic Church in Greensboro, North Carolina in 1975. A casting of the model for this work also was acquired by the North Carolina Museum of Art at Raleigh. In 1979 *Child of Peace*, a life-size figure of a young boy clasping a dove to his chest, was awarded the Dr. Maurice B. Hexter Prize for sculpture in the round at the 86th annual exhibition of the National Sculpture Society. Hoffman was commissioned by the Society of Medalists in 1980 to create its 102nd issue. He employed designs from two of his popular depictions of childhood: *Alice in Wonderland* on the obverse, and *Winnie the Pooh* on the reverse.

In 1985 the sculptor published a catalogue of his work, *Reaching...and other Sculptures*, which included a foreword by Donald De Lue and an essay on his life by Nancy Mungall. Hoffman's bronze group, *Reaching*, depicting the playful relationship between a mother and her child, was installed in 1990 at the Society of the Four Arts at Palm Beach, Florida. The model for this work had been awarded the Artists Fund Prize for Best in Show at the National Academy of Design in 1969.

Edward Fenno Hoffman III died at Bryn Mawr, Pennsylvania on September 20, 1991. He was an academician of the National Academy of Design, a fellow of the National Sculpture Society and held membership in Allied Artists of America, Artists Equity and the Rosicrucian Order, a philosophical society. Hoffman was awarded the Francis Keally Prize for service to the National Sculpture Society in 1975. One of his avocations was landscape design and over a 30-year period he and his wife transformed the woods on his property into terraced gardens with sites for sculpture.

CHILD WITH FLOWER

 Plaster. Height: 33cm. Signed: *1960 / Edward Fenno Hoffman III* S.1973.006, placed in 1973. Gift of Anna Hyatt Huntington.

Child with Flower

A small child wearing a long robe looks down at a flower held in its right hand, while gesturing with its left hand. The sculpture is sensitively rendered with simple detail. It was modeled in 1958 to be cast in an edition of seven. *Child with Flower* won the Gold Medal award at the 70th Award Exhibition of the Catharine Lorillard Wolfe Art Club in 1967. It was formerly in the collection of Anna Hyatt Huntington.

Joseph Walter

JOSEPH WALTER was born in 1896 and worked as a sculptor for a time in Brooklyn, New York. In 1932 he and Bertha H. Walter were married. Some-time during the 1930s he moved to Washington, D.C. and set up a studio.

In addition to work for interior settings such as *Cantata,* a relief panel for the auditorium of Brooklyn High School, Walter received requests for reliefs on buildings. In 1948 a war memorial was commissioned by the Senior Classes from 1942 to 1949 of Andrew Jackson High School in St. Albans, New York. The memorial in honor of the young men from the school who died in World War II bears the inscription: "In memory of our heroes of World War II; they went where duty seemed to call, they only knew they could but die." The plaque was unveiled on March 31, 1949.

A life-size relief depicting the return of Mowgli to visit his animal friends, from *The Jungle Book* by Rudyard Kipling, was done for the Prospect Park Zoo, Brooklyn, in the 1930s. Mowgli, standing in the jungle, is flanked on the left by a wolf, bear and two monkeys, and on the right by a lion, jackal and parrot. Joseph Walter himself executed the design, made the model and carved the panel in stone.

A portrait bust in bronze of Dr. Lyman James Briggs, former director and president emeritus of the National Bureau of Standards in Washington, D.C., was presented by alumni in 1971 to the Lyman J. Briggs College of Michigan State University. The sculptor's wife was employed by Briggs at the National Bureau of Standards and the portrait was modeled from life in 1958. The bust had been exhibited previously at the Bureau and at the National Geographic Society, where Briggs served as chairman of the research and exploration

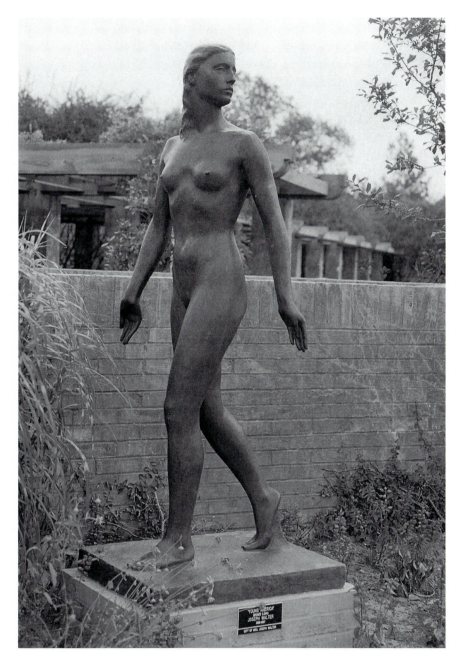

YOUNG AMERICA

Bronze. Overall height: 172.1 cm. Signed *JW* [very faint]. S.1990.001, placed in 1990. Gift of Mrs. Joseph Walter.

committee from 1934 until 1959.

Joseph Walter was a fellow of the National Sculpture Society. He died in Washington, D.C. in 1987.

Young America

A life-size female nude strides forward, with her arms at her sides and palms held outward. Her head is turned to look over her left shoulder and her hair falls loosely on her right shoulder. Also known as *Retrospective* and *Spirit of Young America*, this figure was done in the 1940s. Shortly after completion it was exhibited in a show at The Metropolitan Museum of Art in New York.

This posthumous example, cast from the original model in 1989 by New Arts Foundry in Baltimore, Maryland, was to be donated to a museum according to directions made in the sculptor's will. Through the efforts of Dr. George Gurney of the National Museum of American Art, it was donated to Brookgreen Gardens by the sculptor's widow.

Marshall Fredericks

A DISTINGUISHED SCULPTOR who gained recognition in the 1930s but whose art blossomed after World War II, Marshall Fredericks and his work stand alone stylistically and quantitatively in 20th century American sculpture. Echoes of his teacher, Carl Milles, fused with elements of Asian and Oriental art and an indefatigable sense of humor have created a unique blend of simplistic line, refinement of detail and uncanny ability to capture the essence of the subject. At the same time, his work radiates energy and emotion. From heroic monuments to commemorative medals, his singular style is instantly recognized in some of the finest architectural and civic sculpture in the United States.

Marshall Maynard Fredericks was born in Rock Island, Illinois, January 31, 1908, to Frank A. and Frances Margaret (Bragg) Fredericks. During his youth Fredericks worked for his father, a construction engineer, and attained technical knowledge and skills that he would employ in later years. He attended the John Huntington Polytechnic Institute and graduated from the Cleveland School of Art in 1930. With traveling scholarships he was able to

tour Europe for a year and study its art, history and heritage. In Stockholm he visited the studio of the great Swedish sculptor, Carl Milles, and worked with his stonecarvers. At Milles' suggestion he went on to study at Heimann Schule and Schwegerie Schule in Munich, the Academia Scandinav in Paris, and at private studios in London and Rome.

After returning to the United States, Fredericks served on the faculty of the Cleveland School of Art and was awarded First Prize in Sculpture in 1931. That same year, Carl Milles was appointed resident artist and head of the sculpture department at Cranbrook Academy of Art in Bloomfield Hills, Michigan, and invited Fredericks to join his staff. Eliel Saarinen, Director of Cranbrook, recognized Fredericks' ability and awarded him a scholarship. From early 1932 to late 1942, he was a faculty member at Cranbrook Academy of Art teaching sculpture, and head of the Sculpture and Ceramics Department at its related organization, Kingswood School. He was also head of the Art Department at Cranbrook School from 1932 through 1938. Continuing to work with Carl Milles, he gained experience in the creation of monumental sculpture and the mechanics of engineering and placing large works.

In 1942 Marshall Fredericks enlisted in the United States Armed Forces serving in this country with the Engineer Corps and in the Pacific and Far East with the 20th Bomber Command and the 20th and 8th Air Forces. He attained the rank of Lieutenant Colonel. On September 9, 1943, he married Rosalind Bell Cooke and in 1945, after discharge from military service, returned to Michigan and set up a studio in Royal Oak.

Having had more than 500 major sculptural commissions, including six from the United States government, Marshall Fredericks has an impressive reputation in the field of monumental works. The colossal Cleveland War Memorial Fountain, titled the *Fountain of Eternal Life*, was begun in 1946 and required 19 years for completion. The central bronze figure, 36 feet tall, stands on an illuminated sphere covered with symbolic and allegorical reliefs in swirling patterns. This 10-foot diameter sphere is filligreed and illuminated from within as well as from the exterior with alternating white and gold lighting. Symbolizing humanity, the monumental figure reaches for the firmament while flames from the sphere, representing destructive forces such as war, rise around his legs. Surrounding the fountain are four monolithic granite carvings representing the Nordic, Eastern, Southern and Western civilizations. Placed within a basin of polished Norwegian granite, the fountain covers 2,500 square feet and is the largest in the United States. Around its rim are bronze plaques with the names of over 5,000 persons who died in World War II and the Korean conflict.

Christ on the Cross, a 26-foot bronze Corpus on a 55-foot cross of California redwood was dedicated at Indian River, Michigan on August 16, 1959. Commissioned by the Diocese of Grand Rapids, the Crucifix forms a shrine in honor of Kateri Tekakwitha, an Indian maiden known as the Lily of the Mohawks. The Crucifix is the largest in the world.

Man and the Expanding Universe was placed in the fountain of the South Court at the State Department Building, Washington, DC, in 1963. A monumental bronze figure of a muscular male crouches astride a planetary sphere encircled with an orbit of polished nickel. He sends into space two new planets of cast nickel which he holds in each hand. The surface of the large sphere, covered with 5,000 stars in correct celestial position, is sprayed by jets of water. The sculpture was erected to celebrate this nation's first exploration of outer space.

Freedom of the Human Spirit, a monumental bronze of two figures, male and female, soaring skyward with three wild swans, was commissioned by the World's Fair Corporation for the New York World's Fair in 1964. It was placed in the Court of the States in front of the United States Pavilion and was one of three monumental bronzes that remained in Flushing Park after the Fair ended. In 1983 permission was obtained to have a second casting made and installed in Shain Park in honor of the 50th Anniversary of Birmingham, Michigan.

For the *Saints and Sinners Fountain* of 1976 at Oakland University in Rochester, Michigan, Fredericks employed a humorous theme to contrast with the academic atmosphere. A group of seven male and female bronze figures on polished granite bases depict saints and sinners. Each of the 11-foot tall figures, standing upon a globe with feet placed almost perpendicularly to the straight, elongated bodies, is reminiscent of Gothic sculpture with smooth, slender lines. The figures gesture symbolically or hold symbolic objects, for example, one saint has his hands clasped in prayer and Eve holds her apple.

Another massive work, 30 feet tall, decorates the facade of the Veteran's Memorial Building in Detroit. The *Victory Eagle*, carved in ten sections from 210 tons of Vermont marble in 1947, is poised to strike, its wings forming a V-shape symbolizing both victory and veteran. As it projects more than four feet away from the facade, it is a fine example of precision in design and execution. The sculptor's sensitivity to line and form is evident in the nearly abstract design.

Although originally not given a title by the sculptor, the *Spirit of Detroit*, placed at the City-County Building in 1958, has become the name of the sculpture and the symbol of that municipality. A religious theme, a verse from Second

Corinthians, invoked the idea of the heavenly spirit in connection with Liberty. A 26-foot bronze kneeling figure holds a family group in one hand and a sphere radiating bright shafts of light encircled with three rings — the Holy Trinity — expressing the spirit of man, the deity and the family. The family and the deity symbol are of gilt bronze. The group was placed before a 60-foot concave marble wall with carved rondels of the seals of the city and county and the verse, "Now the Lord is that Spirit and where the Spirit of the Lord is, there is liberty."

A 20-foot tall cast aluminum relief, *The Family, Protected by Healing Herbs*, was placed on the facade of William Beaumont Hospital in Royal Oak, Michigan, in 1957. It depicts with spare, economical lines a young father, a mother holding an infant and a second small child. A *Siberian Ram* in limestone, emanating monumental energy, was dedicated in 1966 at the Birmingham-Bloomfield Bank in Birmingham, Michigan, and later placed at the entrance to the Baldwin Public Library.

The Henry Ford I Memorial, installed in 1978 in the Henry Ford Centennial Library, Dearborn, Michigan, was the first major memorial to the automotive genius. The over-life-size bronze figure of Ford stands in contemplation, gazing downward, with hands in pockets. It is flanked by four bronze reliefs, two on either side. Three of the reliefs depict significant episodes in Ford's life. The fourth relief illustrates buildings historically important to the Ford Motor Company including the first workshop. The reliefs are mounted on a background of Vermont verde antique marble, 16 feet in length. In the recessed panel directly behind the figure is carved the signature of Henry Ford, embellished with gold leaf.

Although not as well known for this aspect of sculpture, Marshall Fredericks has completed many portrait commissions. A bronze portrait relief of Senator Arthur H. Vandenburg is at the University of Michigan, Ann Arbor. A gilt bronze portrait relief of Mr. & Mrs. George G. Booth, benefactors of the Cranbrook Educational Community, was done in 1950 for a memorial at the Cranbrook Institute of Science. A portrait relief of Mary A. Rackham and fifteen other reliefs at the Horace H. Rackham Memorial Building in Detroit, and an over-life-size head of *President John F. Kennedy* at the Macomb County Administrative Complex in Mt. Clemens are other examples of his work in Michigan. A memorial to Sir Winston Churchill at Freeport, Grand Bahama Island, done in 1968, contains a larger-than-life-size portrait bust of the English statesman.

An innovator in the use of fiberglass as a sculptural medium, in 1953 Fredericks created a series of 16 eight-foot reliefs illustrating various products

used in the automotive industry for the Ford Rotunda in Dearborn. Although destroyed by fire in 1962, the panels were the first major pieces to be cast in fiberglass resin laminate. He designed fiberglass and stainless steel activity implements and furniture in 1954 for the Holden Great Ape Exhibit at the Detroit Zoological Park.

Three-dimensional sculpture designed for placement on a building, such as the bronze *Indian and Wild Swans,* 35 feet in height, decorating the main facade of the Milwaukee Public Museum, is another Fredericks innovation. The Henry and Edsel Ford Auditorium sculptured mural in Detroit is a 150-foot linear abstraction in brass and aluminum. Hundreds of welded and polished joints represent the forces and products of nature and the skills and talents of man culminating in the major buildings and products of the Ford Empire. This is flanked by six 14-foot figures in high repousse relief of clowns, musicians, dancers and acrobats with circus trains and animals in copper, all hammered from the back and front in sand and plated with gold, cadmium and zinc. The unique techniques used in producing these three dimensional murals, similar to those used in the production of fine jewelry, are difficult in such huge dimension. Done in 1957, it is the longest fabricated metal relief sculpture ever made. A 20-foot aluminum relief for the facade of the Dallas Public Library in 1956, *Youth in the Hands of God,* portrays the spirituality and innocence of youth as well as a fundamental belief in reading as a source of learning and well being.

The smooth simple lines of Fredericks' sculpture appeals to children. A number of playful, fairy-tale-like compositions created specifically for young people have been placed at public sites. *Childhood Friends,* a bronze bas-relief of a boy, girl, bear and moose, for the Jefferson Elementary School at Wyandotte, Michigan, in 1958, infuses fantasy with whimsy and warmth. *The Lion and the Mouse,* placed in 1957 at the Eastland Shopping Center in Grosse Point, depicts the Aesop's Fable with a huge limestone lion, languidly reclining on its back, and a tiny gilded bronze mouse perched on its chest. The lion's mane is modeled in uniformly coiled ringlets. Since 1954, *Boy and Bear,* a huge friendly bear carved in limestone and a boy in cast gold plated bronze on his back, has attracted children at Northland Shopping Center, in Southfield, Michigan. This was the first sculpture placed in a shopping center designed by the architect Victor Gruen.

Marshall Fredericks' talent translates equally well to the field of medallic art. The *Mary Soper Pope Memorial Medallion,* designed for the Cranbrook Institute of Science in 1946, utilizes the themes of mother and child on the obverse and nature in the form of plantlife and a small lizard on the reverse. For the 71st

Annual Convention of the American Numismatic Association at Detroit in 1963 he designed a medal with his *Spirit of Detroit* on the reverse. The left side of the obverse, an American eagle, is mirrored on the right side by a grouping of maple leaves, signifying the first time the ANA and the Canadian Numismatic Association met jointly. He utilized a triangular shape for the Fine Arts Gold Medal of the American Institute of Architects in 1951. The 60th Anniversary Medallion of the Rebild National Park Society in 1972 features the American eagle and the official Danish Coat of Arms on the obverse and Abraham Lincoln's profile and log cabin on the reverse.

Marshall Fredericks has received numerous sculptural awards including the Fine Arts Gold Medal of the American Institute of Architects in 1952 which, in an 84 year period, has been given to only five sculptors. He was the first sculptor to be given honorary life membership in the Michigan Society of Architects. A second Gold Medal was given him by the Michigan Academy of Science, Arts and Letters in appreciation for his contribution to the state's artistic development. He is a member of the Architectural League of New York which awarded him its Gold Medal of Honor in 1956. In 1972 he received the Henry Hering Medal from the National Sculpture Society for six monumental limestone reliefs depicting the history of the Ohio River Valley that were carved in place by the sculptor and two assistants on the Student Union Building of Ohio State University at Columbus. The Society bestowed on him in 1982 its Herbert Adams Memorial Medal for outstanding achievement in sculpture and in 1985 he was the recipient of the Society's highest award, the Medal of Honor, in recognition of his distinguished body of works in this country and Europe. Also, in 1985, he was awarded First Prize in Sculpture at the 160th Annual Exhibition of the National Academy of Design. In 1992 he received the prestigious Silver Arts Award given by the American-Scandinavian Foundation.

His Norwegian-Danish heritage is a source of pride and fulfillment. Marshall Fredericks has been decorated by many governments including Denmark and Norway. In 1963 King Frederik IX of Denmark bestowed on him Knighthood of the Order of Dannebrog and, in 1971, the Order of Dannebrog First Class. In 1978 Her Majesty Queen Margrethe II conferred upon him the Commander's Cross of Dannebrog. In 1966 he was appointed Royal Danish Consul for the State of Michigan. His Majesty King Olav V of Norway conferred upon him in 1972 the Knighthood of the Order of St. Olav First Class. Fredericks' *Memorial to Norwegian Emigrants*, incorporating the gazelle figure from the Levi Barbour Memorial Fountain, was placed at Stavanger, Norway in 1958. *Flying Wild Geese* and *The Thinker* are located at the Foreign Ministry in Copenhagen. Four of

his monumental bronze works, the largest metal sculptures to cross the Atlantic Ocean intact since the Statue of Liberty, were modeled and cast in Oslo. To this country, Fredericks introduced the sculptural and architectural uses of Norwegian Emerald Pearl Granite.

A deep interest in the welfare of his fellow man has led Marshall Fredericks to activity in humanitarian organizations and efforts. In 1965 with the cooperation of the Lord Mayor of Copenhagen, he established the DIADEM (Disabled Americans' Denmark Meeting), an exchange program between Denmark and the United States of physically disabled young adults. Its satellite programs, DIADEM LEADER, a leader dog training program for the blind, DIADEM RETURN and similar programs have been successful in providing rehabilitative and cultural opportunities. For his work with the President's Committee for the Employment of the Handicapped he received citations from Denmark and the United States. He is the recipient of the Distinguished Service Award of the Michigan Association of Professions, the Golden Plate Award of the American Academy of Achievement and the President's Cabinet Medallion from the University of Detroit. He serves as an advisor to the International Center for the Disabled in New York City.

Marshall Fredericks is an academician of the National Academy of Design, a life fellow of the International Institute of Arts and Letters, and is a fellow of the National Sculpture Society. He is a member of the Federation Internationale de la Medaille and an honorary member of Beta Sigma Phi, the National Society of Interior Designers, and the American Society of Landscape Architects.

He resides in Birmingham, Michigan, and maintains studios in nearby Royal Oak and Bloomfield Hills.

Gazelle Fountain

A sleek gazelle is captured in a characteristic movement called wheeling. It was adapted from the central figure of the Levi L. Barbour Memorial Fountain at Belle Isle, an island in the Detroit River. In 1936 his design won first prize in a national competition. The *Gazelle* was one of four purchase prize winners of a nationwide open sculpture competition sponsored by Brookgreen Gardens in 1972. Brookgreen Gardens' American Achievement Award, designed by Fredericks in 1986, utilizes the gazelle theme as does Brookgreen Gardens' Membership Medal issued in 1977.

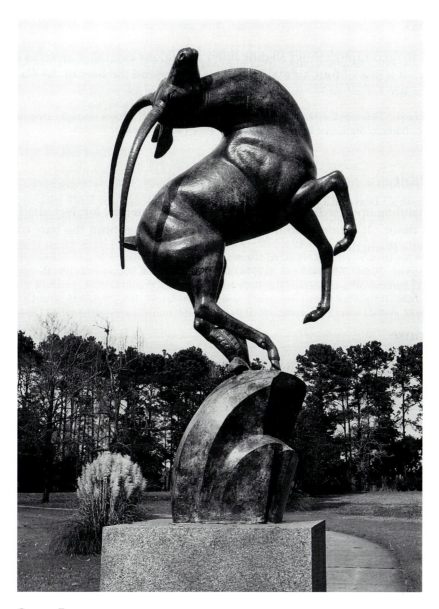

GAZELLE FOUNTAIN

Bronze. 223 x 52 x 21 cm. Signed: *MARSHALL . M . FREDERICKS . N . A .*
Founder's mark: BEDI-MAKKY ART FOUNDRY, N.Y. S.1972.013, placed in 1972.
Other examples: Detroit, MI. Levi L. Barbour Memorial Fountain, Belle Isle Park;
University Center, MI. Fountain Plaza, Saginaw Valley State University; Marshall M.
Fredericks Sculpture Gallery, Saginaw Valley State University (original model);
Stavanger, Norway. Emigrant's Monument; Denmark. Royal Marselisborg Castle;
Spartanburg, SC. Milliken Company Headquarters; Midland, MI. The Dow Gardens.

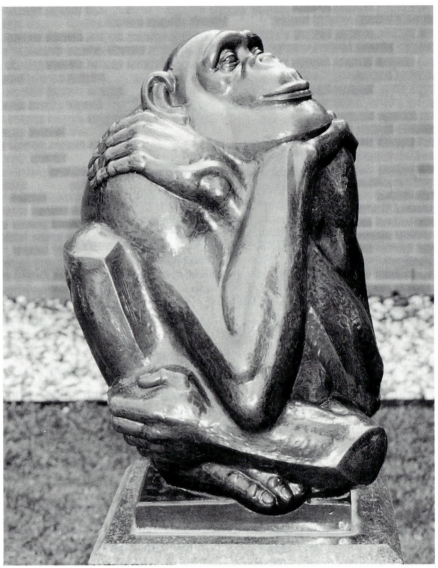

THE THINKER

Bronze. 62.2 x 42 x 45 cm. Signed: *Marshall M. Fredericks* Founder's mark: MENGEL ART FOUNDRY S.1982.003, placed in 1983. Gift of the sculptor. Other examples: Bloomfield Hills, MI. Cranbrook Museum of Art (Black Mellen Granite); Lidingo, Sweden. Millesgarten (black granite); University Center, MI. Marshall M. Fredericks Sculpture Gallery, Saginaw Valley State University (original model); Copenhagen, Denmark. Foreign Ministry Building; Grand Rapids, MI. Michigan Botanical Gardens.

Baboon

A female baboon sits in a crouching position with her hands folded across her updrawn knees. This example was cast in 1985 from the original half-scale model of a figure from the Baboon Fountain, commissioned for the 1939 New York World's Fair. The original group of five cast stone figures, 14 feet tall, were situated on pedestals around a glass pool in front of the Glass Industries Building.

Bronze. 185.4 x 51.1 x 53.3 cm Signed: *MARSHALL M. FREDERICKS* Founder's mark: BEDI-MAKKYN.Y.C. S.1985.010, placed in 1986. Partial gift of the sculptor. Other examples: University Center, MI. Marshall M. Fredericks Sculpture Gallery, Saginaw Valley State University (bronze and original model).

Baboon

A male baboon sits in a crouching position, his hands on each knee and his teeth bared. This example was cast in 1985 from the original half-scale model of a figure from the Baboon Fountain, commissioned for the 1939 New York World's Fair.

Bronze statue. 184.2 c 51.4 x 52.7 cm. Signed: *MARSHALL M. FREDERICKS* Founder's mark: BEDI-MAKKY N.Y.C. Partial gift of the sculptor. S.1985.011, placed in 1986. Other examples: University Center, MI. Marshall Fredericks Sculpture Gallery, Saginaw Valley State University (bronze and original model).

The Wings of the Morning

The hand of God cradles a reclining winged male figure accompanied by two swans in flight. The figure lies on his back, arms stretched over his head. The title of the sculpture is taken from verses 9 and 10 of the 139th Psalm: "If I take the wings of the morning, and dwell in the uttermost parts of the sea; even there shall Thy hand lead me, and Thy right hand shall hold me." These verses are inscribed on a pedestal of Black Indian Granite upon which the sculpture is placed.

Bronze group. Signed: *MARSHALL M. FREDERICKS* © Gift of the sculptor. S.1989.005; placed in 1989. Other examples: Bloomfield Hills, MI. Kirk in the Hills Presbyterian Church; Grand Rapids, MI. Michigan Botanical Gardens; University Center, MI. Marshall M. Fredericks Sculpture Gallery, Saginaw Valley State University.

Charlotte Dunwiddie

ELIZABETH CHARLOTTE EUGENIA NATALIE KLEIN was born in Strasbourg, Alsace-Lorraine, France on June 19, 1907. She is the daughter of a famous French attorney, Dr. Charles Klein, and Elsa Alexandra (Demier) Klein. After her father's death, her mother remarried and Charlotte was adopted by her stepfather, Adolph Hannau, a leading German industrialist. During the winters her family lived in Dusseldorf and the summers were spent on their estate in Wiesbaden. By the age of seven, Charlotte already had begun to paint, to study the ballet and piano.

Since her stepfather owned race horses and had his own racetrack, she learned to ride when she was a small child and later trained her own horses. At the age of fifteen she won her first championship in dressage. Following her own inclinations and without formal instruction, she put to use her intimate knowledge of the anatomy of the horse and her grasp of the personality of each individual in modeling her favorite animals. When she was twenty, after her work had been shown to Professor Wilhelm Otto, Director of the Berlin Academy of Fine Arts, he accepted her as a private pupil. She married but continued to study sculpture. This pleasant life ended abruptly when her husband died suddenly.

She left Germany to seek a change of environment in other countries, first in Paris and then in Madrid, where she resumed the study of sculpture with a well-known Spanish sculptor, Mariano Benlliure y Gil. At the outbreak of World War II she managed to leave Spain for Argentina and lived in Buenos Aires for five years. For a time she studied with Alberto Lagos and then began to work independently, carrying out her own commissions for portrait busts and reliefs. These included a life-size bust in 1941 of Santiago Cardinal Copello, Primate of Argentina and Archbishop of Buenos Aires, located in the Throne Room of the Cardinal's Palace. In 1943 a bas-relief head of Jozef Pilsudski, former President of Poland, was placed in the Bank of Poland at Buenos Aires.

When she married D. Stanley Dunwiddie, head of the Goodyear Tire and Rubber Company in Peru, she went with him to Lima. They raised horses and dogs, good subjects for Mrs. Dunwiddie's career as a sculptor. She continued sculpturing portraits of leading government and diplomatic officials, educators, clergymen and industrialists. One of these was a life-size bust of Jose Maria Ortiz-Tirado of Mexico. In addition to portraits, her works included an angel protecting fallen heroes for a war memorial done in 1947 for the Church

of the Good Shepherd at Lima. A life-size statue of Saint Theresa teaching a child to read was done in 1948 for the Church of Santa Maria at Cochabamba, Bolivia. *Mater Dolorosa*, done in 1950, was placed in the palace of the Papal Nuncio in Lima.

Another sharp break in her life came with the sudden death of her husband as they were about to leave on a European vacation. She distributed all her possessions and moved to New York in 1956. Only a year later the Kennedy Galleries gave her a solo show featuring bronzes of thoroughbred horses and other small sculpture. Her work was an immediate success, and many owners of thoroughbred horses asked her to model likenesses of their champions. Among these famous horses were *Bold Ruler*, "Horse of the Year" for 1957, owned by Mrs. Henry C. Phipps, and *Adios Harry*, the all-time highest money winner in harness racing, owned by Howard Lyons. A statue of *Messenger* was placed in the Club House at Aqueduct Race Track in 1961. For the Thorough-bred Racing Association, a series of medals of horses' heads in gold, silver and bronze in 1974 celebrated the nine winners of the triple crown, ending with *Secretariat*.

From the beginning, animal sculpture seems to have been her preferred field of emphasis. Her intimate knowledge of the horse creates a quality of empathy and enables her to inject power into her equine subjects yet, at the same time, to portray personality with sensitivity. This quality is shared by all the animal sculpture of Charlotte Dunwiddie.

Soon after her first exhibit in New York, her work began to win prizes in important art exhibitions such as those of the National Academy of Design and the National Sculpture Society. Charlotte Dunwiddie has been awarded nearly every major prize in sculpture. *Dying Chiron*, a small bronze sculpture of the mythical centaur about to collapse as he grasps his wound, was awarded a Silver Medal by the National Sculpture Society in 1957 and the Pauline Law Prize of the Allied Artists of America in 1965. Her bronze sculpture of *Bold Ruler* won Best in Show at the Pen and Brush in 1958. A small equestrian of Queen Elizabeth II of England, *Trooping the Colors*, won gold medals from both the Pen and Brush and the Catharine Lorillard Wolfe Art Club in 1962 and, in that same year, a spirited bronze of a horse named *Intrepid* won the Pauline Law Prize of the Allied Artists of America.

Pegasus, a bronze horse with outspread wings, was awarded a gold medal by the American Artists Professional League in 1966. A dignified equestrian of General George Patton in cavalry uniform received a gold medal in the Winners Show of the Hudson Valley Art Association in 1977, and a gold medal of the Academic Art Association exhibition of 1978. In 1985 a bronze of a

striding Clydesdale, *Festina Lente,* or "make haste slowly" in Latin, received the Bedi-Makky Prize at the National Sculpture Society exhibition.

Her animal sculpture was not limited to horses. She portrayed *Whitneymere* in 1957, Cornelius Vanderbilt Whitney's champion Aberdeen Angus Bull. The dangerous *African Cape Buffalo,* radiating raw power, won the Artists Fund Prize of the National Academy of Design in 1974.

She also received commissions for portrait sculpture. A life-size bronze bust of General Lemuel C. Shepherd, Jr., former commandant of the Marine Corps, was placed in 1956 at O'Bannon Hall on the Quantico Marine Corps Base in Virginia, and a second bust was acquired in 1958 by the Marine Corps Museum in Washington, D.C. A bronze bas-relief of Pope John XXIII was done for the Seminary of Redemptorist Fathers at Suffield, Connecticut, in 1963. A bust of John Sullivan is located at the Hospital of Sisters of Mercy in Watertown, New York. Her life-size portrait bust of *Gertrude,* a granddaughter of Gertrude Vanderbilt Whitney, received a first place award at the annual exhibition of the Pen and Brush in 1958. A bronze bas-relief entitled *Self Portrait* received the National Sculpture Society's Lindsey Morris Memorial Prize in 1971 and is in the collection of the National Academy of Design. Another example is located at the New Britain Museum of American Art in Connecticut. Although not a portrait, a nearly life-size bronze figure, *Korean War Orphan,* depicts the suffering of a homeless child.

Charlotte Dunwiddie has been active in many artists' societies. She is an academician of the National Academy of Design and a fellow of the Royal Society of Arts, London, and of the Allied Artists of America. She is a fellow of the National Sculpture Society, of which she was president from 1982 to 1985 and is currently honorary president. In 1976 she received the Francis Keally Memorial Prize for service to the National Sculpture Society, and in 1990 she was awarded the Herbert Adams Memorial Medal for her many contributions to the Society and the field of sculpture. She also has been president of both the Pen and Brush and the Catharine Lorillard Wolfe Art Club and has been a director of the American Artists Professional League.

Charlotte Dunwiddie maintains a studio and lives in New York City.

Toro Bravo

A result of knowledge of bullfighting gained from living in Spain and Peru is *Toro Bravo.* The sculptor chose the dramatic moment when the fighting bull emerges from the dark corral into the dazzling light of the arena, hesitating before he makes his first charge. This bronze was awarded the Ellin P. Speyer

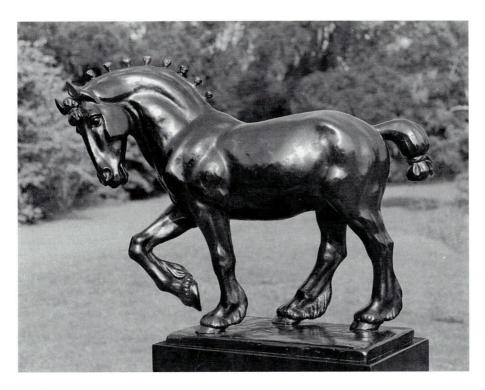

BUSTER

Bronze. 31.1 x 23.5 x 13 cm. Signed on base at top: *DUNWIDDIE* © Founder's mark: TX [Tallix Foundry]. S.1986.005, placed in 1986. Gift of the sculptor.

Prize of the National Academy of Design in 1969 and the Gold Medal of Honor of the Allied Artists of America in the following year.

Bronze. 33 x 43.2 cm. Signed on base at rear: *DUNWIDDIE* Founder's mark: ROMAN BRONZE WORKS INC. N.Y. S.1977.001, placed in 1977.

Buster

A young Clydesdale horse walks with his right front leg lifted high in the characteristic manner of this breed. His powerful neck is arched, displaying a braided and decorated mane, and his tail is cropped and bound. The sculptor has captured a feeling of movement and spirit with attention to anatomical detail. This sculpture was modeled in 1984.

Tete-a-Tete

A pair of horses standing side by side are nuzzling one another as if having a conversation. This sculpture won the Artists Fund Prize for the finest sculpture in the exhibition of the National Academy of Design in 1972.

Bronze. 40.6 x 40 x 27.3 cm. Signed on base at top: *DUNWIDDIE*. S.1992.003, placed in 1992. Gift of the sculptor.

Charles Parks

THE SCULPTURE OF Charles Parks is as diverse as his methods of style. Simple acts and pleasures of life, such as a girl combing her hair and a child holding a rabbit, are modeled with sensitivity and warmth. His mastery of portraiture, especially evident in works of children, is presented with a fresh approach to the formal portrait bust. He has interpreted some of his sculpture through the medium of welded metal in an innovative manner that is peculiarly his own.

Charles Cropper Parks was born June 27, 1922 on the Eastern Shore at Onancock, Virginia, to George Washington and Lee Swanger (Cropper) Parks. When he was two years old his family moved to Wilmington, Delaware, where he has spent nearly all of his life. He attended the public schools in the area and exhibited an interest in art at an early age. Drawings of ships and soap carvings of animals composed his initial experimentation.

Beginning in the tenth grade in 1938, through friendship with a painter and framemaker, Frank Coll, he visited the Graphic Sketch Club in Philadelphia. There, during the winters, two nights each week for two years, he studied with the sculptor, Marcus Aurelius Renzetti. During the summers, work at a machine tool company founded by his grandfather gave him a good knowledge and understanding of tools, mechanics and welding.

Upon graduation from high school in 1940 he took a job as a laboratory assistant with the DuPont Company of Wilmington and worked there for two years. During that time, the United States entered World War II and, in 1942, he enlisted in the Army Air Corps and entered pilot's training. A physical disability grounded him; however, he attained the rank of First Lieutenant and served until 1946. On August 12, 1942, he married Inge Elizabeth Ruehl, a concert pianist from Wilmington. In 1946 he returned to work as foreman at the family's Cropper Machine Company, a position he held until 1960.

In the fall of 1947, Charles Parks entered the University of Delaware to resume his art studies. To help support his family, he conducted sculpture classes at night at the Delaware Art Museum and began carving in wood. One of the carvings from this period is in the permanent collection of the Museum. In 1948 he began a four year period of study at The Pennsylvania Academy of the Fine Arts; by 1950, his sculpture began to attract attention and honors. That year he was awarded three student prizes — the Walker Hancock Prize, the Lila Agnes Kennedy Hill Memorial Prize and the Edmund Stewardson Prize. In 1951 he received an honorable mention for the Cresson Prize; and a marble bust, *Althea*, won the Jurists' Prize from the Delaware Art Museum. His carving in mahogany of the Great Seal of the State of Delaware was placed in the chambers of the State Supreme Court in Dover.

In 1954 a commission for a tympanum and four walnut and aluminum plaques to decorate the Warner Memorial Doors of the First Unitarian Church in Wilmington marked the beginning of local recognition for Charles Parks' sculpture. His work was encouraged in 1957 by the receipt of a Tiffany Foundation Award for Creative Sculpture and in 1958 by an award from the Delaware Chapter of the American Institute of Architects. A life-size mahogany crucifix of an agonizing Christ for the altar of St. Matthews Church and a colossal fiberglass-reinforced epoxy crucifix of a contemplative Christ for Zion Lutheran Church were done in 1960. Two years later, a larger than life-size *Mother and Child* in welded steel at St. Mark's Lutheran Church and a relief panel in aluminum for the Family Court Chambers were placed. In 1963 *Mother and Child* received the First Prize for Sculpture and the mahogany crucifix was awarded the Grand Prize of Show at the Exhibition of Contemporary Liturgical Arts in Philadelphia.

The period of the 1960s was the onset of sculpture as a full-time career for Charles Parks. He quit his job with the family company and devoted all his energy to the creation of his art. Experimentation with non-traditional sculpture materials and design created divergent artworks like nothing he had previously done. The Brittingham Arts Foundation Award in 1961 allowed him to study the new media and techniques made available by technology. His previous experience with welding inspired the medium for a number of welded corten steel sculptures and reliefs. A *Gamecock* (sometimes entitled *Blue Hen's Chick*), the mascot of the University of Delaware, was done in 1964 for the Student Center. A war memorial for Mid-Atlantic Industrial Park, Camden, New Jersey, in 1969, *What Shall I Cry?*, fused movement and pathos in the figures of a symbolic angel carrying the lifeless body of a black youth. Even with the challenge of new materials, he continued to create works with

more traditional styling intended for bronze. In 1962 the Delaware Swedish Colonial Society presented *Sprite of the Brandywine* to Kalmar, Wilmington's sister city in Sweden. The first casting of this lively figure holding a small millwheel, representing Prometheus running with the fire of the industrial revolution, was presented to Prince Bertil in 1963.

A travel grant from the Wemeys Foundation in 1965 allowed Charles Parks and his family to spend a year studying and working in Greece. There he experimented with wrought iron and stone and immersed himself in the artistic tradition of the Mediterranean. Influences from this period appear in his use of strong, spare line, particularly in religious themes, and in works with richly modeled detail. The wool of *Aries*, a life-size bronze ram done in 1966, is patterned in precise curls similar to the treatment of fur in Archaic Greek sculpture. *Joseph of Arimathea With the Body of Christ*, a monumental altar group in welded steel, for the United Methodist Church of Hockessin, Delaware, depicts the somber figure of Joseph carrying the body of Christ, forming the shape of an elongated cross. The tactile quality of the medium sharply enhances the image of grief and suffering. The cross motif appears in subsequent works. By utilizing only the figure of Christ and changing the medium to bronze in *Christus*, a life-size altar sculpture, Charles Parks softened the image but retained the aura of sadness. The body of Christ, held by disembodied hands, is modeled with smoothly rounded contours. The feeling of lifelessness is emphasized by the body's long horizontal line, supported by the dangling limbs.

Also, during the 1960s, Charles Parks began to work in portraiture, a style to which he is particularly suited. His subjects, characteristically shown in informal clothing and poses, vary widely in age and background. A serene bust of his wife done in 1956 and an engaging head of his daughter, Ingelora, created in 1960, were early indications of his ability to blend strength and delicacy in works that became not just accurate renditions of facial features, but character studies, as well. Some of these commissions included portrait busts and figures of South Carolinian Robert R. Coker, former chairman of Coker Pedigreed Seed Company, midwesterner Dean Buntrock, chairman of Waste Management, Inc., and former postmaster general of the United States, Winton M. Blount, chairman of Blount, Inc.

A life-size monument to Richard DeVos and Jan Van Andel, founders of the Amway Corporation at Ada, Michigan, shows the two portrait figures in a casual office setting: one standing, the other seated in an office chair. An over life-size bronze monument to the Honorable James F. Byrnes, South Carolina statesman, was done in 1970 and placed on the State House grounds at

Columbia in 1972. The former Supreme Court Justice and Secretary of State, wearing jurist's robes, is seated with crossed hands resting upon a law book on his lap. The half-size model of the full figure of Brynes, cast in bronze, is located at Aiken, South Carolina. A larger than life equestrian monument of General Harry C. Trexler looks out across Trexler Memorial Park from a hilltop at Allentown, Pennsylvania and a life-size bronze statue of Dr. James C. Giuffre in surgeon's garb was placed at the Giuffre Medical Center, Philadelphia, in 1981. In these works, Parks ably combines two often dissimilar components: the fine, delicate qualities of portraiture and the monumental grandeur of a permanent memorial.

But, it is in sculpture of children that Charles Parks excels. This special affinity enables him to translate the essence of the sitter to heads, busts and life-size figures. The latter works, depicted in casual settings with the subject's favorite pets or playthings, combine the elements of portraiture and outdoor sculpture in a pleasing manner. The innocence or inquisitiveness of childhood are revealed in *Jimmy's Dog*, *Lex and Fawzia* and *Boy with Kitten*, three of a great number of commissions that reflect his portrait talents. *The Grandson*, a delicately modeled life-size bronze figure of a toddler, received the Elizabeth N. Watrous Gold Medal from the National Academy of Design in 1980.

Likewise, the childhood theme is utilized in figures intended to be viewed purely for their decorative qualities. A life-size bronze, *Boy with Duck*, is the center of a fountain in Wilmington's Cool Spring Park. *Easy Riders*, a welded steel statue of two life-size children enjoying a wild ride on the back of a bucking bronco, is at Gauger Middle School in Newark, Delaware. *The Shawl*, a life-size group of a teenage girl holding her young brother, both enveloped by a textured shawl, was awarded the Gold Medal at the National Sculpture Society exhibition in 1971. A smaller example cast in bronze is in the collection of the National Academy of Design. Two fanciful compositions of young girls seated upon gigantic flowers, *Zinnias* and *Dandelions*, depict with sturdy line yet delicate features, the fantasy and charm of youth. By replacing the young girls with alluring female nudes, Parks has used this theme in an entirely different manner. Exuding nonchalance and holding an apple while sitting on the leaf of a giant plant, *Eve* won the Leonard J. Meiselman Prize for classical sculpture in the round at the National Sculpture Society exhibition in 1980.

A strong religious belief underlies Charles Parks' philosophy of art and its place in the world. His concern for and empathy with his fellow man has formed the basis for a number of works of a social nature. At the National Urban League in New York City, *The Family*, a life-size group of a father, mother

and child, breaks away from tradition in its depiction of the classic family unit as black. Placed in Spencer Plaza at Wilmington in 1970, *Father and Son*, an over life-size bronze of a young black man tenderly cradling his sleeping child in his arms, won First Award from the Academic Artists Association and a citation from the New York City Planning Commission. Two works at Philadelphia comment on the opposite ends of life: childhood and old age. *A Friend*, a monumental bronze group of a uniformed policeman holding a lost little girl at the Police Administration Building, reflects the theme that children are taught to respect and trust law officers. An indication that the end of life can be as joyful as its beginning, *Grow Old Along With Me*, a welded steel fountain group at University Plaza, features two elderly women and one man jubilantly celebrating their old age. In *Vietnam*, a monumental war memorial for New Castle County, Delaware, a black soldier carrying the body of a dead comrade movingly symbolizes loss of life.

In the early 1960s Charles Parks developed a method to enlarge and weld steel from a small model. This technique, perfected through years of work, was exemplified by *Our Lady of Peace*, the largest sculpture of its type. Begun in 1978 with a small clay model, the work was to represent the vision of the Virgin Mary reportedly seen at Fatima, Portugal, by a young girl in 1970. In that vision the Madonna appeared bathed in light. The work was enlarged to ten feet in height in 1979. The figure's head, hands, foot and thorn-encircled heart, symbolic of Christ's crown of thorns, were cast in stainless steel and the garment and veil were formed from welded strips of stainless steel. From the ten-foot-tall model the figure was again enlarged to its final height of thirty-two feet. This process took two years and required that new clay models be made for the cast sections and the stainless steel strips be welded, painstakingly, piece by piece to create a smoothly flowing effect, quite different from the rough surfaces of his earlier welded forms. The result, from a method unique to Charles Parks, was a beautifully serene Madonna with outstretched arms wearing a richly draped robe and veil. Sunlight streams through the cracks between each strip creating the effect of a glowing figure, as related by witnesses of the vision. *Our Lady of Peace* was exhibited in Rodney Square at Wilmington, at Logan Circle in Philadelphia in late 1982, and Chicago in early 1983 before it was installed at Our Lady of Peace Catholic Church in Santa Clara, California in October 1983. Another sculpture created by the same method, *Christ the King*, was placed at Catholic Cemeteries of Chicago, at Hillside, Illinois, in 1986.

As his sculpture was recognized on a national level and continued to garner awards, Charles Parks became active in civic programs and professional

organizations. For ten years, beginning in 1960, he served on the Brandywine Arts Festival Committee and as chairman in the final year. During that period he was director of the Brandywine Valley Art Association and a member of the New Castle County Beautification Board. In 1969 he was appointed to The President's Advisory Committee on the Fine Arts for the John F. Kennedy Center. From 1971 to 1976 he served on the Delaware State Arts Council. The Governor of Delaware conferred on him the Distinguished Citizen Award in 1973. The following year he was elected an Advisor and, in 1979, a member of the Board of Trustees of Brookgreen Gardens. From 1978 to 1983 he served as a Trustee of the Delaware Art Museum.

He was elected a member of the National Sculpture Society in 1960 and a fellow in 1966. He served as a special editorial advisor to the Society's publication, *National Sculpture Review,* from 1972 to 1976 and as a member of Council from 1984 to 1987. He was elected president of the National Sculpture Society in 1976. Two years later he was appointed chairman of the Coalition to Save the Hall of Fame for Great Americans, comprising 31 art organizations. Charles Parks is an academician of the National Academy of Design, a fellow of the American Artists Professional League and Allied Artists of America, and a member of New York Artists Equity.

While not always intended to be symbolic, his work never fails in its ability to set a mood or convey emotion. Of his sculpture, Charles Parks has stated, "The comprehension of the structural harmony that pervades all creation must finally lead one to create symbols that fill a spiritual need in one's own time."[1]

Long Long Thoughts

A young, barefoot boy dressed in shorts and shirt is seated on a tree stump, gazing at his hands resting on his knees. The palms and fingers are upturned and cupped as if holding or about to receive an object. The slightly bowed head and contemplative look create an engaging study of youth and its characteristics. The bronze sculpture was mounted on the stump when it was placed at Brookgreen Gardens.

Referring to this piece, the sculptor wrote: "There is something serious and profound in every child…a sort of inner being."[2] In 1971 it won the gold medal at the Grand National Exhibition of the American Artists Professional League in New York. The popularity of the sculpture persuaded the owner to allow it to be cast in an edition of 25. The title was taken from lines by Longfellow, "A boy's will is the wind's will, and the thoughts of youth are long, long thoughts."[3]

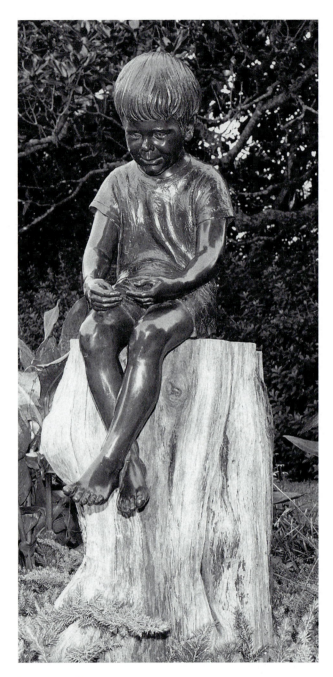

LONG LONG THOUGHTS

 Bronze. Height: 87.6 cm Signed on shirt at back: *PARKS*
© 5 S.1980.004, placed in 1980.

Sunflowers

A long-haired girl in a short dress plays a flute while seated upon a gigantic sunflower flanked by two smaller flowers with foliage. Intricate modeling enhances the delicacy of the flute keys and the hands and feet of the figure. The smooth vertical shafts of the plants provide support for the overall composition. The girl's bare legs and feet dangling over the edge of the huge sunflower bloom and a bullfrog seated at the base of one of the flowers complete the element of whimsy.

Sunflowers, done in 1974, was acquired by the Equitable Life Assurance Society of the United States. This casting was located in the company's New York City headquarters from 1976 until it was donated to Brookgreen Gardens in 1984.

Bronze. Height: 304.8 cm Signed on back of base: *PARKS 74* S.1984.004, placed in 1984. Gift of the Equitable Life Assurance Society of the United States. Other example: Wilmington, DE. New Castle City/County Public Building.

American St. Francis

A boy dressed casually in a button-front shirt with rolled-up sleeves and belted jeans stands between two baying hounds. His left hand is placed protectively on a raccoon perched upon his shoulder, its forefoot resting on his chest. The boy's right arm is at his side and his fingers are slightly lifted in a gesture of benediction. The skinny hounds are seated with their backs to the boy, their heads thrown backward. The skin is modeled tautly, emphasizing bone and muscle structure; fur is indicated by patterns of fine lines. The smooth curves created by the backs and raised heads of the dogs is in perfect counterpoint to the lean vertical line of the standing boy.

This work, originally entitled *Boy and Dogs*, was created in 1969 although a similar composition was used in an earlier group, *Mother and Dogs*, in 1956. The idea of predator and prey existing in harmony, represented by the hounds and raccoon, each one protected, yet able to be destroyed by the intervention of man, is a recurring theme in Charles Parks' work. *Boy and Dogs* was placed at Fountain Plaza in Wilmington, Delaware, the former site of a watering trough for horses which bore the inscription: "Kindness to God's creatures is a service acceptable to Him." This lettering has been repeated around the sculpture base. In 1972, after giving it an Award of Merit, the American Society of Landscape Architects submitted this work as the sculpture entry for the International Exposition of Landscape Architects held in Brussels. The

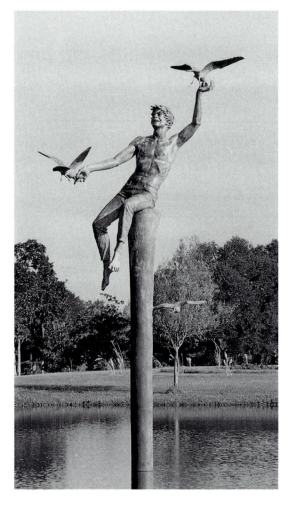

HIGH TIDE

Bronze. Height: 457.21 cm. (including piling).
Signed on edge of piling: © *PARKS 85* S.1989.002,
placed in 1989. Other example: Mystic, CT. Mystic
Seaport Museum (variant). Jacksonville, FL. South-
east Bank Building; Galveston, TX. Pier 21, The Strand
Harborside.

bronze owned by Brookgreen Gardens was cast in 1986 by Tallix Foundry,
Fishkill, New York.

Bronze. 179.1 x 104.1 x 50.8 cm Signed on base: *PARKS 69.* Around edge of base:
KINDNESS TO GODS CREATURES IS A SERVICE ACCEPTABLE TO HIM Founder's
mark: T/X S.1986.001, placed in 1986. Other example: Wilmington, DE. Fountain Plaza.

High Tide

A barefoot, shirtless boy, clothed in blue jeans, is seated on top of a tall piling. The left arm is lifted above his head and the right is extended forward. The boy, his hair tousled by the wind, laughs in joy as three sea gulls fly around him, two lighting to eat from his outstretched hands. This over life-size piece was modeled in 1985 and cast in 1989. It is similar to an earlier design entitled *Boy and Gulls* for Mystic Seaport Museum at Mystic, Connecticut, done in 1976. *High Tide* is a gift of the family of Robert Richardson Coker.

April

A tall female figure stands barefoot atop a cylindrical pedestal ringed with flowers. She wears a diaphanous shift which clings to her body and a wreath of flowers encircles her neck. Her long flowing hair is pulled straight back and tied high upon her head with a bow.

This figure was modeled in the late 1980s from an earlier sculpture entitled *Flora*, the goddess of flowers. The casting of this work, done in a commercial foundry from several small rubber molds, was something of an experiment for Charles Parks. The sculpture was presented to Brookgreen Gardens by him and renamed *April* as a gift in honor of his parents.

Bronze. Height: 212.7 cm. Signed: © *Parks / 1988* S.1992.005, placed in 1992.

1 Parks, Charles C., "Sculptures by Charles Cropper Parks," privately printed, 1981.
2 Craven, Wayne, "A Catalogue of an Exhibition of Sculpture by Charles Parks," The Wilmington Society of the Fine Arts and The Delaware Art Museum, Wilmington, Delaware, September 10, 1971 to October 3, 1971.
3 Longfellow, Henry Wadsworth, "My Lost Youth," refrain, 1858.

Jane B. Armstrong

JANE BOTSFORD was born at Buffalo, New York, February 17, 1921, to Samuel Booth and Edith (Pursel) Botsford. Upon graduation from the Buffalo Seminary, she attended Middlebury College in Vermont and the Pratt Institute in New York. After teaching school for a time, she became a journalist, eventually specializing in business and scientific writing. On July 3, 1960, she

and Dr. Robert T. Armstrong, a vice-president of the Celanese Corporation, were married.

In 1964 Jane Armstrong enrolled in sculpture classes at the Art Students League and became a student of Jose de Creeft and John Hovannes. Both of these sculptors were exponents of the direct carving method in which the artist carves directly into the stone without making a preliminary model. Within three years her work attracted national attention and began to receive awards. The subject matter of Jane Armstrong's sculpture is drawn primarily from nature. She tries to capture in a material as unyielding as stone the rhythms of living creatures of sea, air and land with form and flow suggested by each subject taking precedence over detail and anatomy. In her animal sculpture (and earlier female figure work which she abandoned in the early 1970s) the design emerges from areas of rough stone as if it were rising from the depths of the marble. In contrast, about one-third of her work has been abstractions called *Seaforms* and *Stone Poems*, strongly influenced by the veining and markings of varied marbles.

In her 1974 book, *Discovery in Stone,* Jane Armstrong explained her sculpture process: "For a direct carving on limestone, alabaster or any medium-hard stone, I first sketch the general shape of a sculpture on the piece to be carved. Then I mark the high points, or places where the final sculpture will touch the surface. From these points I begin working into the stone. I am an egg peeler. Some artists go right into the stone at sharp angles, but I feel as if I'm pulling off the excess, and work in very gradually..."[1] In the last few years Armstrong has done more complicated groupings for which she does a careful clay model "so not to waste precious stone" and studies it for some months before executing the carving.[2] One such group, *Bathers*, an elephant family in Belgian marble, was awarded the bronze medal in 1988 by the National Sculpture Society.

Joie de Vivre II, an animated seal carved in Vermont radio black marble, received the Gold Medal of the Allied Artists of America in 1976 and a Plaque of Honor from the National Arts Club in 1977. It is now in the permanent collection of the Wichita Art Museum. *Pasture Child*, an engaging portrait of a newborn calf in Italian black and gold marble, received the Anonymous Members' Award of the National Association of Women Artists in 1984. It was acquired that same year by the Museum of Western Art in Denver, Colorado. Another work, a newborn foal carved in similar marble, *First Breath*, was awarded the Mrs. Charles D. Murphy Memorial Prize of the National Association of Women Artists and the Eliot Liskin Award of Knickerbocker Artists, both in 1979. *Sun Worshippers*, a group of two walruses carved in Belgian black

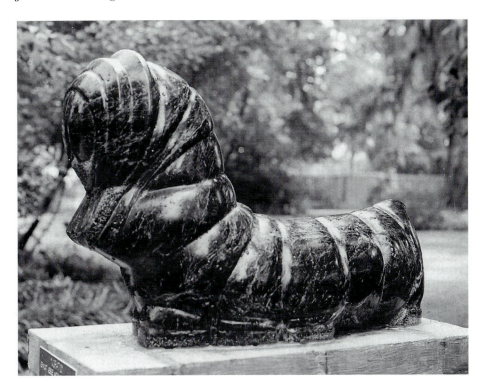

VORATIO

Vermont Verde Antique marble. 40.6 x 71.1 x 19.1 cm. Gift of the sculptor. S.1986.002, placed in 1986.

marble, was given the North American Pemco Award at the exhibition of the Catharine Lorillard Wolfe Art Club in 1984.

Hatching Alligator and *Hatching Bird* in Vermont Cippolino marble are in the permanent collection of the New York Zoological Society at the Bronx Zoo. *Breakthrough* in Vermont Delft marble, a much enlarged turtle emerging from its shell, was awarded the Pauline Law Prize of Allied Artists of America in 1969 and the Charles N. Whinston Memorial Prize of the National Association of Women Artists in 1973. *Prairie Family*, a group of three inquisitive prairie dogs in Tennessee marble, received the Council of American Artists' Societies Prize at the exhibition of the National Sculpture Society in 1972. A Vermont gray marble group, *Opossum Family I*, was given a Certificate of Merit by the National Academy of Design in 1973. *Swimming Otter I*, carved in Tennessee marble in 1970, was awarded the Pauline Law Prize of the Allied Artists of America that year and the Medal of Honor by Audubon Artists in 1972.

Frequently sought by corporate entities, three of her works are located at

the headquarters of Texas Gulf Chemicals in Raleigh, North Carolina, and another at the headquarters of Southern Life Insurance at Greensboro, North Carolina. *Nocturne*, an ethereal abstraction of a cloud-shrouded moon carved in Vermont Westland marble, and *Footwork*, a Vermont black marble penguin looking down at its egg, were acquired by Northern Telecom, Inc. of Raleigh, North Carolina, in 1984 for its Research Triangle Park. *Stone Poem III* had been acquired previously for the campus of the Research Triangle Institute. *Stone Poem II* in Vermont Mariposa Cloud marble, is in the Hayden Gallery of the Massachusetts Institute of Technology. *Kudzu Variation*, an abstract relief in Vermont olivio marble, was acquired by the Albright-Knox Gallery of Buffalo, New York, in 1985.

A Gold Medal of Honor for distinguished achievement in sculpture was awarded to Jane Armstrong in 1986 by the Knickerbocker Artists. Her art is in public and private collections throughout the United States and in Canada, Great Britain and Europe. She is a fellow of the National Sculpture Society, and a member of the Sculptors Guild, Allied Artists of America, National Association of Women Artists, Audubon Artists, and the National Arts Club.

Jane Armstrong is the author of the book, *Discovery in Stone*, published in 1974, and numerous articles on stone and carving. After living in New York for many years, she lives and works year round in East Dorset, Vermont.

Voratio

Carved direct in Vermont verde antique marble, this sphinx caterpillar is solid and stylized. The sculptor has depicted aptly the larva's rounded, chunky form and has given the stone a high polish. Voratio was carved in 1969. A smaller version, *Sphinx*, was done the following year in Norwegian rose marble.

The sculptor wrote in 1974: "Of the Vermont marbles, Verde Antique is the hardest; it is nearly as rugged to carve as granite...Polishing reveals dark green with lighter green as well as gray and white veinings which suggest the mysterious swirling currents of the sea...Because they were so difficult to carve, my few Verde Antique works remain fixed in my mind..."[3]

1 Armstrong, Jane B., *Discovery in Stone*, East Woods Press, Inc., New York, 1974, no pagination.
2 Letter from Jane Armstrong, undated, received May 4, 1989, "Jane B. Armstrong," Sculptor's Correspondence File, Brookgreen Gardens Archives.
3 Armstrong, *op.cit.*

Isidore Margulies

ALTHOUGH ISIDORE MARGULIES was born April 1, 1921, at Vienna, Austria, his parents, Ber and Bertha Margulies, brought their family to the United States in 1925. He began art study in 1940 at Cooper Union School of Art in New York, but took a leave of absence in 1942 to work in a defense plant during World War II. In 1943 he married Bernice E. Blumenreich. While Margulies worked to support his family, thirty years passed before he was able to return to sculpture as a profession, rather than as a hobby.

At the age of fifty, he enrolled at the State University of New York at Stony Brook, and earned a liberal arts degree in 1973. During this period, Margulies attended classes taught by Robert White and James Kleege. He went on to C. W. Post College and received a master's degree in 1975, where he studied with Alfred Van Loen. After graduation he remained at the college as assistant professor adjunct in sculpture. When Van Loen took a sabbatical for one year, he appointed Margulies to take over his class. He also taught sculpture at SUNY at Stony Brook.

Margulies had a solo show of kinetic, figurative and abstract pieces at SUNY in 1973 and, in the following year, at the Suffolk Museum, Stony Brook, New York. In 1976 there was another solo exhibition at the Harbor Gallery in Cold Spring Harbor, New York, and in 1979 at the Nassau Community College Firehouse Gallery. Each time his work was well received and praised for its grace, elegance and sensuality of surfaces and images. The female nude is his forte: torsos, fragments and life-size figures.

From the beginning of his career, Margulies participated in prestigious group shows such as those of the National Academy of Design and the National Sculpture Society. It was not long before his work began to win awards including the Long Island Show Award of Excellence at the Hecksher Museum for *Linda I* in 1978 and for *Honeycomb*, a kinetic sculpture, in 1979. The Council of American Artist Societies' Prize was received in 1979 for *Debbie*, a seated female nude about to pull a sweater over her head, and the C. Percival Dietsch Sculpture Prize in 1983 for *The Flute*, another seated female nude playing a flute. Both of these prizes were awarded in exhibitions of the National Sculpture Society.

Debbie was the first nearly life-size figure created by the artist. Followed by *Debbie II*, also four-fifths life-size, its contrasting textures and patinas resulted in an extremely realistic figure which gave the impression of having been cast from life, when, in reality, the image was achieved through careful modeling

in wax. Sculpture by Isidore Margulies is in the permanent collections of several organizations in the metropolitan New York City area. *The Pitch* is located at the Long Island Hall of Fame at SUNY, Stony Brook. The Purolator Corporation owns a casting of *Virginia II*, as does the Suffolk Museum. *The Flute* is owned by City University of New York, NYC Technical College, Brooklyn and the Doan Corporation in Florida. Castings of *Debbie* are located at the San Diego Opera in California and the Doan Corporation.

Two works in bronze, *Eve* and *Leda*, were shown in an exhibition of religious sculpture sponsored by the National Sculpture Society at the Cathedral of St. John the Divine in 1990. Six of his bronzes were exhibited at the Ambassador Gallery in Soho from September 1990 through June 1991. In 1991 Margulies created an over life-size seated female nude.

Margulies made a statement about his work in 1980: "I am concerned with the total look of the sculpture. The gesture and the figure it cuts in space are equally important. Sometimes, what isn't in the sculpture is as vital as what is. I want the viewer's eye to fill in those details that I have left out. My purpose is to enhance reality with suggestion rather than statement... Bronze lends itself to a great sensuality of surface. With the addition of patina, I use both form and color to create the total effect, to complete the image that I am seeking."[1]

Isidore Margulies is a fellow of the National Sculpture Society and has served as an officer. He was chairman of the Huntington Township Art League from 1976 to 1978, and is a member of Artists Equity and the College Art Association. He lives and works in Plainview, New York.

Debbie II

A slender female nude casually leans backward against a wooden railing, her weight supported by the rail which, seemingly, is suspended in mid-air. Her left hand rests on the wood next to her body, the right arm hangs slack in a relaxed manner. Her hair, pulled back and up on her head, is modeled with thick bangs across the forehead and tied with a green grosgrain ribbon which trails across her left shoulder and down her back.

Three different patina colors are utilized in the sculpture: a dark brown for hair, a lighter brown for skin and a green for the hair ribbon which was not modeled but cast from a real ribbon. The sculptor's combination of delicate modeling and use of varied surface coloring present a work of startling realism.

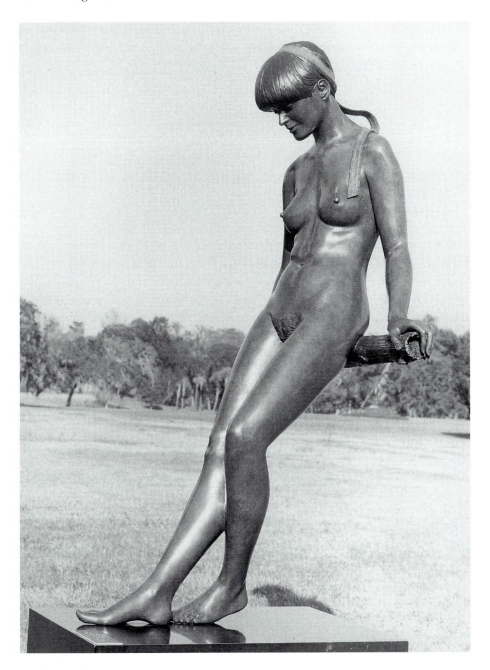

DEBBIE II

 Bronze. Height: 138.5 cm, base width and depth: 65.4 x 63.5 cm. Signed (on hair clasp at back of head): *DEBBIE II © 8/15 12/79* [artist's monogram] *I.MARGULIES* Founder's mark: JM (logo of Joel Meisner & Co., Inc.) S.1981.003, placed in 1981.

Modeled in 1979, *Debbie II* was awarded the Gold Medal at the National Sculpture Society's exhibition in 1980. This example was the eighth casting of an edition of fifteen.

1 "Isidore Margulies, Recent Bronze Sculpture," (Joel Meisner Gallery, 120 Fairchild Avenue, Plainview, NY, 1980).

Anthony Frudakis

ANTHONY FRUDAKIS was born at Bellows Falls, Vermont on July 30, 1953 to EvAngelos William and Virginia (Parker) Frudakis. His father, a figurative sculptor, began a career as assistant to Paul Manship and Jo Davidson and studied at the Beaux Arts Institute of Design, the Pennsylvania Academy of the Fine Arts and the American Academy in Rome. His mother was a painter and graduate of the Pennsylvania Academy of the Fine Arts. Although he grew up in an artistic environment he was allowed to pursue his own interests.

While working toward a pre-law degree at Duke University he enrolled in a sculpture course which determined him in 1973 to leave college and become an apprentice in his father's studio. During this time he compiled a portfolio of work which earned scholarships to continue his art studies. With tuition scholarships from the Dolfinger McMahon Foundation in 1973 and the National Sculpture Society in 1974 he studied at the Pennsylvania Academy of the Fine Arts in Philadelphia. While at the Academy, Frudakis received honorable mention in 1975 and was awarded the Edmund Stewardson Prize in 1976 in a competition for the best full-length figure from life. After receiving a certificate from the Academy in April 1976, he was awarded a Bache Foundation Traveling Grant, using it to travel and study in London, Paris, Florence, Rome and Athens.

In 1976 the Frudakis Academy of the Fine Arts was founded in Philadelphia. In addition to teaching there, Anthony Frudakis served as the academy's director. To increase his knowledge of the human form he studied anatomy at the University of Pennsylvania in 1977 and, in the same year, taught sculpture and drawing in the evenings at Stockton State College at Pomona, New Jersey. He received the John Spring Art Founder Award at the National Sculpture Society's 1977 annual exhibition for best portrait, a life-size head of a young woman entitled *Deborah*.

Portrait of a Wrestler, a small bust of a young male athlete, was modeled in 1978 and exhibited at the National Academy of Design. For *Calypso*, a recumbent female nude, he was awarded the Walter Lantz Youth Prize in 1978 by the National Sculpture Society. Although Frudakis had assisted with several of his father's major commissions, in 1978 he received his first independent commission by winning a statewide competition to create a statue commemorating the 100th anniversary of Atlantic City High School in New Jersey. *The Viking*, a life-size bronze figure of the school logo, was installed in 1979. In 1981 Frudakis won a commendation from the National Sculpture Society when he submitted the plaster model of this work to the Society's Young Sculptor's Awards program. His work was being recognized in his home state by 1979 and earned First Prize that year in the New Jersey State Juried Art Show. *Wave Rider*, a male swimmer buoyed on a crest of a wave, was cast in bronze in 1979.

By 1981 he had a studio in New York City where a series of figures depicting Greek gods and goddesses was commissioned by Metaxa, the Greek cognac manufacturer. At the same time he taught sculpture at the Fashion Institute of Technology in New York. But after a few years, he relocated to the area of his former home in southern New Jersey.

One sculpture, in particular, has garnered a number of prizes for Anthony Frudakis. A life-size female nude standing with her arms draped over her head, eyes closed in a dreamy expression, was exhibited at the Allied Artists of America where it won the Maurice B. Hexter Award in 1982. In that year the National Sculpture Society awarded it a Gold Medal at its annual exhibition. In 1988, for this work, the Society gave Frudakis the Walter and Michael Lantz Prize stating that the sculpture "demonstrated ability in the use of form, composition and comprehension of techniques."[1] Prior to that, the National Sculpture Society had recognized his accomplishments in 1983 by awarding to Anthony Frudakis the prestigious Gloria Medal for a meritorious body of work by a young sculptor.

As his technique matured, the sculptor began to produce work on a larger scale. A monumental bas-relief depicting the winged horse, *Pegasus*, was created in 1983 for the Atlantic County Library in Hammonton, New Jersey. In 1986 Frudakis received commissions from two Atlantic City hotels. *Summer*, a monumental bronze group of a young, bathing suit-clad couple, running on the beach, was created for the Tropicana Hotel & Casino. A life-size *Otter Fountain* in cold cast bronze was placed in the health spa at Bally's Park Palace Hotel & Casino. Prior to working on this commission, the sculptor observed and videotaped the animals at play in the otter exhibit at the Philadelphia

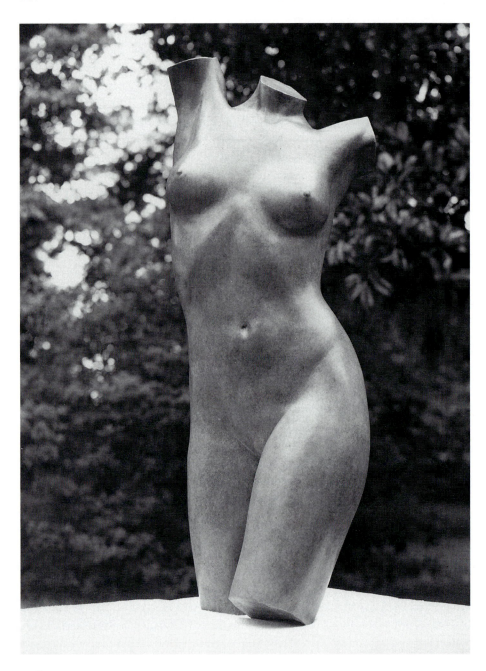

TORSO

 Bronze torso. 90.2 x 30.5 x 25.4 cm. Signed at bottom of right leg: *Anthony Frudakis* ©
S.1984.003, placed in 1984. Gift of Dr. Ira M. Trocki.

Zoological Garden. Additional research of their bone and muscle structure was done at the University of Pennsylvania and the Academy of Natural Sciences of Philadelphia. The inherent underwater grace and playful nature of the species is depicted in the group of seven otters forming a figure-eight composition.

In 1986 he was awarded the Leonard Meiselman Prize at the annual exhibition of the National Sculpture Society for *Floating Nude.* Two years later a *Mother and Child,* installed in cold cast bronze, was commissioned by the Atlantic City Day Nursery. In 1989, for the Cape May Court House, Anthony Frudakis designed a monumental bas-relief entitled *Justice.* His bronze portrait bust of the physician and medical researcher, Dr. Charles Drew, was unveiled at the opening of Drew Court, a housing project built by the Atlantic City Improvement Authority.

Frudakis is a fellow of the National Sculpture Society and has served on the Atlantic City Fine Arts Commission. For many years he lived and worked in Linwood, New Jersey where he derived inspiration from the seashore environment. In 1991 he moved to Hillsdale, Michigan, where he is sculptor in residence at Hillsdale College.

Torso

A life-size torso of a slender female in a dance movement is sensitively modeled. The right arm extends above the head; the left arm extends toward the left at a right angle to the torso. The left leg moves forward as the upper body twists to the left in contrast to the lower body's movement in the opposite direction. The ribcage is pressed against the abdominal skin due to the flexion of the figure. *Torso* was modeled in late 1983 and was cast by Joel Meisner & Company, Plainview, New York. This work was given the John Spring Art Founder Award at the National Sculpture Society Exhibition in 1985. *Torso* was donated to Brookgreen Gardens by Dr. Ira M. Trocki of Northfield, New Jersey.

1 "1988 Young Sculptors Awards," *Sculpture Review,* Vol. XXXVII, No. 3, 1988, p.16.

Derek Wernher

DEREK WERNHER'S work encompasses the range of abstraction to realistic genre and is found in corporate, civic and private collections across the country. He was born in New York City, June 1, 1938, to Philipp and Margaret (Delmar) Wernher of Bronxville, New York. At the age of 14 he decided to become a sculptor after an art teacher took him to visit Joe Brown, a sculptor and designer who taught at Princeton University. Brown, who had been a pupil of R. Tait McKenzie, was known for sculptures of athletes and sports figures, particularly boxers. It was there that Wernher first learned the methods of creating sculpture.

The painter, Andrew Wyeth, after seeing some of Wernher's early work, believed that he showed promise and arranged for him to study with George Demetrios and Walker Hancock. He moved to Philadelphia, continuing his studies at the Pennsylvania Academy of the Fine Arts, where Walker Hancock was chairman of the sculpture department. After serving for two years in the United States Navy, Wernher studied at the California College of Arts and Crafts at Oakland and received a Bachelor of Fine Arts degree in 1966. He then enrolled at the Cranbrook Academy of Fine Arts in Bloomfield Hills, Michigan, to study with Julius Schmidt. He graduated in 1968 with a Master of Fine Arts degree.

Settling in Metamora, Michigan, Derek Wernher taught sculpture at Oakland Community College, located near Cranbrook, and then became director of the Pontiac Creative Art Center. Much of his early work in sculpture concentrated on abstract designs featuring curves, concentric circles and spheres in relation to cubes. In 1975 he was commissioned to design *Earth Maze*, a massive bronze sphere with areas cut away to reveal inner, segmented sections comprised of rectilinear shapes. He resigned his position at the Art Center to devote his complete energy to the work which was placed in front of the Northfield Hilton Inn at Troy, Michigan. An abstract columnar work is exhibited in the lobby of law offices at Lapeer, Michigan. His abstract works are in a number of corporate and private collections in California, Texas and Michigan.

Another facet of Derek Wernher's sculpture includes realistic depictions of people in everyday settings and activities. A characteristic of this work is his practice of incorporating real objects such as chairs or benches into his compositions. The life-size genre group, *The Kid Takes it All*, consisting of two bronze poker players sitting in wooden chairs at a bronze table, is located at

Westgate Mall in Amarillo, Texas. In 1989 a group of children playing musical chairs was placed at the University of Michigan Hospital in Ann Arbor.

Derek Wernher prefers to depict his portrait subjects in casual settings and relaxed attitudes. A series of seven portraits of the television news journalist, Chet Huntley, were placed at the Huntley Lodge in Big Sky, Montana. A life-size statue of William Durant, a founder of the General Motors Corporation, was installed in Carriage Town, a restored section of Flint, Michigan in 1989. In the following year, Wernher received the commission to create a statue of J. Dallas Dort, another founder of General Motors, for the city of Flint, and a life-size sculpture of Albert Koegel. The Durant and Dort monuments were initially conceived in 1985 as a group conversing casually with Charles Nash, founder of American Motors.

Derek Wernher casts much of his work in his bronze foundry at Metamora, Michigan. A life-size group of children was cast by Wernher 1990.

Len Ganeway

An old farmer clad in shirt, overalls, work boots and hat is seated on an outdoor bench. He holds a newspaper open in front of him, his gaze directed toward the paper. The farmer's worn hat is pushed back on his head, his long-sleeved shirt is rolled up to each elbow, and his feet are planted firmly on the ground. The face, with a moustache and hooded, pouchy eyes, has the wrinkled skin of a person accustomed to outdoor work. Clothing and accessory details, such as a pen in his chest pocket, a wristwatch on his left arm and the L. L. Bean duck shoes, add to the realistic effect. Although the figure is depicted in a relaxed attitude, it is true to life, reflecting the image of a person who has worked long and hard for a living. The sculptor has modeled it with a rough finish, adding to the impression of leathery skin and advanced age.

Owners of *The Lapeer County Press*, located in the county seat of an agricultural community in central Michigan, commissioned Derek Wernher in 1980 to create a sculpture that would symbolize the newspaper and its readers. Wernher, with the help of his wife and two friends, cast the sculpture in his own studio foundry. Over a period of several weeks he chased and patinated the bronze figure, and added the copper sheets for the newspaper. The life-size figure is seated on an antique oak and cast iron bench from a Michigan Central railroad station.

Although a local dairy farmer was used as a model for some of the work, the

LEN GANEWAY

Bronze figure, copper newspaper, oak and cast iron bench. 123.2 x 96.5 x 91.4 cm
S.1985.004, placed in 1985. Gift of Mr. & Mrs. Robert Myers.

figure does not represent a particular individual. The title was derived from
the pen name of the publisher who commissioned the sculpture. When *The
Lapeer County Press* was purchased by a new owner, *Len Ganeway* was donated
to Brookgreen Gardens by Mr. & Mrs. Robert Myers of Lapeer, Michigan.

Lee Letts

LEE HAROLD LETTS III was born in Conway, South Carolina on April 8, 1951
to Lee Harold Letts, Jr. and Elizabeth (Jordan) Letts. His family encouraged
artistic pursuits and appreciation. Visits to Brookgreen Gardens as a youngster
had a profound influence on his early development through learning about

native wildlife and American sculpture.

He attended the public schools in Myrtle Beach. After a brief time at the University of South Carolina, in 1970 Letts began a two-year period of study with Truman Moore, an architect and sculptor who had graduated from The Art Institute of Chicago. During this time his interest in bronze sculpture and the influence of Brookgreen Gardens made him realize the importance of acquiring additional art training. From 1973 to 1975 Letts studied drawing and sculpture at the School of The Museum of Fine Arts in Boston. Friendship with David Austin, a goldsmith and instructor at the museum school, led to an interest in goldsmithing and apprenticeship with John Franchot Story Street Goldsmiths at Harvard Square in Cambridge. Through study of art history he began to understand the significance of craftsmanship and the role of lost wax casting in the history of art, especially in the creation of the bronze sculpture and gold objects of the Italian Renaissance. For his own work in bronze, Letts began to form ideals around classicism, drawing inspiration from the period which centered on the work of Augustus Saint-Gaudens.

In 1976 he returned to the low country of South Carolina and opened a studio. Although he specialized in goldsmithing, he was drawn to study the intricate anatomies of native birds and methods of portraying them in sculpture. An interest in wildlife photography enhanced his studies of the region's wildlife and their habitats. In order to sharpen his goldsmithing skills and understanding of lost wax casting, in 1977 Letts traveled to the Netherlands and served an apprenticeship at Court Jewelers 'tMannetje in The Hague. At the same time he studied drawing and sculpture at the Academy of Art.

Although Lee Letts continued goldsmithing after returning to the United States in 1978, he began to place more emphasis upon the creation of life-size figures of birds for casting in bronze. By 1981, he had turned completely to modeling in clay or wax. He worked from study skins, mounted specimens and observation of birds near his studio at Longwood, a former rice plantation on the Waccamaw River between Georgetown and Conway, and at the Santee Delta and Cape Romain National Wildlife Refuge near McClellanville, South Carolina.

In 1981 Lee Letts became acquainted with the sculptor Donald De Lue who visited his studio and rendered valuable criticism of his work. This was a turning point in his career. In the following year, one of his works in bronze that Donald De Lue had approved was accepted to be placed in the collection of Brookgreen Gardens. Donald De Lue wrote in 1985, "There was a fine school of pioneer artists who recorded so much of our North American

wildlife now a national treasure of finest quality. Audubon and Catesby high
on this list. Lee Letts, a native of South Carolina, has worked in this great
American tradition. A most sincere artist devoted to the high principals of his
artistic and scientific forebears. He is a fine naturalist and studies his birds in
their natural habitat and he makes many drawings, anatomical studies, clay
models and expert bronze casts doing…his own chasing, choosing his bronze
and adding a patina that most suits the type of bird…"[1]

From 1980 to 1984 Letts employed the craftsmen at Roman Bronze Works
to cast his sculpture in New York City. There he applied his knowledge of the
time honored methods of lost wax casting and the discipline of a studio artist
to carefully develop his work in bronze, overseeing every step of the process
which had been developed and perfected by Riccardo Bertelli.

A particular interest in birds of prey led to the creation of a bald eagle with
outspread wings in celebration of the 200th anniversary of the national
emblem of the United States. A casting of *Presidential Eagle* was presented by
the artist to President Ronald Reagan in 1983. The sculpture was exhibited in
the White House during his term of office and is part of the permanent
collection of the Reagan Presidential Library and Museum. *Gamecock*, a life-
size figure of a fighting rooster, the mascot of the University of South Carolina,
was done in 1985. In that same year he created four other works for casting
in bronze: *Hawk, Mandarin Ducks, Buffel Head Duck* and *Wood Ducks in Flight.*

In 1986 to be closer to casting facilities, Lee Letts established a studio in New
York City. His wildlife sculpture was exhibited at J. N. Bartfield Galleries and
Hammer Galleries of New York. He continued his study of wildlife at the
American Museum of Natural History and has developed an interest in African
birds and animals. Artists who have inspired him are Andrew Wyeth, Carl
Rungius and Bruno Liljefors. After returning periodically to South Carolina
to explore the marshes and maritime forests of the barrier islands at Cape
Romain, he left New York and moved his studio to Charleston, South Carolina.

Swallow-tailed Kite

A swallow-tailed kite perches on a branch forming a steep, pedestal-like
base. Its characteristic, elongated tail feathers spread down the opposite side
of the pedestal.

During the modeling of this figure, an eighty-year-old study skin of a
swallow-tail on loan from The Charleston Museum was used to ensure accu-
racy. The sculptor wrote of this work: "No other North American bird

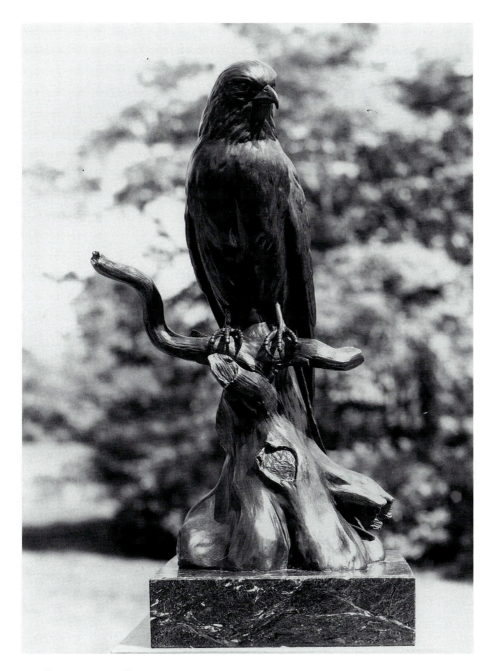

SWALLOW-TAILED KITE

Bronze. Height: 40.6 cm Signed: *Lee Harold Letts, AP, 1981* S.1982.004, placed in 1982. Gift of the L. Maud Kimbel Trust.

approaches the swallow-tail in the grace and beauty of its flight; the duck hawk alone equals it in speed. The former conveys the impression of lightness in the air; the latter, of power and impetuosity."[2]

1 Copy of a letter of recommendation from Donald De Lue, Honorary President of the National Sculpture Society, September 10, 1985, "Lee H. Letts," Sculptors' Correspondence Files, Brookgreen Gardens Archives.
2 "Lee H. Letts," Sculptors' Correspondence Files, Brookgreen Gardens Archives.

Greg Wyatt

GREGORY ALAN WYATT was born at Nyack, New York, on October 16, 1949. His father, Stanley Wyatt, a painter and illustrator on the faculties of Columbia University and the City College of New York, encouraged an early interest in art. Although his father's work reflected the influence of cubism and expressionism, Greg Wyatt's teenage interest turned to figurative sculpture, particularly after a visit to the Yucatan where he viewed the delicate reliefs of Mayan sculpture.

He received a Bachelor of Arts degree in art history from Columbia College in 1971 and then earned a master's degree in art education from Teacher's College, Columbia University in 1974. At the same time he studied in night classes at the National Academy of Design School. During this period he received instruction in life sculpture from EvAngelos Frudakis and learned the art of relief from Michael Lantz. In 1974 he enrolled in a doctoral program at Columbia University. A work shown in the annual exhibition of the School of Education Art Department won the Ziegfeld Art Award in 1975.

To support himself during his period of study, Greg Wyatt was an instructor at New York University and Jersey City State College from 1974 to 1975. Later, he taught at Finch College in New York and in the Finch College Summer Program at San Marino, Italy, from 1979 to 1981. Also, he conducted sculpture classes at Riverside Church in New York City.

A half-life-size study done in 1977 of the dancer, Mikhail Baryshnikov, arms extended and legs tensed in mid-leap, is in the collections of the Newington-Cropsey Foundation at Hastings-on-Hudson, New York, The National Arts Club in New York City, and in the library of Princeton University. *Battle of New Orleans*, a series of boxers commissioned by the American Broadcasting Corporation in 1979, is in the Sports Illustrated Magazine Collection in New

York. *Novation*, a work merging both male and female figures into one entity yet each retaining specific attributes, represents a theme often employed by Wyatt — communion between man and woman — in what he refers to as a "sharing-of-anatomy" technique. First done in 1981, the composition was reworked in 1989. Continuing that theme is *Double Helix*, composed of two chains of male and female figures spiraling upward, joined at the legs and heads, the uppermost figure pointing toward infinity with one hand and reaching down to grasp the hand of a companion with the other. Bronze castings of both of these works are in private collections.

Monumental sculpture has been Greg Wyatt's specialty. His first major commission came in 1978 for the facade of the international headquarters of the American Bureau of Shipping located in the Wall Street section of Manhattan. The ten-foot by eight-foot bronze *Eagle*, wings spread as it grasps an anchor in its talons, is reminiscent of a ship's figurehead. Although the design was based on an engraving of an American bald eagle that appeared on the bureau's classification certificates, Wyatt attempted to create a new image that would appear both powerful and benevolent. Since the eagle was to be suspended 75 feet from the sidewalk, he distorted the wingspread, talons and anchor to create the proper perspective for the pedestrian. The large work was completed in four months.

His subsequent creations were infused with fantastic and whimsical interpretations of the human figure and animals. One scholar has termed his work fantasy realism; that is, sculpture that utilizes visual distortion, expressive intensity and universality in theme to portray its idea.[1] Five years after his first commission, *Fantasy Fountain* was completed and placed in Gramercy Park. The fountain was a gift of the National Arts Club which wanted a symbol of its concern for children and the role of the arts in their development. An orb, representing on one side the smiling face of the sun and on the other, the dreaming face of the moon, is encircled by dancing giraffes modeled in fantastic poses for decorative effect. The sculptor chose the giraffe, a peace-loving creature, to symbolize man's ability to freely associate harmoniously with others. One giraffe kisses the face of the moon. The imagery of the group seeks to inspire optimistic beliefs in the future and to encourage children to play around the fountain and develop their imaginations.

In 1983 Wyatt was appointed sculptor-in-residence at the Cathedral of Saint John the Divine in New York City. In this position, he developed for students an apprenticeship program in bronze finishing, mold making and life sculpture. He also coordinated a preservation program with the Parks Department to introduce fifth and sixth grade students to the rich heritage and conserva-

tion needs of the city's public monuments.

An extension of the idea presented in *Fantasy Fountain* but on a much larger scale was revealed in *Peace Fountain*, commissioned by the New York Episcopal Diocese in 1983 for its 200th anniversary celebration in 1985. Working in the crypt beneath St. James' Chapel, Wyatt created the group over a period of two years. The subject comes from the account of Lucifer's defeat at the hands of the Archangel Michael as written in the revelation of St. John the Divine. Depicted in the group is a winged angel combating the forces of evil, surrounded by symbols of peace such as giraffes, a smiling oriental sun and moon, and a lion and lamb. The composition rests on the back of giant crab, symbolizing evil, which, in turn, is supported by a double helix, representing the life force found in a DNA molecule. Elements from previous works by Wyatt were incorporated into the design such as the wings of the archangel from the *Eagle* relief, the double helix design from the sculpture of the same title, and the giraffes and sun face from *Fantasy Fountain*. The forty-foot high work, located on the Great Lawn of the Cathedral, is surrounded by small sculpture of animals representing peace and freedom that were created by children. The children's sculpture was chosen through competitions among students from kindergarten through high school in the New York City area, from Colorado and the island of Bermuda.

Other completed works include a Korean War Memorial and a monument for the Berlin Wall. *Soul of the Arts*, a male figure seated beside an Ionic column and carving a stone, is guarded by a winged female. Both are enveloped in a swirling mass surmounted by a hand emerging from the mass. It was commissioned in 1989 by the Newington-Cropsey Foundation to be placed in a pond near an amphitheatre.

Greg Wyatt is a member of the National Sculpture Society and the National Arts Club. He lives and works in New York City.

Torso

A standing female torso is represented in a relaxed posture, the arms uplifted. It is an example of a contemporary sculptor's use of traditional classic design. Work on the *Torso* was begun in 1973 and completed in 1975 during Wyatt's doctoral study at Columbia University. This example is the third casting in an edition of six. Two other castings are in private collections; a fourth is in the collection of the Indiana Museum of Arts and Sciences.

In 1979 this sculpture won both the Helen Foster Barnett Prize at the National Academy of Design exhibition and the Walter Lantz Youth Prize of

TORSO

Polished bronze on a Verde Antique Green marble base. Height: 90.2 cm; Width: 35.6 cm Signed: *Greg Wyatt* © - *3/6 - 1975* S.1982.001, placed in 1982. Gift of Robert H. Sweet. Other example: Evansville, IN. Indiana Museum of Arts and Sciences.

the National Sculpture Society. *Torso* was a gift of Robert H. Sweet of New York City.

[1] Anthony Janson, "Greg Wyatt," Bergen Museum of Art and Science, Paramus, NJ, p.4 (exhibit catalogue, not dated).

Hope Yandell

HEIR TO an artistic heritage, Hope Yandell was encouraged by her family to develop her artistic inclinations. Her great-aunt, Enid Yandell, who trained with Frederick MacMonnies, Lorado Taft, and Karl Bitter, was associated with Auguste Rodin. Hope Yandell was born at Burlington, Vermont, July 11, 1947, to David Wendell and Catherine Sloan (Colt) Yandell. One of her earliest memories is of sitting before an open fire at nursery school waiting for a ball of cold clay to soften between her hands. In grade school she took classes in painting at the Robert Hull Fleming Museum at the University of Vermont in Burlington. As a teenager she made sketches and portraits of her father's horses. While attending a private boarding school she excelled in art and took an interest in sculpture.

Her penchant for art was confirmed when she studied photography, writing and sculpture at the Maryland Institute in Baltimore. Because her father was a violinist she also had an interest in music, especially in composition. Later, at Reed College in Portland, Oregon, where she majored in music, this interest was abandoned when she discovered she was not suited temperamentally to its requirements.

Hope Yandell spent four years living among Eskimos and preparing a manuscript for a documentary on their way of life. To support herself she wrote freelance articles for a magazine in Anchorage and worked as a cook on an oil barge. After leaving Alaska in the early 1970s she traveled to Newfoundland. During this period she illustrated children's books including one entitled *Borrowed Black* by Ellen Bryan Obed. The illustrations were colorful, fanciful depictions to match the tone of the story about a monster made of borrowed parts.

By the close of the 1970s Hope Yandell decided to take up sculpture again. She began study in New York at the National Academy of Design School in 1980 and won the Helen Smith Prize for sculpture composition in a student exhibition. The idea of portraying realistic figures in a fresh manner, suggesting reality but allowing the viewer to form his own interpretation, interested her. A larger than life-size fragmented torso won for her the first Antoinette Jacobi Memorial Scholarship to study under Bruno Lucchesi. The torso, with rough surface modeling but fluid line, has an intact head and arm and a hollow ribcage. She stated, "There is a relationship between the interior and the exterior of the work. The natural movement of the eye lifts the viewer into the torso which, I am told by others, evokes an emotional, haunting,

LIONESS AND CUB

 Bronze. Signed on lioness's left rear leg: © *82 H. YANDELL*; on right front leg: +++*82* height: 71.1 cm, length: 137.2 cm S.1986.004, placed in 1986. Signed on cub's right rear leg: *H. YANDELL*; on left front leg: © +++ *82* height: 45.7 cm, length: 83.8 cm S.1986.005, placed in 1986.

dreamlike quality."[1] Other sculptors she studied with at the Academy were Albert Wein and Ruth Nickerson. A background in the technical aspects of sculpture creation was learned from Gary Sussman, the only apprentice of Jose de Creeft, and John Rackham at The Sculpture Center. She had instruction in figure drawing from Gustav Rehberger at the Art Students League.

 Departures from the traditional depiction of portraits have resulted in finely detailed faces framed only by representational portions of hair, a hand or an arm. Hope Yandell pursues the presentation of the art work to the minimal points required by the viewer to recognize the subject. Using the idea of how little can be taken from life to portray a figure, her goal is to allow the viewer greater freedom in his own response to the art work.

 Motion is a common theme in her work — not a defiance of gravity but disruption of the traditional approach in the use of gravity. An untitled sculpture depicting three horses in a loosely structured ascent evokes a feeling of flight. The manner in which the human eye might travel across a view is recorded in the sculpture; the rest is intended to be felt by the viewer. Likewise, a figure of a running cat portrays an animal in flight; primal speed and motion are strongly felt. In 1987 the horse group won the Anna Hyatt

Huntington Prize at the exhibition of the Catharine Lorillard Wolfe Art Club.
Hope Yandell lives in Williston, Vermont.

Lioness and Cub

The sculptor's first major commission, *Lioness and Cub*, was designed in 1981 for a specific outdoor setting on a Florida estate. Although it incorporates feelings of motion and gravity, the bronze group is somewhat different from the rest of her work in that it is more true to the traditional tenets of realism. The rock base of the sculpture is an integral part of the overall work. It gives altitude to the animal group and serves as a focal point for the viewer by eliminating the formality usually associated with a sculpture base. The rocks were laid by stone masons using the mill rush method under the sculptor's supervision. *Lioness and Cub* is a gift of the sculptor in honor of Margaret Mason Peabody.

[1] Interview with the sculptor, April 12, 1987.

Betty Branch

AN ARTIST whose talents originally surfaced in painting, Betty Branch turned to sculpture in the 1970s as a better means of expressing her ideas. She was born at Winchester, Virginia, March 26, 1934, to Claude W. and Laura K. (Castleman) McAlister. After attending the public schools of Winchester, in 1951 she entered David Lipscomb College at Nashville, Tennessee and studied there for two years. She married Billy H. Branch in 1952; six years later they moved to Roanoke, Virginia.

By 1970 Betty Branch had begun to fulfill a childhood dream of being an artist and was painting impressionistic oils. She returned to her formal training at Virginia Western Community College, then enrolled at Hollins College in 1975. There she received a Bachelor of Arts Degree in studio art in 1979. Her thesis work, a life-size family group of three separate figures in plaster, was representative of her influences for some time. One of these figures, a pre-adolescent female entitled *New World*, was cast in bronze and exhibited extensively. Branch pursued her Master of Arts Degree from Hollins

College, receiving it in 1987. During this period of study, she apprenticed briefly with Miles and Generalis Sculpture Services in Philadelphia for technical experience, learning the skills of plaster casting and armature construction.

The female form has been dominant in Branch's work. During a six-week trip to Athens and Crete, she traveled to archaeological sites and studied artifacts in museums. At the same time, she developed an interest in the historical portrayal of the female figure in art as it related to family and societal roles. *The Mothers*, a series of five works in bronze of androgynous figures covered by several smaller forms, projects the strengths she found. The modeling of the mother forms reinforce the clinging, climbing, holding, carrying, protecting and cradling activities that mothers provide. A series of goddess figures exploring the mystique of women was another result of this period of self-study. In her sculpture Branch has defined the female rites of passage, often in terms of feminist imagery, utilizing unorthodox methods and materials.

Another series of works begun in 1985 featured an unusual depiction of textiles in the finished bronze. In *Brides*, the total illusion is one of demure, ethereal young women about to embark on their next passage in life. The medieval costumes of the brides appear to float and drift with an unseen wind. The airiness is achieved through the use of a welding torch to pierce sections representing cloth. Her interest in textiles led to independent study in design and fabrication of clay and fiber in the Bahamas. Branch experimented by creating earthenware with faces and amorphous shape, and weaving natural fibers and plant materials found on the beach on a crude loom fashioned from an iron bedstead.

Abstraction entered her work through two groups of monolithic fabrications of burlap and straw entitled *Mothers* and *Victims*, and the ceramic work, *Dragon's Teeth*. The latter is a group of fifteen separate tooth-like shapes that incorporate passive female faces and the suggestion of genitalia. Winner of three awards, *Dragon's Teeth* was part of the Virginia Women Artists Traveling Exhibition, "Experience in Art," for 1985 and 1986. At the same time, a photograph of the group was published in an album collection of more than 300 American women artists exhibited at the United Nations Conference on Women in Nairobi, Kenya. The album was later published in book form.

Mothers, a group of five bulky figures fabricated of burlap and straw, were destined to fulfill a new need for the artist. Unlike her works in other, more permanent material, *Mothers* was destroyed and in that process became a performance piece entitled *Ritual Fire*. Their end, captured in an educational

television documentary on the artist, was more powerful than their beginning. Afloat on a funeral-like structure in a dark quarry, the figures were lit by the artist from a canoe and their shadows and flames covered the quarry walls while a few participants were serenaded by a bagpiper.

Sought after for formal portraiture, Betty Branch has produced busts of two college presidents: Willard Collins of David Lipscomb College in 1980, and Carroll Brewster of Hollins College in 1982. She also has received numerous private portrait commissions. Her work is represented in the permanent collections of the Alabama School for the Deaf and Blind at Talladega, the City of Roanoke, and Sovran Bank. A life-size bronze of a child was placed in the Roanoke Public Library in 1988.

Betty Branch's independent studies and projects have taken her to British Columbia to explore the totem culture of the Pacific Northwest. A trip to Peru allowed her to research the ancient art of the Incas and their culture. From a desire to learn stone carving, Branch traveled for several summers to Carrara, Italy to learn about the properties of stone and techniques in carving. In 1987 she carved a series of sleek, highly polished female torsos in Carrara marble. Entitled *Fire Dancers*, each torso is different but all have a lyric, fluid, upward thrust suggesting flickering flames. These pieces are reminiscent of *Ritual Fire*, the work created during the burning of *Mothers*, and *Bent Torso*, an earlier work in bronze. In 1988 the *Gift Bearers*, a series of heroic pyramidal female forms, evolved with strong passive heads and out-reaching hands above a slender pyramidal base. The *Michael Series*, her first male forms, began in Carrara in late 1988.

Betty Branch teaches sculpture regionally for the Roanoke Museum of Fine Arts School, Hollins College, and the Roanoke City School System. She is a member of the Tri-State Sculptor's Society and Virginia Independent Visual Artists. In 1987 Betty Branch redesigned and renovated a three-story 19th century warehouse on Roanoke's historic Warehouse Row that includes enough space for a studio, gallery, storage, an office and a study. Much of her time is spent there sketching and modeling new works. Not only did she find a space that was ideal for her use, but she was a positive force for the redesign of urban space while remaining faithful to historic preservation.

Isabel

In 1983 Betty Branch modeled *Isabel*, a nude three-quarter life-size seated figure. Branch was struck by the self acceptance and gentleness of the young model, who was a friend of her teenage daughter. The youthful beauty, grace

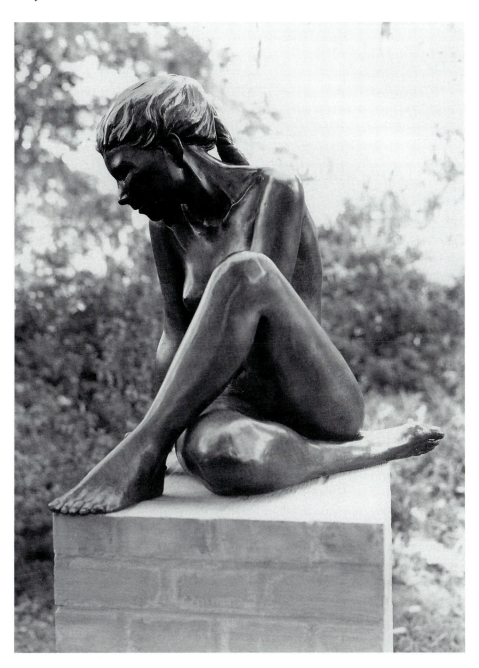

ISABEL

Bronze. 66x55.9x58.4 cm Signed: *BRANCH 3/6* S.1985.006, placed in 1985. Gift of the sculptor. Other example: Roanoke, VA. Museum of Fine Arts.

and contemplative air of the sculpture presents one of many images of woman, this being one of the more appealing.

The sculpture was cast in 1985 by Wegner Metal Arts of Fredericksburg, Virginia. It is third in an edition of six plus an artist's proof.

Veryl Goodnight

VERYL GOODNIGHT was born at Denver, Colorado, January 26, 1947, to Illif Dale and Rose (Gergotz) Goodnight. A love of animals, particularly horses, could be seen in her childhood drawings. In high school she participated in local sidewalk art shows, winning Best of Show at the age of sixteen, and sold her paintings to earn money. A plan to study art at the University of Colorado was abandoned when she learned that abstract art was emphasized in the curriculum. She enrolled instead in a local business school and, upon graduation, worked there for two years while she took art classes at night from various individuals. She opened her own studio at the age of twenty, taking part-time jobs when necessary to supplement her income. By this time her artistic interest had shifted from painting horses to landscapes. Marriage to an attorney in 1973 allowed her to travel the United States, photographing the wildlife which eventually became the focus of her painting.

In 1972 she took up sculpture as an exercise to improve her knowledge of animal anatomy. Soon afterward she realized that as an art form sculpture allowed her to incorporate the sense of touch and express movement. It also allowed her to create a more emotional impact with her work and she set aside painting.

After a divorce in 1982, Veryl Goodnight bought a small ranch south of Denver. For the next six years, she worked in a studio converted from a barn with an adjoining stall that housed the models for her sculpture. Preferring to work from live models, she traveled extensively throughout the Rocky Mountains to study animals in their native environment. She obtained a state wildlife license which allowed her to raise animals on the ranch including cow elk, deer, domestic sheep, a coyote and a prairie dog. Her own Arabian horse, "Gwalowa," was a frequent model for her sculpture and was depicted in three small bronze groups: *Into the Wind, Come Forth — A Dream,* and *What Friends Are For.*

Goodnight's first monumental sculpture, *Old Maude,* a bronze group of a

longhorn cow and calf, was placed in 1983 in front of the Haley Memorial Library at Midland, Texas. In 1988, the life-size nickel-plated bronze, *Paint Mare and Filly*, was installed in the garden of the National Cowboy Hall of Fame and Western Heritage Center at Oklahoma City. It was funded by subscriptions for a one-fifth life-size version of the work sold under the auspices of the American Paint Horse Association headquartered in Fort Worth, Texas. The composition allowed the sculptor to represent both the tobiano and overo coloring typical of the breed. Sales of the bronze group, *The Lesson*, a coyote with three pups, benefited the environmental organization, Colorado Open Lands.

During this period her emphasis shifted from animal sculpture to works that explored the relationships between animals and human beings. The first piece created in this vein, *Cares for Her Brothers*, examined both the strength and the vulnerability of the pioneers and the wildlife they encountered. The female figure depicted in that work reappeared in *Common Goals*, a small bronze group of a pioneer woman, swinging a milk bucket as she walks along, accompanied by two hungry cats. The working partnership between man and dog in the American West, a subject which Goodnight believed had been overlooked by artists even though it possessed as much drama and legend as other Western themes, was depicted in *Shepherds of the High Plains*. Drawing on her own experience, the figure of the shepherd was modeled after her father and her border collie served as the model for the sheepherder's dog. This work received a Merit Award at the 1986 exhibition of the Northwest Rendezvous Group in Helena, Montana. Continuing that idea, *Team Ropers*, an over-life-size monument of a young cowboy and his dog, was placed in 1988 at the entrance to Stroh Ranch near Parker, Colorado. In late 1989, Goodnight's small group of five energetic horses symbolizing freedom and tentatively titled *Equine Spirits* was submitted in competition for a commission to design a monumental bronze group for the entrance to the Lely Development in Naples, Florida. Known as *The Lely Freedom Horses* and having the subtitle, *The Day the Wall Came Down*, the monument was placed in 1991.

Veryl Goodnight's sculpture and paintings have been exhibited across the Western United States. In 1978 *The Bluff*, a study of two bighorn rams and, in 1979, *Elk Mountain Burn* were awarded gold medals by Wildlife Artists International. In addition to the Northwest Rendezvous Group, such prestigious shows as the Governor's Invitational in Cheyenne, Wyoming, and the Artists of America exhibition in Denver have featured her work in recent years. Some of her small bronzes toured China and others were exhibited in the United States Embassy in Botswana, Africa as part of the Art in Embassy Program.

On the East Coast her sculpture has been exhibited in shows of the Allied

CARES FOR HER BROTHERS

Bronze. 88.4 x 96.5 x 81.3 cm. Signed: *Veryl Goodnight 1985* S.1987.001, placed in 1987. Gift of Wynant J. Williams. Other examples: Denver, CO. Zoological Gardens; Bolivar, MO. Dunnegan Gallery of Art.

Artists of America where she received the Pietro and Alfrida Montana Award in 1980 for *Last of the Wild Mustangs*. The following year, *On the Crest of a Wave*, a half-life-size bronze of a bald eagle, was given the Marylou Fitzgerald Award by the Allied Artists of America. *Paint Mare and Filly* was shown in the 52nd Annual Exhibition of the National Sculpture Society in 1985.

Veryl Goodnight is a member of the Northwest Rendezvous Group, the Society of Animal Artists and Allied Artists of America. In 1989 she moved her home and studio to a location ten miles north of Santa Fe, New Mexico. The studio was specially built so that animals, including horses, could be brought inside onto a skylit modeling stage. Although her sculpture is cast elsewhere, since 1980 she has employed craftsmen who complete the chasing and patinas in her own studio. In 1990 Veryl Goodnight and Roger Brooks, her business manager, were married.

Cares for Her Brothers

A young woman in pioneer garb crouches next to a mule deer fawn which she protectively cradles in her arms. Its neck extended across her chest and ears laid flat, the fawn nuzzles her left shoulder. The woman wears an apron over a longsleeved shirtwaist dress and a petticoat; her hair is loosely pulled into a twist on the back of her head and she is barefoot. The figure is depicted in an authentic work dress researched with the assistance of the Colorado Historical Society. An orphaned fawn, raised by the sculptor from the age of ten days, was the animal model.

Cares for Her Brothers was the first sculpture in which the artist attempted to explore the theme of animal and human interrelationships. The sculptor wrote: "I had the latitude to portray the situation in many ways. I chose to depict a young pioneer woman from the 1860s because these women were symbolic of the combination of strength and compassion necessary to survive their loneliness and hardships...I used many ladies as models to complete the figure, changing facial features over and over again. The hands are slightly large to show strength, but they are holding the fawn ever so lightly to portray gentleness."[1] The sculptor was inspired by an excerpt from a Cheyenne Indian tale: "I told my grandmother of a lady whose beautiful thoughts go out to all living things. I told her of the lady's great love of our animal brothers. She said I should know her as Ewo-Wumishi-He-Me...Cares for Her Brothers."[2]

This sculpture also was produced in a one-third life-size edition. *Cares for Her Brothers* was cast at Quest Foundry, Boulder, Colorado. It was a gift of Wynant J. Williams of West Hartford, Connecticut

[1] *Cares for Her Brothers* sculpture brochure, "Veryl Goodnight," Sculptor's Correspondence File, Brookgreen Gardens Archives.
[2] *Ibid.*

Kristin Lothrop

KRISTIN LOTHROP is dedicated to the belief that traditional forms of art offer the greatest challenges in composition, innovation, imagination and execution. She was born in Tucson, Arizona on February 8, 1930 to Thomas and Elizabeth (Longfellow) Curtis. While attending Bennington College in Vermont she studied sculpture with Simon Moselsio. On December 27, 1951

she was married to Francis B. Lothrop, Jr.

At the Corcoran Gallery of Art in Washington, DC, she received further instruction from Heinz Warneke and studied sculpture and drawing for four years with George Demetrios in Gloucester, Massachusetts. Her friend and mentor, the sculptor Katharine Lane Weems, provided welcome encouragement and advice. Mrs. Lothrop specializes in portrait sculpture but also creates figures and animals. Although she prefers to work in wood, clay is her usual medium and she has done a few pieces in marble.

Kristin Lothrop believes that the purpose of art is communication. "The often intentional inaccessibility of much that is promoted by critics, dealers and museums today is, to my way of thinking, a kind of violation of that purpose. At the least the tendency is to confuse and disengage the attention of the public. 'Traditional' Art can be as new as the most 'Modern', and probably more meaningful, if it is good, and fresh, and full of content. In this cacophonous age it is surely needed and appreciated more than ever."[1]

Her work has been exhibited in prestigious group shows including those of the National Academy of Design and the National Sculpture Society. At the National Academy of Design exhibitions in 1968 she received the Thomas R. Proctor Prize for *Black USA*, carved in lignum vitae, in 1969 the Dessie Greer Portrait Prize for a bronze portrait head, *Andrew*, and in 1970 the Daniel Chester French Award for *Dryad*, a female figure emerging from a tree in elm wood. In 1967 *Robin*, a marble bas-relief, won the Mrs. Louis Bennett Prize at the National Sculpture Society exhibition. The Hudson Valley Art Association gave an honorable mention to *Black, USA* in 1968. The New England Sculptors Association awarded her work honorable mention in 1986 and first prize in 1987. In 1985 Kristin Lothrop won a national competition to execute a portrait bust of Chris Schaller, cast in bronze, for the State House in Carson City, Nevada.

She is a member of the National Sculpture Society and the New England Sculptors Association. Kristin Lothrop lives and works in Manchester, Massachusetts.

Early Morning Work-Out

A young oarsman, standing on a floating dock, holds an oar upright, leaning slightly against it for balance. Dressed in trunks and socks, he is mentally preparing himself for single scull rowing. The sculptor described the action: "This is a portrait of my son, Tony, an athlete and an oarsman…He holds a scull oar as opposed to a sweep oar which is longer and used when

EARLY MORNING WORK-OUT

 Bronze. Height: 93.2 cm. Signed on base: *K.C. Lothrop '86*
Founder's mark: 3C S.1987.002, placed in 1987. Gift of Elliot and
Joyce Liskin. Other example: Salem, MA. The Peabody Museum.

rowing in a four or eight-oared shell. He will use a pair of these to row in his single shell. He stands on the corner of a floating dock; it is slightly tipped with his weight…He wears socks only, as he will tie his feet into the rowing shoes fastened to the foot 'stretcher' in the shell. Oarsmen wear as little clothing as possible to eliminate the problem of chafing. He stands relaxed, but concentrating. He is physically ready, but is psyching himself up to the necessary energy level. The rising sun reflects in his eyes. In the early morning he will have the river to himself. To row alone, and only against oneself, requires extraordinary discipline and commitment. To row competitively requires an output found in few other sports."[2]

Early Morning Work-Out was awarded the Elliot and Joyce Liskin Purchase Prize of the National Sculpture Society in 1986.

[1] "Kristin C. Lothrop," Sculptors' Correspondence Files, Brookgreen Gardens.
[2] *Ibid.*

William Turner

A NATIVE OF Virginia's Eastern Shore, William Henry Turner grew up attuned to its abundant natural life and has cultivated a lifelong fascination with the flora and fauna of that region. He was born near Jamesville, in Northampton County, Virginia, on May 27, 1935, to Major Evans and Nellie (Custis) Turner. His first artistic efforts were carving duck decoys and wood likenesses of the animals he observed. By the age of fourteen he was building boats and assisting in his father's cabinetmaking business.

A childhood interest in taxidermy was heightened when Robert Henry Rockwell came to live in his community. Rockwell, a noted taxidermist and sculptor, retired in 1942 as curator from the American Museum of Natural History. Informal study with Robert Rockwell helped provide a knowledge of animal anatomy and sparked his desire to make a record of the vanishing American wildlife in sculpture rather than in taxidermy. Turner assisted in the studio and received criticisms from Rockwell. He also was befriended by the older artist who continued to create sculpture and encouraged William Turner to do the same. His relationship with Rockwell continued until his mentor's death in 1973.

In 1957 William Turner completed a degree in anthropology at the

University of Virginia. For a while he taught school at Yorktown, Virginia, and then served in the United States Navy. Deciding that a degree in dentistry would enable him to return to the Eastern Shore and work while pursuing his love of sculpture, he attended the Medical College of Virginia from 1965 through 1969. During this period he earned a living by designing and manufacturing earthenware wildlife figures.

In 1969 Turner acquired acreage on Folly Creek in Accomack County which had a wealth of habitats for observing the subjects of his animal designs. His porcelain figures were in great demand and were sold to galleries and major retailers such as Abercrombie & Fitch, Neiman-Marcus and Cartier. For a period of four years he designed limited edition wildlife figures for the waterfowl conservation organization, Ducks Unlimited. He soon earned a national reputation for his finely detailed porcelain work. Turner's personal interest in the work of the Nature Conservancy assisted in spreading word about his artistic talents.

After becoming disenchanted with the repetition and limitations of the porcelain medium, Turner began to cast some of his animal designs in pewter and was intrigued by the greater artistic possibilities of working with molten metals. For a time he created wildlife statuettes for Lance International. Eventually, he sold his porcelain business and turned his attention to modeling sculpture in clay for casting in bronze.

William Turner's first sculpture commission came in 1979 when, after a nationwide search, Anne Morrow Lindbergh asked him to create a memorial to her husband, the aviator Charles Lindbergh. This life-size bald eagle cast in bronze was exhibited for several years in the Rotunda of the Capitol at St. Paul, Minnesota. It is now located at the Lindbergh Museum in Little Falls, Minnesota. He also designed a medallion featuring the Lindbergh Eagle which is presented to recipients of the Charles A. Lindbergh Foundation Award.

Near Onley, Virginia, in 1982, William Turner renovated a former restaurant building and equipped it for use as a studio, gallery and art foundry so he could cast his art works using the lost wax method. After careful study of the process, Turner designed and constructed a gas-fired, roll-in furnace in order to have greater control over the quality of the finished cast. By 1983 his son, David, had graduated from college and come to work with him in this enterprise. Eventually, the father and son collaborated on several large commissions. *School of Lookdown Fish*, a species native to the Chesapeake Bay, was commissioned by the Virginia Marine Science Museum at Virginia Beach in 1984 and placed in the museum's reception area. The following year,

Lookdown Trio, an heroic group, was placed at the entrance to the museum. One of the largest commissions, a group of fourteen *Canada Geese* landing in a pool of water, was created for the Chicago Botanic Garden in 1990. Construction of a special building was required to house the sculpture during modeling.

In addition to those in private collections, William Turner has an impressive number of works in public places. In 1985 *Canada Goose* was placed outdoors at the Chicago Botanic Garden, and *Diving Pelicans,* a life-size group of two brown pelicans diving into a school of pompano, was installed in a pool near the entrance to the Collier County Conservancy in Naples, Florida. In the following year, Turner modeled a stalking *Florida Panther,* an endangered species, that was placed adjacent to the *Diving Pelicans* at the entrance to the conservancy facility. A third work, a pair of *Anhingas* on a twisted branch, has been located in the lobby of Blair House at the conservancy since 1988. In 1992 the National Audubon Society requested that he create a pair of *Woodstorks* that was placed at Corkscrew Swamp near Naples.

In 1987 William Turner created a sculpture in honor of G. Norman Albree, the inventor of the monoplane. The Albree Flight Memorial, a life-size golden eagle striking a pintail duck, was dedicated at Swampscott, Massachusetts, on the Fourth of July. A *Black Bear* standing on its hind legs, with a front paw resting on the stump of a tree, was unveiled in 1988 in Swank Park on the campus of Lees-McRae College at Banner Elk, North Carolina. *Rutting Whitetail Bucks,* an action group of two deer with antlers locked in combat, was placed on the campus of The University of Virginia in 1992. The New York Zoological Society acquired a pair of *Beluga Whales* for the New York Aquarium at Brooklyn in the spring of that year.

William Turner's love of nature and understanding of animal anatomy is evident in his careful studies of wildlife, many observed in the natural habitats of his property. As a self-taught artist, he boldly experiments with modeling and casting techniques, adapting what seems to him the best of several methods to create his sculpture. Realistic detail is important in his work but it is not a mechanical reproduction. For a *Bonefish* completed in sterling silver, he modeled it with no detail, cast it in plaster and engraved each scale on the plaster model to ensure clarity in the finished sculpture. An example of this sculpture was presented to President George Bush at the White House in 1989.

Animals in action are his most frequently depicted subjects: "A sculptor who works from photos is limiting his perception of wildlife to what the camera saw, meaning one side only. Although I recommend study skins or mounts over photos, I see too many young sculptors merely copying the mistakes made by

TIMBER WOLF FAMILY

Bronze. Length: 274.3 cm. Signed: *W. H. Turner / 1990.* S.1992.004, placed in 1992. Gift of Dorothy R. Blair. Other example: New York, NY. American Museum of Natural History.

taxidermists. Photos and taxidermy are important teaching and reference aids, but they can never serve as a substitute for hours of observation of living wildlife."[1]

A man of many professional interests, William Turner supports environmental causes and devotes extensive time to wildlife observation. He continues to build the wooden rowboats typically used on the Chesapeake Bay and also paints in watercolor.

Great Blue Heron

A great blue heron stands on a tree branch. Two lily pads float at the base of the branch; one supports a small frog with throat sac inflated. Feathers on the bird's head and breast were attached separately after casting to give a more realistic look. *Great Blue Heron* was modeled in 1985 and cast in an edition of 25. The example at Brookgreen Gardens is the artist's proof.

Bronze. 86.4 x 61 x 30.5 cm. Signed: *WH Turner / 1985 / AP.* S.1988.001, placed in 1988. Gift of the sculptor.

Timber Wolf Family

In 1989 the sculptor was commissioned by the American Museum of Natural History to create a group of wolves as a memorial to his mentor and the museum's former curator, Robert Henry Rockwell. The sculpture was placed there in 1991. The wolf family includes an adult male standing attentively with its left front paw lifted, followed by a female with head lowered, watching over four playful pups. The scene of the wary adults contrasting with the exuberant antics of their offspring is both engaging and realistic. The example at Brookgreen Gardens is the only other casting.

1 Reiger, George, "My Dentist the Sculptor," *Field and Stream*, December 1983, p. 98.

Zenos Frudakis

Zenos Frudakis was born in San Francisco, California, on July 7, 1951 to Basilis and Kasiani (Alexis) Frudakis but was raised in Gary, Indiana.

From 1973 to 1976 he attended the Pennsylvania Academy of the Fine Arts at Philadelphia. There he studied painting with Arthur DeCosta, anatomy with Robert Beverly Hale, clay modeling with Karl Karhrmaa and Tony Greenwood, and attended other sculpture classes instructed by David Slivka. In 1977 Frudakis taught drawing and painting at LaSalle College in Philadelphia. He then enrolled in the art department of the University of Pennsylvania, where he received a bachelor of fine arts degree in 1981, and a master of fine arts degree in sculpture in 1983.

For a two year period following graduation, Zenos Frudakis taught courses in sculpture at Rutgers University in Camden, New Jersey. In 1988 he returned to teach a class in figure sculpture. As part of the humanities program at the Medical College of Pennsylvania at Philadelphia, he was a guest lecturer on sculpture and anatomy in 1986 and 1987. He served as a juror for the 11th James Wilbur Johnston Competition for Figure Modeling sponsored by the International Sculpture Center at the Maryland Institute College of Art in 1989. In that same year, he was a juror and a judge for the North American Sculpture Exhibition at The Foothills Art Center in Golden, Colorado, and conducted a workshop on figure sculpture at the Scottsdale Artists' School in Arizona.

Portrait sculpture is an important part of Frudakis' body of work. A portrait relief of Harry A. Kalish was created for the Philadelphia law firm of Dilworth, Paxson, Kalish in 1981. Bronze portrait busts of Mayor W. Wilson Goode, City Council President Joseph E. Coleman, and K. Leroy Irvis, Speaker of the House of Representatives of the Commonwealth of Pennsylvania, were done in 1984. In 1985, Frudakis participated in a competition sponsored by the National Endowment for the Arts for a professional sculptor to create a bust of Dr. Martin Luther King, Jr., for the United States Capitol. As one of three finalists in the competition, he received a development grant from the NEA for his work on that portrait. A half-life-size bronze casting of the portrait was presented to Bishop Desmond Tutu of South Africa in 1986 by the Committee for a Sane Nuclear Policy. The Archdiocese of Philadelphia purchased a life-size cast in 1988 for the Martin Luther King Center for Non-Violence in Philadelphia. Another portrait of King was created in 1987 in a national public art competition for a memorial park at Kalamazoo, Michigan. In 1988 the United States Embassy in Pretoria, South Africa, purchased a life-size bronze cast of this portrait for permanent installation in an outdoor garden. Frudakis was commissioned in 1986 to create a portrait of the Pulitzer Prize winning journalist, Vance Henry Trimble. A portrait relief of Joseph Ruvane, Jr., former chairman of the pharmaceutical company, Glaxo, Inc., was done in 1988 for the headquarters in Raleigh, North Carolina. A bas-relief portrait of former Mayor Richardson Dilworth was commissioned in 1991 for the International Air Terminal which bears his name at Philadelphia.

Zenos Frudakis has received several challenging commissions to design large-scale figures for fountains and public places. *Elephant Fountain,* a life-size bronze group of a female elephant spraying water on a laughing ten-year-old boy perched on her back, was commissioned by Strawbridge & Clothier in 1981 and placed in a Burlington, New Jersey shopping mall in 1982. A creation from an entirely different perspective, *Dream to Fly,* consists of three heroic bronze figures in an upward spiral, suspended on stainless steel poles, 30 feet in height from a circular pool. The group represents movement through three stages of development, escaping from gravity and, ultimately, mortality. It was placed at the entrance to an office complex designed by Rouse & Associates at Cherry Hill, New Jersey in 1987. Later that year, Frudakis was chosen from a competition of fifty sculptors to create figurative sculpture for Capital Center Plaza, a part of the renovation of downtown Indianapolis, Indiana. *Reaching,* a group of two over-life-size bronze figures, was installed there in 1987. The sculptor was invited to exhibit these figures at The Rodin Grand Prize Exhibition held in 1990 at the Utsukushi-Ga-Hara Open-Air

Museum on the northern part of Honshu Island, Japan. He was the only American sculptor chosen from 442 entries representing 31 countries.

A different kind of commission was *Prometheus*, a small, 23 carat gold-leafed sculpture that depicted the bringing of science, in the form of fire, to mankind. It was given to the Nobel Foundation, grantor of the Nobel Prize, in recognition of the foundation's contributions to humanity through its honoring the greatest accomplishments in science, medicine, literature and peace. The presentation was made at the Bicentennial Conference on Global Interdependence in Science, Medicine and Technology in an Era of Coopera- tion and Competition, sponsored by the Franklin Institute and the Academy of Sciences at Philadelphia in 1989. A monumental bronze group, *The Worker's Memorial*, was dedicated in the spring of 1991 by the United States Secretary of Labor at the Rose Garden in Bethlehem, Pennsylvania. The sculpture was sponsored by industries in the cities of Easton, Allentown and Bethlehem.

Zenos Frudakis has won a number of awards for his work, particularly in exhibitions in New York. In 1979 he was given a certificate of merit for portraiture by the National Academy of Design. From the National Sculpture Society he received the John Spring Art Founder Award for a bust of Samuel L. Evans and the Gloria Medal given to promising young sculptors in 1981, and the Tallix Foundry Prize to cast *Two Babies* in 1982. The Society in 1985 awarded to him the President's Prize for the best portfolio of work submitted by an artist under the age of 35. In that same year, the American Artists' Professional League gave him its Council of American Artists' Societies Award and he received the Liskin Award at the juried annual exhibition of Knickerbocker Artists.

Frudakis is a fellow of the National Sculpture Society and a member of the National Academy of Design and the fellowship of the Pennsylvania Academy of the Fine Arts. He is a member of Allied Artists of America, Knickerbocker Artists and the American Artists' Professional League. His studio home is located at Glenside, Pennsylvania.

Wolf and Wolfhound

A snarling wolf with lowered head, bared teeth, and arched back, faces a wary wolfhound. The hound stands tensely, ears flattened and mouth opened slightly, its attention focused on the circling wolf. Both animals appear ready for attack although the wolf seems to be the aggressor. The group is modeled with anatomical accuracy; the fur is smoothly patterned in overall striations.

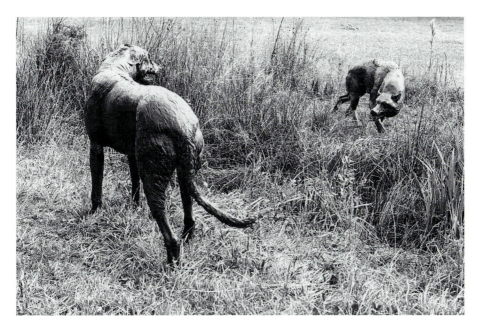

Wolf and Wolfhound

Bronze. Hound – height: 102.9 cm, length: 142.2 cm; Wolf – height: 73.6 cm, length: 133.4 cm. Signed on hound's left rear leg; *ZENOS FRUDAKIS © 1988 1* Founder's mark: [Laran Bronze insignia] S.1988.005 and S.1988.006, placed in 1988.

Although designed to be exhibited together, the group is comprised of two separate sculptures, each capable of standing alone. The hound, exhibited under the title *Irish Wolfhound*, was awarded a Silver Medal at the National Sculpture Society exhibition in 1986. The group was commissioned in 1985 for the landscaped garden entrance to a private estate at Vineland, New Jersey, where the hound and wolf were placed on opposite sides of a stream. In 1988 a fiberglass casting of this group was shown in an annual outdoor exhibition of contemporary sculpture at Chesterwood, the estate of Daniel Chester French in Stockbridge, Massachusetts. The group owned by Brookgreen Gardens was cast in 1988 by Laran Bronze, Inc. at Chester, Pennsylvania.

Leonda Finke

Born in Brooklyn, New York, on January 23, 1922, Leonda Froelich is the daughter of Herman and Evelyn (Praeger) Froelich. From early childhood she had an interest in drawing. Her teachers noticed her artistic inclinations and encouraged her parents to send her to art school.

As a child she lived near Audubon Terrace located at 155th Street and Broadway, the site of a cluster of museums supported by Archer Huntington. Her memories are linked with this site: "I played in the brick paved courtyards there almost daily. I often wonder what kind of subliminal influence worked on me — while spending so much time among the [Anna] Huntington sculptures. It seemed a natural environment. Wandering among those large sculptures — going in and out of the museums there and always drawing, I remember as the good times of childhood."[1]

Later, she worked as a commercial artist while she studied drawing and sculpture in classes five nights a week at the Art Students League and the Educational Alliance. In 1947 she married Arnold Finke. Although her work as an artist did not halt, it slowed during a time when her three children were young.

Typical of her sculpture method is a rough surface which is not applied, but "grows from the inside out as the forms develop."[2] The shapes she creates are basic, often left without detail, yet they forcefully convey emotion and expression. Her interest in the human figure has led Mrs. Finke to specialize in the female form, however, she has not been limited to this subject. Drawing, particularly in silver point, continues to be an art form she enjoys. Leonda Finke has written that her need to draw is a kind of physical need: totally absorbing and immediately rewarding.[3]

In 1965 she received the Pauline Law Prize from the National Association of Women Artists and a first prize for sculpture from Operation Democracy, an exhibition at Hofstra University. In 1969 she was Yaddo Fellow at the artist colony in Saratoga Springs, New York. From this point on, in nearly every year, her work has received awards from important art organizations. Since the late 1960s, Leonda Finke has had more than 15 solo exhibitions of her sculpture and drawings and has participated in over 30 group exhibitions in the United States and in Europe, Asia and the Middle East. In 1980 Leonda Finke received the Medal of Honor of the National Association of Women Artists. Four years later, Audubon Artists gave her its Medal of Honor. The National Academy of Design recognized her artistic achievements in 1990 with the Alex Ettl Award

and elected her to membership in 1993.

Whether monumental or miniature, the emotional force of her sculpture is undeniable. *Survivors*, a group of two small figures, one seated on a bench, the other standing alone, was awarded the Edith and Richman Proskauer Prize of the National Sculpture Society in 1981. *Night Thoughts*, a group of four individual female figures in different poses, placed on three steps of different levels, presents a dream-like scene. Though quite small, each figure has her own formidable presence. *Woman in a Hammock* presents the subject reclining in a hammock fashioned from metal meshing. The interesting tactile quality of the sculpture provides counterpoint to the woman's posture of total relaxation. *Time of Darkness*, a crouching figure covered in a hooded cloak, conveys sadness and gloom. The hand covering the shadowy face adds to the mystery.

Portraits of prominent individuals have been an important part of her work. A bronze head of Georgia O'Keeffe is in the permanent collection of the National Portrait Gallery in Washington, DC. This work received the Tallix Foundry Prize at the National Sculpture Society exhibition in 1977. A bronze relief, *Virginia Woolf with Asphodel*, depicts the face of the writer within a rectangular format, sprigs and flowers of the plant sprouting across the bottom of the relief. Examples of this work are in the collections of The Chrysler Museum at Norfolk, Virginia, and in the Museum of Foreign Art at Sofia, Bulgaria.

The medal, with its techniques relating to drawing, is an art form she began to experiment with in the 1980s. Many of her designs utilize non-traditional shapes and are cast rather than struck. An oval cast bronze medal of the French sculptor, Camille Claudel, pupil and mistress of Rodin, features the artist's portrait in the upper half of the obverse; her forearms and hands reaching up from the lower half of the reverse. Her arms are bound by ropes which encircle the medal, both reverse and obverse, indicating Claudel's artistic and personal frustrations in Rodin's shadow and her family's censure. This medal is in the collection of the National Museum of American History in Washington, DC. In 1989 Leonda Finke designed a cast bronze medal of Virginia Woolf for the British Art Medal Society which portrays the theme, *A Room of One's Own*, a title from Woolf's writings. Similar to the portrait relief of the writer, the obverse depicts her face framed on the right with a decorative floral border, and the reverse carries out the title with a small female figure standing in the open doorway of a room. The irregular shape of the medal incorporates the composition elements of both the obverse and the reverse.

In 1988 she was commissioned to design the 117th issue of the Society of

Medalists. Her theme, *The Prodigal Son*, utilizes the family — father, mother and son — with the woman being the pivotal figure, balancing the relationship between the father and son. On the obverse the mother and father stand together on the far left, comforting one another, as the son walks away from them on the far right. The figures are placed on opposite sides of the circular background and the void across the center emphasizes the tension of the scene. On the reverse the family group has been reunited, hands on each other's shoulders in a protective circle, framed by peonies, symbolic of love and affection.

Leonda Finke is active in many professional organizations. She serves on the executive boards of the American Medallic Sculptors Association, the Sculptors Guild, and the National Sculpture Society. She is a past president of Audubon Artists and holds membership in the New York Society of Women Artists and Artists Equity. Since 1969 she has been an adjunct professor in the art department of Nassau Community College at Garden City, New York. In 1992 she was awarded the First Annual Faculty Distinguished Achievement Award and the Adjunct Faculty Association's Professional Excellence Award. She has lectured at the University of Hartford in Connecticut, at the British Medal Society in London, and at the Foothills Art Center in Golden, Colorado.

Explaining her philosophy and technique, Leonda Finke writes: "I try to make sculpture that expresses feelings or ways of being which, hopefully, ring a chord of response in the viewer. Finding the forms for all ways of being is part of my motivation. [It is] A large range — from feeling at one with the works in the life-giving sun, to the extremes of isolation or anguish. The surfaces of my works are the result of searching for the forms. I never work over the surface merely to smooth or achieve texture. When the form feels right, I leave it alone."[4] She lives in Roslyn, New York where she maintains a studio.

Seated Woman

An over-life-size female figure is seated on a small bench, her hands crossed behind her back and resting on the top of the bench, her legs stretched out in front and her feet bare. Her face is lifted upward, toward the sky, with eyes closed and an expression of total relaxation as she basks in the sun. The woman is clothed in a mid-calf-length dress which is pulled tightly across her chest and abdomen and falls in small folds across her lap and legs. Her mature body is not so much covered by the dress as emphasized by it. The subject's informal, relaxed posture and the sculpture's rough texture enhance the

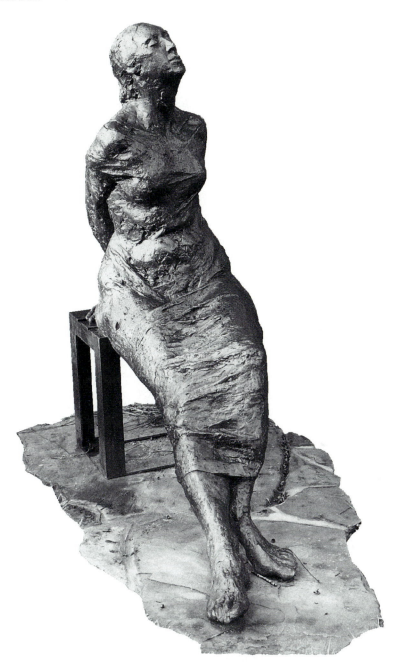

SEATED WOMAN

 Bronze. 135.9 x 49.5 x 132.1 cm. Signed: *Leonda Finke* © Founder's mark: "Roman Bronze Works" S.1992.001, placed in 1992. Gift of Mrs. Edward M. Rosenthal. Other example: Atlanta, GA. Trammell Crow Corporation.

realism. The upper surface of some forms are polished so that these areas actually glow in the sunshine.

The seated woman is one of a group of three separate female figures, collectively titled *Women in the Sun,* that were created in 1988 for a corporate park in Atlanta, Georgia. The sculptor designed the area so viewers could walk through a landscaped circle and be able to touch and examine each sculpture. In 1989 *Standing Woman* from this group was awarded the Gold Medal at the National Sculpture Society's 56th annual exhibition. *Seated Woman* is a gift of Mrs. Edward M. Rosenthal.

¹ Letter dated March 17, 1992, "Leonda Finke," Sculptors' Correspondence Files, Brookgreen Gardens Archives.
² "The Prodigal Son by Leonda F. Finke, 117th Issue of the Society of Medalists," promotional flyer, "Leonda Finke," Sculptors' Clipping Files, Brookgreen Gardens Archives.
³ "Drawings in Silverpoint," by Leonda Finke, *National Sculpture Review,* Vol. XXXI, No. 1, Spring 1982, p. 19.
⁴ Letter dated March 17, 1992, "Leonda Finke," Sculptors' Correspondence Files, Brookgreen Gardens Archives.

David Turner

DAVID HUNTER TURNER, born on the Eastern Shore of Virginia at Nassawa-dox on March 5, 1961, is a son of the sculptor, William Turner. At the age of seven, he began modeling animals in stoneware clay which were fired at the family's porcelain factory in Accomac, Virginia. With his father, he made visits to the studio of Robert Henry Rockwell, a sculptor and curator of the American Museum of Natural History, who had retired on the Eastern Shore.

As a youngster, David Turner studied sculpture informally with his father and worked in the porcelain factory. His interest in animal sculpture grew as he continued to create stoneware clay figures and worked at the potter's wheel during his high school years. Following his father's example, David Turner became an avid naturalist and outdoorsman.

In 1979 Turner enrolled at the College of William and Mary in Williamsburg, Virginia. While pursuing a degree in biology, he frequently chose field courses in order to strengthen his knowledge of animal habit and anatomy. In the summer of 1982, he released peregrine falcons into the wild as part of Cornell University's falcon reintroduction program. At William and Mary, Turner also studied pottery and sculpture, including bronze casting, with Carl A. Roseberg.

During this period, William Turner sold the porcelain business and built a bronze foundry to cast his own sculpture. David Turner's first work in bronze, a bison, was cast by his father.

In 1983 he received a B.S. degree in biology and a minor in studio art. After graduation he married a fellow student, Beverly Anne Crossett, of Arlington, Virginia. Turner took a job in Bethesda, Maryland, as supervisor and caretaker at a laboratory animal facility for the Navy's Uniformed Services University of the Health Sciences. Although he cared for the animals, he did not like the sterile atmosphere of the facility and was dissatisfied with life in the city.

By this time, William Turner's work in sculpture had grown to the point where assistance was required in the bronze foundry, so David Turner returned to the Eastern Shore. Given the job of foundry manager, he was put to work on the production of his father's sculpture and, upon occasion, was given design responsibilities. He began creating fish and waterfowl designs for jewelry that he cast in pewter and sold in the family gallery. The business thrived and the operation of Chesapeake Wildlife Designs, including the foundry and a gallery, moved to its present location near Onley, Virginia. David Turner's interest in sculpture was heightened and soon he was creating his own work that depicted the Eastern Shore's native wildlife.

As a partner in the family business, now named Turner Sculpture, David Turner creates sculpture of wildlife, cast in limited edition, and accepts commissions for public sculpture. Some of these commissioned works were created in collaboration with his father. A flock of fourteen *Canada Geese* landing in a pool was installed near the main entrance to the Chicago Botanic Garden in 1989. *Generation*, a trio of playful dolphins in an underwater setting, was designed for the lobby of the Esperante Building in West Palm Beach, Florida, and two groups of *Lookdown Fish* were commissioned by the Virginia Marine Science Museum in Virginia Beach in 1984.

In addition to working with William Turner on large commissions, David Turner has received a number of independent commissions from prestigious organizations. In 1987 he modeled a pair of *Bottle-nosed Dolphin* and a *Loggerhead Turtle* for the Dolphin House at Chicago's Brookfield Zoo. In 1991 he designed a life-size *Baby Giraffe* that was placed inside the zoo's giraffe house. A pair of dolphins bursting from the water made a lively fountain installed in 1987 at the Mystic Seaport Museum in Mystic, Connecticut. A sculpture of three separate figures entitled *Whitetail Doe and Fawns* was placed in 1989 at the Cofrin Memorial Arboretum of the University of Wisconsin at Green Bay. In 1990 he modeled *Black Bear Family*, a life-size group of four playful cubs surrounding a mother bear scooping honey from a cavity of a tree. Castings of this

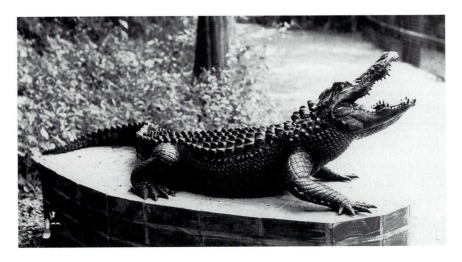

ALLIGATOR

Bronze. Length: 182.9 cm. Signed: *DAVID H TURNER 1990 2/18* S.1990.005, placed
in 1990. Gift of the sculptor. Other example: Loveland, CO. Benson Park Sculpture
Garden.

sculpture were placed at the Frances Pew Hayes Bear Museum in Naples,
Florida, and at the Philadelphia Zoo in 1991. Prior to being placed at the zoo,
Black Bear Family was the centerpiece of an exhibit including the sculpture,
Penguins, by Albert Laessle, at the Philadelphia National Flower Show. For the
Virginia Fish and Game Commission he is designing a series of small sculpture
depicting endangered species which will be sold to benefit the Commission.
The first in the series is a Bewick's Wren perched on a branch.

Besides the wildlife sculpture which comprises much of his work, David
Turner depicts the human figure. He has accepted a number of private
commissions of portrait sculpture and has designed a life-size group of two
children feeding barnyard animals which was placed in 1990 at Youth Haven,
an orphanage in Naples, Florida. Turner has taught a course in the theory and
practice of sculpture at Eastern Shore Community College located near his
home in Onancock, Virginia.

Alligator

A life-size American alligator is stretched out, the tail forming an s-shaped
curve. The reptile's mouth is open and rows of sharp teeth are exposed. The
sculptor used a preserved specimen as a model and worked from observations

in the wild. *Alligator* was exhibited in 1991 at the annual outdoor show, Sculpture in the Park, at Loveland, Colorado, and was chosen to be placed there permanently.

Tom Allen, Jr.

TOM ALLEN, JR. was born in Havana, Cuba, January 23, 1927, while his parents were on assignment as foreign correspondents with United Press International. His youth was spent in Latin America where he attended school. In 1939 sketches he made were published in the *Buenos Aires Herald.*

Allen studied architecture at the University of Havana, literature at the University of Madrid, art at The Royal Academy of Fine Arts at San Fernando, Spain, and eventually graduated from George Washington University where he received an associate degree in art. During World War II he served in the United States Army as an infantry sergeant. His sketches of the campaign in the Philippines were published by newspapers in the United States. In 1946 he was an art instructor for the 20th Army Air Force at Guam.

For the Poor Richard Club at Philadelphia in 1952 he executed an heroic frieze depicting the life of Benjamin Franklin. The Department of Recreation of the City of Philadelphia commissioned him in 1958 to create a departmental symbol and medal. In 1970 he was the winner of the National Open Competition of the Society of Medalists. In 1974 he designed a monument for the Philadelphia Zoological Garden. His sculpture has been exhibited at shows of the National Sculpture Society, the American Numismatic Society, the Philadelphia Art Museum, the Pennsylvania Academy of the Fine Arts and the Federation Internationale de la Medaille.

Structural and interior design is another area of interest for the artist. He has designed and executed attractions at the Willow Grove Amusement Park and window displays for banks and stores. He worked as scenic designer at the Valley Forge Music Fair in 1955. From 1959 through 1962 he was director of advertising and promotion for Johnson and Johnson International at New Brunswick, New Jersey. He has designed trademarks for corporations and initiated a pilot therapeutic program of arts and crafts in the Philadelphia penal system.

Allen is a member of the Art Directors Club, the International Center of

Topographical Arts, the Philadelphia Art Alliance and Artists Equity. He lives in Somerset, New Jersey.

Ecology, the Life Force Medal

The 82nd issue of the Society of Medalists deals with the idea of ecology as a vital concern of mankind, a concept that was beginning to be recognized globally in 1970. The sculptor has depicted on the obverse a flame as a symbol of life. The flame, made up of interconnecting figures representing the continuity of generations, rests in the palm of the hand of collective mankind. The reverse is framed by a ring of flame which represents the earth and humanity. Within the circle is the Latin phrase, *Pro Vita / Terra / Aqua / Aer / 1970.*

Allen wrote, "Within a stylized ring of flame representing the earth and humanity, the phrase — PRO VITA-TERRA-AQUA-AER-1970 — translated means that fertile earth, purer sea, fresh water and clean air are needed to sustain life. The year to start is 1970! The use of a mother tongue such as Latin is to express the continuity and universality of the problem."[1]

Bronze. 7.3 cm diameter. Signed: *TA © 1970.* N.1988.010, placed in 1989. Gift of Beatrice Gilman Proske.

1 "The Society of Medalists Eighty-Second Issue, December 1970, Tom Allen, Jr., Sculptor," descriptive brochure, Sculptor's Clipping Files, Brookgreen Gardens Archives.

Abram Belskie

FOR THE sculptor's complete biography, please refer to *Brookgreen Gardens Sculpture,* pp. 442-445.

In 1969 Abram Belskie created a series of 50 medals of "Great Men in Medicine," a favorite subject , for Presidential Art Medals, Inc. The series was issued in both silver and bronze. He also designed the National Football Hall of Fame medal in 1969 and five medals for the Hall of Fame for Great Americans. The American Numismatic Association selected him Sculptor of the Year in 1974.

Abram Belskie died in Closter, New Jersey, on November 17, 1988. His

desi
his
ove
the
Savi
priv
Sou
to f
196
Uni
Juri

Bea
art.

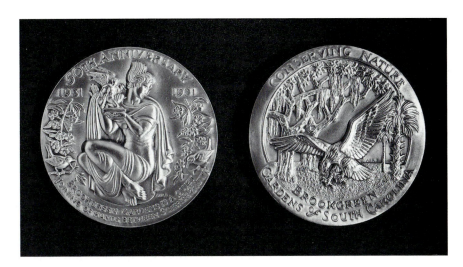

BROOKGREEN GARDENS 50TH ANNIVERSARY MEDAL

Bronze. 7.6 cm in diameter. Signed on obverse and reverse: *ABR.B* N.1981.001, placed in 1981. Other examples: New York, NY. American Numismatic Society, National Sculpture Society; London, England. The British Museum.

Th

mo
Bor
the
syn
exp
sim
spa
ma
pul
Ma

An
mc
fro
of
the

Bea

family gave the contents of his studio to the town of Closter for the purpose of creating a museum to him and his work. On October 4, 1992, the Abram Belskie Museum was dedicated as a special addition to the Closter Public Library.

Brookgreen Gardens 50th Anniversary Medal

The year 1981 was the 50th anniversary of the founding of Brookgreen Gardens. Archer Huntington and his wife, Anna Hyatt Huntington, were interested in all aspects of nature and they decided to increase the scope of the gardens so that the land would be used as a wildlife sanctuary for the preservation of the flora and fauna indigenous to South Carolina. Later, Archer Huntington wrote about their creation: "Brookgreen Gardens is a quiet joining of hands between science and art."

In his composition, Abram Belskie symbolized sculpture with a classical female figure holding aloft a small statuette of a winged kneeling figure in whose hands are the mallet and chisel—age-old tools of the sculptor. Framing this central figural group are tendrils of yellow jessamine, the state flower of South Carolina. On each side perches the Carolina wren which is the state

Granville Wellington Carter

GRANVILLE CARTER, born November 18, 1920, to Brooks Eaton and Araletta Tarr (Payne) Carter, took up wood carving as a boy in Augusta, Maine. A serious study of art began at the Portland School of Fine and Applied Art in 1944 where he was taught by Alexander Bower. For the next four years he attended the National Academy School of Fine Arts, where he studied with John Flanagan, and the New York City School of Industrial Art. In 1946 and 1947 he won student prizes at the Academy School. Carter was awarded two Tiffany Fellowships in 1954 for further study in Europe. For the next two years he attended the Grand Chaumiere de Paris and the Scuolo del Circolare Internazionale di Roma, and spent one year in residence at the American Academy in Rome. On October 15, 1955 he married Senta Jacobshagen, a German artist.

During his time at the National Academy, Granville Carter came to the attention of the sculptor, Herbert Haseltine. Over a ten-year period he assisted Haseltine with three equestrian statues: *Man O' War* at Lexington, Kentucky, a monument to *Sir John Dill* at Arlington National Cemetery, and a statue of *George Washington* located at the National Cathedral. He also assisted for short periods the sculptors Bryant Baker, Joseph Kiselewski and Sidney Waugh.

Among his most important commissions were several works for the National Cathedral in Washington, D.C. The first one occurred in 1961 when he created a figure of Saint Augustine of Canterbury that was carved in limestone for an outer aisle bay. Following that, two heroic limestone figures of the Archangels Michael and Gabriel were commissioned to flank the rose window above the entrance to the south transept. In 1965 he completed the models for a series of 31 bosses depicting the Passion of Christ which are located in the clerestory of the central nave. Carter also designed a medal to commemorate the dedication of the central tower. In 1968 his work at the National Cathedral received the National Sculpture Society's Henry Hering Memorial Medal as an outstanding example of collaboration between sculptor and architect.

Following his success in ecclesiastical sculpture, Granville Carter received commissions for two important public monuments. The heroic bronze group, *West Texas Pioneer Family*, was placed in a downtown park at Lubbock, Texas, in 1971. It was commissioned by American State Bank to depict the homesteaders who laid the foundation for the area's agricultural economy. A group of three figures dressed in pioneer clothing — a father carrying a hoe, a mother

with a Bible, and a young boy holding a lasso — represent the peaceful, religious people who settled the frontier.

An heroic bronze equestrian monument to the American Revolutionary war hero, *General Casimir Pulaski,* was commissioned in 1973 to commemorate the nation's bicentennial. After extensive study to determine the appropriate uniform, saddle and horse, Carter depicted the general wearing a Continental Army uniform, with saber drawn, about to lead a charge. Astride a rearing mount, Pulaski is seated upon a cossack saddle which was a sheepskin-covered wood frame. The monument was dedicated before a crowd of 8,000 people at Hartford, Connecticut, on July 3, 1976.

Sculpture portraits were another aspect of his career. A bronze bust of Jane Addams was modeled for the Hall of Fame for Great Americans at New York University. This led to a commission in 1969 of a three-times-life-size bust of Alexander Stewart, the founder of Garden City, New York. An heroic bust of Chiang Kai-Shek, commissioned by the Asian Studies Department, was placed at St. John's University in 1979, and another casting was made for the Chiang Kai-Shek Memorial at Taipei, Taiwan, in 1980. The clay model of the bust was exhibited in 1980 at the National Sculpture Society where it received the Therese and Edwin H. Richard Memorial Prize. A bronze portrait plaque of Coach John Heisman is at the Georgia Institute of Technology in Atlanta, and a memorial bust of Jay Panzirer was commissioned by his mother, Leona Helmsley, for a medical clinic in Orlando, Florida.

The art of the medal was an area where Granville Carter excelled. His design of the official Sesquicentennial Medal for the State of Maine was used as a cover embossment on the book, *Maine, a Guide Down East.* A panel of the silver and bronze issues of this medal was presented by the Governor of Maine to the Smithsonian Institution. Portrait medals of George Washington, James Fenimore Cooper, Thomas Edison, Jane Addams and Stonewall Jackson represented busts at the Hall of Fame for Great Americans. The George Washington Medal and a dedication medal for the Pulaski Monument were acquired by the Museum of Medals in Wroclaw, Poland. Plaques from the Thomas Edison medal were placed at the Edison National Historic Site at West Orange, New Jersey and the Edison Winter Home and Museum at Fort Myers, Florida. His medallic art earned him the coveted J. Sanford Saltus Award of the American Numismatic Society in 1976.

Granville Carter became a sculptor member of the National Sculpture Society in 1956 and was elected a fellow in 1959. He served as President of the Society from 1979 to 1982. Carter was elected an academician of the National Academy of Design in 1970 and a life fellow of the American Numismatic

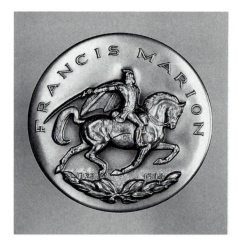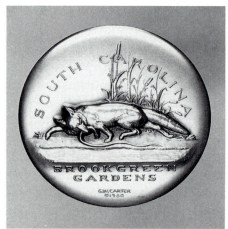

THE FRANCIS MARION MEDAL
BROOKGREEN GARDENS MEMBERSHIP MEDAL, 1980-81

Bronze. 7.6 cm in diameter. Signed on the reverse: *G.W. CARTER / © 1980* N.1980.001, placed in 1980. Other examples: New York, NY. American Numismatic Society, National Sculpture Society; London, England. The British Museum.

Society in 1976. The Council of American Artists Societies elected him President in 1981. He was a fellow of the American Artists Professional League which twice awarded him its Gold Medal. In 1981 he was elected a member of the Brookgreen Gardens Advisory Board.

Granville Carter died at Baldwin, New York on November 21, 1992.

The Francis Marion Medal
Brookgreen Gardens Membership Medal, 1980-81

Granville Carter's design for the tenth Brookgreen Gardens Membership Medal commemorated South Carolina's Revolutionary War hero, General Francis Marion, the Swamp Fox. General Marion is depicted on the obverse in an heroic equestrian composition. Astride his horse, Ball, with saber drawn, he looks back to urge his men onward. The words, *Francis Marion,* encircle the upper portion of the obverse. Below the horse and rider are his dates, *1732* and *1795,* and a spray of laurel signifying his victories.

The reverse of the medal depicts a fox devouring a snake, symbolizing the defeat of the British at the hands of Francis Marion. The fox is placed in a swamp environment of marsh grass and cattails. Encircling the upper area of

the design are the words, *South Carolina*, and beneath the fox and snake is *Brookgreen Gardens*.

M. Herring Coe

MATCHETT HERRING COE was born at Loeb, Texas, on July 22, 1907. He attended public schools and college in Louisiana and Texas and majored in electrical engineering before he became interested in sculpture. Later he studied with Carl Milles at the Cranbrook Academy of Art in Bloomfield Hills, Michigan. Coe served in the military during World War II.

In 1936 the State of Texas awarded him the commission for a bronze monument in memory of Dick Dowling placed at Sabine Pass, Texas. In a statewide competition he won first place for his design of a granite frieze for the New London School Memorial. The colossal bronze, *The Texan*, was created for the Texas State Confederate Monument at Vicksburg National Military Park, Mississippi, in 1960. Three bas-reliefs depicting vertebrates, invertebrates and the earth decorate the facade of the Biology-Geology Building at Lamar State College of Technology in Beaumont, Texas. A seated *Madonna and Child*, carved in wood, was exhibited at the National Sculpture Society's 75th anniversary exhibition in 1968.

Coe received several commissions of architectural sculpture for public buildings in the city of Houston. His work can be seen at the City Hall, the library of Rice University, St. Mary's Seminary chapel, St. Placidus Home for the Aged, and First Presbyterian Church. Stone reliefs for the pylons at the entrance to Hermann Park Zoo were commissioned by the City of Houston in 1952, and he also designed ornamentation for the Reptile Building.

Herring Coe's talent as a relief sculptor easily translated to work in the field of medallic art. In 1967 he was commissioned to design the 75th issue of the Society of Medalists. His medals were exhibited at the biennial congress of the Federation Internationale de la Medaille at Lisbon in 1979. He is a member of the National Sculpture Society and maintains a studio in Beaumont, Texas.

FANTASY MEDAL

Bronze. 7.3 cm in diameter. Signed on the reverse: *MHC / 1967*. N.1988.004, placed in 1989. Gift of Beatrice Gilman Proske.

Fantasy Medal

The 75th issue of the Society of Medalists incorporates a theme taken from original lines by the sculptor on the reverse of the medal: "Beyond the sky and beneath the sea are known but to God and fantasy." Herring Coe depicted on the obverse an underwater scene with a frolicking seahorse and mermaid. The circular design of the two aquatic acrobats is indicated by stylized line and little detail. The reverse of the medal features a flying saucer with beams of light flashing overhead. Arching around the top half of the medal are the theme lines.

Coe explained his rationale: "We attribute to the unknown aspects of the familiar, and it is not that we believe what we see, but that we see what we believe. Our eyes receive color patterns from afar, and the mind translates these into concepts that must fit into a limited capacity for perception...My marine equestrian could have been done long ago, but my flying saucer was designed with thoughts of energy fields and speculations about matter and anti-matter. Laser beams of light suggest the idea of directing radiant lines of force into parallel paths to maneuver a fantastic space ship far in advance of anything projected by man."[1]

1 "The Society of Medalists, Seventy-Fifth Issue, July 1967, Herring Coe, Sculptor," descriptive brochure, Sculptors' Clipping Files, Brookgreen Gardens Archives.

John Cook

A PROMINENT international medalist and professor of art, John Cook has been a major figure in a movement to reinstate the medallic art form to a position of prominence in the United States. His efforts have been directed toward ensuring the future of medallic art by fostering an interest in participation among young artists.

John Alfred Cook was born in Excelsior, Minnesota, on June 2, 1930. He received a Bachelor of Arts degree with distinction in 1954 from Arizona State University and a Master of Fine Arts degree in sculpture in 1956 from the State University of Iowa where he studied with H. Albrizio. To perfect his technique he studied from 1962 to 1963 under a Fulbright Research Fellowship at the Akademie der Bildenden Kuenste in Munich. He received a diploma in 1981 from the Stewart International School for Jewelers, and in 1982 studied at The Jewelry Institute in Providence, Rhode Island. Cook has been a professor of art at The Pennsylvania State University since 1964 and is a senior member of the graduate faculty.

Since 1960 Cook has had more than twenty solo shows and has participated in numerous group exhibitions. He has executed many public and private commissions including the United States Commemoration Medal of the XIX FIDEM Congress held in Florence, Italy in 1983.

John Cook designed *Frivolity and Vanity*, the Society of Medalists 105th issue, in 1982. In the following years he received many commissions for award medals including The Dickinson College Art Award in 1983 and the Margaret Kleppinger Zimmerman Award and The Pennsylvania Council of the Arts Distinguished Artists Medal in 1984. He has completed several commissions for Penn State including two presentation sculptures and nine commemorative and award medals. In 1982 Cook was commissioned to execute a bronze relief for the Atherton Memorial at the University in collaboration with Marcel Breuer Architects of New York City. The University entrusted to him the restoration of sculpture by George Grey Barnard at the auditorium in 1972, restoration of the *Nittany Lion* with Heinz Warneke in 1979, and restoration of *Faith in Church in the Future* in 1982.

His medals are in the collections of The British Museum, the Hungarian National Museum, the Swedish Royal Coin Cabinet, the Gulbenkian Modern Art Center at Lisbon, the Estense Gallery Cabinet of Medals at Modena, the American Numismatic Society, the Corcoran Gallery, the Smithsonian Institution, the Museum of the American Numismatic Association and The Pennsyl-

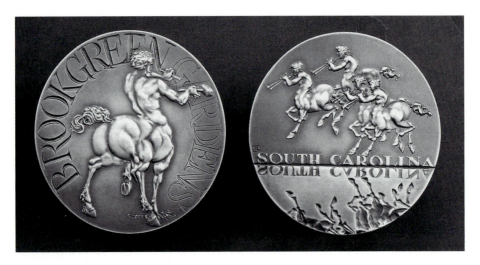

THE CENTAUR CARVER MEDAL
BROOKGREEN GARDENS MEMBERSHIP MEDAL, 1986-87

Bronze medal. 7.6 cm in diameter. Signed on obverse and reverse: *JC*. Stamped on edge: © 1984 MEDALLIC ART CO. - DANBURY, CT - BRONZE N.1985.001, placed in 1986. Other examples: New York, NY. American Numismatic Society, National Sculpture Society; London, England. The British Museum.

vania State University Museum of Art.

John Cook is a member of the Federation Internationale de la Medaille at Paris. He has served on the board of directors of the American Medallic Sculpture Association, of which he was a founder, and has been an arts advisor to the Council of the Mid-Atlantic Conference of Canadian Studies.

In the summer of 1984, he spearheaded the International Medallic Art Workshop which was held on the Penn State campus. He has organized traveling exhibitions of medallic art in order to give American audiences a view of contemporary international medals. John Cook has been instrumental in stimulating a renewed interest in relief sculpture and medallic design as a part of art curricula in art schools and universities. He continues to promote the transition of the American medal into a celebrated art form through public lectures, addresses, publications and exhibitions. In 1987 he received the J. Sanford Saltus Award of the American Numismatic Society in recognition of his distinguished medallic work.

The Centaur Carver Medal
Brookgreen Gardens Membership Medal, 1986-87

The 1986-87 medal featured on the obverse a mythical centaur — half man, half horse — carving the words, *Brookgreen Gardens,* which encircle the outer edge of the medal. The creature, facing away from the viewer, is about to strike a chisel held in its left hand with a mallet in its right, as it carves the letter *n* in *Brookgreen.* The word, *Gardens,* is shown in outline, awaiting completion by the bearded centaur carver. A small pile of stone chips lies at the feet of the centaur.

On the reverse John Cook depicted a multiple image of the centaur playing double pipes and galloping across the words, *South Carolina.* A mirror image of the centaur, shown as four figures, and the legend cover the lower quarter section of the medal creating a reflection like that of a still pool.

John Cook explained his use of intaglio, a sunken design engraved on a surface: "As to reasons for my use of intaglio rather than modelling for constructing the pattern, it seemed appropriate as my centaur on the obverse is also a carver. Moreover, I wanted a very clean jewel-like image and felt that I could gain this most readily by stroking the plaster with carving hooks, thus allowing the linear quality of the stroke to define the form. This was especially so on the reverse where each stroke on the image was repeated four times. The 'reflection' on the reverse was simply a mould of the original intaglio image, the entire reverse then cast again to produce the final positive/negative images."[1]

1 Letter to Joseph Veach Noble, September 2, 1984, Correspondence File, Brookgreen Gardens Archives.

Laci de Gerenday

LACI ANTHONY DE GERENDAY, born in Budapest, Hungary, August 17, 1911, was brought to this country as an infant by his parents. His father, Ladislaus de Gerenday, a writer and minister on sabbatical leave, took the family to Connecticut. The First World War prevented their scheduled return to Hungary and they decided to remain in the United States. The father's work took the family to Ohio and to South Dakota. His mother, Helen (Jiraszek)

de Gerenday, was an opera singer and music teacher who encouraged her son's artistic talent. At the age of ten, young Laci won a state-wide competition for a drawing after which he studied at the Butler Institute in Youngstown, Ohio.

After attending the South Dakota School of Mines from 1929 to 1930 and Ursinus College at Collegeville, Pennsylvania from 1930 to 1931, de Gerenday traveled to New York City to study at the National Academy of Design School and the Beaux Arts Institute of Design. An initial interest in painting led to studies with Charles Hinton, Leon Kroll and Arthur Covey. Then, from 1932 to 1935, he studied sculpture during the days with Charles Keck, Chester Beach, Gaetano Cecere, Ulric Ellerhusen and Anthony de Francisci at the Academy and Beaux Arts Schools. In the evenings, for a period of three years, de Gerenday was apprenticed to the Hungarian sculptor, Alexander Finta.

He was married December 19, 1939 to Mary Ellen Lord. After enlisting in the United States Army during World War II, de Gerenday served for three years as a combat engineer in the Mediterranean and European theaters of operation. For his service he was awarded four battle stars and a bronze arrow head. At the end of the war, he was one of two persons from each Division chosen to attend a foreign university. He elected to further his education at the University of Shrivenham in England with studies in philosophy, art history and Russian history.

The sculptor's great love for animals is expressed in his work and whenever possible animals are incorporated into his designs. In 1947 a medal of St. Francis of Assisi was awarded the Ellin P. Speyer Prize of the National Academy of Design. *Mother and Child*, a small bronze of a Rhesus monkey cradling her infant, was awarded the Bedi-Makky Foundry Prize in 1983 at the National Sculpture Society exhibition. A linear composition of a stalking *Cougar* with taut musculature exudes feline grace and stealth. In contrast, a standing American *Bison* and the North African wild sheep or *Aoudad*, modeled with smooth surfaces and decorative fringes of hair, display solidity and compaction of line. All three are cast in bronze.

A large body of Laci de Gerenday's work is comprised of relief sculpture. The first of two Lindsey Morris Memorial Awards for bas-relief was awarded to plaster reliefs of *St. Francis of Assisi* in 1955 at the National Sculpture Society exhibition. The second was given in 1981 to a bronze *Self Portrait*, the sculptor's diploma work for the National Academy of Design. A bronze relief, *Animals of Saint Francis*, was awarded the Lindsey Morris Memorial Prize of the Allied Artists of America in 1969. A portrait relief of the sculptor, Jacques Lipchitz, was purchased by Lipchitz as a gift for his daughter after he saw it cast in bronze

at the foundry. In 1973 a personal interest in ecology led him to create a bronze relief, eleven inches in diameter, honoring the marine biologist and author of *Silent Spring,* Rachel Carson. An equestrian relief in bronze in memory of Lieutenant Junot of the French Foreign Legion is in the Museum of Algiers in Algeria, Northwest Africa.

Using many of the skills perfected for working in relief, Laci de Gerenday also is a fine medalist. *Preserve Our Heritage,* the 1981 issue of the Society of Medalists, depicted a cougar on the obverse and, on the reverse, a group of animals that represented the vanishing wilderness. This medal received the Wendell Clinedinst Award of the Allied Artists of America in 1982. For the Hall of Fame for Great Americans at New York University, de Gerenday designed a medal in honor of Admiral David Glasgow Farragut. He is the creator of the Gold Medal of the Society of Electrical Engineers and the Golden Anniversary Medal of the City of New York. For the National Commemorative Society he designed silver coins in honor of the Battle of the Alamo and the Centennial of Professional Baseball.

Ecclesiastical subjects occupy an important position in his collection of works. Laci de Gerenday's plaster model of *Saint Kapisztran* received the Roman Bronze Foundry Award at the 1980 exhibition of the National Sculpture Society. A mahogany portrait relief of Hungary's Roman Catholic prelate, Cardinal Jozsef Mindszenty, whose strong opposition to communist rule was evidenced during the post-World War II era, was given the Lindsey Morris Memorial Award by the Allied Artists of America in 1978. A small walnut carving of *St. Francis and Birds,* shown in 1986, depicted the legend of the friar's sermon to the birds. In *Birth of Jesus,* a small bronze group of the Holy Family, Mary holds the infant while Joseph, standing behind her and looking down upon the sleeping baby, rests his hands protectively upon her extended arms. The repetition of circular patterns conveys the idea of unity and safety. This group received the Silver Medal of Honor from the Allied Artists of America in 1977.

Laci de Gerenday is an excellent woodcarver, preferring the textures and simplicity of design that can be achieved through this medium. A second Ellin P. Speyer Prize in 1963 was awarded to a depiction of St. Francis carved from a large cherry log found near Bethlehem, Pennsylvania. In 1977 this carving was given the Council of American Artist Societies' Award for traditional work at the 44th Annual Exhibition of the National Sculpture Society. *Noon Mail,* a walnut relief five feet in diameter, is in the United States Post Office in Tell City, Indiana. A six-foot square relief carved in cherry, entitled *The Building of Grand Crossing,* was done in 1940 and placed at the Court House in Aberdeen,

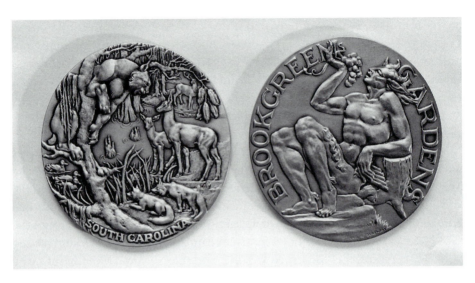

T HE M YTHICAL AND THE R EAL W ORLD M EDAL
B ROOKGREEN G ARDENS M EMBERSHIP M EDAL, 1987-88

Bronze. 7.6 cm in diameter. N.1985.002, placed in 1987. Other examples: New York, NY.
American Numismatic Society, National Sculpture Society; London, England. The British
Museum.

South Dakota. He received these government commissions as a result of being
a runner-up in a national competition to design sculpture for the United States
Treasury Department.

Laci de Gerenday is a fellow of the National Sculpture Society and an
Academician of the National Academy of Design. He holds membership in
Allied Artists of America, the Hudson Valley Art Association, the National
Society of Literature and the Arts, the American Medallic Sculpture Associa-
tion and The National Arts Club. After the death of his wife in 1976, he
married a fellow sculptor, Elisabeth Gordon Chandler, on May 12, 1979. They
are both instructors at the Lyme Academy of Fine Arts in Old Lyme, Connecti-
cut, where de Gerenday has taught figure sculpture since 1980. He lives and
has his studio in Old Lyme.

The Mythical and the Real World Medal
Brookgreen Gardens Membership Medal, 1987-88

This membership medal for Brookgreen Gardens provided an opportunity
for Laci de Gerenday to portray his love for living things. In 1986 he and his
wife visited Brookgreen to study the sculpture, animals and plantings. The

title, "The Mythical and the Real World," refers to the collections of Brookgreen Gardens: the sculpture (mythical) and the animals and plants (real).

On the obverse of the medal a satyr reclines against a stump and holds a bunch of grapes that he is about to lower into his open mouth. In his left hand the satyr holds a syrinx, the musical instrument made from reeds of descending size, bound together with vines. Around the perimeter of the medal is the legend, *Brookgreen Gardens.*

Animals and plants indigenous to the Southeast, particularly South Carolina, are depicted on the reverse of the medal. A fascination with the cypress knees and Spanish moss seen during the sculptor's visit to Brookgreen found expression in the design. Virginia white-tailed deer — buck, doe and fawn — a bobcat, a pair of foxes, and three ducks are species typically found in a swamp environment. The legend, *South Carolina,* frames the bottom of the reverse.

"The Mythical and the Real World" was one of the medals chosen to represent the United States in the exhibition of the Federation Internationale de la Medaille held for the first time in this country at the American Numismatic Association, Colorado Springs, Colorado, in 1987. In the following year, the obverse of the medal was awarded the Lindsey Morris Memorial Prize at the National Sculpture Society exhibition.

Donald De Lue

FOR THE sculptor's biography, please refer to pp. 101-104.

The Sculptor's Medal
Brookgreen Gardens Membership Medal, 1978-79

This high-relief medal was the first of six in the Brookgreen Gardens series to depict the theme of the sculptor at work. Donald De Lue submitted an unprecedented total of 33 completely rendered sketches of designs for this medal. The two chosen designs depicted a sculptor modeling Diana, goddess of the moon and the night, in clay and carving Apollo, god of the sun and the day, in stone.

On the obverse the sculptor sits before his creation modeling the clay statue

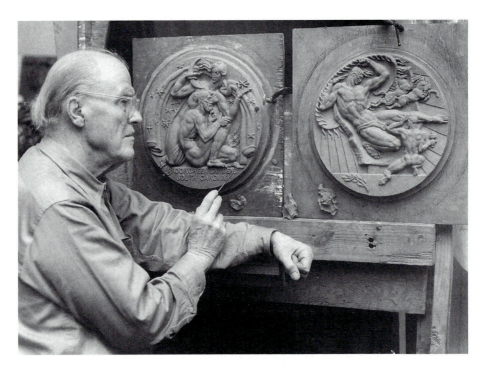

THE SCULPTOR'S MEDAL
BROOKGREEN GARDENS MEMBERSHIP MEDAL, 1978-79

Bronze 7.6 cm in diameter. Signed: *D De LUE / Sc* © *78* N.1978.001, placed in 1978. Other examples: New York, NY. American Numismatic Society, National Sculpture Society; London, England. The British Museum.

of Diana. In his left hand he holds clay to be applied to his work and with his right thumb he models her arm. She is wearing a diaphanous gown and thrown over her shoulders is her cloak spangled with stars. The crescent moon floats beside her. The words, *Brookgreen Gardens / South Carolina*, appear beneath the sculptor. On the reverse the sculptor, resting on one knee, carves in stone the colossal figure of Apollo. The sun god is shown at the moment of his awakening, raising the flaming sun on his shoulders, as the horses of the sun begin their journey across the sky. The rays of the sun fill the field of the medal. A branch of laurel, symbolic of praise awarded great sculpture, rests in the area below the sculptor.

The medal presents opposites — night and day, stone and clay, male and female, positive and negative space. The high relief of this design was difficult to reproduce and, like De Lue's later medal for the Society of Medalists, set a new standard for excellence in medallic art. The medal was commissioned by

Brookgreen Gardens for distribution to its Sustaining, Patron and Life Members during the 1978-79 membership year.

Don Everhart II

DON EVERHART was born in York, Pennsylvania, on August 19, 1949. He attended Kutztown State University, graduating in 1972 with a Bachelor of Fine Arts degree. Although he began employment as an illustrator, in 1974 he joined the staff of the Franklin Mint as Sculptor-in-Residence. He held this position until 1980 when he left to establish his own studio. Everhart now devotes his time to sculpture, creating figures and portrait busts, and to work as a freelance designer of collectible figures and medals for a number of firms specializing in that field. Some of his clients include Walt Disney Productions, The Bradford Exchange, Lenox, Tiffany & Co., Lance, Reed Barton and Schmid. Private commissions include a pewter figurine for the Philadelphia Flyers Hockey Team and a crystal *Space Shuttle Challenger* for the Chrysler Corporation.

Another facet of his career is medallic art design. Don Everhart has designed more than 700 coins and medals for nations and collections throughout the world. *The Guitar Player*, created in 1977, was accepted for the exhibition of the American Medallic Sculpture Association in 1983. His *Dance of the Dolphins*, the 106th Issue of the Society of Medalists, won first prize in 1985 at the National Sculpture Society's Reliefs and Medals Exhibition in New York. This medal was included in the 21st World Exposition of the Federation Internationale de la Medaille, held in 1987 at Colorado Springs, Colorado. Also in 1985 Manfra, Tordella and Brookes, Inc. commissioned him to design a fine silver trade piece commemorating the 1986 centennial of the Statue of Liberty. This led to designs for all of the Liberty commemorative fine art bullion ingots and medals offered by that firm. In 1987 he was one of eleven American artists selected by the United States Treasury Department to submit designs for coinage celebrating the Bicentennial of the Constitution. The Georgetown University Bicentennial Medal was commissioned in 1988. Medals he designed are in the collections of the Smithsonian Institution and the American Numismatic Society.

Don Everhart is a member of the American Medallic Sculpture Association,

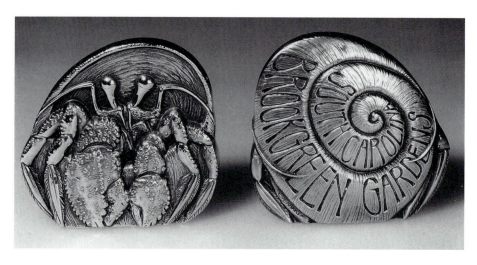

T HE H ERMIT C RAB
B ROOKGREEN G ARDENS M EMBERSHIP M EDAL, 1991-92

Bronze. Irregular width: 7.3 cm; height: 6.7 cm. Signed on reverse: *EVERHART* Stamped on bottom edge: © 1991 N.1990.001, placed in 1991. Other examples: New York, NY. American Numismatic Society, National Sculpture Society; London, England. The British Museum.

the Federation Internationale de la Medaille, the American Artists Professional League, Knickerbocker Artists and the Philadelphia Watercolor Club. He was an instructor of sculpture at the Chester County Art Association from 1985 to 1988, and received first prize in its 1990 juried sculpture show. Today he lives in West Chester, Pennsylvania.

The Hermit Crab
Brookgreen Gardens Membership Medal, 1991-92

A departure from previous medallic designs in the Brookgreen Gardens series, this ingenious free-standing medal actually is a small sculpture. On the obverse is depicted a hermit crab, *Pagurus pollicaris*, peeking out from the shelter of its home, *Polinices duplicatus*, the moon shell. Both species are abundant in South Carolina. The reverse shows what an observer would see in the wild: the rear view of the shell with the crab's appendages tucked in close to the sides. Within the spiral of the shell are lettered the words, *Brookgreen Gardens* and *South Carolina*.

The sculptor wrote, "I wanted to do something different than the tradi-

tional round art medal and I wanted to incorporate an aquatic theme. I was not aware of any previous medal in the series that addressed the coastal region of the state. During my research I came across some photos of hermit crabs. They intrigued me because not only were two animals involved (the crab and the empty moon shell) but the crab carries its home with him wherever he goes. In these days of homelessness it seemed like a theme worth pursuit. Although this subtle social parallel exists, I mainly wanted to portray something every South Carolina beachcomber sees in a new light. The lettering on the shell just seemed to be a natural to me, as though it was carved into the shell itself. The style is half art-nouveau and half psychedelic poster lettering from the '60s."[1]

The inaugural Hermit Crab Medal was presented to the Honorable James Brown Morrison of Georgetown, South Carolina.

1 Undated letter, "Don Everhart II," Sculptor Correspondence Files, Brookgreen Gardens Archives.

Marshall Fredericks

SEE pp. 126-137 for the sculptor's biography.

The Gazelle Medal
Brookgreen Gardens Membership Medal, 1977-78

The design of the medal's obverse was adapted from the sculptor's *Gazelle* at Brookgreen Gardens. On the reverse are two Carolina wrens, South Carolina's state bird, perched in rhododendron foliage. The reverse design is modeled in low relief, nearly concave, while the obverse is slightly raised.

The Gazelle Medal was part of the United States entry in the biennial exhibition of the Federation Internationale de la Medaille held in Florence, Italy, in 1983. The sculptor was commissioned to design the medal for distribution to Sustaining, Patron and Life Members during that membership year.

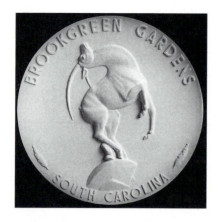

THE GAZELLE MEDAL
BROOKGREEN GARDENS MEMBERSHIP MEDAL,
1977-78 (OBVERSE)

Bronze. 7.6 cm in diameter. Signed on reverse: *Marshall M. Fredericks Sculptor* Around edge: MEDALLIC ART CO. N.1977.001, placed in 1977. Other examples: New York, NY. American Numismatic Society, National Sculpture Society; London, England. The British Museum.

Edward R. Grove

EDWARD RYNEAL GROVE was born to Harry Muth and Bertha Mae (Sigler) Grove at Martinsburg, West Virginia, on August 14, 1912. He graduated from the National School of Art, Washington, DC, in 1933, then studied at the Corcoran School of Art from 1934 to 1936 with Hans Schuler, Heinz Warneke and Eugen Weisz. Following graduation he worked as a die sinker and vignette and portrait engraver for the Bureau of Engraving and Printing. Later, in 1946, he continued his study of painting under Robert Brackman at Noank, Connecticut. Edward Grove married the sculptor, Jean Virginia Donner, on June 24, 1936.

An offer to work for the Security-Columbian Bank Note Company in 1947 took him to Philadelphia. For the next fifteen years he refined his skills in portrait and vignette engraving and produced nine postage stamps for the United States and hundreds of issues for foreign countries, and designed currency of Vietnam, Laos, Indonesia and Sudan. A major commission was received in 1958 to design and paint *The Communion of Saints* for the Episcopal Church of the Holy Comforter in Drexel Hills, Pennsylvania. Completed with the help of his wife over a six-year period, the work was a 400 square foot oil-on-tempura mural. Grove authored and illustrated a descriptive brochure for the church and had a solo exhibit, "Development of a Church Mural," at the Philadelphia Art Alliance in 1960.

In 1962 he accepted a position as a sculptor-engraver with the United States Mint at Philadelphia and a new kind of career opened up to him. During his three years at the mint, Grove designed a number of important works including the Congressional Gold Medal which was awarded to the enter-

tainer, Bob Hope, by President John F. Kennedy in 1963. He was given the job of creating the Martha Washington test coin for the first clad coinage. In 1965 Grove moved to West Palm Beach, Florida and set up his own studio to pursue a full-time free-lance career.

Portraits have been an important part of his work. He has received more than 600 commissions in this field which range in medium from murals to medals. A portrait in oil entitled *Sculptor by Firelight; the Artist's Wife* was painted in 1946. An oil portrait of Reverend Canon Hundson Cary, Jr., rector of the Church of Bethesda-by-the-Sea in Palm Beach, was done in 1972. A larger-than-life bronze portrait plaque of Paul B. Magnuson, M.D., was commissioned by the Rehabilitation Institute of Chicago and dedicated in 1974.

Edward Grove has enjoyed an outstanding career in the field of medallic art. His series of thirty medals commemorating famous people and events of World War II was issued by Presidential Art Medal, Inc., between 1966 and 1970. Plaster models for the Churchill-Dunkirk Medals from the series were shown in 1967 at the 34th annual exhibition of the National Sculpture Society where they received the Lindsey Morris Memorial Prize. In 1966 and 1974 he was commissioned to design medals of William Penn and Francis Parkman for the Hall of Fame for Great Americans. In 1969 he was presented the Gold Medal of the American Numismatic Association and was named Sculptor of the Year at its annual meeting. The National Sculpture Society recognized his expertise in bas-relief by awarding him the Mrs. Louis Bennett Prize in 1971.

To commemorate its Fiftieth Anniversary in 1980, he created one of two anniversary medals for the Society of Medalists. The obverse featured a montage of symbols from nature that had appeared on previous issues, and the reverse included in a circular pattern the names of all the medalists who had created designs for the Society. In 1982 he collaborated with his wife in designing a goldpiece for the American Express Company. He was an American delegate to the XIX Congress of the Federation Internationale de la Medaille held at Florence, Italy, in 1983. For a distinguished body of work, in 1985 he received the J. Sanford Saltus Award of the American Numismatic Society.

A departure from his usual medallic work was an *American Eagle*, an heroic gold-leafed bronze commissioned for the Town of Palm Beach. This American Bicentennial monument was dedicated on July 4, 1976. Edward Grove has been the official sculptor-engraver of the Order of St. John of Jerusalem, Knights of Malta since 1967, and is a past president of the Steel and Copper Engravers League. He is a fellow of the National Sculpture Society, an

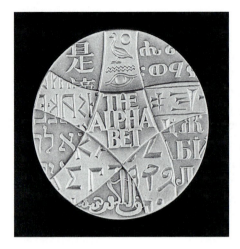 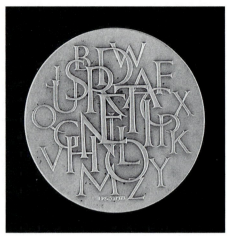

THE ALPHABET MEDAL

Bronze. 7.3 cm in diameter. Signed: *ERG © 1973* N.1988.016, placed in 1989. Gift of
Beatrice Gilman Proske.

associate of the National Academy of Design and a life member of the
American Numismatic Society. He is involved in other organizations includ-
ing the Token & Medal Society, Federation Internationale de la Medaille,
American Numismatic Association, American Medallic Sculpture Association
and Artists Equity. In addition to his own work as an artist, Edward Grove has
taught drawing and portraiture at the Flagler Art Center in West Palm Beach.

The Alphabet Medal

The 88th issue of the Society of Medalists dealt ingeniously with the subject
of the alphabet and its evolution. On the five raised arms of the obverse,
Edward Grove showed the key stages in the development of the Roman
alphabet which is seen in the center panel.

Clockwise from the top are Egyptian hieroglyphs, Babylonian cuneiform
and characters from the Moabite Stone — a Semitic work dating from the 9th
century B.C., Greek and Oscan. The latter is considered the final link with the
Roman letters used today. The lower triangular areas include examples in
relief of other well known alphabets in contemporary use: Ethiopian, Cyrillic,
Arabic, Hebrew and Chinese. The reverse depicts a montage of the 26
characters in the Roman alphabet, arranged in descending size according to
their frequency of use.

In explaining the medal, Grove wrote: "Frederick W. Goudy, dean of American typographic designers, referred to the development of the alphabet as 'the most fruitful of all achievements of the human intellect.' This design is intended to honor the significance of the achievement, to trace briefly its evolution and to depict the abstract beauty of the forms so familiar to us."[1]

1 "The Society of Medalists Eighty-eighth Issue, Edward R. Grove, Sculptor, Fall, 1973," descriptive brochure, Sculptor's Clipping Files, Brookgreen Gardens Archives.

Adlai Hardin

FOR THE sculptor's biography, please see pp. 118-121.

The Allston Medal
Brookgreen Gardens Membership Medal, 1983-84

A topic from Brookgreen's plantation history served as the theme of the 1983-84 membership medal. One branch of the illustrious Allston Family had been owners of the property throughout the 18th century. Adlai Hardin depicted William Allston, owner of Brookgreen Plantation, and his wife, Rachel Moore Allston, standing in front of their house. He used a photograph of a portion of the original house, which was destroyed by fire in 1901, to recreate the design for the Brookgreen home. Live oaks, shown behind the house, are abundant on the property. Allston's birth and death dates, *1739* and *1781*, appear to the left and right of his name and beneath that is the designation, *Plantation Owner*. The legend, *Brookgreen Gardens South Carolina*, fills the lower part of the medal.

On the reverse is their son, Washington Allston, seated at his easel and canvas, palette and brushes in hand. Washington Allston, born at Brookgreen Plantation in 1779, was the most celebrated American painter of the Romantic Period. His name is flanked by his birth and death dates, *1779* and *1843*, and the legend, *Distinguished Painter*, encircles the lower portion of the design.

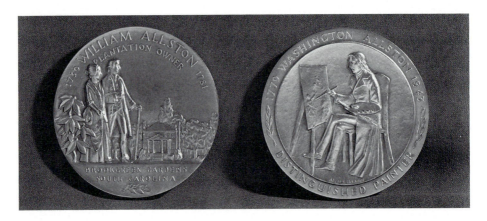

THE ALLSTON MEDAL
BROOKGREEN GARDENS MEMBERSHIP MEDAL, 1983-84

Bronze. 7.6 cm in diameter. Signed: *ADLAI S. HARDIN* N.1982.001, placed in 1983. Other examples: New York, NY. American Numismatic Society, National Sculpture Society; London, England. The British Museum.

Terry Iles

A NATIVE OF Morayshire, Scotland, Terry Iles began her study of sculpture as an adult. During World War II, she made her first visit to America in a convoy of Liberty ships as a Commander of the Women's Junior Air Corps. Her husband had died in 1940, leaving her with three children, and eventually she felt that America with the freedoms it offered would be the best home for her family.

After relocating permanently, the next twelve years were spent establishing herself in this country and earning a living. During this period she developed the desire to become a sculptor but never had the opportunity to acquire the training for it. After her children became independent, she was able in the evenings to attend the National Academy of Design School where she studied under Joseph Kiselewski and other academicians.

Although she works in many mediums, including direct carving, she concentrates on portrait busts, reliefs and medallic art. For the State of Wyoming she created the Buffalo Bill and the Esther Hobart Morris Medal. Her sculpture, *Nereid*, received a bronze medal in 1968 from the National Sculpture Society, and a bust of Joseph Kiselewski was awarded the Dessie Greer Prize of the National Sculpture Society. A bust of Julian Clarence Levi

was given an honorable mention when exhibited at the Fine Arts Museum of Springfield, Massachusetts. In 1967 she was elected a member of the National Sculpture Society.

Research Medal

For the 77th issue of the Society of Medalists, the sculptor chose to depict the theme of research. The obverse illustrates a scientist looking through a microscope, his notes laid out near his left hand. He represents the concentration and dedication required to conduct scientific research. Framing the scene is the legend, *Perseverance and Dedication.* The reverse features a spider on an orb web, the epitome of patience and persistence. The asymmetrical design of the web, accented by the spider and a leafy frond, creates a pleasing composition.

Terry Iles explained her rationale: "A scientific theory is built up, fact by fact, as the web is built up, thread by thread. When the theory proves inadequate, it is altered or abandoned as the web is repaired or replaced when damaged in use. The scientist probes one possibility after another until at length he arrives at a fact or an insight, just as the spider sends out thread after thread until at length one holds fast and becomes the suspension cable of the web. The scientist builds upon his fact, as the spider upon his web line."[1]

Bronze. 7.3 in diameter. Signed on obverse: *T. ILES © 1968.* On the edge: MEDALLIC ART CO. N.Y. N.1988.007, placed in 1989. Gift of Beatrice Gilman Proske.

1 "The Society of Medalists, 77th Issue, November 1968," descriptive brochure, Brookgreen Gardens Archives.

Sten Jacobsson

BORN IN Stockholm, Sweden, on March 28, 1899, Sten Wilhelm John Jacobsson was the son of creative parents. His mother was a teacher of weaving and crafts and his father was a self-employed designer and tailor. Jacobsson studied architecture, art and engineering at schools in Sweden, Germany and France.

He came to America in 1925 with the Swedish Art Exhibit shown at The Metropolitan Museum of Art in New York. Deciding to remain in this country,

he became associated with an architectural firm in New York City which specialized in work for churches and remained in that position until 1929. Moving to the midwest, he became head of the Art Department at Artisan Guild, a part of the Henry Ford Art School in Michigan. He held positions as instructor at Wayne State University and Detroit Country Day School, and eventually became assistant to Carl Milles at the Cranbrook Academy of Art in Bloomfield Hills, Michigan.

During World War II, Jacobsson volunteered and was assigned to Army Ordinance as an engineer-designer. After the war he worked with the Federal Housing Administration as an architectural examiner and construction analyst. For ten years he was president of a corporation which promoted fine creative design. He was appointed to serve as an examiner of candidates of master of arts degrees in the graduate school at Wayne State University.

In the early 1970s Sten Jacobsson retired to Detroit, Michigan. He died in 1983.

Christ and Humanity Medal

The 85th issue of the Society of Medalists dealt with the human condition of the 1970s as compared with ancient times. On the obverse a bearded figure in a long robe stands with arms outspread before the masses of humanity, representing the crowded world of the present. The people are delineated by a series of small rectangles for bodies and circular knobs for heads, creating a maze-like effect. According to the sculptor, "The Christ-like figure reminds of the necessity of exhibiting ethical consideration toward one another. The figure also represents the urgent need for cooperation for the benefit of all in the world."[1]

The reverse depicts five figures in outline, floating and turning in playful postures. Silhouettes of birds complete the scene. The reverse represents the relatively uncrowded world of centuries ago and the pagan joys that were associated with those times.

Bronze. 7.3 cm in diameter. Signed: *S.J.* © / *1972* N.1988.013, placed in 1989. Gift of Beatrice Gilman Proske.

1 "85th Issue, The Society of Medalists, Sten Jacobsson, Sculptor, Spring, 1972," descriptive brochure, Sculptor's Clipping Files, Brookgreen Gardens Archives.

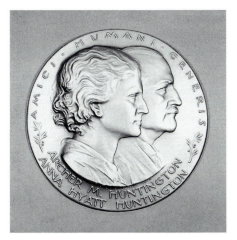

THE HUNTINGTON RELIEF AND
BROOKGREEN GARDENS MEMBERSHIP MEDAL, 1973-74

Bronze. 7.6 diameter. Signed: *C.P. JENNEWEIN SC. 19©70* N.1971.001, placed in 1973. Other examples: New York, NY. American Numismatic Society, National Sculpture Society; London, England. The British Museum.

Carl Paul Jennewein

SEE pp. 56-64 for the sculptor's biography.

The Huntington Relief and Brookgreen Gardens Membership Medal, 1973-74

In 1971 Brookgreen Gardens initiated a membership program with one of the benefits being an art medal commissioned and struck each year. Paul Jennewein, president of the Board of Trustees, used his design of a relief commemorating Archer and Anna Huntington for the inaugural medal.

On the obverse, portraits of the Huntingtons are shown in profile with the legend, *Amici . Humani . Generis*, encircling the top. The Latin inscription refers to their attributes: friends, philanthropists, creators. The reverse illustrates Jennewein's adaptation of the sculpture, *Fighting Stallions*. Created by Anna Hyatt Huntington in 1950 for the highway entrance, the sculpture is an important landmark and the symbol of Brookgreen Gardens. Her name appears to the right of the sculpture and the words, *Brookgreen Gardens*, appear

across the bottom.

The galvanos were made and the medal was struck by the Medallic Art Company of Danbury, Connecticut.

Bronze galvano. Obverse: 21.8 cm in diameter. Signed: *C. P. JENNEWEIN SC. 19 © 70* R.1971.003, placed in 1971. Reverse: 19.9 cm in diameter. Signed: *Anna Hyatt Huntington* R.1971.004, placed in 1971.

Marcel Jovine

MARCEL JOVINE emigrated to the United States after World War II and began a new life that drew upon his background in horsemanship, architectural training and engineering. Born in Naples, Italy, on July 26, 1921, and raised in Turin, he attended the University of Naples and was commissioned by the Military Academy at Turin, which is the Italian equivalent of the U.S. Military Academy at West Point. While Jovine served in the Italian army, a fellow officer, the sculptor Bruno Burachini of Siena, was impressed with his potential talent and taught him the rudiments of sculpture. He has had no sculpture training other than a few months with Burachini.

After coming to America, Jovine worked for over 15 years as an industrial designer for Ideal, Mattel, Aurora and other large toy companies. The *Visible Man* and *Visible Woman*, complete models of the human body with removable, anatomically correct organs, were two of his creations. Still popular items, they are frequently used in schools.

Jovine has become well known for his renditions of great thoroughbred race horses. His list of famous horses immortalized in bronze includes Wajiama, Affirmed, Seattle Slew, Myrtlewood, Spectacular Bid, Nashua, John Henry, Fiddle Dancer Boy and Conquistador Cielo. Sculptures of Myrtlewood, the founding mare of Spendthrift Farms in Lexington, Kentucky, owned by Leslie and Brownell Combs, and Spectacular Bid, the Derby winner from Baltimore, Maryland, owned by Mr. & Mrs. Harry Meyerhoff, were donated by their owners to the National Museum of Racing in Saratoga Springs, New York. At the 1983 exhibition of the National Sculpture Society, the bronze, *Spectacular Bid*, was awarded the M.H. Lamston Prize for meritorious sculpture.

Marcel Jovine devised a new technique of armature construction to create the most lifelike poses for his horse sculpture. Working with the belief that the

frame upon which the clay is built up must be accurately articulated in order to achieve a good clay model, he designed and constructed a highly detailed skeleton, fully jointed and in accurate scale. This custom skeleton was attached to a vertical framework of his own design and construction which allowed the model to be suspended and rotated at every possible angle. The resulting flexibility enabled a stopped-action pose upon which the clay could be applied.

Another facet of Jovine's sculptural talent is medallic art. He has achieved international stature as a creator of medals which are noted for detail, historical authenticity, and superb artistry. A series of calendar medals for the Medallic Art Company of Danbury, Connecticut, have become collectors' items. Seventeen-inch models for his 1976 Bicentennial Calendar, commissioned by the American Revolution Bicentennial Administration, won the Lindsey Morris Memorial Prize for bas-relief of the National Sculpture Society in 1977. He was commissioned to create the 100 Year Anniversary Medal of the Kentucky Derby. In 1980 he received the commission to design a medal commemorating the Olympics held at Lake Placid, New York. His design incorporated nine winter sporting events of the Olympic games. He also was selected to create a series of sculpture of Olympic athletes for American Telephone and Telegraph. These art works depict each athlete at his moment of greatest achievement.

The 1980 issue of the Society of Medalists was another Jovine creation. In 1982 he won the competition to design presentation medals for the winners of the International Violin Competition held in Indianapolis, Indiana. He has designed commemorative medals for the Viking I and II missions and the Soyuz-Apollo Linkup for the National Aeronautics and Space Administration, a series of 36 medals commemorating "The Opening of the West" for Wells Fargo. The 60th anniversary medal for the Grand Central Art Gallery in New York City, done in 1981, depicted the statuary atop Grand Central Station on the obverse, and the likenesses of the founding artists John Singer Sargent, Edmund Greacen, and W.L. Clark on the reverse.

Jovine was a winner from among seven sculptors of the 1982 competition for the design of the American Numismatic Society's 125th anniversary medal which became one of the most successful issues in the Society's century–long series. The rectangular-shaped medal depicts on the obverse a minter striking a coin with a hammer. Behind the minter are representations of various coins from the Society's collection. The reverse portrays a screw press and a pantograph machine, used for reducing designs in the preparation of dies. The relief of the medal was executed so the obverse was visible when the medal was

THE SCULPTOR AT WORK MEDAL
BROOKGREEN GARDENS MEMBERSHIP MEDAL, 1985-86

Bronze. 7.6 cm in diameter. Signed with the artist's cipher. Stamped on the edge: ©1986 MEDALLIC ART CO. – DANBURY, CT. – BRONZE N.1984.001, placed in 1985. Other examples: New York, NY. American Numismatic Society, National Sculpture Society; London, England. The British Museum.

laid on a flat surface, as well as when viewed in the conventional manner.

Marcel Jovine was selected by the American Numismatic Society as the 1984 recipient of its prestigious J. Sanford Saltus Award, presented for lifetime achievement in medallic art. At the presentation of the citation, Jovine was praised for a "style of figurative art that is at the same time varied and individualistic. He has combined a baroque sense of decorative invention with an art nouveau love of swirling forms and an art deco conventionalization of figurative portrayal. Yet there is nothing old-fashioned or stilted about his work; it is clearly in the contemporary spirit."[1]

Marcel Jovine's bas-relief skills were utilized in 1981 when he was commissioned to design doors at the entrance to the abbey of Montecassino in Italy. His creation commemorates the heroic stand of the Polish troops against the Fascist forces there at the end of World War II.

He has stated his philosophy of becoming a sculptor: "I do not believe that you can become an artist by profession. I think you are born an artist. Like a good businessman, you can be a good artist. You can be taught technique, but no teacher is going to make an artist out of you."[2]

The Sculptor at Work Medal
Brookgreen Gardens Membership Medal, 1985-86

The theme of the medal is "the sculptor at work." The obverse depicts a sculptor chiseling the head of a stone horse. He holds a chisel in his left hand and strikes it with a mallet in his right hand. The smooth muscular expanse of the figure's right arm and shoulder fills the lower left of the design. The classical features of the figure are in profile, with eyes directed toward the stone sculpture. The right side of the horse's head and neck dominates the field of the medal. The flowing mane, wildly staring eye, bulging veins and angle of the head indicate action.

The reverse depicts the completed sculpture seen on the obverse: Pegasus, the winged horse of Greek mythology. The wings with detailed feather striations enfold the body of the rearing steed and frame the medal design. The legend, *Brookgreen Gardens South Carolina*, encircles the bottom portion of the medal. Pegasus is a symbol of artistic inspiration and completes the medal's theme.

This medal was chosen for exhibition at the 20th biennial of the Federation Internationale de la Medaille at Stockholm, Sweden in 1985. Medallic Art Company was awarded the First Place Supplier Achievement Award for Medal Striking by the Specialty Advertising Association International. This award was given in recognition of the firm's part in producing and striking the medal.

1 American Numismatic Society press release, Sculptor's Correspondence Files, Brookgreen Gardens Archives.

2 Artist's Profile, Sculptor's Correspondence Files, Brookgreen Gardens Archives.

Mico Kaufman

MICO KAUFMAN, known primarily as a medallic artist, was born in Romania on January 3, 1924 and survived concentration camps during World War II. In 1947 he began his art study at the Academy of Fine Arts at Rome and Florence and graduated in 1951. He came to the United States in the late 1950s and eventually became an American citizen.

Kaufman has done a few public monuments including *Italia* for Kennedy Plaza and *Claude Debussy* for Lowell University, both at Lowell, Massachusetts

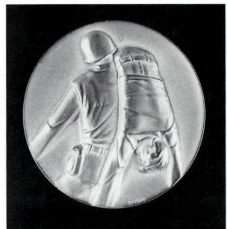

YOUTH AT PEACE AND WAR MEDAL

Bronze. 7.3 cm in diameter. Signed: *Mico K.* N.1988.015, placed in 1989. Gift of Beatrice Gilman Proske.

in 1987, and a sculpture of Anne Sullivan and Helen Keller at Tewksbury, Massachusetts in 1985. A bas-relief is in the collection of Rivier College in Nashua, New Hampshire and *Homage to Women*, done in 1981, is part of St. Joseph's Shrine at Lowell, Massachusetts.

Mico Kaufman's skills as a medalist are in great demand as evidenced by a large body of work in this field. The plaster cast for a medal commemorating the death of Israeli athletes at the Munich Olympics in 1972 was exhibited by the American Medallic Sculpture Association in 1983 and early 1984. It depicts a prostrate figure, head bowed low in grief, upon a stylized track above the Olympic logo with one of the linked circles in the shape of a menorah. A Star of David is embroidered on the sleeve of the grieving figure. In 1976 he designed the official North Carolina Bicentennial Medal.

Kaufman has designed 200 medals for a series depicting the history of America for the Danbury Mint. For the American Numismatic Association, he created the 82nd and the reverse of the 85th convention medals. The latter, selected through an open national competition in 1976, featured a perspective view of New York City buildings including Trinity Church, the Empire State Building and the World Trade Center. In 1974 Kaufman was commissioned to sculpture the obverse of the official inaugural medal of President Gerald Ford. The reverse was the work of Frank Eliscu. After that, he designed the official inaugural medals for Presidents Ronald Reagan and George Bush.

Mico Kaufman's expertise was recognized in 1978 when the American

Numismatic Association awarded him its Gold Medal for excellence in medallic art. The American Numismatic Society gave him the J. Sanford Saltus Award in 1992. His work is frequently exhibited in the expositions of the Federation Internationale de la Medaille and in 1987 he was chosen to create the FIDEM 50th Anniversary medal. From the Rockport Artists Association in 1967 he received the Alma & Ulysses Ricci Award for best conservative sculpture and, in 1969 and 1972, the R. V. T. Steeves Award for most outstanding work in sculpture. The Concord Art Association awarded him its Bronze Medal of Honor in 1969.

Mico Kaufman is a member of the National Sculpture Society, the New England Sculpture Association, the Cambridge Art Association and Rockport Artists Association. He is a life fellow of the American Numismatic Society. Kaufman has been a teacher and lecturer at Nashua Arts and Sciences, the Boston Center for Adult Education and the New England School of Art. He also has authored articles on sculpture techniques for art publications. Mico Kaufman lives and works in North Tewksbury, Massachusetts.

Youth at Peace and War Medal

In 1973 the Vietnam war was a major event that had divided the nation. For the 87th issue of the Society of Medalists, Mico Kaufman chose to contrast the two sides of youth of that period. The obverse portrays a solitary young man seated cross-legged and playing a guitar. The reverse depicts a combat soldier carrying the body of a fallen comrade. The design has a strong linear pattern which is typical of the work of Mico Kaufman. This is one of only a few medals for this series designed without an inscription, however, the message of peace versus war stands clearly without words.

Joseph Kiselewski

SEE pp. 110-112 for the sculptor's biographical information.

The Bicentennial Medal
Brookgreen Gardens Membership Medal, 1976-77

In commemoration of the nation's Bicentennial, Brookgreen Gardens commissioned Joseph Kiselewski to create a special medal for its membership

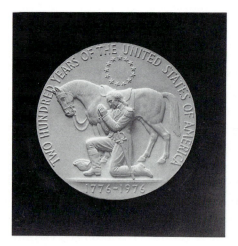 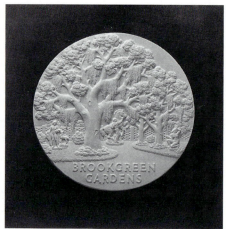

T HE B ICENTENNIAL M EDAL
B ROOKGREEN G ARDENS M EMBERSHIP M EDAL, 1976-77

Bronze. 7.6 cm in diameter. Signed: *J. KISELEWSKI* N. 1975.002, placed in 1976. Other examples: New York, NY. American Numismatic Society, National Sculpture Society; London, England. The British Museum.

year. The obverse depicts George Washington kneeling in prayer on one knee with his hands folded and head bowed. He wears the uniform of an army officer, sword at his side and tricornered hat on the ground next to his foot. His saddled horse stands behind him in the background. Above the horse's back are thirteen stars in a circle representing the original colonies. Across the bottom are the dates, *1776 – 1976,* and around the edge of the design is the legend, *Two Hundred Years of the United States of America.*

The reverse is a representation of Brookgreen Gardens showing three works of sculpture in settings under the moss-draped live oaks. From left to right are *Forest Idyl* by Albin Polasek, *Youth Taming the Wild* by Anna Hyatt Huntington and *Joy* by Karl Gruppe. Across the background is the open-work garden wall. The words, *Brookgreen Gardens,* appear in the lower center of the design.

This medal was distributed to Sustaining, Patron and Life Members during the 1976-1977 membership year. The inaugural medal was presented to businessman Robert R. Coker.

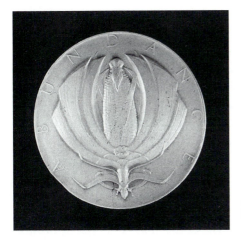

ABUNDANCE MEDAL

Bronze. 7.3 cm in diameter. Signed: *Albert /Laessle/* © N.1988.002, placed in 1989. Gift of Beatrice Gilman Proske. Other example: New York, NY. The Metropolitan Museum of Art.

Albert Laessle

PLEASE REFER TO *Brookgreen Gardens Sculpture* pp. 180-183 for the sculptor's biography.

Abundance Medal

Although it was designed during the Great Depression, the 10th issue of the Society of Medalists in 1934 portrays the theme of America as the land of plenty. The obverse depicts a proud Thanksgiving turkey, the gift of the new world to the early settlers. The reverse of the medal features an ear of corn, the indigenous crop of the settlers and their gift from the Native Americans. The word, *Abundance*, appears on the reverse. The turkey and the corn symbolize the abundance which the name of America signified among the nations at that time. The design is modeled in low relief, providing an elegant and beautiful medal.

Albert Laessle explained his thoughts: "Wishing to symbolize the abundance of America, I have chosen for my medal two truly American subjects, the turkey and the corn…Roaming wild through the forest, the turkey by its

strength and love of liberty foreshadowed the strength and liberty of the new country. I have depicted the turkey with ruffled feathers, its pride and the vigor of its youth symbolizing the growth of the young America."

"Ever since the famine of 1620, when the Pilgrims shot turkeys and cultivated maize, this courageous bird has symbolized the favor of Providence for the American. Nature is kind to the United States…There is something especially beautiful about the growing corn, with its long leaves rustling in the wind. The flower appears, and finally the ear, — the apotheosis of the corn. The ear of corn which I have depicted is triumphant, — rhythmic with the pulse of life. It symbolizes true wealth. It is the culmination of the harvest, when man, flushed by his labors in the summer sun, gathers to his granaries the fruits of the earth."[1]

Albert Laessle received the J. Sanford Saltus Award of the American Numismatic Society in 1951 for his outstanding body of medallic work.

1 "The Society of Medalists, Tenth Issue," descriptive brochure, Sculptors Clipping Files, Brookgreen Gardens Archives.

Michael Lantz

SEE pp. 92-96 for the sculptor's biography.

The Ecology Medal
Brookgreen Gardens Membership Medal, 1979-80

The sculptor employed an ecology theme for the obverse of the medal, commissioned in 1978 and completed in 1979. It illustrates the food chain with a line of wild creatures of various sizes and appetites curving around the edge of the medal. Nature's inexorable cycle of life is enacted by a great blue heron, which has just caught a fish in its mouth, standing near an alligator, its body moving toward an unsuspecting bullfrog which, in turn, is about to swallow a hovering insect. The legend, *Brookgreen Gardens*, encircles the upper edge of the design.

The medal's reverse represents the sculpture of Brookgreen with the artist's own creative rendition of Pegasus, accompanied by a winged colt, flying

THE ECOLOGY MEDAL
BROOKGREEN GARDENS MEMBERSHIP MEDAL, 1979-80

Bronze. 7.6 cm in diameter. Signed: *Michael Lantz / 1979 / Sc.* © N.1979.001, placed in 1979. Other examples: New York, NY. American Numismatic Society, National Sculpture Society; London, England. The British Museum.

through the heavens. The frisky colt was added for artistic interest. Clouds and stars, indicated by bold strokes of clay, dot the firmament behind the equine figures. This was the seventh in the series of membership medals.

Gertrude Lathrop

FOR THE sculptor's updated biography, please see pp. 64-66.

Wildlife Medal
Brookgreen Gardens Membership Medal, 1974-75

For the second issue in the series of Brookgreen Gardens Membership medals, Gertrude Lathrop's beautiful medal of 1945 was restruck.[1] The design of this medal, which had been commissioned by Archer Huntington for the

Wildlife Medal
Brookgreen Gardens Membership Medal, 1974-75

 Bronze. 7.6 cm in diameter. Signed: *G. K. LATHROP* On the edge: Medallic Art Co. N.Y.
BRONZE N.1945.001. Other examples: New York, NY. American Numismatic Society,
National Sculpture Society; London, England. The British Museum.

Brookgreen Trustees, was so outstanding that it was chosen so that it would
have a wider distribution. This medal reflected both the sculptor's personal
interests and one of the purposes of Brookgreen Gardens: to protect the native
wildlife.

 The obverse depicts the extinct Carolina parakeet (or paroquet) perched
on the seed pod of the southern magnolia, *Magnolia grandiflora,* as the bird
extracts a seed with its beak. The colorful Carolina parakeet, once a common
sight in the South Carolina skies of the 18th and 19th centuries, had been
hunted to extinction for its plumage by the beginning of the 20th century.

 The reverse shows a reclining buck framed by a magnolia branch with a seed
pod and a blossom. The Virginia white-tailed deer has become a majestic
symbol of the south and its forests. An ardent conservationist and animal
lover, Gertrude Lathrop was one of this country's finest animaliers.

 She wrote of the commission of the first medal: "I visited the Gardens and
was thrilled at the beautiful setting and the fine collection of sculpture...I
wondered what I could use on the medal and as I drove into the Gardens a deer
walked quietly by. There was one subject, and the southern magnolia seemed
appropriate also. Mr. Huntington was pleased with my choice and with the
Carolina paroquet."[2]

 The Wildlife Medal was distributed to Sustaining, Patron and Life Members

of Brookgreen Gardens during the 1974-75 membership year. Galvanos of the obverse and reverse also were produced for exhibition.

Bronze galvanos. 30.4 cm in diameter. R.1971.001 and R.1971.002, placed in 1971.

1 See *Brookgreen Gardens Sculpture* (Proske) p. 413.

2 Letter from Gertrude Lathrop, April 5, 1972, Sculptor's Correspondence Files, Brookgreen Gardens Archives.

Albino Manca

FOR ADDITIONAL information please refer to pp.106-108.

Mona Lisa Medal

The obverse depicts the painting of the *Mona Lisa* by Leonardo da Vinci. On the left edge of the portrait are the words, *Mona Lisa*, and the words, *by Leonardo*, are on the opposite side. The reverse of the medal includes a self-portrait of Leonardo da Vinci encircled by his name and birth and death dates, 1452-1519. The self-portrait hangs in Turin's Royal Library. The sculptor was inspired to design this commemorative medal after the *Mona Lisa* was brought to the United States for exhibition in 1963. This is one of a series entitled "Masterpieces in Medals" for Contemporary Commemorative Medals of New York.

Michelangelo Medal

The obverse of the medal depicts the famous self-portrait of Michelangelo Buonarroti that hangs in the Uffizi Gallery in Florence. Encircling the portrait is the artist's name and dates, 1475-1564. On the reverse are two supreme accomplishments of the artist — the statue of David and the dome of St. Peter's Basilica in Rome. Around the edge of the scene are words from the 23rd Psalm: *The Lord is My Shepherd... Will Dwell in the House of the Lord Forever.* The medal was commissioned by Contemporary Commemorative Medals to mark the 400th anniversary of Michelangelo's death. It was part of the "Masterpieces in Medals" series.

Bronze. 7.3 cm in diameter. Signed on the obverse: *ALBINO MANCA 1964* ©. Signed on the reverse: ©/*ALBINO MANCA*. N.1988.018, placed in 1989. Gift of Beatrice Gilman Proske.

MONA LISA MEDAL

Bronze. 7.3 cm in diameter. Signed: *A Manca* © *1963.* N.1988.017, placed in 1989. Gift of Beatrice Gilman Proske.

Pope Paul VI Peace Medal

On the obverse is a portrait of Pope Paul VI encircled by the inscription, *Paul VI Mission to the United Nations, New York Oct. 4, 1965.* To the right of the pontiff's head is the papal seal. On the reverse is the United Nations Building with the superimposed invocation of St. Francis of Assisi, *Lord Make Me an Instrument of Thy Peace.* October 4, the day of the papal visit, was the feast day of St. Francis.

This medal was commissioned by Contemporary Commemorative Medals to commemorate the mission of peace of Pope Paul VI to the United Nations in 1965. At the invitation of United Nations Secretary General U Thant, the pontiff appeared before a special meeting of the General Assembly to foster agreements for peaceful relations between nations. This visit marked the first time a reigning pope had set foot on American soil and the first time a pope had addressed a gathering of political leaders. An example of this medal, struck in 18 carat gold, was presented to Pope Paul VI by Francis Cardinal Spellman.

Bronze. 7.3 cm in diameter. Signed: *ALBINO MANCA/1965* ©. N.1988.019, placed in 1989. Gift of Beatrice Gilman Proske.

Bruno Mankowski

For ADDITIONAL INFORMATION about the sculptor, please refer to pp. 112-115.

American Folklore Medal

Bruno Mankowski featured two of America's folk heroes as the theme for the 79th issue of the Society of Medalists in 1969. The obverse depicts a larger-than-life Paul Bunyan, the fabled woodsman, felling trees with an ax — his blue ox, Babe, in the background. The legend, *American Folklore Paul Bunyan*, appears around the top half of the design. The reverse portrays a full profile of John Chapman, better known as Johnny Appleseed, striding along as he sprinkles seeds to plant his orchards of apples. A knapsack is slung over his left shoulder and he carries a spade in his left hand. His name, *Johnny Appleseed*, frames the top center of the medal.

The sculptor wrote, "America was born in folklore, it is the story of a folk of pioneers who did not stop seeking, discovering and inventing, and through their individual competitive aggressiveness and boundless optimism were breaking the sod for unnumbered millions to come."

"This medal tells the story of two men, one the mythical lumberjack who through his miraculous deed supplied the lumber to build the new towns to come, the other the apple missionary who had his heart set to wrest the bounty of the soil out of the wilderness."[1]

1 "The Society of Medalists, 79th Issue, Bruno Mankowski, Sculptor, June 1969," descriptive brochure, Sculptors' Clipping Files, Brookgreen Gardens Archives.

Bronze. 7.3 cm in diameter. Signed: *B. M. © 1969* N.1988.008, placed in 1989. Gift of Beatrice Gilman Proske.

Chester Martin

CHESTER MARTIN acquired an interest to create sculpture after enjoying a career as a graphic artist and watercolorist. He was born in Chattanooga, Tennessee, on November 2, 1934, to Woodfin Ballenger and Mabel Willett

(Young) Martin. After an enlistment in the United States Air Force, he studied at the University of Chattanooga with George Cress who was the head of the art department. Martin graduated with a bachelor of fine arts degree in 1961.

While employed as a graphic artist after college, he entered open competitions in the fine arts, winning awards for philatelic design in California and Alabama, and in numismatic design from the Franklin Mint's United States Bicentennial contest. His watercolors twice won the top prize in the Tennessee All-State Competition and received an honorable mention and second prize in the Benedictine Art Awards in New York City. Murals painted by him are in the executive offices of Chattem, Inc., and in the main lobby of the Mountain City Club, both in Chattanooga.

Although he was noted for portraits and detailed interpretations of the Southern Appalachian landscape, he began to experiment in relief sculpture. As a successful figurative painter, Chester Martin believed that studying sculpture would help him acquire a better understanding of form. By the time he was chosen to design the 1984-85 Brookgreen Membership Medal, Martin had worked in marble and wood and cast bas-relief designs in porcelain, a medium which he uses today.

In 1980 Martin entered the Society of Medalists national competition to design its 50th anniversary commemorative medallion. His submission won first place and the pictorial side of the medallion, entitled *The Sixth Day*, was enlarged and presented to Brookgreen Gardens during its golden anniversary celebration in 1981. In another competition sponsored by the United Nations in 1984, Martin won the commission to design the World Food Day Medal.

In 1986 Chester Martin's career took a new direction when he became assistant sculptor-engraver at the United States Mint in Philadelphia. There he has been involved with several important commissions. In 1989 he sculptured the obverse and reverse of the Bicentennial of Congress silver dollar. In that same year he created the Andrew Wyeth Congressional Medal and sculptured the design of the reverse of the Eisenhower commemorative silver dollar. In 1990 he was given responsibility for the design and sculpture of the reverse of the George Bush Presidential Medal.

Chester Martin is a member of the Federation Internationale de la Medaille President from 1987 to 1988. He was a United States delegate to the FIDEM Congresses at Florence in 1983 and Stockholm in 1985.

He divides his time between Philadelphia and Chattanooga.

THE SIXTH DAY

Bronze bas-relief. 91.4 cm in diameter. Signed: *CHESTER MARTIN*. R.1981.001, placed in 1981. Gift of The Medallic Art Company, Danbury, CT.

The Sixth Day

The obverse of the Society of Medalists 50th Anniversary medal depicting "The Sixth Day" is based on the concept of the spiral. A snail with spiral shell rests upon a twig around which a vine is twisted, creating another spiral. Behind this scene is the expanse of a heavenly spiral nebula. The competition theme, "The Natural World," inspired the sculptor to select the snail to represent the verse from Genesis, "let the earth bring forth creatures of all

kinds, cattle and creeping things and beasts of the earth." On the reverse
Martin portrayed the image of a sculptor holding in his hands the obverse and
reverse of this medal — his tribute to the many sculptors who have designed
medals for the Society of Medalists.

The Medallic Art Company presented the enlarged obverse of *The Sixth Day*
to Brookgreen Gardens along with two of the medals. One medal entered the
Brookgreen collection and the other was presented to South Carolina Gover-
nor and Mrs. Richard W. Riley at the Governor's Mansion by members of the
Board of Trustees of Brookgreen Gardens.

Bronze medal. 7.3 cm in diameter. Signed on obverse: CHESTER MARTIN. N.1982.002,
placed in 1982. Gift of The Medallic Art Company, Danbury, CT.

South Carolina Wildlife Medal
Brookgreen Gardens Membership Medal, 1984-85

South Carolina wildlife was the theme of the 1984-85 medal. The obverse
depicts a South Carolina coastal setting of cabbage palmettoes (the state tree),
yuccas and moss-draped longleaf pines lining the banks of a creek. The
legend, *South Carolina*, is located in the upper left of the scene. The reverse
depicts a raccoon in its native forest setting, a fallen tree next to a small
woodland pool adding decorative interest. The animal, with front paws
resting on the tree trunk, watches a fish jump and break the water's smooth
surface. Trees, ferns and thick foliage cover the background; three birds fly
into the distance. The words, *Brookgreen Gardens*, appear on the bottom center
of the design. The raccoon's fur and the bark of the fallen tree are modeled
in precise detail.

Chester Martin explained his thoughts on the design of the medal: "When
I received the commission to design the wildlife medal for Brookgreen
Gardens it was with a full awareness of the uniqueness and quality represented
there, both in landscape and sculpture. How would I use my humble talents
to fit in with the Brookgreen experience? Two special trips to see the Gardens
had revealed the existence of many waterways in the area which are associated
with the folklore surrounding Theodosia Burr Alston's fateful journey. Even
the sounds in the name Murrells Inlet helped to evoke an image which
resulted in the side of the medal I call 'the Bayou.' And the 'Raccoon' side
came about through something I once read about South Carolina which told
of early rising swimmers being astonished to find raccoons playing on the
nearly deserted beach. A walk through the nature garden at Brookgreen

inspired me, however, to place the animal in a more inland setting."[1]

Bronze medal. 7.6 in diameter. Signed on obverse: CHESTER MARTIN. N.1982.002, placed in 1984. Other examples: New York, NY. American Numismatic Society, National Sculpture Society; London, England. The British Museum.

1 Martin, Chester, "Some Thoughts on Designing a Medal," Sculptor's Correspondence Files, Brookgreen Gardens Archives.

Donald Miller

DONALD RICHARD MILLER was born in Erie, Pennsylvania. After serving in World War II he enrolled at the Dayton Art Institute in 1947, studied sculpture with Robert Koepnick, and received a bachelor of fine arts degree in 1951. Upon graduation he received an Atelier Scholarship from the Institute and continued his studies until 1952. He moved to New York City and from 1955 to 1957 attended classes at the Pratt Institute, then from 1958 to 1961, at the Art Students League. From 1956 to 1960, he served a four year apprenticeship under the architectural sculptor, Ulysses A. Ricci.

Through the 1950s and early 1960s, Donald Miller worked in the studios of a number of sculptors, assisting with large sculpture projects such as the facade of the Mayo Clinic Hospital by William Zorach in 1952, the Cleveland War Memorial by Marshall Fredericks from 1956 to 1963, the scale model for the U.S. Federal Court House in Brooklyn by Joseph Kiselewski in 1961, and two reliefs for the Reptile House at Grant Park Zoo in Atlanta by Julian Harris in 1964.

After executing two animal gargoyles for the Washington Cathedral in 1960, Donald Miller decided to focus his attention on the sculpture of animals. His animal sculpture is simply modeled with little detail yet it always conveys the essence of the subject. Although all species interested him, the wildlife of Africa held a particular fascination and appeared frequently in his work. Miller was often commissioned to create decorative relief panels for gates, grilles and building facades. Public examples of his work in this field are at the Philadelphia Zoological Park and the Cincinnati Zoological Society.

After his design was selected for the 76th issue of the Society of Medalists in 1967, he was in demand to create a number of commemorative and limited edition medals. Presentation medals were designed for the American Geographical Society in 1968 and 1970, the American Society of Civil Engineers

in 1969, and The Society of Animal Artists in 1979. Heridities Limited of Westmoreland, England commissioned him in 1971 to model a collection of animals to be distributed in limited edition. For Ducks Unlimited of the United States and Canada he designed a series of twenty medals of waterfowl in 1974.

His sculpture was exhibited in important shows including those of the Allied Artists of America which awarded him the Sculpture Association Award in 1977, and the Academic Artists Association which gave him an award in 1969. The American Veterans Society of Artists gave him its Gold Medal in 1964. In 1968 Donald Miller won the first of four awards from the National Sculpture Society when the bas-relief of his design for the Society of Medalists 76th issue received the Mrs. Louis Bennett Prize. He was awarded the Tallix Foundry Prize in 1980 for *The Water Hole*, a polished brass giraffe leaning over to drink from a pool of water. The Lindsey Morris Memorial Prize was received in 1982. The Dr. Maurice B. Hexter Prize was given in 1983 to *Amikuk*, a sea otter in bronze reclining upon its back. Only parts of the animal's body in bronze appear above the surface of the water which is indicated by a carved block of walnut. From the Hudson Valley Art Association he received the Mrs. John Newington Award twice and four awards of honorable mention.

He became a sculptor member of the National Sculpture Society in 1967 and was advanced to fellow in 1970. He was a fellow of the American Artists Professional League and an associate of the National Academy of Design. He also held membership in the Academic Artists Association, Allied Artists of America, Audubon Artists, the Society of Animal Artists and the Hudson Valley Art Association. Since 1972 he served as an adjunct instructor of sculpture for the Fashion Institute of Technology. Donald Miller died on August 21, 1989.

Thoreau Medal

The 76th issue of the Society of Medalists featured an environmental message within a pentagon-shaped design. On the obverse, inside the triangular segments created by each of the five sides, are fitted a bird, fish, butterfly, snake and mountain goat, representatives of the orders of the animal kingdom. The focal point of the medal is a quotation from Henry David Thoreau: "In wildness is the preservation of the world." This statement appears prominently on the reverse of the medal along with a forest scene of trees with the sun peeking over mountains in the background.

Donald Miller wrote, "Had this quotation from Thoreau been written today

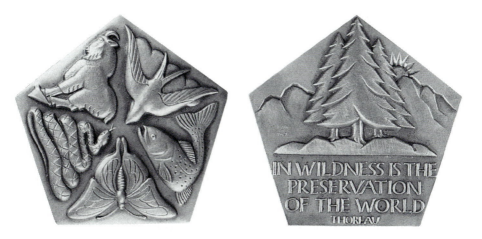

THOREAU MEDAL

Bronze. Roughly 7.3 cm in diameter. Signed: *DRM/©/1967* N.1988.005, placed in 1989. Gift of Beatrice Gilman Proske.

instead of over one hundred years ago, he might, in desperation, have worded it to read — 'In Wildness is the Preservation of the *Sanity* of the World.' His words are more timely in our day than in his and, now, wildness itself must be preserved in order that it may serve as a stabilizer of the human spirit. Hence, the creation of this medal is also a plea that the world's animal inhabitants be permitted to perpetuate themselves in a five-sided interrelationship with their natural surroundings."[1]

1 "The Society of Medalists 76th Issue, November 1967, Donald Richard Miller, Sculptor," descriptive brochure, Sculptors Clipping Files, Brookgreen Gardens Archives.

Hal Reed

HAL REED was born in Frederick, Oklahoma on February 22, 1921. By the time he was six years old, the family had moved to California. His mother, who had been a college art teacher prior to her marriage, laid the groundwork for his career by encouraging and supporting an interest in the fine arts. He studied at the Trade Technical College of Los Angeles, at the Art Students League of San Francisco, and privately with Nicolai Fechin and Burt Proctor.

Reed joined the Army Engineers at the outbreak of World War II and was in charge of the photogrammetric section of the First Army during the European operation. He was awarded a battlefield commission and won the bronze star and five battle stars for distinguished service. During the Korean Conflict he served as operations officer for a topographic unit.

Upon discharge from military service, he worked with the Atlantic Richfield Company over a 25 year period. For this major oil company Reed served as head of photogrammetric, cartographic and reproduction sections, as coordinator of special projects, and as a land administrator. He also was director and vice president of Joaquin Ranch Company and Palomar Land Company, two subsidiary companies of Atlantic Richfield. In 1970 he discontinued this work to begin a full time art career.

He founded the Art League of Los Angeles in 1965 where he continues to teach classes in composition and color harmony, anatomy, perspective and advanced painting techniques. His book, *How to Compose Pictures and Achieve Color Harmony*, was published in 1969 and went through several printings. From 1983 to 1986 he appeared on television as an art instructor. Reed's oil paintings and portraits won a number of awards and are in many private collections as well as in the Governor's Office in Sacramento and in the permanent collection of Los Angeles City Hall.

In 1970 he turned to sculpture as a medium when he was commissioned to design a medal of Eleanor Roosevelt for the Societe Commemorative de Femmes Celebres. In that year he also won the open competition of the Society of Medalists. A medal of Robert Fulton was created in 1971 for the National Commemorative Society. For the United States Mint, he designed the US Navy and the US Marine Corps Bicentennial Medals. The Judah L. Magnes Museum at Berkeley, California, commissioned him in 1979 to create commemorative medals of Jonas Salk and Levi Strauss. Later that year a bronze bust of Albert Einstein became part of the permanent collection of the Los Angeles County Museum of Science and Industry. Also, a bronze depicting the story, *Brea in Progress*, was placed at Brea, California, in 1979. His portrait plaque of the Olympic athlete, Jesse Owens, is at the Los Angeles Coliseum, and two portrait bronzes are located at St. Mary's Hospital in Long Beach.

Hal Reed is a fellow of the American Artists Professional League and the American Institute of Fine Arts. In 1971 he was elected to a two-year term as president of the Council of Traditional Artists Societies. He lives and works in Woodland Hills, California.

Unleashing the Atom Medal

In his design for the 83rd issue of the Society of Medalists, the sculptor has paid homage to the men whose theories and experiments were instrumental in opening up the atomic age. The medal was commissioned in 1970 after the artist won an open competition.

The obverse features the profile portraits of four scientists whose work played an important role in the development of the atom. From the left, with each profile superimposed upon the previous one, are Otto Hahn, the German chemist who first split the atom; Niels Bohr, the Danish physicist who developed the theory of atomic structure; Sir Ernest Rutherford, the English physicist who discovered the atom nucleus; and Albert Einstein, the American physicist who provided the equation and theory regarding matter and energy. The faces are modeled with rough accuracy, emphasized by shaggy eyebrows and prominent noses. Encircling the profiles are the names of the individuals.

On the reverse, two muscular male figures depict the release of the atom for the benefit or, possibly, for the destruction of mankind. The kneeling figure leans over with hands bound behind his back. Behind him a second figure lifts upward, his hands freed and bindings hanging from each wrist. Both figures are modeled with anatomical detail. Encircling the top of the reverse is the legend, *Unleashing the Atom.*

Bronze medal. 7.3 cm in diameter. Signed: ©*1970 HR.* N.1988.011, placed in 1989. Gift of Beatrice Gilman Proske.

Alex Shagin

THE CREATOR of the sixteenth medal in the Brookgreen Gardens series, Alex Shagin, came to this country from Russia in 1979. In the brief period since that time, he has built a medallic career of international stature. Maturing under communist control, Alex Shagin essentially lived a double life: one shaped by his artistic talent which offered opportunities unavailable to most people his age; the other formed by his Jewish heritage which imposed severe limitations on his personal life. His story is one of struggle, perseverance, dedication and, finally, triumph.

Born in Leningrad in 1947, Alex Shagin was accepted for art study at the Vera Muchina School of Arts and Design in 1966. There he was able to study

western-oriented styles of graphic arts and design because the school, the only one in Russia to do so, encouraged its pupils to acquire these styles to create products suitable for exportation. At school he was spared some of the political and ideological dogma that pervaded Russian learning, however, elsewhere he was under constant surveillance because of his religious beliefs. For graduation in 1972 he created a series of medals honoring Peter the Great.

Upon receiving his diploma he entered the Leningrad Mint as a sculptor-engraver trainee but was called to serve in the army. After one year the government returned him to the mint to fill a vacancy left by a deceased colleague. During the next few years he designed commemorative medals and coins of Russian history and contemporary events. Even though he was allowed greater artistic latitude than some of his colleagues because of his talent, he was growing increasingly dissatisfied under Soviet dominance.

A medal honoring the 1975 Apollo-Soyuz space project was presented to the American astronauts during their visit to the Soviet Union. In 1975 medals were commissioned to commemorate the 150th anniversary of the 1825 Decembrists revolt and the 30th anniversary of World War II Victory Day. Medals in honor of the artists Michelangelo, Titian and Rubens were created in 1975, 1976 and 1977, respectively. Three of his medals were in the Russian contribution to the 1977 exhibition of the Federation Internationale de la Medaille in Budapest, Hungary.

Although he knew that an application for permission to leave Russia would bring about the loss of his career, his artistic creations and, possibly, his freedom if permission were denied, in 1975 Alex Shagin began to seriously consider such a move when he received an invitation to resettle in Israel. By that time he had submitted designs for the 1976 Summer Olympics held in Montreal. His most significant work for the Soviet Union, the designs for the official series of silver commemorative coins for the Summer Olympics held in Moscow in 1980, was to be his last in his native land. Shagin was commissioned to create the entire coinage series but gave it up after completing designs for the first six coins because he realized it would hamper his goal to emigrate.

In 1977 he had toured Poland with a government-organized exhibition of works by young Leningrad artists. At Gdansk, Shagin was exposed to the atmosphere of social unrest prior to the organization of the Solidarity Movement. Finally, inspired by what he had witnessed in Poland, the right to pursue his artistic dreams in a free society prevailed over his fears of government reprisal. As predicted, both his job and the right to keep his art works were lost when he applied for an exit visa. There followed a waiting period of fourteen

difficult months with no source of income before he was granted permission to leave.

After emigrating to the United States in 1979 with his mother and step-father, Alex Shagin settled in Los Angeles and opened a graphic design studio. In 1980 he exhibited work at the Los Angeles Art Festival for Russian Newcomers. His medallic talent was recognized and he was commissioned by the Greater Los Angeles Federation Council to design three medals: the Prophets Awards. In 1982 his designs were shown in a solo show at Santa Barbara University.

The themes of liberation and freedom recur in his art work. Not surprisingly, Alex Shagin regards the Statue of Liberty as the most important symbol of all. He was one of 15 artists commissioned to create a series of bas-reliefs on the theme of Liberty for the Museum of Immigration at Ellis Island. He also completed a medal that commemorates Liberty's centennial on the obverse and its 2086 bicentennial on the reverse. Medals of Poland's leader Lech Walesa, Sweden's Raoul Wallenberg, Russian dissidents Alexander Solzhenitsyn and Andrei Sakharov, Hindu nationalist Mohandas Gandhi and America's human rights advocate Martin Luther King, Jr. were created to honor these international champions of freedom. The Walesa medal was Shagin's personal tribute to the role Solidarity played in his decision to leave Russia. In 1985 he became an American citizen.

A medal commemorating George Orwell, pen name of Eric Blair, the author of the post-World War II book, *1984*, was created for Hofstra University. Perhaps better than many American artists, Shagin understood the book's subject matter of life in the year 1984 with a Soviet-like working class controlled by Big Brother. The medal's reverse contains George Orwell's name written in a series of parallel lines in an allusion to lines from Ray Bradbury's *Fahrenheit 451*, another book with the theme of suppression. The design was the symbol for a conference on the works and times of George Orwell held in 1984 at the Cultural Center of Hofstra University.

A commentary on world peace, the 114th issue of the Society of Medalists, entitled *One Planet*, features children holding hands while dancing around the revolving earth. His design of five running athletes bearing a torch became the symbol of the United States Track and Field Team that competed in the 1984 Summer Olympics in Los Angeles. Exhibited in 1983 at the American Medallic Sculpture Association show held at the American Numismatic Society, it was chosen as the official medal of the exhibition and received the A.M.S.A. Prize. His medals have been shown in the biennial expositions of the Federation Internationale de la Medaille beginning in 1983. Eight of his cast

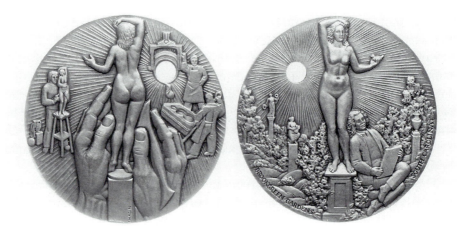

THE SCULPTOR AND THE GARDEN MEDAL
BROOKGREEN GARDENS MEMBERSHIP MEDAL, 1988-89

Bronze. 7.6 cm in diameter. Signed: *SHAGIN* N.1988.001, placed in 1988. Other
examples: New York, NY. American Numismatic Society, National Sculpture Society; London,
England. The British Museum.

medals were chosen for exhibition at the FIDEM 50th Anniversary Congress
and Exposition hosted by the American Numismatic Association in Colorado
Springs, Colorado in 1987. One of these medals, *Amasis, Painter*, was chosen
for the FIDEM traveling exhibition that toured the United States through
1988.

In his own foundry Alex Shagin casts many of his medals by hand, a
painstaking process which differs from that of a medal struck from a die. After
the design is incised in a wax disk the size of the actual diameter of the finished
medal, a liquid refractory material is applied to the pattern to harden and form
a ceramic shell mold. Then molten metal is poured into the mold and allowed
to cool. When the medal is removed from the mold, the fine engraving and
patination processes are completed by hand. Because he casts much of his own
work, he is allowed more freedom in the shape of the medal and has created
free-standing and tri-partite medals. For the celebration of the United States
bicentennial of the Constitution in 1987, he designed a cast medal in the shape
of a colonial drum. His hand cast medals often bear the personal imprint, *Opus
Artum.*

Alex Shagin regards reading as a method of learning about his new country
and the free world. He prefers to dedicate his time to creativity and those
activities that enhance or support it. He likens himself to a journalist or scribe

working in bronze: "I put my statement on metal —it's the best way to preserve a very precious, very important message for the future. My medallic sculpture is like a mini-time capsule."[1] He issues a descriptive statement, frequently in free verse, with each medal he designs.

Since he has been in the United States, Alex Shagin has received the American Medallic Sculptors Association Award, the Society of Medalists Prize and has been invited to participate in a number of design competitions by the United States government and the Olympic Committee. In 1982 under a scholarship awarded by the Alvin Bronstein Fund, he created medals honoring Anatoly Shcharansky, Albert Einstein and Sigmund Freud. He is a member of the American Medallic Sculpture Association and the Graphic Artists Guild.

The Sculptor and the Garden Medal
Brookgreen Gardens Membership Medal, 1988-89

The theme of the medal for 1988-89 was "The Sculptor and the Garden." It required 15 months to complete and was the first pierced medal in the series. The obverse depicts a sculpture garden of fantasy. The sculptor, seated at the foot of a statue of a goddess, dreams of his work in harmony with nature. In the dreamscape background are other sculptures on pedestals surrounded by dense foliage. Enhancing the fantasy effect, decorative shafts of light radiate from the sun. The orb representing the sun is pierced. The legends, *Brookgreen Gardens* and *South Carolina*, are incised on the lower left and right edges of the medal.

Depicted on the reverse are three scenes of the sculptor's workplace. In the center is the reverse view of the statue on the obverse. This time it is a small model dwarfed by the sculptor's hands working with a modeling tool. On the left, the sculptor in his studio enlarges the original design in clay. On the right, a foundry worker pours molten metal from a crucible into a sculpture mold. A second technician holds a paddle used to scrape dross from the surface of the molten metal prior to pouring. The mouth of the crucible is pierced, corresponding to the pierced sun on the obverse. Radiating from the crucible are shafts of light, continuing the theme from the obverse.

Alex Shagin expressed his thoughts on this medal in free verse: *The Sculptor and the Garden: In the sculpture garden...In the sculptor's studio...Two sides — two worlds, a dreamland — a workplace. On one side what God made, the other what man made. Hold this medal in your hand, and let the art touch your heart.*[2]

1 Interview by Ellen Hoffs, *California Living*, July 6, 1986.
2 "Alex Shagin," Sculptors' Correspondence File, Brookgreen Gardens Archives.

Joseph Sheppard

JOSEPH SHEPPARD enjoys a dual career as an award-winning sculptor and painter. His paintings are seen in numerous public places from the office of a U.S. Senator in Washington, to the Maryland Governor's Mansion, to the National Headquarters of NFL Alumni in Fort Lauderdale, to the Church of Buriano, Italy. Since the 1970s he has painted several murals in Baltimore including those at the Police Headquarters, the Peabody Court Hotel, the New Shiloh Baptist Church and the Pavilion in the Park. He has received sculpture commissions in the city, as well. A bronze bas-relief, *Fireman Saving a Child*, was placed in 1977 at the Baltimore City Fire Department. *Holocaust*, a monument dedicated to victims of war, was placed at Holocaust Plaza in 1988. The sculpture consists of a huge ball of flame engulfing emaciated human figures, struggling to escape. The marble pedestal is inscribed with the words of George Santayana — "Those who cannot remember the past are condemned to repeat it." In 1990 Sheppard was commissioned to model an over-life-size figure of St. Francis which was presented to St. Joseph Hospital.

Scenes from everyday life occupy a large segment of the artist's work. His paintings and sculpture depict such varied subjects as street life, boxing matches and beach-goers. The human figure is one of his favorite subjects and he portrays it expressively and truthfully. In 1983 *Knockdown*, depicting the denouement of a boxing match, received the Tallix Foundry Prize at the 50th annual exhibition of the National Sculpture Society. *Standing Nude*, an over life-size female in a relaxed position with hands on hips, was awarded the Agop Agopoff Memorial Prize at the Society's 53rd annual exhibition in 1986.

Joseph Sheppard was born in 1930 in Owings Mills, Maryland. In 1948 he entered the Maryland Institute of Art on a four-year scholarship, where he studied painting with Jacques Maroger, who had rediscovered the medium of the old masters, and sculpture with Hans Schuler, Jr. The Peale Museum in Baltimore gave him several awards during the 1950s and, from 1955 to 1957, he was artist-in-residence at Dickinson College. In 1957 he received a Guggenheim Traveling Fellowship.

For many years he taught drawing, anatomy and painting at the Maryland Institute of Art. He is the author of six books on drawing and anatomy and in 1982 published a retrospective, *The Work of Joseph Sheppard, Selected Paintings, Drawings, Watercolors and Sculpture from 1957 through 1980*. His works are in many public collections including those of the Butler Institute of American Art at Youngstown, Ohio, the University of Arizona Museum of Art at Tucson,

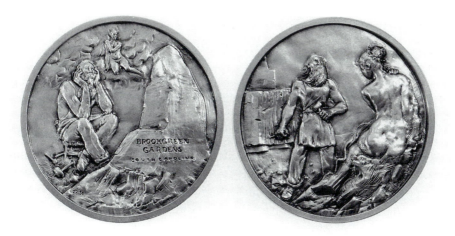

INSPIRATION MEDAL
BROOKGREEN GARDENS MEMBERSHIP MEDAL, 1992-93

Bronze medal. 7.6 cm diameter. Signed: obverse: *JS 90*, reverse; *Sheppard 90*. Stamped on edge: © MEDALLIC ART CO. BRONZE. N.1991.002, placed in 1992. Other examples: New York, NY. American Numismatic Society, National Sculpture Society; London, England. The British Museum.

the Davenport Municipal Art Gallery in Iowa, the Columbus Museum of Fine Arts in Ohio, the Carnegie Institute Museum of Art at Pittsburgh, the New Britain Museum of American Art in Connecticut, and the Norfolk Museum of Arts and Sciences in Virginia.

Joseph Sheppard's credo states: "I believe that technical skill is still an important element in art. I believe that there is no object to non-objective, minimal is less, junk sculpture is junk and form in painting relates to the illusion of three dimensions. I believe that the combination of technical ability and aesthetic awareness enjoyed by the artists of the seventeenth century has never been equaled. My art is based on a return to those standards which demand the knowledge of composition, perspective, color, three dimensional form, draftsmanship and anatomy. With these skills I endeavor to reassert and celebrate the aesthetics of the human form and its living environment."[1]

Joseph Sheppard is a member of the Allied Artists of America, the Knickerbocker Artists, the Society of Animal Artists and the National Sculpture Society. He lives in Pietrasanta, Italy where he maintains a studio.

Inspiration Medal
Brookgreen Gardens Membership Medal, 1992-93

In depicting the medal, Joseph Sheppard chose the theme of inspiration and creativity — the artist at work. His message is that creativity is not happenstance; it is the product of constancy and discipline.

Sheppard wrote, "A creative idea can hit like a bolt of lightning out of the blue, or appear in the middle of a dream, but for most creative people inspiration comes from the habit of constant labor. One project gives birth to another. The artist does not wait for commissions or clients, but creates everyday, keeping him conscious of the many difficulties as well as keeping him close to the creative forces. My medal shows the sculptor contemplating a block of marble and the figure it suggests to him. The second side shows the figure emerging from the stone as the sculptor chops away the excess marble."[2]

On the obverse, the legend, *Brookgreen Gardens South Carolina*, is inscribed on the base of the sculptor's block of marble. The inaugural medal was presented to Dorothy R. Blair of Naples, Florida.

1 *Exotica, New Works by Joseph Sheppard*, exhibition catalogue, Carolyn Hill Gallery, New York, November 16 - December 2, 1990.

2 Letter from the sculptor, November 25, 1991, Sculptor's Correspondence Files, Brookgreen Gardens Archives.

Marika Somogyi

BORN AT Budapest, Hungary, in 1936 Marika Harmat and her family suffered under Nazi occupation during World War II. Through the efforts of the Swedish diplomat, Raoul Wallenberg, her family and thousands of others were saved from concentration camp internment. She studied art at the College of Fine Arts in Budapest. In 1956 she escaped from Soviet oppression in her native land and emigrated to the United States where she became a naturalized citizen.

For the next 20 years she worked as a graphic designer at Cornell University, Rutgers University and the University of California at Davis. During this time Marika Somogyi studied sculpture with Robert Arneson at the University of California at Davis and attended graduate classes taught by Arnoldo Pomodoro at Mills College in Oakland. She is married to Laszlo Somogyi, a biochemist.

Her medallic work features innovation and daring, frequently coupled with mystical messages. She recommends that her medals be held or touched so that the contours of each sculpture can be experienced with all the senses possible.

For the Judah L. Magnes Memorial Museum at Berkeley, California, she created a series of medals commemorating the humanitarian Raoul Wallenberg in 1982, Israeli statesman David Ben-Gurion in 1986, the artist Marc Chagall in 1987, and the Statue of Liberty in 1985. The latter, cited for its dynamic, unconventional and high level of creativity, was selected for permanent display at the Statue of Liberty National Monument Museum in New York. The obverse depicts the face of Miss Liberty from the point of view of an immigrant — what the sculptor termed "that first tremendous impact."[1]

Her design for the Lew Christensen Award, created for the San Francisco Ballet in 1983, was shown that same year at the American Medallic Sculpture Association exhibition. Its obverse depicted a portrait of Christensen. A medal commemorating the centennial of the birth of Eleanor Roosevelt, again featuring a portrait, was created in 1984. A medal in honor of the composer Kurt Weill and his wife, the actress-singer Lotte Lenya, was issued in conjunction with a conference at Yale University sponsored by the Yale Music Library and the Kurt Weill Foundation for Music in 1984. The medal format, four inches square with rounded corners and weighing two pounds, was unusual in shape and size. Another medal has been done in honor of the violinist Nathan Milstein.

In 1986 Somogyi was chosen to create the 113th issue for The Society of Medalists. Her design, entitled *Vanitas*, features a beautiful woman looking into a mirror on the obverse. The mirror image on the reverse reveals the devil looking back at the woman, alluding to the medieval belief of vanity as one of the seven deadly sins. The medal is pierced at the mirror.

Marika Somogyi was invited twice by the U.S. Treasury to submit designs for the one dollar and five dollar coins commemorating the U.S. Constitution and the U.S. Congress Bicentennial. Her works were exhibited at the World Congresses and Expositions of the Federation Internationale de la Medaille held in Florence in 1983, Stockholm in 1985 and Colorado Springs in 1987. Her medals are in the permanent collections of the Swedish Royal Museum in Stockholm, The Maurice Spertus Museum in Chicago, The Jewish Museum in New York, the American Medallic Art Society Museum in New York, the Statue of Liberty National Monument Museum in New York, and the Judah L. Magnes Memorial Museum in Berkeley.

In addition to her medallic creations, Marika Somogyi has other art works

in prominent public collections in California. *In Memoriam,* a seven-foot-tall sculpture, a comment on the horrors of war, is in the Judah L. Magnes Memorial Museum at Berkeley. A life-size portrait of Richard LeBlond, director of the ballet company, was commissioned by the San Francisco Ballet Association and unveiled in 1988. Moved by the accidental death of Calvin Simmons, the talented young conductor of the Oakland Symphony, Somogyi was inspired to create a small portrait figure. Another large bronze sculpture is located at Davis, California.

She is a member of the American Medallic Sculpture Association and of the Federation Internationale de la Medaille. Since 1970 the sculptor has lived and worked in Berkeley, California.

Adam and Eve in the Garden
Brookgreen Gardens Membership Medal, 1989-90

There are several aspects of the 1989-90 Brookgreen Gardens medal that make it different from previous medals in the series. The design is unusual in that it is in the shape of an apple sliced open to reveal two halves. This is the first Brookgreen medal struck in copper; the reddish copper represents the color of the red apple. Also, each medal weighs a little over one pound.

The figures of Adam and Eve on the obverse are sculptured in high relief on both sides of the apple half. They represent the duality of man. Eve, facing the viewer from the right side of the cut apple, extends an apple to Adam: "And when the woman saw that the tree was good for food, and that it was pleasant to the eyes, and a tree to be desired to make one wise, she took of the fruit thereof, and did eat, and gave also unto her husband with her; and he did eat."[2] As in medieval art, she is the personification of woman. Behind her, hanging from the bare branches of a small shrub, is the intaglio image of a monkey, an ancient symbol of both wisdom and foolishness. Adam, with his back to the viewer, stands on the left side of the apple. He is accompanied by four animals carved in intaglio relief into the apple: a hound, stag and two rabbits. Each one of these images are attributes of the male in medieval art. The medal depicts the moment prior to eating the apple after which Adam and Eve became aware of their nakedness — "And the eyes of them both were opened, and they knew that they were naked."[3]

The reverse of the medal centers on the tree of life in the Garden of Eden. A male and female figure are entwined in the trunk of the tree of life. The faces of nine babies peeking out from the tree's foliage represent the fruit of the tree

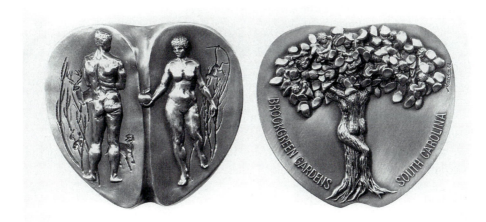

ADAM AND EVE IN THE GARDEN
BROOKGREEN GARDENS MEMBERSHIP MEDAL, 1989-90

Copper medal. Irregular height: 7.6 cm, width: 8.2 cm. Signed: *Marika '88* Stamped on edge: MACO CU. N.1989.001, placed in 1989. Other examples: New York, NY. American Numismatic Society, National Sculpture Society; London, England. The British Museum.

or the nine generations descended from Adam to the time of the destruction of the world by flood (Seth, Enos, Cainan, Mahalaleel, Jared, Enoch, Methuselah, Lamech, Noah). On the lower left of the field in raised letters is the legend, *Brookgreen Gardens,* and on the lower right is *South Carolina.*

Marika Somogyi explains her philosophy of *Adam and Eve in the Garden* by first citing Genesis 2:9: "And in the middle of the garden He set the tree of life and the tree of knowledge of good and evil." She continues:

"Using the two sides of this medal I have tried to show that duality is only an aspect of the greater unity. The ideas of the Tree of Life and the Tree of Knowledge were my inspiration. By eating from the Tree of Knowledge man became aware of his mortality and, therefore, his separateness from God, or the Divine Life Force. Man fell into the world of dualism; Thou and Not Thou, or Good and Evil.

"However, there is a way to overcome this duality. When one realizes oneself to be both mortal and immortal, duality makes way for a mysterious fusion, a unity. 'Yin' or the Earth couples with 'Yang', the moving spirit resulting in a most powerful unity, the basis of all creation. Thus, the Tree of Life is but the other side of the Tree of Knowledge or Good and Evil. Hence, my medal is in the shape of an apple, the fruit of the Tree of Knowledge, with Adam and Eve on one side, and the Tree of Life on the other.

"Monique Visser, a wonderful young poet, wrote about this idea:
'A simple apple once was
the fruit of temptation
to aspire to be like the Gods
begetting unjustly the loss
of mere mortal sight forever
striving and turning and turning
deeper inward until I find you
always in me for Thou art I
and I am only you, yes, we
are the mystery of creation...'"[4]

1 Hamilton, Mildred, "Bay Area Artist's Face of Liberty," *San Francisco Examiner,* January 14, 1986, Clipping Files, Brookgreen Gardens Archives.
2 *The King James Bible,* Genesis 3:6.
3 *Ibid.,* 3:7
4 Letter from the sculptor, February 26, 1989, Sculptors' Correspondence Files, Brookgreen Gardens Archives.

John Svenson

A SCULPTOR whose entire career has been spent on the West Coast, John Edward Svenson was born at Los Angeles, California, on May 10, 1923. During World War II he served in the African and Italian campaigns. He attended Claremont Graduate School in Claremont, California, where he studied with Henry Lee McFee, Phil Dike and Millard Sheets. Then Svenson worked as assistant in the studio of Albert Stewart and continued to study sculpture under him. Stewart and Paul Manship nominated him for membership in the National Sculpture Society in 1966.

John Svenson's sculpture has received awards in his native state. His work won first prize at the Greek Theater in Los Angeles in 1951 and 1954, as well as Purchase Prize at the National Orange Show in 1951. The Los Angeles County Fair awarded him a purchase prize in 1952 and first prize in 1955. In 1957 and 1961 he received the Award for Excellence in Sculpture from the American Institute of Architects. At the Laguna Art Festival in 1961 he was awarded first prize.

Svenson has worked in a variety of materials including fiberglass, ceramic,

cast stone, crystal, iron, brass, aluminum, bronze and limestone. Some of his most interesting commissions have been carved in wood. A colossal carving in California redwood, *Ranchero*, was placed at Pomona. *Crucifixion*, an over-life-size carving, is located at Precious Blood Catholic Church in Los Angeles. Panels depicting the history of California were commissioned for the San Gabriel Mission Chapel. A bronze porpoise fountain was placed at the Ritz Carlton Hotel in Laguna Niguel. For the facade of the Purex Corporation building at Lakewood, California, he designed sculptural ornamentation and large freeform sculpture in cast stone.

In addition to decorative, historical and religious themes, John Svenson has specialized in depicting the Native American people of the Southwest and Northwest. These powerful representations have been executed in solid form with spare detail. *Comanche Winter*, a small bronze of a figure enveloped in a hooded buffalo robe, was shown in the 50th annual exhibition of the National Sculpture Society in 1983.

A number of portrait medals have been designed by Svenson including medallions of King Hussein of Jordan and Ibn Saud of Saudi Arabia. He created the medal of Charlotte Cushman for the Hall of Fame for Great Americans at New York University in 1972 and, in that same year, was commissioned to design the 86th issue of the Society of Medalists.

John Svenson is a fellow of the National Sculpture Society, an honorary life member of the Riverside, California, Art Association, and an honorary member of the Federation of Canadian Woodcarvers. He serves on the board of trustees of Alaska Indian Arts, Inc. in Port Chilkoot. Svenson teaches sculpture privately and maintains a studio and gallery at Upland, California. In 1993 he was recognized for a lifetime of achievement in artistic endeavors by The Arts Foundation of San Bernardino County, California.

Alaskan Indian Medal

The 86th issue of the Society of Medalists in 1972 focuses on a favorite theme of the sculptor — Native Americans of the Northwest. The culture of the Tlingit Indians who live in Southeastern Alaska is based on a respect for nature and a closeness to the land. Their art features flowing lines and stylized, nearly abstract, portrayals of Alaskan creatures which appear on totem poles, in jewelry and in designs painted on bark and woven into robes.

The obverse depicts the head and shoulders of a chieftain in ceremonial robe and headdress. The word, *Chilkat*, vertically bisects the right section of the

ALASKAN INDIAN MEDAL

Bronze. 7.3 cm in diameter. Signed: *SVENSON 72©* N.1988.014, placed in 1989. Gift
of Beatrice Gilman Proske.

obverse. The center reverse depicts carvings on a totem pole with a Chilkat
ceremonial robe forming the background and a mask on each side of the pole.
The Chilkat robe of the Tlingit nation was worn in ceremonial dances by chiefs
and leaders of high social rank. Across the bottom of the reverse is the word,
Alaska, and along the top forming two semi-circles on either side are *Tlingit* on
the left and *Indians* on the right.

Patricia L. Verani

ALTHOUGH she has gained a distinguished reputation in the numismatic
field, particularly that of commemorative coin design, Patricia Verani is better
known as a portrait sculptor, working primarily in bas-relief. She has made
engaging studies of animals, some cast in bronze and others carved in wood,
which have been shown in exhibitions of the National Sculpture Society, Pen
and Brush, the New England Sculptors Association and the Copley Society of
Boston. She also has carved small works in alabaster.

Patricia Lewis was born January 2, 1927, at Plandome, Long Island, New
York. Her art studies began at the Boston Museum School of Fine Art in 1944

where she was awarded a half tuition scholarship during the first year and full scholarships the following three years. There she studied art history, design, drawing, anatomy, perspective, jewelry, sculpture and ceramics, graduating with highest honors in June of 1948. Her sculpture instructors during those years were Frederick W. Allen, Elizabeth MacLean-Smith and Peter Abate. One summer session was spent at the Boston Museum School in the Berkshires where the Yugoslavian sculptor, Ivan Mestrovic, was her teacher. After graduation, she returned to Boston for a fifth year of part time study in wood carving.

Upon graduation she had been awarded the Mrs. David Hunt traveling Scholarship for a year's study in Europe. During her European sojourn, which lasted for three years, she traveled in England, Denmark, Sweden and Italy to broaden her artistic horizons, living for eighteen months each in France and Italy. In Paris, Patricia Verani had brief instruction from Ossipe Zadkine, a modernist, whose linear figures were quite popular in the decade following World War II. She supported herself during the time in Italy by working in a pottery shop, making designs in terra cotta to be fired and sold to customers.

On April 24, 1950, Patricia Lewis was married to Osvaldo Verani. They stayed in Italy until the fall of 1951 when they returned to the United States, eventually settling in Londonderry, New Hampshire. Through the 1950s and 1960s she raised four children and helped her husband with his restaurant and, later, a real estate business. In 1964 she learned the craft of throwing pottery on the wheel with Nedo Pazzini during a summer in Italy. To supplement her knowledge, she spent a semester studying ceramics at the Manchester Institute of Arts and Science. But her work in sculpture was only sporadic during these years. By the 1970s, the children were old enough to allow her more time for sculpture.

A round bas-relief, created in honor of the American Bicentennial and placed in 1976 at Londonderry, New Hampshire, won the Mrs. Louis Bennett Prize at the National Sculpture Society Exhibition in 1979. Entitled *Bicentennial '76*, it featured three militia men in profile kneeling with aimed muskets and superimposed over the shape of the state of New Hampshire. She designed a Crucifix in oak for the Church of the Resurrection at Brookline, New Hampshire.

Verani won first prize in the competition to design the "Fighting Black Bear," the mascot of the University of Maine. In 1979 the eight-foot bronze bear was installed on the campus at Orono. In 1980 she was commissioned by friends of Sherman Adams, Governor of New Hampshire, to carve a large cherry wood relief as a gift for him. A bronze portrait bust of the philanthro-

pist, Larry Elliot, was installed in 1983 in front of the Amoskeag Bank at Nashua, New Hampshire. In 1984 *Rock-Springer* in bronze was given the Tallix Foundry Award at the Pen and Brush exhibition and, in the following year, *Ruminating* in terra cotta received honorable mention. At the same time Verani was a semi-finalist in a state-sponsored "% for Art" competition for a sculpture to be placed in Sunapee State Park, at Sunapee, New Hampshire.

During the summer of 1986 a small statue of Saint Bridget in polyester resin was completed for St. Mark's Church in Londonderry, New Hampshire, and a bronze bust of Governor Sherman Adams was installed in front of the Governor's Lodge, Loon Mountain Ski Resort at Lincoln, New Hampshire. Her largest sculpture commission was received in 1988 from the alumni association of the Boston Children's Hospital School of Nursing, which trained pediatric nurses, to commemorate the centennial of the school's founding. The life-size bronze group of a student nurse in the school's uniform, holding the hand of a child standing beside her and a teddy bear under one arm, was installed in the Prouty Garden of the hospital on National Nurses' Day in 1989.

Patricia Verani was invited in 1987 by the United States Treasury to submit designs for a silver dollar and a gold coin to commemorate the 200th Anniversary of the United States Constitution. Her design for the silver dollar was chosen by the Treasury Secretary. Featuring a quill pen and the inscription "We the People" above four sheaves of paper representing the Constitution on the obverse, and depictions of Americans from various periods of history on the reverse, it was named "Most Popular Coin of the Year" by the publishers of *Numismatic News.* Verani's design of the torch of the Statue of Liberty and the Olympic Torch merging into a single flame was chosen for the obverse of the Olympic silver dollar commemorating the United States' participation in the 1988 games at Seoul, South Korea. Another design depicting the head of *The Statue of Freedom* by Thomas Crawford, which stands atop the Capitol Dome, was chosen in competition sponsored by the United States Mint for the obverse of a fifty cent piece issued for the Bicentennial of the United States Congress in June of 1989. Other commemorative coins were designed for the New Hampshire towns of Londonderry, Windham and Derry. As a result of her work with the special issue coins, Verani was invited in 1988 to testify before the Subcommittee on Consumer Affairs and Coinage for the redesigning of regular United States currency coins.

In 1983 a plaster relief in profile of Coach Paul "Bear" Bryant of the University of Alabama, wearing his signature hat, was shown at the American Medallic Sculpture Association exhibition. Two cast bronze medals, *Naptime*

THE MEDALIST'S MEDAL
BROOKGREEN GARDENS MEMBERSHIP MEDAL, 1990-91

Bronze medal. 7.6 cm diameter. Signed on the reverse: *PV*; stamped on the edge: ©*1990 BROOKGREEN GARDENS, BRONZE.* N.1989.002, placed in 1990. Other examples: New York, NY. American Numismatic Society, National Sculpture Society; London, England. The British Museum.

and *Out of the Chute*, were chosen for exhibition at the 50th Anniversary Congress and Exposition of the Federation Internationale de la Medaille held at Colorado Springs, Colorado, in 1987. The 118th issue of the Society of medalists, *Snow and Sand*, a triangular-shaped study in contrasts, was completed in 1988. The theme of the obverse, Arctic snow, depicts an Eskimo dependent upon his four sled dogs. The reverse focuses on arid sand, four camels and an Arab rider who is equally dependent on the "ships of the desert." Her medallic work is exhibited at the American Numismatic Society in New York City and the Medallic Art Company in Danbury, Connecticut. Several bas-relief portraits are at The Lawrence Public Library in Lawrence, Massachusetts.

Patricia Verani is a member of the National Sculpture Society, Pen and Brush, the New Hampshire Art Association and the Copley Society of Boston. She is a charter member of the New England Sculptors Association and of the American Medallic Sculpture Association. She lives and works in Londonderry, New Hampshire.

The Medalist's Medal
Brookgreen Gardens Membership Medal, 1990-91

Although sculpture, as represented by "The Medalist," was the theme for the eighteenth in the series of Brookgreen Gardens Membership Medals, Patricia Verani incorporated the native wildlife of the Southeast into the design, as well. On the obverse are depicted the hands of the sculptor, or medalist, from which spring a herd of six deer, as if given life by the creative process. A sculptor's tool is held in one hand and a lump of clay is pressed between the thumb and index finger of the other hand. The reverse shows the finished medal with a family of deer, alert to the many dangers of life in the wild.

Patricia Verani explained her ideas: "I was very enthusiastic about submitting sketches for the Brookgreen Gardens Medal because one of the several themes, 'Flora and Fauna,' would incorporate my favorite subject, animals. When the theme 'Medalist' was also suggested, my idea was to show the completed medal on one side and the medalist working on the opposite side. The deer are all running, cavorting and leaping about on the obverse, probably as they did in my mind, then passing through my fingers to the final positioning on the medal.

"Perhaps the deer on the reverse hear all the commotion on the obverse. The doe and buck are frozen in attention, while the fawn has not yet taken over the responsibility of his well-being, and looks only to be reassured by his mother. The Spanish moss give them an almost surreal feeling, hiding and binding them in their woodland sanctuary."[1]

1 Letter from the sculptor, Sculptor's Correspondence Files, Brookgreen Gardens Archives.

Elbert Weinberg

ELBERT WEINBERG was born in Hartford, Connecticut on May 27, 1928. He studied at the Hartford Art School with Henry Kreis and at the Rhode Island School of Design where he received a bachelor of fine arts degree in 1951 and was awarded the Prix de Rome to study at the American Academy. Upon return to the United States from Italy in 1953, he enrolled at Yale University

and earned a master of fine arts degree in 1955. While pursuing the master's degree he studied with Waldemar Raemisch.

In 1959 he was commissioned by Mr. & Mrs. Albert List of the Jewish Museum to create a bronze procession sculpture. In 1964 *Jacob Wrestling with the Angel* was placed at Brandeis University in Waltham, Massachusetts. A bronze sculpture entitled *Shofar* was done for Rockdale Temple at Cincinnati in 1969. A figure of *Justice* was commissioned for the lobby of Boston University Law School in 1974 and, in the following year, another procession sculpture was designed for Beth El Temple in West Hartford, Connecticut.

Elbert Weinberg has taught sculpture for many years in art schools and universities. From 1956 to 1959 he was an instructor at Cooper Union. Since 1970 he has been a visiting professor of sculpture at Boston University and at Tyler School of Art. In 1976 he was the artist-in-residence at Union College in Schenectady, New York.

In 1953 his work received honorable mention in the International Unknown Political Prisoner Competition sponsored by the Institute of Contemporary Art. In 1959 he was awarded a Guggenheim Fellowship and ten years later he received the Sculpture Award from the American Institute of Arts and Letters. He is a member of the Sculptors Guild.

Pandora's Box Medal

The 84th issue of the Society of Medalists in 1971 dealt with the idea of death and destruction brought about by nuclear holocaust. The medal's obverse depicts the myth of Pandora's box where the miseries of the world were unwittingly released by the curious woman, Pandora. However, the sculptor allegorically equated the creation of the bomb and the myth by depicting a grinning death's head rising from the box. It bears the inscription *Pandora Two.* On the reverse an atomic cloud signals the end of the world.

Bronze. 7.3 cm in diameter. Signed: *EW 1971* © N.1988.012, placed in 1989. Gift of Beatrice Gilman Proske.

Robert A. Weinman

For ADDITIONAL INFORMATION about the sculptor, please refer to *Brookgreen Gardens Sculpture*, pp. 504-507.

One of the nation's most accomplished medallic artists, Robert Weinman has carried on proudly the family tradition of fine sculpture. His output has included well over 100 medals including six for a series honoring persons enshrined in the Hall of Fame for Great Americans at New York University. He completed medals of Orville and Wilbur Wright for the Aviation Hall of Fame in 1975. A large wall relief portraying six members of the Joseph R. Wilson family was placed on the interior wall of the Student Commons Building at the University of Rochester.

His *Socrates* medal, the 69th issue of the Society of Medalists, was shown in an exhibit of the American Medallic Sculpture Association in 1983 and 1984 which traveled to the American Numismatic Society, the American Numismatic Association and the San Francisco Old Mint. The Pennsylvania Masonic Grand Master medal, illustrating the tricentennial of William Penn, was created in 1982. The obverse depicts Penn framed on one side by a pair of Native Americans, and on the other by a pair of Pennsylvanians. This medal was chosen for exhibition at the XX FIDEM exposition, held in Stockholm in 1985.

His commission in 1987 to design the 115th issue of the Society of Medalists brought about a need to create something entirely different from his previous work for the Society. The result was a whimsical *Cat and Mouse*, the first free-standing medal in the series. The obverse consists of a chunk of Swiss cheese with a small mouse curled up in a cavity on the lower right. In the upper left, the head of a cat peers around the corner of the cheese. The reverse is the exact reverse image — that of the body of the cat with its head around the corner. This popular medal was exhibited at the XXI exposition of the Federation Internationale de la Medaille held in 1987 at Colorado Springs, Colorado.

In recognition of his meritorious body of medallic work, in 1975 Robert Weinman was named Sculptor of the Year by the American Numismatic Association. He is an academician of the National Academy of Design and a fellow of the National Sculpture Society which he served as President from 1973 to 1976. Weinman chaired the committee which selected the United States Bicentennial coinage issued in 1975. He lives and works in Bedford, New York.

 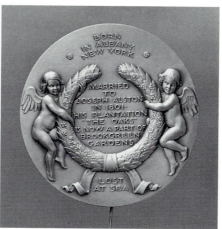

THEODOSIA BURR ALSTON MEDAL
BROOKGREEN GARDENS MEMBERSHIP MEDAL, 1975-76

Bronze. 7.6 cm in diameter. Signed on obverse: *R.A.* / *19©75* / *W* N.1975.001, placed in 1975. Other examples: New York, NY. American Numismatic Society, National Sculpture Society; London England. The British Museum.

Theodosia Burr Alston Medal
Brookgreen Gardens Membership Medal, 1975-76

The third medal in the Brookgreen membership series focused on an aspect of Brookgreen's historical heritage. Theodosia Burr Alston, daughter of Aaron Burr and wife of Governor Joseph Alston, was a brilliant though tragic figure in American history, surrounded by mystery, intrigue and grief. She and her husband came to live on his plantation, The Oaks, now a part of Brookgreen Gardens, shortly after their marriage in 1801. Robert Weinman's commission in 1975 dealt with the story of Theodosia and was the first medal to incorporate biographical material into the design.

The obverse contains a profile portrait of Theodosia adapted from the portrait by John Vanderlyn that is now at the Yale University Art Gallery. To the left of the profile is her name, *Theodosia Burr Alston,* and to the right are her dates, *1783-1813.* The words, *Brookgreen* and *Gardens,* appear at the top and bottom of the design. On the reverse, a pair of winged cherubs supporting a wreath frame a history of Theodosia's brief life: *Born in Albany, New York. Married to Joseph Alston in 1801. His plantation "The Oaks" is now a part of Brookgreen Gardens. Lost at sea.* The inaugural medal was presented to Dr. Samuel Engle Burr, Jr., president of the Aaron Burr Society.

Nina Winkel

NINA KOCH was born in Borken, Westfahlen, Germany, on May 21, 1905, to Ernst and Augustine (Bauer) Koch. The daughter of a teacher of Latin, Greek and history, she was introduced to the classics at an early age. Suffering from migraine headaches from childhood, she was bedridden until the age of fourteen. During this confinement her mother would amuse her with storytelling — sometimes fairy tales but more often stories from the Bible, and especially those related to the life of Christ. In 1919 she was allowed to live and work on a farm, an experience which improved her health and expanded her practical knowledge.

She took up acting, touring Switzerland with a traveling company and playing for four years at the Bochum Theatre in the Ruhr Valley. During this time, on an impulse, she began to fashion a small figure in plasteline and a friend, impressed by the promise it showed, offered to help her study sculpture. From 1929 until 1931 she studied under Richard Scheibe at the Staedel Museum Art School in Frankfurt. She moved to Paris in 1933 where she met George J. Winkel, a German citizen living in France, and they were married on December 15, 1934. Her husband joined the French army in 1939 and during the German occupation of France in 1940, she was interned in the Gurs concentration camp near the Spanish border. Upon her release from the camp and his discharge from the army, they lived under difficult circumstances in the south of France until they were able to escape to Portugal. In 1942 they received immigration papers, came to America and settled in New York. Nina Winkel became an American citizen in 1945.

Upon her arrival in New York City, she took classes at The Clay Club on Eighth Street. The director, Dorothea Denslow, recognized her talent and made the facilities available to her. By 1944 she had the first of four solo shows there. From that point, Nina Winkel's career was launched and she began to work in terra cotta and to experiment with alternative techniques. Unable to carve stone in the traditional way due to the migraines which plagued her throughout life, she enjoyed alabaster which could be worked more gently by filing and sanding. In 1959, at the suggestion of a friend, she began to work with light gauge coppersheet and silversoldering. These thin sheets of copper were hammered, shaped and soldered into the whimsically expressive figures for which she became known.

The stories her mother told her stayed in her memory and provided inspiration for much of her work. *Foolish and Wise Virgins*, done in 1961 in

hammered coppersheet, is an interpretation of a parable from the book of Matthew. The wise one is modest and quiet, while the foolish virgin is vain and proud. *Penitent*, a despairing figure in copper, curled in a fetal position, is reduced to simple line with little or no detail. Dated 1981-82, it is in the collection of the State University of New York, Plattsburgh. A life-size relief was commissioned for the town hall, as well as a life-size figure of Christ Crucified for a church in Borken, Germany, in 1984. For the Albert Schweitzer School in Wiesbaden, Germany, a group of children was created. Wall panels commissioned by the Hanes Corporation depict the early Moravian settlers of Winston-Salem, North Carolina.

Nina Winkel has been the recipient of many awards for her art and innovation. From the National Academy of Design she received the Elizabeth Watrous Gold Medal in 1945, 1978 and 1983, and the Samuel F. B. Morse Gold Medal in 1964. The National Sculpture Society awarded her its bronze medal for *Apocalyptic Rider* in 1967 and for *Adoration* in 1971, the Mrs. Louis Bennett Prize for a copper bas-relief, *Fermata*, in 1975, and the Joyce and Elliot Liskin Purchase Prize for *Justice Protectress*, a two-figure group in copper and brass in 1981. The Pen and Brush gave her its Founders' Award in 1982.

The National Sculpture Society had recognized her sculptural ability by electing her to membership in 1958 and advancing her to fellow in 1963. She was the recipient of its Medal of Honor for notable achievement in American sculpture in 1988. Nina Winkel was an associate of the National Academy of Design, a member of the Sculptors Guild, and a professional member of the Sculpture Center. In 1972 a retrospective of her work was shown there.

In 1985 the State University of New York awarded her an honorary Doctor of Fine Arts degree. In October 1987 the Winkel Sculpture Court, containing forty of her works, was opened at the State University of New York at Plattsburgh and she received its Distinguished Service Medal. She also served as a trustee for several organizations including the Sculpture Center in New York City, the Adirondack Museum in Elizabethtown, New York, and the Keene Valley Library Association.

Another interest of the artist was in the field of antique art. Recognized an authority on antique mosaics, she frequently lectured on the subject and was the author of a definitive work on Byzantine mosaics. She died on May 24, 1990.

New York City. She became the third woman in seventy years to receive this award.

Karen Worth has designed over 150 medals for the Judaic Heritage Society including a series of 120 medals entitled *The History of Jews in America*. She has created five of the nine medals in the Man of the Year series including the 1981 issue in honor of Raoul Wallenberg, a Swedish humanitarian, who is referred to as the Holocaust's "lost hero." In 1981 she was awarded the Lucy Lohat Prize of the Judaic Heritage Society for the most distinguished relief sculpture on a theme related to Judaic heritage.

Karen Worth's art is not confined to one medium; she has designed plates in silver, fine china for Wedgwood of England, and a relief in crushed stained glass. In 1982 she modeled a portrait bust of Major Thomas McGuire that was placed on the grounds of McGuire Air Force Base along with other commissions that were exhibited in a museum there.

Believing that one cannot live in seclusion and express real life in one's art, she has firm convictions concerning the creation of medallic art: "What is a medal? For the recipient, it is a monument to hold in the hand. To the giver — a flash of glory, a token of triumph. For you, the collector, a medal is a celebration. We cannot all be astronauts, presidents or Nobel prize winners, but we can share vicariously the achievements of our heroes and heroines. Sometimes we simply want to possess a medal for its beauty or its special meaning for us. And think about this: we listen to music, watch a sunset or travel to exotic places — not as an investment but as a beautiful experience. Who can measure its intrinsic worth? Beauty is an incense in the heart..."[1]

Karen Worth resides in Orangeburg, New York.

The Pygmalion and Galatea Medal
Brookgreen Gardens Membership Medal, 1982-83

There are two legends of classical Greek mythology which touch on subjects of particular interest to Brookgreen Gardens. The first is the story of Pygmalion and Galatea which relates how a sculptor became so enamored of a statue of a maiden he had carved that ultimately it was brought to life for him. The other is the legend of Orpheus, a musician so skilled that when he played his lyre even the wild animals paused to listen. Appropriately, sculpture and wildlife, the two themes of Brookgreen Gardens, are interpreted on the two sides of the medal.

The obverse depicts Pygmalion, a legendary king of Cyprus, who carved the

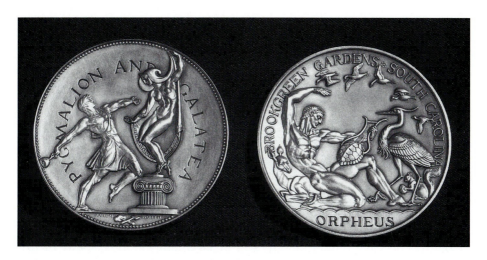

THE PYGMALION AND GALATEA MEDAL
BROOKGREEN GARDENS MEMBERSHIP MEDAL, 1982-83

Bronze. 7.6 cm in diameter. Signed: *KAREN* [crossed mallets] *WORTH* N.1981.002, placed in 1982. Other examples: New York, NY. American Numismatic Society, National Sculpture Society; London, England. The British Museum.

figure of a beautiful maiden and immediately fell in love with it. He prayed to Aphrodite, the goddess of love, that the statue might be transformed into a real woman. The medal portrays the magical moment when the statue becomes the maiden, Galatea, and Pygmalion, overjoyed, reaches out toward his creation.

On the reverse is Orpheus who was celebrated in Greek literature as the outstanding poet of his age. There are many myths about him, however, the one depicted here has to do with his musical accomplishments. He was given a lyre by Apollo, and the muses instructed him in its use. So skillful did he become that his music enchanted the wild animals and they followed him as he played. The lyre is shown as the ancient Greek type with the sounding box made from the shell of a tortoise. The wild animals are those native to South Carolina — the great blue heron, white-tailed deer, grey squirrel and flying birds.

1 "The Depth of Karen Worth, Sculptor," *Coin World*, January 30, 1980, p.4.

Charles Cushing Wright

BORN IN Damariscotta, Maine, May 1, 1796, Charles Cushing Wright was orphaned at an early age and was adopted by Charles Cushing whose name he incorporated into his own. After serving as a soldier in the War of 1812, he settled in Utica, New York, where he apprenticed to John Osburn, a jeweler and watchmaker. During this time he taught himself copper plate engraving. He eventually became a sculptor of dies and hubs for medals. The die is an intaglio or sunken sculpture design, and the hub is a relievo or projecting design. This work was commonly called die sinking during the antebellum period.

By 1819 he was an itinerant engraver in Savannah, Georgia, where he lost all his possessions in the fire that destroyed the city. In 1820 he moved to Charleston, South Carolina, where he remained for four years. Also in 1820 he married Lavinia Dorothy Simons, an amateur still life and portrait artist, who was a native South Carolinian. While working in Charleston he executed a number of dies and portraits including one of Charles Cotesworth Pinckney which is purported to be the first portrait sunk in steel by an American artist. In 1821 he organized and served on the first board of directors of the South Carolina Academy of Fine Arts, a short-lived organization devoted to exhibitions. Four works by Wright are in the collection of the Carolina Art Association at the Gibbes Museum of Art: an engraving from *Illustrations of Shakespeare* by Boydell of *The Tempest*, an engraving for a Wagner Day Ticket for the South Carolina West Indian Exposition, and bronze medallions of Washington Allston and Gilbert Stuart.[1]

In 1824 he returned to New York due to ill health and formed a partnership with Asher B. Durand in the bank note engraving business. Subsequent partnerships in the engraving field were formed with James Bale in 1829 and with Nathaniel Smith Prentiss in 1835. He also made dies for a number of medals awarded by the federal and state governments including presentation medals for the State of New York, the Michigan State Agricultural Society and the Middlesex Mechanic Association of Lowell, Massachusetts. In 1849 he was commissioned to engrave dies for the Congressional Medals awarded to Generals Scott and Taylor for victories in the Mexican War. Wright produced dies for the first of two varieties of the octagonal fifty dollar gold coin issued by Augustus Humbert in 1851. The medal for the Exhibition of the Industry of all Nations held at the Crystal Palace, New York, in 1853 was his work.

His skill as a die engraver could be seen in medal portraits of prominent

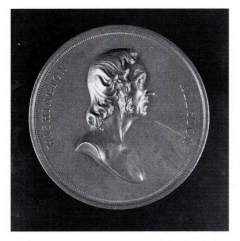 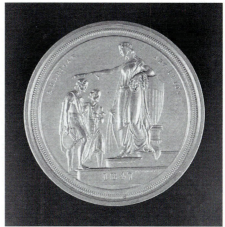

WASHINGTON ALLSTON — AMERICAN ART-UNION MEDAL

Bronze. 63 mm in diameter. Signed on obverse: *C.C. WRIGHT F.* and *P.P. DUGGAN DEL.* Signed on reverse: *P.P. DUGGAN DEL.* and *C.C. WRIGHT SC.* N.1987.001, placed in 1987. Other examples: Charleston, SC. Gibbes Museum of Art.

men such as George Washington, Daniel Webster and Henry Clay. They were strongly individualized portraits rather than bland profiles, and Wright's careful attention to inscriptions and decorative borders added interest. In addition to designing his own medals, Wright often engraved medals from reliefs modeled by other artists.

Besides engraving bank notes, medals and tokens, Wright was one of the first to make steel pens in the United States, and made watch cases and engraved watch papers. Charles Cushing Wright was a founder of the National Academy of Design in New York City in 1826. He exhibited there from 1826 and lectured on the art of the medal. He died in New York City on June 7, 1854.

Washington Allston — American Art-Union Medal

The obverse of the medal depicts a bust of the painter Washington Allston in profile. On either side of the bust are the words, *Washington* and *Allston*, and a decorative border encircles the edge. The reverse depicts a scene of Fame crowning an artist with laurel and holding another wreath in readiness in her left hand for the sculptor waiting his turn. Fame in flowing robes stands next to a large urn at the top of three steps. On the bottom step is the date 1847. Circling the design on the left is the word, *American*, and on the right are the

words, *Art-Union.*

Charles Cushing Wright engraved the medal which was designed by Peter Paul Duggan, a portrait artist and medal designer who was a member of the National Academy of Design. Duggan came to America from Ireland as a child in 1810 and lived in New York City until 1856 when ill health forced him to retire. After that he lived in London and Paris where he died October 15, 1861. The medal was one of a series of three medals struck at the mint for the American Art-Union. The others honor the painters Gilbert Stuart and John Trumbull.

1 Letter from Charlotte Brailsford, Registrar, October 1, 1987.

References

Source material not indicated in the bibliography has been furnished by the National Sculpture Society and the George Arents Research Library, Syracuse University. No attempt has been made to compile a complete bibliography for each sculptor. Please refer to *Brookgreen Gardens Sculpture*, pp. 513-544, for additional source material.

BY SCULPTOR

Akeley, Carl

BODRY-SANDERS, PENELOPE, *Carl Akeley, Africa's Collector, Africa's Savior*, Paragon House, New York, 1991.

"Carl E. Akeley and His Work," *The Mentor*, June 1924, pp. 21-28.

GREENE, DOROTHY S., "Carl Akeley — Sculptor-Taxidermist," *The American Magazine of Art*, 1924, pp. 125-130.

"The Work of Carl E. Akeley," *The American Museum Journal*, Vol. XIII, No. 4, April 1913, pp. 173-178.

Allen, Tom Jr.

"The Society of Medalists Eighty-Second Issue, December 1970, Tom Allen, Jr., Sculptor," descriptive brochure.

Armstrong, Jane

ARMSTRONG, JANE, *Discovery in Stone*, East Woods Press, Inc., New York, 1974.

Homage to Stone, Jane Armstrong, Grand Central Art Galleries, New York, NY, November 28, 1989.

SAUNDERS, RICHARD, *Jane Armstrong*. Christian A. Johnson Memorial Gallery, Middlebury College, VT, 1989.

TYSON, ELIZABETH, "Sculpture Wins Prize," *News Journal*, Florida, February 17, 1977, p.B7.

Belskie, Abram

"ANA Cites Sculptor Abram Belskie," *Coin World*, 1974.

Branch, Betty

ANGELL, JANIS, "Forms Fascinate Roanoke Sculptor," *The News Journal*, Radford, VA, November 1, 1981, p. A5.

"Betty Branch," *Brookgreen Journal*, Vol. XV, No. 3, 1985.

KENNEDY, JOE, "With 10 You Get Diversity," *Roanoke Times & World News*, Roanoke, VA, March 23, 1983, p. C1.

MATHEWS, PATRICIA, "Betty Branch," *Virginia Women Artists - Female Experience in Art*, VPI and State University, Blacksburg, VA, 1985, p. 18.

WALKER, PENELOPE, ED., "Pursuing Realism," *International Sculpture*, March-April, 1986, Vol. 5, No. 2, p. 10.

WEINSTEIN, ANN, "Sculptor Betty Branch's Figurative Figures," *Roanoke Times & World News*, December 20, 1987.

———- "One About Women, One by Women," *Roanoke Times & World News*, May 19, 1985, p. E2.

Carter, Granville

AMES, CHARLOTTE, "LIer Sculpts Gen. Pulaski on Horseback," *Long Island Press*, March 7, 1976, p. 19.

———- "LIer Sculptures Pulaski," *Long Island Press*, July 11, 1976, p. 17.

"Baldwin Sculptor Presides at Honors/ Awards Dinner," *The Baldwin Citizen*, December 3, 1981, p. 3.

BELL, DENNIS, "Achievers: A Profile for Sculpting Success," *Newsday*, May 12, 1980.

Carter, Granville, *continued*

"NSS Elections," *National Sculpture Review*, Vol. XXVII, No. 1, Spring 1979, p. 5-7.

"Pioneer Family Asset for City," *Lubbock Avalanche-Journal*, June 10, 1971, Section E., p. 10.

PRICE, JO-ANN, "Easter Story in Sculpture," *The Sunday Herald Tribune*, Brooklyn-Long Island, April 18, 1965, Section 5.

"They Tamed the Plains," *Southern Living*, November 1984, p. 42.

Coe, Herring

FUNDERBURK, EMMA LILA & THOMAS G. DAVENPORT, *Art in Public Places in the United States*, Bowling Green University Popular Press, Bowling Green, OH, 1975.

"The Society of Medalists, Seventy-fifth Issue, July 1967, Herring Coe, Sculptor," descriptive brochure.

Cook, John

"ANA to Host International Medallic Art Exposition," *The Numismatist*, February, 1987, pp. 340-341.

COOK, JOHN, *The Resurgent Art Medal: An International Selection*, Museum of Art, The Pennsylvania State University, University Park, PA, July 10-August 26, 1984 (exhibit catalogue).

LACEWELL, ROBERT M., "Parmeshwari Gupta, John Cook Receive Top American Numismatic Society Honors," *Coin World*, January 13, 1988, pp. 1 & 10.

MUIR, CHUCK, "Art of Medals Needs Youth, PSU Professor Says," *Patriot News*, Harrisburg, PA, November 28, 1983, p. B4.

"Works of 41 Medallic Sculptors to Represent United States at FIDEM," *Coin World*, April 13, 1983, pp. 1 & 22.

Daingerfield, Marjorie

CLEMENT, MELISSA, "Sculptor Remembered," *The Fayetteville Observer*, Fayetteville, NC, Friday, April 1, 1977, p. 15A.

DAINGERFIELD, MARJORIE, *The Fun & Fundamentals of Sculpture*, Charles Scribner's Sons, New York, 1963.

"An Exhibition of Sculpture by Marjorie Daingerfield," The Mint Museum of Art, Charlotte, NC, March 4-25, 1962.

WARREN, HAROLD, "Eminent N.C. Sculptor Marjorie Daingerfield Dies," *The Fayetteville Observer*, Fayetteville, NC, March 19, 1977.

De Lue, Donald

FLARTEY, HAROLD, "De Lue Captures Sculptor of Year Laurels," *Coin World*, September 23, 1979.

———- "Donald De Lue, Sculptor," *The Numismatist*, December 1979.

———- "New Medal, 'Bursting the Bounds,' Winning Accolades," *Daily Record*, Northwest, NJ, January 26, 1986.

HOWLETT, D. ROGER, *The Sculpture of Donald De Lue, Gods, Prophets, and Heroes*, David R. Godine, Publisher, Boston, 1990.

LANTZ, MICHAEL, ED., "Reminiscing with Donald De Lue," *National Sculpture Review*, Summer 1974.

NOBLE, JOSEPH VEACH, "1978 Brookgreen Gardens Medal," *Brookgreen Bulletin*, Vol. VIII, No. 2, 1978.

REITER, ED, "Medallic Art Moves to the Fore," *The New York Times*, February 2, 1986.

TORTORELLA, KAREN, "Donald De Lue: A Man and a Monument; Sculptor Captures Magnificent Spirit," *The New York Times*, December 10, 1982.

Demetrios, George

DAME, LAWRENCE, "Left Greece to Become Folly Cove Sculptor," *The Boston Herald*, August 27, 1939.

DEMETRIOS, GEORGE, "My Adventure in Drawing," *National Sculpture Review*, Summer 1969, pp. 23-26.

"George Demetrios, Sculptor and Teacher," *National Sculpture Review*, Summer 1969, pp. 15, 26, 30.

"George Demetrios (1896-1974) Sculptor and Teacher," August 1-November 15, 1986, Cape Ann Historical Association, Gloucester, MA (exhibit catalogue).

GILSTRAP, MAX K., "Wonders of Research: Sculpture in Color," *The Christian Science Monitor*, Boston, January 22, 1942.

Finke, Leonda

"New Medals from BAMS," *The Medal*, No. 15, Fall 1989, p. 99.

"Drawings in Silverpoint," by Leonda Finke, *National Sculpture Review*, Vo. XXXI, No. 1, Spring 1982, p. 19.

Fredericks, Marshall

ABATT, CORINNE, "A Quiet Artist Leaves Giant Footprints," *The Eccentric*, Birmingham-Bloomfield Edition, Birmingham, MI, May 12, 1983, p. 1E.

CAMPEN, RICHARD N., *Outdoor Sculpture in Ohio*, W. Summit Press, Chagrin Falls, OH, 1980, p. 147.

COLBY, JAY HAKANSON, "The Dragons of Marshall Fredericks," *The Magazine of the Detroit News*, February 28, 1982.

MALONEY, SUSAN CAREY, "Divinely Inspired," *The Nordic News*, Detroit, MI, March, 1983, p. 1.

McKAY, DAVID, "Miracle in a Bean Field," *Detroit Free Press*, Detroit, MI, November 6, 1990, p. 8F.

McLEAN, EVELYN G., "Marshall M. Fredericks, K. D. — Sculptor" *The University of Windsor Review*, Windsor, Ontario, Spring, 1971, Vol. VI, No. 2.

SAWYER, SALLY, "Marshall Fredericks, Sculptor," *Home Journal*, Detroit, MI, November 17, 1983.

"The Sculptor Who Put Spirit into the Spirit of Detroit," *Detroit Free Press*, Detroit, MI, December 1, 1985.

Frudakis, Anthony

DONCHEY, MARJORIE, "For Otter Sculpture at Bally's, Frudakis Videotaped his Models," *The Press*, Atlantic City, NJ, p. G1.

—— "Linwood Artist Wins $1,000 Prize from National Sculpture Society," *The Press*, Atlantic City, NJ, June 19, 1988, p. B10.

"1988 Young Sculptors Awards," *Sculpture Review*, Vol. XXXVII, No. 3, 1988, p. 16.

SHIELDS, SHIRLEY, "Form Follows Beauty," *The SandPaper*, Cape May, NJ, Friday, July 14, 1989, p. 18.

"Winner," *The Press*, Atlantic City, NJ, March 24, 1991, p. E5.

Frudakis, Zenos

BONENTI, CHARLES, "Varied Sculpture at Chesterwood," *Berkshire Eagle*, MA, 1988.

"In Philadelphia and its Suburbs," *The Philadelphia Inquirer*, July 10, 1987, p. 2B.

TEMIN, CHRISTINE, "Prentice is Highlight of Chesterwood this Year," *The Boston Globe*, August 25, 1988, p. 85.

TORCELLINI, CAROLYN, "Lest They Forget," *Forbes*, June 26, 1989, pp. 158, 162, 163.

WRIGHT, PEG C., "Chesterwood Sculpture Landmark," *Schenectady Gazette*, July 14, 1988.

Grove, Edward R.

BECKER, THOMAS. W., "Edward R. Grove: A Commitment to America," *Franklin Mint Almanac*, November, 1969.

CULVER, VIRGINIA, "The Four Best," *Coins Magazine*, June, 1970.

GROVE, EDWARD R., "The Making of a Medal," *American Artist Magazine*, January, 1972.

—— "The Making of a Medal," *The Numismatist*, July, 1978.

HILL, C.W., "Man of Many Talents," *Coins Monthly*, March 1976.

"The Society of Medalists Eighty-eighth Issue, Edward R. Grove, Sculptor, Fall, 1973," descriptive brochure.

WILLIAMS, E., "The Mural," *Today Magazine, Philadelphia Enquirer*, November, 1958.

Hardin, Adlai Stevenson

"Brookgreen Gardens 1983 Membership Medal," *Brookgreen Bulletin*, Vo. XIII, No. 1, 1983.

HANCOCK, WALKER, "Adlai S. Hardin," *National Sculpture Review*, Vo. XVIII, No. 1, Spring, 1969.

Hardin, Adlai Stevenson, continued

"The Society of Medalists, 62nd Issue, November 1960," descriptive brochure.

Harris, Julian H.

"Julian Hoke Harris," *Brookgreen Journal*, Vol. XV, No. 3, 1985.

"Julian Hoke Harris," *National Sculpture Review*, Summer, 1980.

MORRIS, JOSEPH F., *Julian Hoke Harris*, University of Georgia Press, Athens, GA, 1955.

"The Sculpture of Julian H. Harris," *National Sculpture Review*, Summer, 1976, pp. 16-17.

Hartley, Jonathan Scott

FRIED, FREDERICK AND EDMUND V. GILLON, JR., *New York Civic Sculpture: A Pictorial Guide*, Dover Publications, Inc., New York, NY, 1976, p.2.

GOODE, JAMES M., *The Outdoor Sculpture of Washington, D.C.*, Smithsonian Institution Press, Washington, D.C., 1974, pp. 530, 567, 575.

HARTLEY, JONATHAN, "How to Model in Clay," *Art Amateur*, 12, 1885.

LEDERER, JOSEPH AND ARLEY BONDARIN, *All Around the Town: A Walking Guide to Outdoor Sculpture in New York City*, Charles Scribner's Sons, New York, NY, 1975, pp. 5, 6, 70.

MENCONI, SUSAN E., "Carved and Modeled: American Sculpture 1810-1940," Hirschl & Adler Galleries, Inc., New York, NY, 1982, p. 45.

TAFT, LORADO, *The History of American Sculpture*, Arno Press, New York, reprinted 1969, p. 264.

Hartwig, Cleo

BEAMAN, DOUGLAS, "Cleo Hartwig: An Appreciation," *National Sculpture Review*, Vol. XXXV, No. 4, 1988.

BELL, ENID, "The Compatibles: Sculptors Hartwig and Glinsky." *The American Artist*, Summer Issue, 1968.

"Cleo Hartwig wins Today's Art Medal," *Today's Art*, January, 1976.

GLINSKY, VINCENT AND CLEO HARTWIG, "Direct Carving in Stone," *National Sculpture Review*, Summer, 1965.

HAYS, CONSTANCE L., Obituary, *New York Times*, Sunday, June 19, 1988.

"Sculptor's Guild Exhibiting 70 Works at Lever House," *New York Herald-Tribune*, Tuesday, October 18, 1960.

Hirsch, Willard

LEEDS, LYNN, "Work: My Reason For Being," *Star-News*, Wilmington, NC, February 2, 1967.

MORRIS, JACK A. JR., "Willard Hirsch," *Contemporary Artists of South Carolina*, Greenville County Museum of Art, Greenville, SC, 1970.

"Willard Newman Hirsch, Sculptor, Teacher, Dies," *News and Courier*, Charleston, SC, November 30, 1982, p. 15A.

PINCKNEY, ELISE, "South Carolina Sculptor Produces Striking Designs From Varied Media," *News and Courier*, Charleston, SC, 1960.

SEVERENS, MARTHA R., *Willard Hirsch — Charleston Sculptor*, Gibbes Art Gallery, Charleston, SC, 1979.

"South Carolina," *Sculpture of the Western Hemisphere*, International Business Machines Corporation, New York, 1942.

THOMAS, W.H.J., "Warehouse Illustrates 'Adaptive Use' Concept," *News and Courier*, Charleston, SC, March 1, 1971.

"Willard Hirsch," *Brookgreen Journal*, Vol. XV, No. 3.

Hoffman, Edward Fenno III

"Four Arts Dedicates Sculpture by Ned Hoffman," *Palm Beach Today*, December 1 through 7, 1990, p. 2.

HOFFMAN, EDWARD FENNO III, *Reaching...and other Sculptures*, Haverford House Inc., Wayne, PA, 1985.

SOUTHWELL, WILLIAM, "Obituary, Edward Fenno (Ned) Hoffman III (1916-1991)," *Art Matters*, Vol. 11, No. 3, November 1991, p.16.

Huntington, Anna Hyatt

Anna Hyatt Huntington Papers, George Arents Research Library, Syracuse University, Syracuse, NY.

EDEN, MYRNA G., *Energy and Individuality in the Art of Anna Huntington, Sculptor, and Amy Beach, Composer*, The Scarecrow Press, Inc., Metuchen, NJ, 1987.

PROSKE, BEATRICE GILMAN, "A Sculptor in Manhattan," *Sites*, Lumen, Inc., New York, 1987.

WEEMS, KATHARINE L., "Anna Hyatt Huntington," *National Sculpture Review*, Winter 1974, pp. 8-10 and 26.

Iles, Terry

"The Society of Medalists, 77th Issue, November 1968," descriptive brochure.

Jacobsson, Sten

"85th Issue, The Society of Medalists, Sten Jacobsson, Sculptor, Spring, 1972," descriptive brochure.

Jennewein, Carl Paul

BENBOW, CHARLES, "Sculptor Wrought American Ideal in Stone, Metal," *St. Petersburg Times*, St. Petersburg, FL, November 21, 1980.

"Carl Paul Jennewein, 87, Neo-Classical Sculptor," *The New York Times*, February 24, 1978.

CONNER, JANIS & JOEL ROSENKRANZ, *Rediscoveries in American Sculpture, Studio Works 1893-1939*, University of Texas Press, Austin, TX, 1989.

HOWARTH, SHIRLEY REIFF, *C. Paul Jennewein, Sculptor*, The Tampa Museum, Tampa, FL, 1980.

NOBLE, JOSEPH VEACH, "C. Paul Jennewein," *National Sculpture Review*, Vol. XXVII, No. 3, Fall 1978, pp. 16-19, 30.

Jovine, Marcel

FORTUNE, BEVERLY, "And the Parties Continue Long After the Race is Run," *Lexington Herald*, Lexington, KY, May 4, 1981, Section B.

"Jovine Medal Wins Award for Medallic Art Company," *The Numismatist*, May 1986, p. 863.

REITER, ED, "ANS Honors Jovine," *The New York Times*, February 17, 1985.

——- "Rectangular Design Selected for ANS Medal," *The New York Times*, 1982.

"Society of Medalists Issues Special Bicentennial Medal, Selects Jovine's 'Yankee Doodle' Commemorative Design," *The Art Medalist*, Vol. 2, No. 2, April 1976, pp. 1-2.

Kemeys, Edward

CAFFIN, CHARLES H., *American Masters of Sculpture*, Doubleday, Page & Co., New York, NY, 1915, p. 197.

GARDENER, ALBERT TENEYCK, *American Sculpture, A Catalogue of the Collection of The Metropolitan Museum of Art*, New York, NY, 1965, p. 39.

GARLAND, HAMLIN, "Edward Kemeys — A Sculptor of Frontier Life and Wild Life," *McClures Magazine*, V, July 1895.

HAWTHORNE, JULIAN, "American Wild Animals in Art," *The Century Magazine*, XXVII, June 1884.

RICHMAN, MICHAEL, "America's Pioneer Animal Sculptor," *National Sculpture Review*, Winter 1972, pp. 20-21, 27-28.

——- "Edward Kemeys (1843-1907), America's First Animal Sculptor," *Fine Art Source Material Newsletter*, Vol. 1, No. 5, May 1971.

TAFT, LORADO, *The History of American Sculpture*, MacMillan Company, New York, NY, 1924, p. 473.

Lantz, Michael

"Four Freedoms Revealed in Second American Two Part Medal," *The Art Medalist*, Medallic Art Company, Danbury, CT, Vol. 1, No. 4, August, 1975, p. 1.

GOODE, JAMES M., *The Outdoor Sculpture of Washington, DC, A Comprehensive Historical Guide*, Smithsonian Institution Press, Washington, DC, 1974, pp. 145, 476-477, 572.

Lantz, Michael, continued

GURNEY, GEORGE, *Sculpture and the Federal Triangle*, Smithsonian Institution Press, Washington, DC, 1985, pp. 391-402.

LANTZ, MICHAEL, "1979 Medal, Brookgreen Gardens Membership Medal," *The Numismatist*, May, 1980.

——- "Sculptured Outlines in Bronze," *National Sculpture Review*, Winter 1962-63, pp. 19-21.

"Michael Lantz, 1908-1988," *National Sculpture Review*, Vol. XXXVII, No. 2, 1988, pp. 26 and 35.

"Officers Elected, National Sculpture Society," *National Sculpture Review*, Vol. XVIII, No. 4, Winter 1969-70, pp. 3 & 5.

"WPA Teacher Wins Sculpture Award," *New York Times*, January 27, 1938.

Lathrop, Gertrude

"Gertrude Lathrop; Falls Village Artist Wins Another Medal for her Work," *The Lakeville Journal*, September 6, 1973, p. B3.

RICKFORD, KATHRYN, "Animals Are First Love of Falls Village Sculptor," *The Lakeville Journal*, September 7, 1978, pp. 1-2.

Manca, Albino

MANCA, ALBINO, "Designing and Executing a Large Memorial," *National Sculpture Review*, Summer 1963, pp. 23-25.

Mankowski, Bruno

"Mankowski Wins Sculptor of Year Award," *Coin World*, September 3, 1980, p. 81.

"Mankowski Captures Sculpture Award," *The Numismatist*, November 1980, p. 2699.

MANKOWSKI, BRUNO, "Varieties of American Limestone and Marble," *National Sculpture Review*, Winter 1959-60, pp. 23 and 25.

"The Society of Medalists, 79th Issue, Bruno Mankowski, Sculptor, June 1969," descriptive brochure.

Manship, Paul

KITTLESON, GLORIA, ET.AL., *Paul Manship Changing Taste in America*, Minnesota Museum of Art, St. Paul, MN, 1985.

MANSHIP, JOHN, *Paul Manship*, Abbeville Press, Publishers, New York, NY, 1989.

RAND, HARRY, *Paul Manship*, Smithsonian Institution Press, Washington, DC, 1989.

SILBERMAN, ROBERT, "Thoroughly Moderne Manship," *Art in America*, January 1986, pp. 110-115.

TELTSCH, KATHLEEN, "2 Works to Rejoin Prometheus After 50 Years," *The New York Times*, April 8, 1984.

Margulies, Isidore

"Isidore Margulies, Recent Bronze Sculpture," Joel Meisner Gallery, 120 Fairchild Avenue, Plainview, NY, 1981.

Martin, Chester

FERGUSON, MARGARET, "A Medal for Chester," *News-Free Press*, Chattanooga, TN, December 14, 1980.

NAZOR, KAREN, "Striking Gold at the Capitol," *News-Free Press*, Chattanooga, TN, July 2, 1989, p. J4.

PARKER, LIN C., "New from the U.S. Mint: The Eisenhower Centennial Coin," *News-Free Press*, Chattanooga, TN, February 11, 1990.

"The Sixth Day by Chester Martin, 50th Anniversary First Place Winner," descriptive brochure, The Society of Medalists.

Milles, Carl

ARVIDSSON, KARL AXEL, ED., *Carl Milles, Episodes from my Life*, Millesgarden and Ehrenblad Editions AB, Stockholm, Sweden, 1991.

ARVIDSSON, KARL AXEL, *Millesgarden*, Raben & Sjogren, Stockholm, Sweden, 1953.

JONES, VIRGIL, "Milles: Whimsical, Controversial, Great," *National Sculpture Review*, Winter 1985-86, pp. 16-23.

PETERS, FRANK, "A Hospitable but Shabby Urban Environment for Carl Milles' Romantic Aloe Plaza Vision," *St. Louis Post-Dispatch*, December 22, 1985, 5G.

ROGERS, MEYRIC R., *Carl Milles, An Interpretation of his Work*, Yale University Press, New Haven, CT, 1940.

TAYLOR, FRANCIS HENRY, "Aganippe: The Fountain of the Muses," *The Metropolitan Museum of Art Bulletin*, Volume XIV, Number 5, 1956, pp. 109-113.

Parks, Charles

BURROUGHS, BETTY, "Sculptor Creates Tribute to a Wandering Friend," *The Morning News*, Wilmington, DE, September 13, 1977.

CRAVEN, WAYNE, "Charles Parks — A Biography Midway," *National Sculpture Review*, Spring 1972, pp. 16-17 & 28-29.

"Delaware: Who Needs to be Big?" *National Geographic*, August, 1983, p. 194.

"Light Kinney's Statue," *Coastal Observer*, Pawleys Island, SC, September 27, 1990.

MAHR, NANCY, "The Parks Family: Where Extraordinary is the Norm," *Delaware Today*, September, 1971, pp. 11-13, 42-47.

PARKS, CHARLES C., *The Sculptures of Charles Cropper Parks*, privately printed, 1978.

ROBERTS, EDWIN A.J., "Acclaimed Sculptor Would Like to Carve his Niche in Tampa," *The Tampa Tribune*, September 14, 1991.

STEIGER, BILL, "Placing Statue at Brookgreen No Day at the Beach," *The Evening Post*, Charleston, SC, Wednesday, July 12, 1989, p. 8A.

TORCELLINI, CAROLYN, "Lest They Forget," *Forbes Magazine*, June 26, 1989, pp. 158, 162, 163.

Powers, Hiram

CRANE, SYLVIA E., *White Silence*, University of Miami Press, Coral Gables, FL, 1972.

REYNOLDS, DONALD, *Hiram Powers and His Ideal Sculpture*, Garland, New York, NY, 1977.

THORP, MARGARET FARRAND, *The Literary Sculptors*, Duke University Press, Durham, NC, 1965.

WUNDER, RICHARD P., *Hiram Powers*, Volumes I and II, University of Delaware Press, Newark, DE, 1991.

Recchia, Richard

MORGAN, THEODORA, "Richard H. Recchia of Rockport," *National Sculpture Review*, Vol. XXVII, No. 2, summer 1978, pp. 20–22, 26–27.

Reed, Hal

"The Society of Medalists Eighty-Third Issue, Hal Reed, Sculptor, May 1971," descriptive brochure.

Rogers, Randolph

Art in the U.S. Capitol, U.S. Government Printing Office, Washington, D.C., 1978.

BAIGELL, MATTHEW, *Dictionary of American Art*, John Murray Publishers, London, 1980, pp. 307-308.

BULWER-LYTTON, EDWARD, *The Last Days of Pompeii*, Dodd Mead & Company, New York, 1946 (reprint).

CRAVEN, WAYNE, *Sculpture in America*, University of Delaware Press, Newark, DE, 1984 (reprint), pp. 312-320.

THORP, MARGARET FARRAND, *The Literary Sculptors*, Duke University Press, Durham, NC, 1965.

Saint-Gaudens, Augustus

DRYFHOUT, JOHN H., *The Work of Augustus Saint-Gaudens*, University Press of New England, Hanover and London, 1982.

GREENTHAL, KATHRYN, *Augustus Saint-Gaudens, Master Sculptor*, The Metropolitan Museum of Art, New York, NY, 1985.

THARP, LOUISE HALL, *Saint-Gaudens and the Gilded Era*, Little Brown and Company, Boston, 1969.

WILKINSON, BURKE, *The Life and Works of Augustus Saint Gaudens*, Dover Publications, Inc., New York, NY, 1985.

Shagin, Alex

"Alex Shagin Designs Anne Frank Medal," *Coin World International,* June 22, 1988, p. 62.

ALPERT, DON, "Various Commemoratives Pay Tribute to the Olympics," *Los Angeles Times,* August 2, 1984.

HOFFS, ELLEN, *California Living,* July 6, 1986.

"International Exposition Explores Realm of the Art Medal," *The Numismatist,* July 1987, pp. 1479-80.

LEOTTI, E.J., ED., "The 1988 Brookgreen Gardens Membership Medal by Alex Shagin," *The Medallist,* Volume 5, Number 1.

REITER, ED, "Constitution Medals Say an Immigrant's Thanks," *The New York Times,* Pastimes, August 9, 1987, p. 32.

——- "Designed for Peace," *The New York Times,* December 21, 1986.

——- "From Russia With Love," *COINage,* 1988, p. 8.

Sheppard, Joseph

Exotica, New Works by Joseph Sheppard, exhibition catalogue, Carolyn Hill Gallery, New York, November 16-December 2, 1990.

SHEPPARD, JOSEPH, *The Work of Joseph Sheppard, Selected Paintings, Drawings, Watercolors and Sculpture from 1957 through 1980,* Arti Grafiche, Giorgi & Gambi, Florence, Italy, 1982.

Somogyi, Marika

HAMILTON, MILDRED, "Bay Area Artist's Face of Liberty," *San Francisco Examiner,* January 14, 1986.

Turner, David H.

SHEPHERD, VIRGINIA, "Captured in Bronze," *Virginia Wildlife,* Vol. 53, No. 1, January 1992, pp. 14-15.

TURNER, WILLIAM AND DAVID, *Turner Sculpture: American Wildlife in Bronze and Silver,* privately printed, 1991.

Turner, William

"Eagle Captures the Spirit of Lindbergh," *The Eastern Shore News,* Accomac, VA, Vol. LXXXXII, No. 9, June 28, 1979.

"LMC Dedicates Bear Sculpture," *Avery Journal,* Banner Elk, NC, May 12, 1988, p. 17.

MOORE, DICK, "Sculptures Bring Artist National Acclaim," *Lifestyle,* Salisbury, MD, October 5, 1986, Section B.

RAMOS, JANE, "Wildlife Captured in Bronze," *Southwest Times Record,* Fort Smith, AR, October 13, 1985, p. 1B.

REIGER, GEORGE, "My Dentist the Sculptor," *Field and Stream,* December 1983, p. 98.

REIMS, GORDON A., "Achiever in Bronze," *Chesapeake Bay Magazine,* February 1988, pp. 45-47.

RUEHLMANN, WILLIAM, "Nature's Alive in his Eyes and his Hands," *The Virginian-Pilot,* Norfolk, VA, June 27, 1982, pp. B1 & G9.

TURNER, WILLIAM, "Lost Wax Bronze Process," *Virginia Wildlife,* Vol. 53, No. 1, January, 1992, pp. 16-19.

TURNER, WILLIAM AND DAVID, *Turner Sculpture: American Wildlife in Bronze and Silver,* Privately printed, 1991.

WOLFF, MILLIE, "He Sculpts Life into His Subjects," *Palm Beach Daily News,* Palm Beach, FL, Vol. XCII, No. 197, 1987.

Walter, Joseph

"Bronze Memorial Plaque Dedicated to Jacksonites Who Died for Freedom," *The Hickory Log,* Andrew Jackson High School, St. Albans, NY, April 6, 1949.

FJELDE, PAUL, "The Figure in Sculpture," *National Sculpture Review,* Summer 1962, pp. 6-10, 24.

WAGONER, MIKE, "No Pomp, Fanfare; Bronze Head of Lyman James Briggs President to MSU College," *The State Journal,* Lansing, MI, June 4, 1971.

Weems, Katharine Lane

AMBLER, LOUISE TODD, *Katharine Lane Weems, Sculpture and Drawings,* The Boston Athenaeum, Boston, MA, 1987.

WEEMS, KATHARINE LANE, *Odds Were Aginst Me, A Memoir*, Vantage Press, Inc., New York, 1985.

Widstrom, Edward

HONDERS, JOHN, *The World of Birds*, Peebles Press, New York-London.

Winkel, Nina

"Celebration of Faith," *National Sculpture Review*, Vol. XXXI, No. 1, Spring 1982, pp.21 and 25.

DRYFOOS, NANCY, "Nina Winkel...Her Copper Sculpture," *National Sculpture Review*, Vo. XX, No. 4, Winter 1971-72, pp. 18-19 and 28-29.

"The Society of Medalists 77th Issue, May 1968," descriptive brochure.

Worth, Karen

BLACK, PAT, "A Celebration of Life: The Medallic Art of Karen Worth," *The Numismatist*, February, 1979, pp. 265-272.

"The Depth of Karen Worth, Sculptor," *Coin World*, Wednesday, January 30, 1980, p. 4.

REITER, ED, "Holocaust's 'Lost Hero'," *The New York Times*, New York, NY, 1980.

"Saltus Award to Karen Worth," *ANS Newsletter*, American Numismatic Society, New York, NY, Winter, 1980, pp. 1, 4 & 6.

Wright, Charles Cushing

BAXTER, BARBARA A., *The Beaux-Arts Medal in America*, September 26, 1987 to April 15, 1988, The American Numismatic Society, New York City.

Wyatt, Greg

"Confrontation and Peace," *The New York Times*, New York, NY, May 10, 1985.

JANSON, ANTHONY, *The Sculpture of Greg Wyatt*, Bergen Museum of Art & Science, Paramus, NJ, 1990.

JOHNSTON, EVELYN, "The ABS Eagle Surveys Broadway," *Surveyor*, American Bureau of Shipping, New York, NY, November, 1979, pp. 16-19.

LAMBERT, PAM, "The Eagle has Landed on Lower Broadway," *Columbia University Magazine*, Winter, 1979, pp. 49-51.

MCKEOWN, FRANK, "Ancient Art Flourishes," *Daily News*, New York, NY, November 22, 1984, p. K10.

"Peace Sculpture Dedicated to Creativity of Children," *New York Tribune*, October 16, 1984.

"Youth Awards of 1979," *National Sculpture Review*, Fall 1979, pp. 16-17.

Zorach, William

The American Magazine of Art, Volume 28, March 1935, p. 160.

CRAVEN, WAYNE. *Sculpture in America*, University of Delaware Press, Newark, DE, 1984 (reprint), p. 576.

MENCONI, SUSAN E., *Uncommon Spirit, Sculpture in America 1800-1940*, Hirschl & Adler Galleries, Inc., New York, 1989.

PARKES, KINETON, *The Art of Carved Sculpture, Vol. I*, Charles Scribner's Sons, New York, NY, 1931, p. 152.

"William Zorach Memorial Exhibition, Sculpture, Drawings and Watercolors," The American Academy of Arts and Letters, New York, NY, February 28-March 30, 1969.

ZORACH, WILLIAM, *Art is My Life, The Autobiography of William Zorach*, The World Publishing Company, Cleveland and New York, 1967.

Necrology

The necrology lists the birth and death dates (by year) of every sculptor represented in the Brookgreen Gardens collection. This alphabetical list includes sculptors from *Brookgreen Gardens Sculpture* (Proske), as well as from this publication.

Herbert Adams	1858-1945
Robert Ingersoll Aitken	1878-1949
Carl Ethan Akeley	1864-1926
Edmond Romulus Amateis	1897-1981
Robert Alexander Baillie	1880-1961
Percy Bryant Baker	1881-1970
George Grey Barnard	1863-1938
Paul Wayland Bartlett	1865-1925
Chester Beach	1881-1956
Abram Belskie	1907-1988
Karl Bitter	1867-1915
George Winslow Blodgett	1888-c.1959
Gustav Bohland	1897-1959
Gutzon Borglum	1867-1941
Solon Hannibal Borglum	1868-1922
Joseph Lorkowski Boulton	1896-1981
Clio Hinton Bracken	1870-1925
Edith Woodman Burroughs	1871-1916
Alexander Stirling Calder	1870-1945
Granville Wellington Carter	1920-1992
Gaetano Cecere	1894-1985
Cornelia Van Auken Chapin	1893-1972
Nathaniel Choate	1899-1965
Allan Clark	1896-1950
James Lippitt Clark	1883-1969
Henry Clews, Jr.	1876-1937
Joseph Arthur Coletti	1898-1973
Marjorie Jay Daingerfield	1900-1977
Cyrus Edwin Dallin	1861-1944
Jo Davidson	1883-1952
Anthony de Francisci	1887-1964
Donald Harcourt De Lue	1897-1988
George Demetrios	1896-1974
Edwin Willard Deming	1860-1942
Dorothea Henrietta Denslow	1900-1971

Gleb W. Derujinsky	1888-1975
William Hunt Diederich	1884-1953
Abastenia St. Leger Eberle	1878-1942
Joseph Bailey Ellis	1890-1950
Rudulph Evans	1878-1960
Avard Tennyson Fairbanks	1897-1987
Sally James Farnham	1876-1943
Beatrice Fenton	1887-1983
Paul Fjelde	1892-1984
Joseph Charles Fleri	1889-1965
James Earle Fraser	1876-1953
Laura Gardin Fraser	1889-1966
Daniel Chester French	1850-1931
Victor Frisch	1876-1939
Harriet Whitney Frishmuth	1880-1980
Sherry Edmundson Fry	1879-1966
Vincent Glinsky	1895-1975
Frances Bryant Godwin	1892-1975
Charles Grafly	1862-1929
Dorothea Schwarcz Greenbaum	1893-1986
John Gregory	1879-1958
Frances Grimes	1869-1963
Karl Heinrich Gruppe	1893-1982
Trygve Hammer	1878-1947
Adlai Stevenson Hardin	1901-1989
Julian Hoke Harris	1906-1987
Jonathan Scott Hartley	1846-1912
Cleo Hartwig	1911-1988
Eli Harvey	1860-1957
Ernest Bruce Haswell	1889-1965
Benjamin Franklin Hawkins	1896-1989
Elsie Ward Hering	1872-1923
Henry Hering	1874-1949
Paul Herzel	1876-1956
Willard Hirsch	1905-1982
Edward Fenno Hoffman III	1916-1991
Malvina Cornell Hoffman	1885-1966
Ethel Painter Hood	1908-1982
Cecil de Blaquiere Howard	1888-1956
Edith Howland	1863-1949
Ralph Hamilton Humes	1902-1981
Anna Hyatt Huntington	1876-1973

Hazel Brill Jackson	1894-1991
Sten Wilhelm John Jacobsson	1899-1983
Carl Paul Jennewein	1890-1978
Ralph Jester	1901-1991
Grace Mott Johnson	1882-1967
Louis Paul Jonas	1894-1971
Helen Journeay	1893-1942
Sylvia Shaw Judson	1897-1978
Charles Keck	1875-1951
Edward Kemeys	1843-1907
Ernest Wise Keyser	1876-1959
Joseph Kiselewski	1901-1988
Isidore Konti	1862-1938
Mario Joseph Korbel	1882-1954
Benjamin Turner Kurtz	1899-1960
Gaston Lachaise	1882-1935
Anna Coleman Ladd	1878-1939
Albert Laessle	1877-1954
Michael Lantz	1908-1988
Hilda Kristina Lascari	1885-1937
Gertrude Katherine Lathrop	1896-1986
Robert Laurent	1890-1970
Leo Lentelli	1879-1961
Lone Wolf (Hart Merriam Schultz)	1884-1970
Evelyn Beatrice Longman	1874-1954
Arthur Emanuel Lorenzani	1885-1986
Frederick William MacMonnies	1863-1937
Hermon Atkins MacNeil	1866-1947
Oronzio Maldarelli	1892-1963
Albino Manca	1898-1976
Bruno Mankowski	1902-1990
Paul Howard Manship	1885-1966
Harriet Hyatt Mayor	1868-1960
Edward McCartan	1879-1947
Robert Tait McKenzie	1867-1938
Robert Johnson McKnight	1905-1989
Eleanor Mary Mellon	1894-1979
Ralph Joseph Menconi	1915-1972
Donald R. Miller	1925-1989
Carl Milles	1875-1955
Pietro Montana	1890-1978
Bruce Moore	1905-1980

Katherine Gibson Van Cortlandt Morton	1895-1973
Elie Nadelman	1882-1946
Berthold Nebel	1889-1964
Joseph Nicolosi	1893-1961
Charles Henry Niehaus	1855-1935
Constance Ortmayer	1902-1988
Willard Dryden Paddock	1873-1956
Bashka Paeff	1893-1979
Madeleine Park	1891-1960
Edith Barretto Parsons	1878-1956
Haig Patigian	1876-1950
Roland Hinton Perry	1870-1941
Attilio Piccirilli	1866-1945
Bruno Piccirilli	1903-1976
Furio Piccirilli	1868-1949
Horatio Piccirilli	1872-1954
Albin Polasek	1879-1965
Hiram Powers	1805-1873
Alexander Phimister Proctor	1862-1950
Brenda Putnam	1890-1975
Richard Recchia	1888-1983
Frederic Remington	1861-1909
Joseph Emile Renier	1887-1966
Robert Henry Rockwell	1885-1973
Randolph Rogers	1825-1892
Frederick George Richard Roth	1872-1944
Charles Rudy	1904-1986
Charles Cary Rumsey	1879-1922
Augustus Saint-Gaudens	1848-1907
Louis St.-Gaudens	1853-1913
Edward Field Sanford, Jr.	1886-1951
Marion Sanford	1904-1988
Eugene Spalding Schoonmaker	1898-c.1952
Janet Scudder	1873-1940
Eugenie Frederica Shonnard	1886-1978
Amory Coffin Simons	1866-1959
George Holburn Snowden	1902-1990
Erwin Frederick Springweiler	1896-1968
Lawrence Tenney Stevens	1896-1972
Albert T. Stewart	1900-1965
Lorado Taft	1860-1936
Grace Helen Talbot (Randall)	1901-1971

Charles Eugene Tefft	1874-1951
Allie Victoria Tennant	?-1971
Paul Troubetzkoy	1866-1938
Bessie Potter Vonnoh	1872-1955
Joseph Walter	1896-1987
John Quincy Adams Ward	1830-1910
Heinz Warneke	1895-1983
Sidney Biehler Waugh	1904-1963
Katharine Lane Weems	1899-1989
Albert Walter Wein	1915-1991
Elbert Weinberg	1928-1991
Adolph Alexander Weinman	1870-1952
Howard K. Weinman	1901-1976
Gertrude Vanderbilt Whitney	1877-1942
Edward Frederick Widstrom	1903-1989
Wheeler Williams	1897-1972
Nina Winkel	1905-1990
Alice Morgan Wright	1881-1975
Charles Cushing Wright	1796-1854
Julie Chamberlain Yates	?-1929
Ruth Yates	1896-1969
Mahonri Mackintosh Young	1877-1957
William Zorach	1887-1967

Index